Talking Painting

"David Ryan has interviewed twelve of today's leading abstract artists, each of whom has chosen a distinguished art writer to further elucidate their work. The upshot is an illuminating and lively compilation."

Irvin Sandler

Abstract painting continues to engage with a variety of problems and issues whose roots can be located within modernism and yet now reach beyond it. *Talking Painting* asks questions about recent abstract painting and its current status, bringing together twelve key practitioners with eminent critical theorists to provide 'snapshots' of thought processes and attitudes, while also locating painting in a broader cultural and historical context.

Each featured artist has chosen a critical text which they feel illuminates their work, and each of these is, in turn, complemented by David Ryan's in-depth interviews. These conversations address theoretical and practical issues which are both relevant to each artist's concerns and also provide a more general overview from their individual perspectives, while Ryan's introductory essay brings together a diverse range of theoretical motifs which have marked the shifting cultural climate of painting over the last twenty years.

Talking Painting is a book full of insights, juxtaposing the conventional interview with more formal critical commentary, and is invaluable to anyone interested in the continuing debates around the development of abstract art.

David Ryan is a painter and writer, and is currently a senior lecturer at Chelsea College of Art and Design in London. He has previously written on Shirley Kaneda, Bernard Frize, John Riddy, Katherina Grosse, Karin Sander, Fabian Marcaccio, amongst others. He has also contributed to numerous catalogues, including publications for Camden Arts Centre in London, Galeria Salvador Diaz in Madrid, The Tate Gallery in Liverpool, Sammlung Goetz in Munich and the University of Mexico (UNAM) in Mexico City.

with generous support from

Chelsea College of Art and Design, London

Talking Painting

Dialogues with Twelve Contemporary Abstract Painters

David Ryan

Routledge
Taylor & Francis Group

LONDON AND NEW YORK

First published 2002
by Routledge
11 New Fetter Lane, London EC4P 4EE

Simultaneously published in the USA and Canada
by Routledge
29 West 35th Street, New York, NY 10001

Transferred to Digital Printing 2004

Routledge is an imprint of the Taylor & Francis Group

© 2002 Taylor & Francis Books

Typeset in Walbaum by Scientifik Graphics (Singapore) Pte Ltd
Printed and bound in Great Britain by TJI Digital, Padstow, Cornwall

British Library Cataloguing in Publication Data
A catalogue record for this book has been applied for

Library of Congress Cataloging in Publication Data
A catalog record for this book has been applied for

ISBN 0-415-27629-2

Contents

PREFACE

This volume suggests the possibility of examining aspects of the practice of contemporary abstract painting against a shifting theoretical and cultural climate. It has attempted to bring such theory into the studio, so to speak, and aims to remain close to the practice itself. It does not seek to map out any totalising vision for such practices, but rather, through the process of juxtaposing the informal conversational interview and the more formal exposition of critical commentary, to allow a variety of practical, historical and theoretical perspectives to emerge. Both intentionality and critical distance are allowed to unfold here as potential sites for the production of meaning, acting as 'snapshots' of the responses and thought processes of artists and critics. Each essay was chosen by the artist in question, reflecting a diversity of critical approaches and concerns, also bringing together new essays written especially for this collection. Jeremy Gilbert-Rolfe provides a key essay, discussing current painting from the viewpoint of a practitioner and theorist.

A word might be needed about both the scope of the book and the selected artists. Firstly, the majority of practitioners included here came to the fore in the mid to late 1980s, and might be identified as artists reassessing the possibilities of abstraction in the wake of the rather hostile culture of the early 1980s, from which period the earliest of the essays dates. Secondly, most of the painters present in the volume have had to address the kind of spaces that have opened up since the demise of the American formalist discourse within modernism. Such a demise does not, of course, infer any redundancy of formalist approaches or of abstraction's address to form, but instead, marks them off from any linear or totalised and unifying framework. It is now difficult to argue the 'sovereign' place of either abstraction or painting, in the sense of being superior to other genres or mediums, or being heir to a more central or essential lineage. Because of this, painting positions itself in relationship to other media, the everyday and heterogeneous practices in ever new and exciting ways. In the present context, the term 'abstraction' and the debates that such a term develops should be seen as provisional and questioning, rather than as a label or categorical term.

Finally, the artists selected for the book are not to be seen as a coherent grouping or 'movement', even though various painters might share visual similarities or approaches. Nor do they provide any definitive lexicon of 'contemporary' abstract painting, as there are many other practitioners, or even modes of working, that have been excluded. It might be added here, though, that 'complexity' rather than

'reduction' figures as a prominent thematic for the book. The issue of this 'new complexity'—to borrow a term from contemporary music— actually forms a thread that might bind these artists together in a loose way. The emphasis is also on the complex legacy of American abstraction as both a 'negative' catalyst and an ongoing source of reference. For this reason, the core of the interviews took place in New York from 1996–7; in 1997–8, some European artists who had a similar critical relationship to American painting were interviewed, and finally, Jessica Stockholder in 2000. In terms of its span, the book looks back over the last eighteen years, and if it opens more discussion as to the future of abstract art in an ever-changing context then it will have served its purpose.

I would like to thank all the contributors, writers and artists, and the various relevant galleries for their help in realising this project, and also Chelsea College of Art and Design in London for their generous support. Finally, particularly warm thanks go to Jonathan Lasker for his initial suggestions and advice, and also Shirley Kaneda and Saul Ostrow for their invaluable help. I would also like to thank Melissa Larner for her assistance and judgement, Keith Patrick for his support and Katie Pratt for her generous practical help during the early stages of preparing the manuscript.

INTRODUCTION
David Ryan

How do we connect the contemporary condition of abstract painting with its history? Such a question invites not just an interrogation of what we might mean by 'abstraction' but also the complex issue of constructing histories, or even a sense of the 'contemporary', from the perspective of the present. Here, we are immediately presented with the seeming double-bind of the situation of abstract painting: how, for example, might a particular work consciously posit itself within a historical framework, and yet point to its singularity, eluding any simple demonstration or didactic illustration of a tradition or genre? In having to engage with such questions, abstract painting remains more actively involved in its own 'narratives' and histories than many other contemporary approaches to art-making. To some interpreters,

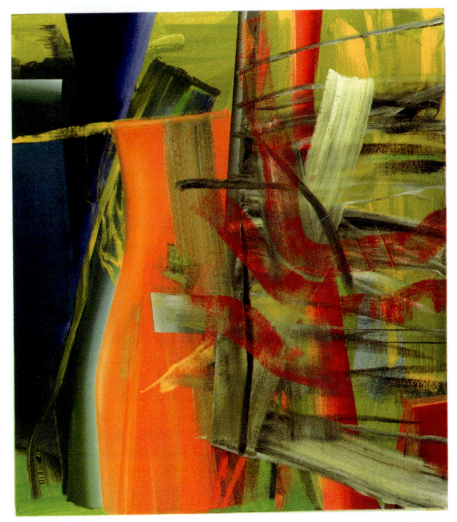

Figure 1 Gerhard Richter, *Vase*, 1984, Oil on canvas, 225 × 200 cm, Courtesy The Artist.

this has appeared a mixed blessing, and is partly responsible for abstraction's perceived 'irrelevance' amongst certain quarters of the critical and curatorial establishment. Seen in this light, abstraction is construed as a discipline that cannot rid itself of its own important role within the twentieth century, where it took on almost emblematic proportions through a sequence of defining moments, which it continues to reflect upon and, some might say, endlessly re-enact. One such moment was abstract painting's paradigmatic functioning within North American formalist criticism, canonical and stifling enough to suggest a situation of exhaustion for later generations of artists.

Despite various declarations of a 'return to abstraction' that have ritualistically, and rather predictably, taken place periodically since the early 1980s, abstract painting continues to develop, in the words of Jeremy Gilbert-Rolfe, 'in a subterranean sort of way'. The present condition of abstract painting is like an inversion of its valorisation within American modernist formalist thinking. Fragmented, multiple, heterogeneous, without any unified or centralised core of theory or history: this is the topography of what might be referred to as *post*-formal. The writings and interviews that form this collection occupy such a multiple space; what follows below will endeavour to provide a broad context, and some kind of background. It seeks to refract the concept of abstraction, and reframe its place within a process of 'moving through' signification and representation—one that is also connective, rather than essentialist or reductive. In order to arrive at this point, it is necessary to cut across a series of concepts, historical moments and accounts, without which it would be impossible to examine various inferences of abstraction: its historical bond with notions of autonomy, its relation to modernism, to language, and finally, the seeming inevitability of the complexity of its present condition.

As a term, 'abstraction' has been with us for a long time and while often causing more confusion than clarification, the term has stuck; and despite the resulting encumbrance, artists and critics have continued its usage, more as a convenience or a convention rather than an accurate pointer.[1] If we think of its literal meaning, then it implies an extraction of some kind, or an essentialist position, which is why so many artists are wary of it as a tag or label. Yet, such processes of extraction, and the deduction of essential principles, cross over with notions of abstract thought in other disciplines: music, mathematics, science and technology; each of these, in fact, was variously invoked as an analogous parallel within the diverse practices of early abstractionists. Modernism (again thinking across disciplines), for at least the first half of this century, put direct emphasis on structure as revelation, as though some 'abstract' basis of the mind, or even reality itself, could be projected, figured and experienced.[2]

Stripped of the idealism of pre-war pronouncements, later modernism sought to reground the transcendental aspects of experimental abstraction back into a material context. In their different ways Clement Greenberg and

Theodor Adorno, prominent cartographers—and war-horses—of the modernist project, suggest divergent topologies of both the abstract and the autonomous. Famously, Greenberg stressed a rationalisation of artistic spheres through the intense process of 'the avant garde's specialisation of itself',[3] while Adorno, more cautiously, always presented the moment of autonomy as one perpetually stalked by the ghost of social heteronomy.

The attempts of Greenberg and Adorno to articulate the logic of abstraction within modernism are, at the end of the day, fundamentally opposed, despite certain overlaps.[4] For one, the movements of the 'logic' of modernism positively rationalised competence; for the other, it was the erosion of these qualities, a brinkmanship that teetered close to the edge. Both these positions formulated critical methods and responses that have heavily influenced the reception and critical discourses of abstract painting, and in many ways continue to do so. In different ways, abstraction figures for them as a negative moment. Greenberg sees abstraction partly defined by a suppression of illusionistic space, or of any particular form that might allude to such space; it is, therefore, defined by what it avoids. Adorno, on the other hand, imbricates the abstract with a negative dialectic—one that is sedimented with the social and yet appears as its 'other'.

More recently, John Rajchman, writing from a Deleuzian perspective, has argued for a sense of abstraction that is opposed to this *via negativa*, which he sees as a thread running throughout modernist narratives, whereby abstraction is figured as

> What is not figurative, not narrative, not illusionist, not literary and so on, to the point where one arrives at a sanctifying negative theology in which "art" (or "painting") takes the place of "God" as That to which no predicate is ever adequate and can only be attained via the "*via negativa*".[5]

Certainly, Adorno would have balked at such a model of the negative being bound up with a unifying transcendental signifier, but Rajchman's point is to stress the differences between an abstraction that is bound up with saying 'Not ... ' and one that enunciates 'And...', therefore to be viewed *with* rather than *against*. Thus the 'stripping-down', 'clearing-away' processes of formalist modernism are replaced with an, 'Abstraction that consists in an impure mixture and mixing up, prior to Forms, a reassemblage that moves toward an outside rather than a purification that turns up to essential Ideas or in toward the constitutive "forms" of a medium'.[6] Such rethinkings, for Rajchman, offer up a realignment of the notion, and nature, of 'abstract' thought processes and the relationship such processes will have with not only a given artwork, but also the world in its broadest sense. These relationships should then be thought of not as concrete oppositions, but as 'forces' that will connect, detach, and re-form with other structures; what

Gilles Deleuze and Félix Guattari have referred to as 'abstract machines'.[7] The reliance of abstraction on form is thus rethought, suggesting the possibility of a less 'leaden' way of thinking—one that is sensitive to intensities that cut across the difference between specific forms and that openly display a 'passage' between; without recourse to any Hegelian informing spirit, Platonic Idea, or materialist structure. These thoughts, it should be stressed, open up a trajectory that reconfigures ways of addressing abstraction, and subtly find connections with recent practice, rather than offering direct explanations or any coherent programme.

Deleuze and Guattari illustrate this possibility of forces and intensities that cut across various manifestations of form with a model of immense variability and potentiality; this model is the rhizome, which is presented in opposition to the root-and-branch classical schemata of the tree as world-image. The rhizome, by contrast, operates as a complex 'transformal' structure that can adopt many different forms and which, 'Vary ... from ramified surface extension in all directions to bulbs and tubers'.[8] Such a position does not engage in revealing primary structures, or entertain any metaphysics of absence that inform many of the ideals of the early abstractionists, including Mondrian and Kandinsky. In one of many such examples, Deleuze and Guattari criticise the basic binary logic of dichotomy that permeates Chomskyian linguistics with their 'deep structures', suggesting that

> Our criticism of these linguistic models is not that they are too abstract but, on the contrary, that they are not abstract enough, that they do not reach the 'abstract machine' that connects a language to the semantic and pragmatic contents of statements, to collective assemblages of enunciation, to a whole micropolitics of the social field. A rhizome ceaselessly establishes connections between semiotic chains, organisations of power, and circumstances relative to the arts, sciences and social struggles.[9]

The 'use' of rhizomatic structures, therefore, allows Deleuze and Guattari to make constant connections between things, as well as to think beyond the erected boundaries of medium-specific criticism, or beyond chronological structuring itself. On one level, the rhizomatic explodes the space-time frame of formalist criticism; but this does not mean any displacement or supercedence as in many crude postmodernist positions or outlines.[10] These 'abstract machines' are always deducted from—and at work in—the singular and particular, even though, 'They know nothing of forms and substances. This is what makes them abstract, and also defines the concept of the machine in the strict sense'.[11] At the same time, because of this, such abstractions are not to be conflated with any informing essence or foundation: 'There is no abstract machine, or machines, in the sense of a Platonic Idea, transcendent, universal, eternal'.[12]

Any discursive theoretical approach to abstraction, especially one that reflects on recent practice, must accept that the concept of autonomy has, in this way, been unravelled. It can also be argued that the purely visual alone—which itself is always a construct—can no longer provide a sufficient basis for the practice of abstract painting. This is not to say that all recent abstraction is overly theoretical or sets out to denigrate the purely visual, but that the forms in themselves that are mobilised put previous theoretical frameworks under pressure. Having said this, it is important, of course, not to smooth out the inherited complex spaces of modernism into a caricature; particularly as the construction of this relationship of the visual to the autonomous finds difficulty being integrated into any one univocal model. Andrew Wilson picks up on this in his essay on Ian Davenport. Wilson makes it clear from the outset that the issue of visuality itself within modernism cannot be reduced to a singular Greenbergian or Friedian reading. Within this context, Maurice Merleau-Ponty's perceiving subject, as one phenomenologically and corporeally positioned, is invoked in order to complicate the site of this visuality. Whereas paintings such as Davenport's might, at first glance, be seen to address an autonomous modernist visuality in the former sense, Wilson stresses the interconnectedness between a triadic projection of the various spaces of *work, production* and *siting*; despite generating different meanings and contexts, each of these spaces can be folded onto each other. The relationship between meaning, making and their connection with the environment is explored through examining various aspects of Davenport's output. Differentiating this approach from Process art or the purely optical, Wilson suggests that, 'The painting can be recognised not as a mute object but as a collection of structures that connect to the space of the viewer as much as the space of the painting and the spaces through which it has been made'.

Likewise, Guy Tosatto discusses the work of Bernard Frize also in relation to autonomy, but reaching very different conclusions. Frize's sense of the autonomous, according to Tosatto, is arrived at through both scepticism and play, which in turn help keep the 'weight' of painting's traditions at a critical distance. Frize's apparently simple approach to composition, chance and colour, display a subtle and disconcerting 'ruffling' of certain assumptions regarding 'craft', process, and the resultant image. In other contexts, colour has often been pinpointed in formal analysis, not to bring attention to itself, but rather to explain the spatial construction of a painting. David Joselit, on the other hand, focuses on the 'virtually literary excess' of Mary Heilmann's loaded colour combinations, which, despite their seemingly formal staging, unbind sensations of time and place. The grid, Joselit argues, formerly the site of 'a perfect spirituality' is now filled, 'Almost to the breaking point—with allusions to the domestic everyday world and to an intense and palpable presence of the body. What was stiff and otherwordly has become intimate and overflowing'.

Such reversals are common within recent practice, but certainly not always programmatic. Gerhard Richter's seminal abstract paintings from the early 1980s, to take an example outside the remit of this book, offer up only enigmatic clues to their intentionality, identity, and positioning within abstract painting's various histories. Benjamin Buchloh has read them as critically (but also ambiguously) conjuring up various moments of 'authenticity' from painting's hallowed past: of chromaticism and its relation to 'spiritual space', and facture as a, 'Symbolic sign that supposedly renders an unmediated and substantial presence of the transcendental experience'.[13] While Ulrich Loock, in another commentary, suggests that Richter utilises such activities as a means of stripping them of their ideological and historical constraints. Richter, Loock suggests, reveals the picture's 'event'—its alignment to the incomprehensibility of the 'real'—engaging a non-systematic but rigorously methodical un-anchoring of the pictorial elements through a play of difference.[14] Here, the important question of the arbitrary is raised, an anxiety that runs through the history of abstract painting, and is tackled head on, reassembling a painterly practice not governed by models or determinable rules. On another level, not only does such a practice question the nature of any binary opposition of figurative/abstract, but also highlights the whole issue of unity and part/whole relationships—in the individual work and also in the larger frame of the oeuvre itself.

Unity, later transposed into 'wholeness' and 'completeness' by the Minimalists, became for formalist modernism another means of achieving an integral and autonomous status for the work of art. This wholeness functioned in a variety of different ways, whether as some kind of acceptance of non-anthropomorphic 'concreteness' for the Minimalists; or for critics such as Greenberg and Fried, a kind of mirage; a sublated *trompe l'oeil* transfigured into the optical field. While recent abstraction has tended to avoid such a conception of wholeness, it would be misguided to suggest that a logic of the detail, fragment or fracture has completely replaced any striving for coherent unity. It is a conception of the whole that has also been re-figured: one that is inclusive, pliable and open to difference. Gilles Deleuze has clearly shown how an obsession with the fragmented and the multiple can fold onto another sense of unity or totality.[15] Citing the philosophy of Leibniz, and the writings of Mallarmé, and Joyce, Deleuze suggests the paradox of the inseparability of a fragmented chaosmos and 'total book'. A Baroque over-determination informs such an outlook, with the work *as* the world. Elsewhere, in his writings on cinema, Deleuze develops another fluid interplay of whole/part relationships, drawing on a Bergsonian notion of Open wholeness. Such a temporal model might, ironically, shed some light on the multiple spaces of much contemporary painting, especially as it was this very temporality that was suppressed in late modernist criticism. I am thinking here of Michael Fried's articulation of 'presentness' in relation to the particular experience of modernist painting, as opposed to

the mundane 'presence' of the everyday.[16] Here, the instantaneity of forming a perception of the whole is stressed, its seeming 'completeness' devoid of any sensation of 'real time'. Contrary to this, in discussing Bergson, Deleuze's projection of the 'whole' works at the level of keeping a series of sub-sets from complete closure:

> A set of things may contain very diverse elements, but it's nonetheless closed, relatively closed or artificially limited. I say 'artificially' because there's always some thread, however tenuous, linking the set to another larger set, to infinity. But the whole is of a different nature, it relates to time: it ranges over all sets of things, and it's precisely what stops them completely fulfilling their own tendency to become completely closed ... It's the whole which isn't any set of things but the ceaseless passage from one set of things to another, the transformation of one set of things into another.[17]

For Deleuze, this interpretation of part-to-whole is suggestive of how cinematic processes actually work. From still-frame to sensations of movement and right through to our perceptions of off-screen action and voice-overs, etc. In considering the complex address to the viewer made by many contemporary abstract paintings, it is possible to translate these concerns back, from a philosophical musing on time via cinema, to the plastic visual arts. Shirley Kaneda's paintings explore multiple spaces that combine the literal and the optical in such a way as to block any 'instantaneous' illusory grasp of the whole. This is replaced by what Andrew Benjamin refers to as, 'Points of dissociation and differentiation'. In developing a kind of contrary motion of splitting apart and moving across, Kaneda implicates the viewer in a slower pace of looking. Benjamin 'writes' and 'thinks through' this process of looking, of piecing together, and identifying the nature of parts and their interconnection, highlighting the whole/part relationships that are manifested through such a process. 'Moving from one stage to the next is to move between elements constituted by interruption. And yet, precisely because this is not a simple activity the question of relation insists'. Such a concern with difference, connectivity, relation and interruption, ensure the figuring, within each work, of a whole that both underlines and realises their singularity and yet potential interconnectedness with other paintings.

David Reed also explores the temporal, but from rather different perspectives. The painterly processes utilised by Reed are difficult to trace in the finished pictured image, with seemingly spontaneous marks frozen and integrated by embellishment. Unity is fractured by Reed on many different levels: by this deferral of the dis*play* of the time of making through its difficult readability; in the environmental realisation of the installational

ensemble of works; and, also, the questioning of the actual 'space' of painting. Arthur Danto concentrates on this latter point in his essay on Reed where he discusses the insertion of his paintings in various stills from Hitchcock's *Vertigo*. This exchange leads to a transformation of each space. What happens, asks Danto, when a museum painting becomes part of the intimate space of the bedroom? How does this change our reading of both? Addressing the artist's installation in Cologne, Danto suggests, 'One of Reed's paintings hangs over the bed, as if to say: "Experience these works as you would if they were your bedroom paintings. Experience them as occasions of intimacy and reverie"'. Danto goes on to point to the nature of the work in this context as being both, 'Real outside the film ... and unreal as part of the bedroom in the film'. This 'virtual' life of the painting explodes the limitations of the physical constraints of the work, putting it in circulation as a fictional image amongst other fictional images.

By complete contrast, Günther Förg emphasises architectural space as both unifying subject matter for his diverse output, and as physical container. The theatricality of such an event is explored by Max Wechsler, who interprets such a staging as a Baroque gesture whereby processes are allowed to flow from one medium to another: from photography to painting, from painting to sculpture and back again. Wechsler suggests that this dialogue allows the development of a discursive approach to, and within, the works themselves. If Förg uses the architecture of a space to allow this discourse to unfold spatially, then Jessica Stockholder goes one step further in dissolving the boundaries between painting, sculpture and installation. Stockholder's dialogue involves a vast array of materials and processes— encapsulating readymade objects and the potentiality of the colour field, together with an active intervention within the space, sometimes actually transforming or cutting into it. Jennifer Higgie takes us through one of Stockholder's more recent installations, allowing a personal and poetic response but also making surprising historical connections on the way: 'Stockholder's giant installation is as indebted to the history of still-life painting as it is to the theatricality of process art, even the most humble of still-life paintings employ a strategy not dissimilar to hers—re-presenting the mundane objects we surround ourselves with, and often ignore, focusing on them with an intensity that casts a different light on both their function and their context'. This, too, is a process of abstracting, and Stockholder herself sees such displacements as setting up a conversation between the objects, the various visual articulations of the installation, and the spectator's discursive journey around the space 'in time'. Here, she alludes to the 'total' experience—which each individual installation can potentially slowly reveal— as being akin to 'fictive narratives'.

Abstraction's relationship to discourse, or more specifically to language, continues to be a moot point. Bound as it is with questions of representation and recognition, it is possible to move between various positions—of

painting's resistance to words, of a parallel language of formal elements that is purely visual, or as a participation in a codified semiotic field. Then there are the problems of commentary, interpretation and theory *per se*.

Shirley Kaneda has suggested that, as a practitioner, these positions are not mutually exclusive:

> Certainly aspects of my work can be verbalised. I can name elements or describe certain passages, but the totality of the work cannot be named. If we accept language's deficiency, it forces us to understand things differently, which to me is something useful ... Our language intrinsically fails to deal with abstract relations, it closes them down and doesn't allow for speculation ... A painting's meaning is what you can attribute to it, and its purpose is to propose something about how meaning is brought about. I believe that there are more types of texts than literary ones and that understanding has a place alongside meaning and interpretation.[18]

Kaneda usefully mobilises, here, different ways of connecting the visual and linguistic, while stressing the ultimate shortfall of the latter. Semiotic analysis, grounded as it is in linguistics, has always had problems when it comes to painting, and especially abstract painting. Roland Barthes suggests, in a rather defeatist tone that, 'We have not been able to establish painting's lexicon or general grammar—to put the picture's signifiers on one side and its signifieds on the other'.[19] This is exacerbated in 'non-representational' painting by the notoriously unclear process of framing legibly semiotic events, and the fact that the 'language' of abstraction consists of what might be seen as 'sub-semiotic' marks, gestures, inflections, too indeterminate to be captured by any stable classification of coding; painting, therefore, remains a medium of excess.[20] Barthes accepts, relishes in fact, this excessive quality, and finds his way out of the semiotic cul-de-sac as follows: it is through the language we use to read a work that a connection is made back to the work—how we *write the picture*; in such a way that each reading (or rather 'writing') *pictures* the picture. The picture 'in itself' will always remain in excess of its reading. Such a situation reverses the traditional semiological equation of a painting being generated by a system of analysable codes, but rather projects painting itself as the generative model. This proposition underlines the indeterminate interface between language and the visual; one that mirrors the increasingly conscious use of indeterminacy on a formal level by practitioners of abstraction. It is this very indeterminacy that brings us back to classical semiotics and also issues of representation.

The complex perceptual processes of signs and codes are now recognised by abstract painters in a very different way from previous generations of practitioners, emphasising, in turn, a realm of inter-subjectivity and discourse rather than the illusion of pure spontaneity or

'private languages'. In this way, the 'isolated' perceiving subject enters a field of signification. 'It takes one person to experience a sensation', suggests Norman Bryson, 'It takes (at least) two to recognise a sign'.[21] This is not to suggest that the actual practice of abstraction is now rigidly socially codified or reduced simply to the level of recycling or quotation. What it does imply is a situation of more fluidity between the purely perceptual and the social space of the sign—or at least more awareness of this process—and in this context, Barthes, again, has discussed this fluidity in relation to representation itself. The word 'representation', with its dual meaning, conjures up a paradox that is writ large within art and its history. Barthes sees this dual meaning as both classical and etymological: in the sense of an analogical copy, 'a resemblance product' (which can be both affective and objective), and literally, a re-presentation, 'The return of what has been presented'.[22]

Desire and pleasure within practice negotiate a path through and around these notions of representation, attempting to explode the already named, but constantly discovering what is already existent and present in language. 'It is here ... ', Barthes argues,

> That the two meanings unite: from one end of its history to the other, art is merely the varied conflict of image and name: sometimes (at the figurative pole), the exact Name governs and imposes its law upon the signifier; sometimes (at the "abstract" pole—which puts it very badly indeed), the Name escapes, the signifier, continually in explosion, tries to undo the stubborn signified which seeks to return in order to form a sign.[23]

Barthes' hesitant reference to the 'abstract pole' illuminates the problems of any binary oppositional categorisation of such terms, as well as the refusal of the 'abstract' to be expropriated from the realms of representation. At the same time, it refuses to be unproblematic when situated here. Hence, a simultaneous triadic movement emerges within a conception of representation, through which we can identify: the analogical, the excessive, and the return of the signified, which constantly attempts to (re)figure its sign-vehicle. Rather than a static model of the sign and signifying systems, into which much of the production of the 1980s was locked, recent abstraction has developed a more dynamic approach that traverses the complex movements and forces that both crystallise and dissolve the formation of signs. If we use a notion of representation, then it is one that is continually in motion—literally a passage—rather than a locatable site.

Fabian Marcaccio's work does just this with a velocity and violence whereby matter transforms into sign, and from swirling textures and quasi-brushmarks we can literally identify crowd scenes, Fascist insignias and

various emblems from pop mythology. Carlos Basualdo sees, in the earlier works a 'Distortion of the alphabet', moving from 'The autistic phrase, and now, the ecstatic representation of a continuous activity, the verbalisation of dead times, the conjunctive tissue of the phrase'. Such an 'Ecstatic representation of continuous activity' might also describe activities at work in Lydia Dona's practice, whereby the elements of each painting have their roots in highly codified signifiers, which in turn are dispersed across what Dona refers to as a 'conceptual site', where identities collide and 'contaminate'. David Moos suggests Dona's work, 'Speaks in two tongues with two referential codes: the textual (Deleuze and Guattari) and the art historical (Duchampesque diagrams, Abstract Expressionist icons, Minimalist components)'. These are not posed as simply contrasting oppositions but constantly reformulated and adapted as 'multiple plateaus'. If Dona and Marcaccio both actively utilise the role of the sign and linguistic analogies, then it is to set in motion an excess of production, a system of leakage whereby a transformational instability replaces any coherent grounding of the sign or code.

Although open to a notion of discourse in a very different way, Jonathan Lasker stresses the inherently visual nature of this process. Lasker presents this dialogue as a kind of ignition between the elements in the painting and the perceiving viewer; almost placeable, almost nameable, the forms in these paintings both partake in and resist the process of recognition, and thus categorisation. Joseph Masheck's virtuoso rollick through art history underlines this point: how do we find any compatible theoretical model that adequately matches the visual experience of a Lasker? Masheck finds, after various temporary locations of rest, resonance in Heidegger's 'world-picture', suggesting the very project of picturability is one that sets Lasker's work apart from many of his contemporaries. Simultaneously archaic and contemporary, Lasker's painting examines the very means of discourse—a picturing that crosses over drawing and the basic elements of writing; that configures the body yet lies beyond it; that embraces a morality that, ultimately, underlies what Masheck calls the artist's 'dandyism'.

For Peter Schjeldahl and Robert Pincus-Witten, the notion of theoretical congruence is not an issue. Schjedahl, writing on Thomas Nozkowski's idiosyncratic abstractions, develops poetic metaphors that run parallel with, yet obliquely contextualise, Nozkowski's work. This stresses the text's adjacency to the work, delicately underscoring an appreciation, as opposed to literal reading or analysis. Pincus-Witten's approach to Gary Stephan, on the other hand, is that of the biographical document; it examines artistic development, personal history and their ensuing formative contact with the volatile social construct of the art world. Pincus-Witten's 'realism' consists of vividly situating the artist at a point in time, and within a given material culture.

Finally, Jeremy Gilbert-Rolfe's introductory essay also highlights the preponderance of the verbal and linguistic through the emphasis put on

'reading' contemporary artworks, which he feels has led to the deprecation of not only non-representational painting, but also the visual as a valid experiential mode in itself. Surface is extrapolated here, as being intimately bound up with, and yet differentiated from, the historical morphology of painting as both skeleton and skin, a site that Gilbert-Rolfe suggests, 'Can persist as a place where the body may think itself'. In stressing the potentiality of surface as one that is periodically redefined in terms of its status as temporal and actual interface—between the subjective and the environmental—Gilbert-Rolfe posits painting in active dialogue with the technological. From its relationship with electronic screens to the blank, smooth plastic surfaces of the contemporary everyday, 'Painting reconsiders, by realising it in terms that have nothing to do with it—and no desire to reproduce or represent it—the zone of alienation between the human and the surfaces within and between which it tries to find its subjectivity, or, if you like, is invented by them'.

The latter point underscores the implicit complex positionality that non-representational or abstract paintings will have today, with their questions of relation (to the environment, the world) and also selfhood. No longer reducible to the cleavage of exteriority or interiority, such selfhood occupies a transverse space, as much realised by as through the materiality it sets in motion. Rather than a 'turning away' from the world, abstraction's continual development exhibits an inexhaustible tropism, constantly forming new connections and surprising allegiances. While still clearing the space for a self-reflexive examination of the medium itself, uniquely, abstract painting proffers, philosophically speaking, an arena where the hermeneutical, the ontological and the phenomenological collide, coalesce and interpenetrate.

NOTES

1. Briony Fer notes: 'as a label, the term "abstract" is on the one hand too all-inclusive: it covers a diversity of art and different historical moments that really hold nothing in common except a refusal to figure objects. On the other hand, "abstract" is too exclusive, imagining a world of family resemblances (geometric, biomorphic or whatever—terms originally deployed by the early critics but still pervasive), which is hermetically sealed from the world of representations around it. As a label it will have to do, because it is a common term in common use, with its own vicissitudes and history'. See Briony Fer, *On Abstract Art*, Yale University Press (New Haven/London), 1997, p. 5.

2. Not only can we think of aspects of the art and writings of Mondrian or Kandinsky here, but also Wilhelm Worringer's *Abstraction and Empathy*. This theoretical underpinning of Expressionism mapped out a position that saw the course of abstract form unaccountable by empathy theory, which could only adequately explain the formulation of an untroubled

mimetic attitude; one that was rooted in an empathy with natural surroundings. According to Worringer's reading, rather than this empathetic response to nature, abstraction asserts a separation, a distinction; the particular object is arrested from the flux of the world and then approximated to a geometric formal regularity. This geometric quality both 'externalises' and seizes the depicted object from the flow of the contingent processes of the world, and accentuates the autonomous sphere of its representation. What is to be underlined here, is the intimate connection of abstraction with the autonomous, and also the corresponding moment of alienation, an *entfremdung* in the Hegelian sense from the natural. Worringer's conclusions suggest that because geometry does not find its basis in nature, its 'absolutism' reflects some deep basis of human organisation, presumably the structure of the mind itself. Thus, the abstract form or line is differentiated and divorced from organic life. This 'urge' towards abstraction has important implications for notions of reworking the spaces of representation. Naturalistic, illusionistic space had to be jettisoned, by reason of its function, in that it stressed the inter-relationship of things and simulated the sensory depth of the perceived world, rather than the tranquillity of the Absolute. See Wilhelm Worringer, *Abstraction and Empathy*, trans M Bullock, Routledge & Kegan Paul (London), 1963.

3. Clement Greenberg, 'Avant-garde and Kitsch' in John O'Brian (ed), *Collected Essays and Criticism*, vol 1, University of Chicago Press (Chicago), 1986, p. 10.

4. One important overlap for Adorno and Greenberg is their division between 'mass culture' and Art. This is also bound up with issues of autonomy, as well as the platitudinous recognisable image. Needless to say, these divisions have long since ceased to be so rigidly upheld. See Greenberg, ibid, and Theodor Adorno and Max Horkheimer, 'The Culture Industry: Enlightenment as Mass Deception' in *The Dialectic of Enlightenment*, Verso (London), 1989, p. 121.

5. John Rajchman, 'Abstractions' in *Constructions*, MIT Press (Cambridge, MA), 1998, p. 57.

6. Ibid, p. 56.

7. See Gilles Deleuze and Félix Guattari, *A Thousand Plateaux*, Athlone (London), 1988, 1996.

8. Ibid, p. 7.

9. Ibid.

10. Aspects of formalist criticism still find a place in their texts and are used in surprising ways—one example is the use made of Michael Fried's analysis of Pollock's line, the unbounded quality of this being, 'Multidirectional, with neither outside nor inside, form nor background, delimiting nothing, describing no contour, passing between points,

stirring a smooth space'. Such a deterritorialisation of the binding activity of line, and thus space itself, emphasises an almost virtual, nomadic quality. See ibid, p. 575, etc.

11. Ibid, p. 511.
12. Ibid, p. 510.
13. Benjamin HD Buchloh, 'Richter's Facture: Between the Synecdoche and the Spectacle' in *New Art: An International Survey*, Academy Editions (London), 1991, p. 194.
14. Ulrich Loock: 'Das Ereignis des Bildes' in Ulrich Loock, Denys Zacharapoulos, *Gerhard Richter*, Verlag Silke Schreiber (Cologne), 1985.
15. See Gilles Deleuze, *The Fold*, trans Tom Conley, Athlone (London), 1993.
16. See Michael Fried, *Art and Objecthood—Essays and Reviews*, University of Chicago (Chicago), 1998.
17. Gilles Deleuze, *Negotiations*, Columbia University Press (New York), 1997, p. 55.
18. 'Peindre? Enquête et Entretiens sur la Peinture Abstraite', in *Positions*, Galerie B. Jaudon M. Devarrieux (Paris), 1996, p 85.
19. Roland Barthes, "Is Painting a Language?", in *The Responsibility of Forms*, University of California (Berkeley/Los Angeles), 1991, p. 149.
20. This is an obvious point, which has lead to some claims that painting cannot be adequately addressed by language. See, for example, James Elkins, *Painting and the Words that Fail Them*, Cambridge University Press (Cambridge), 1998.
21. Norman Bryson, 'Semiology and Visual Interpretation' in Bryson, Holly, Moxon (eds), *Visual Theory*, Cambridge University Press, (Cambridge), 1990.
22. Barthes, 'Réquichot and His Body' in *The Responsibility of Forms*, op cit, pp. 227–8.
23. Ibid, p. 228.

balances fell for a short period,[17] so that in April 1894 the New York rate was cited as 1½ percent.[18] Once again the plentitude of funds in New York was held to be responsible for the reduction of interest payments on country bank deposits in New York.[19] By the spring of 1895 only four or five of the banks that had agreed to pay no more than 1 percent on country balances in November 1894 were adhering to the agreement; the general rate was 2 percent once again.[20] Downward pressures on rates were very strong in 1894, but at the same time it was very difficult to maintain a rate below 2 percent for a significant length of time.

Throughout 1898 and 1899 the New York call loan rate stayed very close to 1 percent; however, in spite of that the rate paid on bankers' balances seems to have been maintained at 2 percent. In February 1898 the Fourth National Bank of New York reduced its interest rate on bankers' balances from 2 percent to 1½ percent.[21] But in the same month it was observed that "after fourteen months of almost a continuous inflow of money into the banks it is not surprising that some of those institutions [New York banks] object to paying 2 percent on deposits which they cannot use."[22] The implication here clearly is that banks were still paying 2 percent on country deposits. Moreover, another article at this time identified 2 percent as the ruling rate in New York, whereas 2½–3 percent was usually paid outside of New York.[23]

[17] *Bankers' Magazine*, XLIX (December 1893), p. 104.
[18] *Bankers' Magazine*, XLIX (April 1894), p. 788.
[19] *Bankers' Magazine*, L (December 1894), p. 194.
[20] *Bankers' Magazine*, L (June 1895), p. 970.
[21] *Bankers' Magazine*, LVI (February 1898), p. 297.
[22] Ibid., p. 320.
[23] B. J. Shreve, "Country Checks and Country Bank Accounts," *Bankers' Magazine*, LVI (February 1898), p. 227. On average, banks in other financial centers paid higher rates on bankers' balances, but because the markets were much thinner, the rates were more variable. For example, in the general decline in rates in 1894 the rate on bankers' balances fell to 3 percent in Louisville and to 1½ percent

Interest Paid on New York Bankers' Balances

IN spite of the central role of correspondent balances in the postbellum financial system and the continuous controversy over the payment of interest on bankers' balances, little attention has been paid to the interest rate that was actually paid on them, the practice that attracted much of them to New York. In fact, no major contemporary commercial publication regularly reported such a rate. Here we shall examine what the rate on New York balances in the postbellum period actually was. In spite of substantial downward pressures in the last decade of the nineteenth century, it remained quite stable at 2 percent per annum during the 1888–1911 period covered in our estimated equations in Chapter VI, evidence of the extreme competitiveness of the New York banking system.

In the antebellum period rates on bankers' balances ranged between 3 and 6 percent.[1] At that time the payment of interest on bankers' balances was not the ubiquitous practice that it later became, even though in 1872 the U.S. Comptroller of the Currency noted that such interest payments were an "old-established custom which cannot be easily changed by legislation."[2] In 1857 only twelve out of the sixty banks in the New York Clearing House explicitly paid interest on correspondent balances.[3] By 1886 about half the members of the Clearing House directly paid in-

[1] Margaret G. Myers, *The New York Money Market, Volume I: Origins and Development* (New York: Columbia University Press, 1931), p. 122.
[2] U.S. Comptroller of the Currency, *Annual Report*, 1872 (Washington, D.C.: U.S. Government Printing Office, 1872), p. xx.
[3] O. M. W. Sprague, *History of Crises under the National Banking System* (Washington, D.C.: U.S. Government Printing Office, 1910), p. 20.

terest on correspondent deposits;[4] those banks that did not pay interest, however, provided other services, such as collecting, free of charge, all out-of-town accounts for correspondents, a service said to be worth 2–3 percent interest.[5] However, by 1891 most New York banks had substituted the direct payment of interest for services rendered.[6] In 1898 it was noted that "there are no balances kept in New York by country banks without interest or its equivalent."[7] By 1911 the Chemical Bank remained the only holdout against the direct payment of interest.[8]

Although more and more New York banks turned to the explicit payment of interest on bankers' balances, it was not embraced with enthusiasm and several collective attempts were made to ban the practice. After the Panic of 1873 a unanimous agreement among New York banks could not be secured to prohibit the payment of interest.[9] In 1884 *Bankers' Magazine* observed: "The banks of New York for a considerable time have been making efforts to reduce the payment of interest on country balances. . . . Various meetings have been held, but nothing effective has been accomplished. . . . Most of the banks were willing to unite in reducing interest, but several strenuously refused, and their refusal has been regarded as fatal to the movement."[10] Evidently there had been a number of previous unsuccessful attempts at restricting interest payments, because it was observed that "this is a very old subject."[11]

The nominal rate paid declined in the postbellum period.

[4] "Interest on Deposits," *Bankers' Magazine*, XLI (December 1886), p. 454.

[5] Ibid., p. 455.

[6] Myers, *The New York Money Market*, p. 249.

[7] "Country Checks and Country Bank Accounts," *Bankers' Magazine*, LVI (February 1898), p. 227.

[8] Myers, *The New York Money Market*, p. 249.

[9] Sprague, *History of Crises*, p. 20.

[10] "Interest on Country Deposits," *Bankers' Magazine*, XXXIX (December 1884), p. 414.

[11] Ibid.

By 1874 the New York rate was reported to have fa 3 to 4 percent.[12] It was noted that explicit payment terest was becoming a pervasive practice in New Y the late 1880s and at that time also the rate of inte bankers' balances stabilized at 2 percent, or put mo quently, "the strength of the magnetic current has been 2 percent. . . ."[13] Sprague pointed out, howeve due to the general decline in interest rates in the post period the 2 percent rate was equivalent, relative to rates, to the 4 percent paid before 1873.[14] The rate bankers' balances remained remarkably stable in the in spite of significant declines in nominal interes which may be taken as an indication of the competi of the New York money market.

In spite of substantial general downward pressure terest rates in the 1890s, the rate on bankers' bala mained virtually fixed at 2 percent with some sh deviations. In the summer of 1892 it was reported t banks are having so much difficulty in using their that some of them either have reduced the rate of which they have been paying on accounts or will so."[15] In August the Importers and Traders Bank York reduced the interest rate paid on country posits by ½ percent, whereupon *Bankers' Maga* torialized in favor of graduated rates on bankers' with lower rates paid when money is plentiful, bu ceded that "competition among banks and similar c tions render the adoption of such a policy difficult.

Similarly, beginning in December 1893, rates on

[12] U.S. House, Committee on Banking and Currency, *pressed before the Committee*, 43rd Congress, 2nd Session 125.

[13] "Notes on Banking in New York City," *Bankers'* XLIII (April 1889), p. 723.

[14] Sprague, *History of Crises*, p. 21.

[15] "The Money Market," *Bankers' Magazine*, XLVI (Ji p. 926.

[16] *Bankers' Magazine*, XLVII (August 1892), p. 85.

The years after the turn of the century were generally ones of high interest rates, so there was no downward pressure. Two 1906 articles mention 2 percent as the rate on bankers' balances,[24] and several textbooks refer simply to 2 percent as the going rate on bankers' balances.[25] Finally, at the end of the period, during the Federal Reserve hearings, the 2 percent rate was often cited.[26]

Over the last part of the nineteenth century and the first part of the twentieth, therefore, the rate paid by New York banks on bankers' balances remained virtually stable at 2 percent. Indeed, reference was made to the "inflexibility" of interest rates paid by New York banks.[27] Even under substantial downward pressure in the 1890s, the rate fell below 2 percent for only brief periods. In 1890 there were 108 banks in New York City with 47 national ones; in 1910 there were 113 with 39 national ones.[28] Only a small part of this total participated actively in the competition for country deposits, but the constancy of the rate on bankers' balances is clearly indicative of an extremely competitive banking market in New York in the postbellum period.

in Chicago and Boston. Two years earlier a number of banks in Boston reduced their rates on interbank deposits to 2 or 2½ percent. *Bankers' Magazine*, LXIV (April 1894), p. 788; *Bankers' Magazine*, XLII (July 1892), pp. 61–62.

[24] George M. Coffin, "The New York Rate of Interest," *Bankers' Magazine*, LXXII (January 1906), p. 46; Festus J. Wade, "What Causes Fluctuations in Money Rates?" *Proceedings of the New York State Bankers' Association*, 1906, p. 36.

[25] For example, see Horace White, *Money and Banking*, 5th ed. (Boston: Ginn and Co., 1911), p. 212.

[26] U.S. Senate, Banking and Currency Committee, *Hearings on HR7837 (S2639)*, 63rd Congress, 1st Session, pp. 1293, 1354.

[27] C. F. Bentley, "Commercial Paper as an Investment for Country Banks," *Proceedings of the Nebraska Bankers' Association*, 1903, p. 184.

[28] Myers, *The New York Money Market*, p. 244.

Bibliography

Alcorn, Edgar G. *The Duties and Liabilities of Bank Directors.* Columbus: Financial Publishing Co., 1908.

Alhadeff, David A. *Monopoly and Competition in Banking.* Berkeley: University of California Press, 1954.

American Bankers' Association. *Proceedings,* 1881–1911.

Andersen, Theodore A. *A Century of Banking in Wisconsin.* Madison: State Historical Society of Wisconsin, 1954.

Andrew, A. Piatt. "The Crux of the Currency Question," *Yale Review,* n.s. II (July 1913), pp. 595–620.

———. "The Influence of the Crops upon Business in America," *Quarterly Journal of Economics,* XX (May 1906), pp. 323–353.

———, ed. *Statistics for the United States, 1867–1909.* Washington, D.C.: U.S. Government Printing Office, 1910.

Andrews, T. W. "Banking Methods—Ancient and Modern," *Proceedings of the South Carolina Bankers' Association,* 1905, pp. 69–86.

Armstrong, Leroy, and Denny, J. O. *Financial California.* San Francisco: Coast Banker Publishing Co., 1916.

Arrington, Leonard J. "Banking Enterprises in Utah, 1847–1880," *Business History Review,* XXIX (December 1955), pp. 312–334.

Bagehot, Walter. *Lombard Street.* New York: Scribner, Armstrong, and Co., 1873.

Baker, W. H. "Commercial Paper," *Proceedings of the American Bankers' Association,* 1887, pp. 45–47.

Balabanis, H. P. *The American Discount Market.* Chicago: University of Chicago Press, 1935.

"Bank Loans," *Bankers' Magazine,* XXXVII (May 1883), pp. 809–811.

"Bank Losses—How Caused and Their Consequences," *Bankers' Magazine,* XXXIX (August 1884), pp. 134–137.

Bankers' Magazine (and Statistical Register), Vols. XXIV–LXXXIII, 1870–1911.

Barnett, George E. *State Banks and Trust Companies since the*

Passage of the National-Bank Act. Washington, D.C.: U.S. Government Printing Office, 1911.

Barsalow, F. W. "The Concentration of Banking Power in Nevada: An Historical Analysis," *Business History Review,* XXIX (December 1955), pp. 350–363.

Beach, W. E. *British International Gold Movements and Banking Policy: 1881–1913.* Cambridge, Mass.: Harvard University Press, 1935.

Beal, Thomas P., Jr. "Effect of Increased Operations of Note Brokers upon the Earnings of Commercial Banks," *Proceedings of the American Bankers' Association,* 1916, pp. 499–506.

Beckhart, Benjamin H., ed. *Business Loans of American Commercial Banks.* New York: Ronald Press Co., 1959.

————. *The New York Money Market, Volume III: Uses of Funds.* New York: Columbia University Press, 1932.

————, and Smith, James G. *The New York Money Market, Volume II: Sources and Movements of Funds.* New York: Columbia University Press, 1932.

Bell, Frederick W., and Murphy, Neil B. "Impact of Market Structure on the Price of a Commercial Banking Service," *Review of Economics and Statistics,* LI (May 1969), pp. 210–213.

Bell, Spurgeon. "Profit on National Bank Notes," *American Economic Review,* II (March 1912), pp. 38–60.

Bentley, C. F. "Commercial Paper as an Investment for Country Banks," *Proceedings of the Nebraska Bankers' Association,* 1903, pp. 174–185.

Blair, William. *Historical Sketch of Banking in North Carolina.* New York: B. Rhodes and Co., 1899.

Blye, A. W. "Collection of Country Checks," *Proceedings of the American Bankers' Association,* 1885, pp. 135–137.

Board of Governors of the Federal Reserve System. *All-Bank Statistics, 1896–1955.* Washington, D.C.: U.S. Government Printing Office, 1959.

Bogue, Allan G. *From Prairie to Corn Belt.* Chicago: University of Chicago Press, 1963.

————. *Money at Interest.* New York: Russell and Russell, 1955.

Bolles, Albert S. *The National Bank Act and its Judicial Meaning,* 2nd ed. New York: Homans Publishing Co., 1888.

Bolles, Albert S. "Notes on Banking in New York City," *Bankers' Magazine*, XLIII (April 1889), pp. 721-727.

――――. *Practical Banking*, 7th ed. New York: Homans Publishing Co., 1884.

Bradstreet's, Vols. XIV–XXXVIII, 1886–1910.

Breckenridge, R. M. "Branch Banking and Discount Rates," *Bankers' Magazine*, LVIII (January 1899), pp. 38–52.

――――. "Discount Rates in the United States," *Political Science Quarterly*, XIII (March 1898), pp. 119–142.

Brokaw, C. L. "A Study in Bank Investments," *Proceedings of the Kansas Bankers' Association*, 1908, pp. 37–48.

Bryan, Alfred C. "History of State Banking in Maryland," *Johns Hopkins Studies in Historical and Political Science*, Ser. XVII. Baltimore, 1899.

Buck, Solon J. *The Agrarian Crusade*. New Haven, Conn.: Yale University Press, 1921.

Cagan, Phillip. *Determinants and Effects of Changes in the Stock of Money, 1875–1960*. New York: Columbia University Press, 1965.

Caldwell, Stephen A. *A Banking History of Louisiana*. Baton Rouge: Louisiana State University Press, 1935.

Cameron, Rondo, ed. *Banking and Economic Development*. New York: Oxford University Press, 1972.

―――― et al. *Banking in the Early Stages of Industrialization: A Study in Comparative Economic History*. New York: Oxford University Press, 1967.

Cannon, J. G. *Clearing Houses*. Washington, D.C.: U.S. Government Printing Office, 1910.

Carson, Deane, ed. *Banking and Monetary Studies*. Homewood, Ill.: Richard D. Irwin, 1963.

Cartinhour, Gaines T. *Branch, Group, and Chain Banking*. New York: Macmillan Company, 1931.

Case, J. H. "The Desirability of Commercial Paper as a Bank Investment," *Proceedings of the New Jersey Bankers' Association*, 1912, pp. 30–40.

Catterall, Ralph C. H. *The Second Bank of the United States*. Chicago: University of Chicago Press, 1903.

Chapman, John M., and Westerfield, Ray B. *Branch Banking*. New York: Harper & Brothers, 1942.

Chase, K. S. "Registration of Commercial Paper," *Proceedings of the Minnesota Bankers' Association*, 1911, pp. 30–44.

Clayton, B. F. "The Banker and His Customer," *Proceedings of the Iowa Bankers' Association*, 1892, pp. 34–40.

Coffin, George M. "The New York Rate of Interest," *Bankers' Magazine*, LXXII (January 1906), pp. 44–48.

Commercial and Financial Chronicle, Vols. XLIV–XCII, 1888–1911.

Commission on Money and Credit, ed. *Private Financial Institutions*. Englewood Cliffs, N.J.: Prentice-Hall, 1963.

Conference on Research in Income and Wealth, ed. *Output, Employment, and Productivity in the United States after 1800*. New York: Columbia University Press, 1966.

———. *Trends in the American Economy in the Nineteenth Century*. Princeton, N.J.: Princeton University Press, 1960.

"The Convention of the Arkansas Bankers' Association," *Bankers' Magazine*, XLVI (June 1892), pp. 941–950.

Conway, Thomas, Jr., and Patterson, Ernest M. *The Operation of the New Bank Act*. Philadelphia: J. B. Lippincott Co., 1914.

Cooke, Thornton. "Branch Banking for the West and South," *Quarterly Journal of Economics*, XVIII (November 1903), pp. 97–113.

———. "Distribution of Small Banks in the West," *Quarterly Journal of Economics*, XII (October 1897), pp. 70–72, 105–109.

———. "The Effect of the New Currency Law on Banking in the West," *Quarterly Journal of Economics*, XV (February 1901), pp. 277–286.

Cooley, Thomas, and DeCanio, Stephen. "Varying-Parameter Supply Functions and the Sources of Economic Distress in American Agriculture, 1866–1914," NBER Working Paper No. 57 (September 1974).

Coulter, E. Merton. *The South during Reconstruction, 1865–1877*. Baton Rouge: Louisiana State University Press, 1947.

Cox, Albert H., Jr. "Regulation of Interest Rates on Bank Deposits," *Michigan Business Studies*, XVII, No. 4, 1966.

Crandall, Noble. "Commercial Paper," *Proceedings of the Nebraska Bankers' Association*. 1903, pp. 185–188.

Crane, F. W. "Commercial Paper Purchased from Brokers," *Proceedings of the Illinois State Bankers' Association*, 1916, pp. 130–139.

Dailey, Don M. "The Development of Banking in Chicago before 1890." Unpublished Ph.D. dissertation, Northwestern University, 1934.

Davis, A. M. *The Origins of the National Banking System.* Washington, D.C.: U.S. Government Printing Office, 1910.

Davis, Lance E. et al. *American Economic Growth.* New York: Harper & Row, 1972.

————. "Capital Immobilities and Finance Capitalism: A Study of Economic Evolution in the United States, 1820–1920," *Explorations in Entrepreneurial History*, 2nd series, I (Fall 1963), pp. 88–105.

————. "The Investment Market, 1870–1914: The Evolution of a National Market," *Journal of Economic History*, XXV (September 1965), pp. 355–399.

————. "The New England Textile Mills and the Capital Markets: A Study of Industrial Borrowing, 1840–1860," *Journal of Economic History*, XX (March 1960), pp. 1–30.

————, and North, Douglass C. *Institutional Change and American Economic Growth.* Cambridge: Cambridge University Press, 1971.

Dawes, Charles G. *The Banking System of the United States.* Chicago: Rand, McNally and Co., 1894.

Deming, J. K. "Modern Methods of Soliciting Business," *Proceedings of the Iowa Bankers' Association*, 1892, pp. 19–22.

Dewald, William. "The National Monetary Commission: A Look Back," *Journal of Money, Credit, and Banking*, IV (November 1972), pp. 930–956.

Dewey, Davis. *State Banking before the Civil War.* Washington, D.C.: U.S. Government Printing Office, 1910.

————, and Shugrue, Martin. *Banking and Credit.* New York: Ronald Press Co., 1922.

Dowrie, George W. *American Monetary and Banking Policies.* New York: Longmans, Green and Co., 1930.

Dunbar, Charles F., "The Bank Note Question," *Quarterly Journal of Economics*, VII (October 1892), pp. 55–77.

————. *Chapters on the Theory and History of Banking.* New York: G. P. Putnam's Sons, 1891.

————. *Economic Essays.* New York: Macmillan Company, 1904.

————. *Laws of the United States relating to Currency, Finance, and Banking.* Boston: Ginn and Co., 1897.

Economic Essays in Honour of Gustave Cassel. London: George Allen and Unwin Ltd., 1933.

Engerman, Stanley. "A Note on the Economic Consequences of the Second Bank of the United States," *Journal of Political Economy*, LXXVIII (July/August 1970), pp. 725–728.

Erickson, Erling A. *Banking in Frontier Iowa, 1836–1865*. Ames: Iowa State University Press, 1971.

Fels, Rendigs. *American Business Cycles, 1865–1897*. Chapel Hill: University of North Carolina Press, 1959.

Finney, Katherine. *Interbank Deposits*. New York: Columbia University Press, 1958.

Fiske, Amos K. *The Modern Bank*. New York: D. Appleton and Co., 1904.

Flechsig, Theodore G. "The Effect of Concentration on Bank Loan Rates," *Journal of Finance*, XX (May 1965), pp. 298–311.

Fogel, Robert, and Engerman, Stanley, ed. *The Reinterpretation of American Economic History*. New York: Harper & Row, 1971.

Forgan, James B. *Recollections of a Busy Life*. New York: Bankers' Publishing Co., 1924.

Foulke, Roy A. *The Commercial Paper Market*. New York: Bankers' Publishing Co., 1931.

———. *The Sinews of American Commerce*. New York: Dun and Bradstreet, 1941.

Franklin, N. E. "Commercial Paper," *Proceedings of the South Dakota Bankers' Association*, 1912, pp. 126–131.

Friedman, Milton. *The Interpolation of Time Series by Related Series*, NBER Technical Paper 16. New York: National Bureau of Economic Research, 1962.

———, and Schwartz, Anna. *A Monetary History of the United States*. Princeton, N.J.: Princeton University Press, 1963.

———. *Monetary Statistics of the United States*. New York: Columbia University Press, 1970.

Gallman, Robert E., and Davis, Lance E. "The Share of Savings and Investment in Gross National Product during the 19th Century in the U.S.A.," in *Fourth International Conference of Economic History, Bloomington, Indiana, 1968*. Paris: Mouton, 1973, pp. 437–466.

Gerschenkron, Alexander. *Ecnomic Backwardness in Historical Perspective*. New York: Frederick A. Praeger, 1965.

Gibbons, J. S. *The Banks of New York, Their Dealers, The Clearing House, and the Panic of 1857.* New York: D. Appleton and Co., 1858.

Gilbert, Claude. "Country Credit Methods," *Proceedings of the Maryland Bankers' Association,* 1914, pp. 43–53.

Goldfeld, Stephen. "The Demand for Money Revisited," *Brookings Papers on Economic Activity,* 3, 1973, pp. 577–638.

Goodhart, C. A. E. *The New York Money Market and the Finance of Trade, 1900–1913.* Cambridge, Mass.: Harvard University Press, 1969.

————. "Profit on National Bank Notes, 1900–1913," *Journal of Political Economy,* LXXIII (October 1965), pp. 516–522.

Gordon, W. C. "The Necessity of Credit Statements and the Desirability for Uniformity Thereof," *Proceedings of the American Bankers' Association,* 1916, pp. 521–528.

Greef, Albert O. *The Commercial Paper House in the United States.* Cambridge, Mass.: Harvard University Press, 1938.

Green, George D. *Finance and Economic Development in the Old South.* Stanford, Calif.: Stanford University Press, 1972.

Gurley, John G., and Shaw, Edward S. "Financial Aspects of Economic Development," *American Economic Review,* XLV (September 1955), pp. 515–538.

————. "Financial Structure and Economic Development," *Economic Development and Cultural Change,* XV (April 1967), pp. 257–268.

Gurney, E. R., "A Study in Liquidation," *Proceedings of the Missouri Bankers' Association,* 1911.

Hague, George. "One-Name Paper," *Proceedings of the American Bankers' Association,* 1884, pp. 64–70.

Hammond, Bray. *Banks and Politics in America.* Princeton, N.J.: Princeton University Press, 1957.

Hammond, C. W. "Clearings of Country Collections," *Proceedings of the American Bankers' Association,* 1890, pp. 106–111.

Harris, Seymour, ed. *American Economic History.* New York: McGraw-Hill Book Company, 1961.

Hazelwood, C. B. "Commercial Paper as a Secondary Reserve for West Virginia Banks," *Proceedings of the West Virginia Bankers' Association,* 1913, pp. 83–92.

Helderman, Leonard C. *National and State Banks*. Boston: Houghton Mifflin Company, 1931.

Henson, G. N. "Selection of Loans," *Bankers' Magazine*, XLVII (February 1894), pp. 613–616.

Hepburn, Alonzo B. *A History of Currency in the United States*. New York: Macmillan Company, 1903.

Hicks, John D. *The Populist Revolt*. Lincoln: University of Nebraska Press, 1931.

Hilliard, H. P. Untitled address, *Proceedings of the Michigan Bankers' Association*, 1904, pp. 65–75.

Hinchman, T. H. *Banks and Banking in Michigan*. Detroit: M. Graham, 1887.

Hodgman, Donald. *Commercial Banks Loans and Investment Policy*. Champaign: University of Illinois Press, 1963.

Hoffman, Charles. *The Depression of the Nineties*. Westport, Conn.: Greenwood Publishing Corp., 1970.

Hogan, John V. "Bond Investments by National Banks," *Journal of Political Economy*, XXI (November 1913), pp. 843–849.

Hollander, Jacob H. "Security Holdings of National Banks," *American Economic Review*, III (December 1913), pp. 793–814.

Homer, Sidney. *A History of Interest Rates*. New Brunswick, N.J.: Rutgers University Press, 1963.

Hughes, Jonathan R. T. *The Vital Few*. Boston: Houghton Mifflin Company, 1965.

Hull, Walter, ed. *Practical Problems in Banking and Currency*. New York: Macmillan Company, 1907.

Huntington, A. T., and Mawhinney, Robert J. *Laws of the United States Concerning Money, Banking, and Loans, 1778–1909*. Washington, D.C.: U.S. Government Printing Office, 1910.

Hurst, J. M. "Interest on Balances and Its Regulation by Open Market Rates," *Proceedings of the Idaho Bankers' Association*, 1916, pp. 59–67.

"Interest on Bank Balances," *Bankers' Magazine*, XV (August 1865), pp. 124–125.

"Interest on Country Deposits," *Bankers' Magazine*, XXXIX (December 1884), pp. 414–415.

"Interest on Deposits," *Bankers' Magazine*, XXXIV (November 1879), pp. 339–340.

"Interest on Deposits," *Bankers' Magazine*, XLI (December 1886), pp. 454–455.

Jacoby, Neil, and Saulnier, Raymond. *Business Finance and Banking*. New York: National Bureau of Economic Research, 1947.

James, F. C. *The Growth of Chicago Banks*, 2 vols. New York: Harper & Bros., 1938.

James, John A. "Banking Market Structure, Risk, and the Pattern of Local Interest Rates in the United States, 1893–1911," *Review of Economics and Statistics*, LVIII (November 1976), pp. 453–462.

―――. "The Conundrum of the Low Issue of National Bank Notes," *Journal of Political Economy*, LXXXIV (April 1976), pp. 359–367.

―――. "The Development of the National Money Market, 1893–1911," *Journal of Economic History*, XXXVI (December 1976), pp. 878–897.

―――. "The Evolution of the National Money Market." Unpublished Ph.D. dissertation, MIT, 1974.

―――. "A Note on Interest Paid on New York Bankers' Balances in the Postbellum Period," *Business History Review*, L (Summer 1976), pp. 198–202.

―――. "Portfolio Selection with an Imperfectly Competitive Asset Market," *Journal of Financial and Quantitative Analysis*, XI (December 1976), pp. 831–846.

Jenkins, Charles. "Collection of Country Checks," *Proceedings of the American Bankers' Association*, 1884, pp. 56–58.

Jones, W. O. "The Ideal Country Banker," *Proceedings of the Oregon Bankers' Association*, 1908, pp. 47–70.

Jonung, Lars. "The Behavior of Velocity in Sweden, 1871–1913," Nationalekomiska Institution, University of Lund, 1976.

Kane, Thomas P. *The Romance and Tragedy of Banking*. New York: Bankers' Publishing Co., 1923.

Keehn, Richard. "Federal Bank Policy, Bank Market Structure, and Bank Performance: Wisconsin, 1863–1914," *Business History Review*, XLVIII (Spring 1974), pp. 1–27.

Kemmerer, E. J. *Seasonal Variations in the Relative Demand for Money and Capital in the United States*. Washington, D.C.: U.S. Government Printing Office, 1910.

Kniffin, William H., Jr. *American Banking Practice*. New York: McGraw-Hill Book Company, 1921.

————. *Commercial Banking*, 2 vols. New York: McGraw-Hill Book Company, 1923.

————. *Commercial Paper*, 3rd ed. New York: Bankers' Publishing Co., 1924.

————. *The Practical Work of a Bank*, 5th ed. New York: Bankers' Publishing Co., 1919.

Knox, John Jay. *A History of Banking in the United States*. New York: B. Rhodes and Co., 1903.

Krueger, Leonard B. *History of Commercial Banking in Wisconsin*. Madison: University of Wisconsin Press, 1933.

Langston, L. H. *Practical Bank Operation*. New York: Ronald Press Co., 1921.

Laughlin, J. Laurence, ed. *Banking Reform*. Chicago: National Citizens' League, 1912.

Lee, Everett S. et al. *Population Redistribution and Economic Growth*, 3 vols. Philadelphia: American Philosophical Society, 1957.

Lockhart, Oliver C. "The Development of Interbank Borrowing in the National Banking System, 1869–1914," *Journal of Political Economy*, Part I, XXIX (February 1921), pp. 138–160; Part II, XXIX (March 1921), pp. 222–240.

Lynch, James K. "Banking in Theory and Practice," *Proceedings of the Arizona Bankers' Association*, 1910, pp. 30–41.

————. "Modern Tendencies and Ancient Principles," *Proceedings of the Arizona Bankers' Association*, 1909, pp. 42–53.

Macaulay, Frederick. *Some Theoretical Problems Suggested by the Movements of Interest Rates, Bond Yields, and Stock Prices in the United States since 1856*. New York: National Bureau of Economic Research, 1938.

McAvoy, Walter. "The Economic Importance of the Commercial Paper House," *Journal of Political Economy*, XXX (February 1922), pp. 78–87.

McGrath, A. J. "The Northern Banker Passing on Paper Offered by the Southern Banker," *Proceedings of the Georgia Bankers' Association*, 1905, pp. 98–102.

Mints, Lloyd W. *A History of Banking Theory*. Chicago: University of Chicago Press, 1945.

Mitchell, Waldo. *The Uses of Bank Funds*. Chicago: University of Chicago Press, 1925.

Moore, Geoffrey, ed. *Business Cycle Indicators, Vol. II*. Princeton, N.J.: Princeton University Press, 1961.

"The Morality of Usury," *Bankers' Magazine*, XXXIV (June 1880), pp. 956–958.

Morrill, E. N. "Reminiscences of Banking in Kansas," *Proceedings of the Kansas Bankers' Association*, 1905.

Moulton, H. G. "Commercial Banking and Capital Formation," *Journal of Political Economy*, Part I, XXVI (May 1918), pp. 484–508; Part II, XXVI (June 1918), pp. 638–663; Part III, XXVI (July 1918), pp. 705–731; Part IV, XXVI (November 1918), pp. 849–881.

Myers, Margaret G. *The New York Money Market, Volume I: Origins and Development*. New York: Columbia University Press, 1931.

Noyes, A. D. *Forty Years of American Finance: 1865–1907*. New York: G. P. Putnam's Sons, 1909.

Padgett, A. E. "The Multiplication of Banks," *Proceedings of the South Carolina Bankers' Association*, 1908, pp. 125–134.

Palyi, Melchior, *The Chicago Credit Market*. Chicago: University of Chicago Press, 1937.

Patchin, Sydney A. "The Development of Banking in Minnesota," *Minnesota History Bulletin*, II (August 1917), pp. 111–168.

Patten, Claudius B. *Practical Banking*, 5th ed. New York: B. Rhodes and Co., 1891.

"Payment of Interest on Deposits," *Bankers' Magazine*, LXI (August 1900), pp. 157–158.

"Payment of Interest on Deposits," *Bankers' Magazine*, LXIX (August 1904), p. 136.

"Payment of Interest on Deposits," *Bankers' Magazine*, LXXX (May 1910), p. 873.

Perloff, Harvey et al. *Regions, Resources, and Economic Growth*. Lincoln: University of Nebraska Press, 1960.

Phillips, Chester A. *Bank Credit*. New York: Macmillan Company, 1920.

———, ed. *Readings in Money and Banking*. New York: Macmillan Company, 1920.

Pollard, Sidney. "Fixed Capital in the Industrial Revolution in Britain," *Journal of Economic History*, XXIV (September 1964), pp. 299–314.

Powlison, Keith. *Profits of the National Banks.* Boston: Gorham Press, 1931.

Pred, Allan A. *Urban Growth and the Circulation of Information: the United States System of Cities, 1790–1840.* Cambridge, Mass.: Harvard University Press, 1973.

Preston, Howard H. *History of Banking in Iowa.* Iowa City: State Historical Society of Iowa, 1922.

Ransom, Roger, and Sutch, Richard. "Debt Peonage in the Cotton South after the Civil War," *Journal of Economic History*, XXXII (September 1972), pp. 641–669.

————. "Documenting Monopoly Power in the Rural South: The Case of the General Store," Southern Economic History Project, Working Paper No. 15, Riverside, Calif., April 1976.

————. "The Ex-Slave in the Postbellum South: A Study of the Economic Impact of Racism in a Market Environment," *Journal of Economic History*, XXXIII (March 1973), pp. 131–148.

Redlich, Fritz. *The Molding of American Banking: Men and Ideas*, 2 vols. New York: Johnson Reprint Co., 1968.

"Report of the Committee on Credit Information," *Proceedings of the American Bankers' Association*, 1908, pp. 195–207.

Report of the Monetary Commission of the Indianapolis Convention. Chicago: University of Chicago Press, 1898.

Riefler, Winfield W. *Money Rates and Money Markets in the United States.* New York: Harper & Brothers, 1930.

Rockoff, Hugh. "Regional Interest Rates and Bank Failures, 1870–1914," *Explorations in Economic History*, XIV (January 1977), pp. 90–95.

————. "Varieties of Banking and Regional Economic Development in the United States," *Journal of Economic History*, XXXV (March 1975), pp. 160–177.

Rogers, G. A. "Loaning Money," *Proceedings of the Kansas Bankers' Association*, 1905, pp. 133–140.

Royse, E. "The Critical Season in Banking in Nebraska," *Proceedings of the Nebraska Bankers' Association*, 1903, pp. 364–367.

Schroeder, W. G. Untitled address, *Proceedings of the Oklahoma-Indian Territory Bankers' Association*, 1907, pp. 63–64.

Scott, William A. *Money and Banking*. New York: Henry Holt and Co., 1910.

———. "Rates on the New York Money Market, 1896–1906," *Journal of Political Economy*, XVI (May 1908), pp. 273–298.

Scoville, C. C. K. "The Best Class of Investments for the Average Kansas Bank," *Proceedings of the Kansas Bankers' Association*, 1903, pp. 72–80.

Selden, Richard T. *Trends and Cycles in the Commercial Paper Market*, NBER Occasional Paper No. 85. New York: National Bureau of Economic Research, 1963.

Sharpe, William F. *Portfolio Theory and Capital Markets*. New York: McGraw-Hill Book Company, 1970.

"Should Bank Deposits Bear Interest?" *Bankers' Magazine*, XXX (February 1876), pp. 596–598.

Shreve, B. J. "Country Checks and Country Bank Accounts," *Bankers' Magazine*, LVI (February 1898), pp. 221–231.

Smiley, Gene. "Interest Rate Movements in the United States, 1888–1913," *Journal of Economic History*, XXXV (September 1975), pp. 591–620.

Smith, C. T. Untitled address, *Proceedings of the Georgia Bankers' Association*, 1917, pp. 117–120.

Smith, Walter Buckingham. *Economic Aspects of the Second Bank of the United States*. Cambridge, Mass.: Harvard University Press, 1953.

Southworth, Shirley D. *Branch Banking in the United States*. New York: McGraw-Hill Book Company, 1928.

Sparks, Earl S., and Carver, Thomas N. *History and Theory of Agricultural Credit in the United States*. New York: Thomas Y. Crowell Co., 1932.

Sprague, O. M. W. "Branch Banking in the United States," *Quarterly Journal of Economics*, XVII (February 1903), pp. 244–260.

———. "The Distribution of Money between the Banks and the People since 1893," *Quarterly Journal of Economics*, XVIII (August 1904), pp. 513–528.

———. *History of Crises under the National Banking System*. Washington, D.C.: U.S. Government Printing Office, 1910.

Stevens, E. M. "Commercial Paper," *Proceedings of the North Dakota Bankers' Association*, 1903, pp. 29–31.

Stevenson, Russell, ed. *A Type Study of American Banking: Non-Metropolitan Banks in Minnesota*. Minneapolis: University of Minnesota Press, 1934.

Stigler, George. "Imperfections in the Capital Market," *Journal of Political Economy*, LXXV (June 1967), pp. 287–292.

Sumner, William G. "History of Banking in the United States," in *A History of Banking in All Leading Nations, Vol. I*. New York: Journal of Commerce and Commercial Bulletin, 1896.

Swartz, D. G. "Interest on Deposits," *Bankers' Magazine*, XXIV (March 1870), pp. 665–670.

Sylla, Richard. "American Banking and Growth in the Nineteenth Century: A Partial View of the Terrain," *Explorations in Entrepreneurial History*, IX (Winter 1971–1972), pp. 197–227.

―――. "The American Capital Market, 1846–1914, A Study of the Effects of Public Policy on Economic Development." Unpublished Ph.D. dissertation, Harvard University, 1968.

―――. "Federal Policy, Banking Market Structure, and Capital Mobilization in the United States, 1863–1913," *Journal of Economic History*, XXIV (December 1969), pp. 657–686.

―――. "Forgotten Men of Money: Private Bankers in Early U.S. History," *Journal of Economic History*, XXXVI (March 1976), pp. 173–188.

Talbert, Joseph T. "Commercial Credits," *Proceedings of the New York Bankers' Association*, 1908, pp. 76–91.

―――. "Commercial Paper," *Proceedings of the Minnesota Bankers' Association*, 1908, pp. 36–53.

Taylor, F. M. "The Final Report of the Indianapolis Monetary Commission," *Journal of Political Economy*, VI (June 1898), pp. 293–322.

Thomas, Rollin G. "The Development of State Banks in Chicago." Unpublished Ph.D. dissertation, University of Chicago, 1930.

Tostlebe, Alvin S. *Capital in Agriculture: Its Formation and Financing since 1870*. Princeton, N.J.: Princeton University Press, 1957.

Trescott, Paul. *Financing American Enterprise*. New York: Harper & Row, 1963.

U.S. Bureau of the Census. *Historical Statistics.* Washington, D.C.: U.S. Government Printing Office, 1960.

―――. *Thirteenth Census of the United States: 1910. Vols. II–III: Population, 1910. Reports by States, with Statistics for Counties, Cities and Other Civil Divisions.* Washington, D.C.: U.S. Government Printing Office, 1913.

U.S. Census Office. *Tenth Census, 1880. Vol. I: Statistics of the Population of the United States.* Washington, D.C.: U.S. Government Printing Office, 1883.

―――. *Eleventh Census, 1890. Vol. I: Report on Population of the United States.* Washington, D.C.: U.S. Government Printing Office, 1895–1897.

―――. *Twelfth Census, 1900. Vols. I–II: Population.* Washington, D.C.: U.S. Government Printing Office, 1901–1902.

―――. *Abstract of the Twelfth Census of the United States, 1900.* Washington, D.C.: U.S. Government Printing Office, 1903.

U.S. Comptroller of the Currency. *Annual Report, 1870–1918.* Washington, D.C.: U.S. Government Printing Office, 1870–1918.

U.S. Congress, House of Representatives. *Investigation by a Select Committee of the House of Representatives Relative to the Causes of the General Depression in Labor and Business, etc.* House Miscellaneous Document No. 29. 45th Congress, 3rd Session, 1879.

―――. *Investigation by a Select Committee of the House of Representatives Relative to the Causes of the General Depression in Labor and Business, etc.* House Miscellaneous Document No. 5, 46th Congress, 2nd Session, 1880.

―――. *Investigation of the Financial and Monetary Conditions in the United States under House Resolutions Nos. 429 and 504 before the Subcommittee on Banking and Currency,* 2 vols. 62nd Congress, 3rd Session, 1912.

―――, Committee on Banking and Currency. *Hearings before the Committee on Banking and Currency on H.R. 8149.* 53rd Congress, 3rd Session, 1894.

―――, Committee on Banking and Currency. *Views Expressed before the Committee on Banking and Currency.* 43rd Congress, 2nd Session, 1874.

U.S. Congress, Senate Committee on Banking and Currency. *Hearings before the Committee on Banking and Currency on H.R. 7837 (S. 2639)*, 3 vols. 63rd Congress, 1st Session, 1913.

U.S. National Monetary Commission. *Report*. Washington, D.C.: U.S. Government Printing Office, 1911.

Van Fenstermaker, J. "The Development of American Commercial Banking: 1782–1837," Bureau of Economic and Business Research Series No. 5, Kent State University, 1965.

Wade, Festus J. "What Causes Fluctuations in Money Rates?" *Proceedings of the New York Bankers' Association*, 1906, pp. 35–41.

Warren, George F., and Pearson, Frank A. *Prices*. New York: John Wiley & Sons, 1933.

Watkins, Leonard L. *Bankers' Balances*. Chicago: A. W. Shaw Co., 1929.

————. "Commercial Banking Reform in the United States," *Michigan Business Studies*, VIII, No. 5, 1938.

Westerfield, Ray B. *Banking Principles and Practice*. New York: Ronald Press Co., 1924.

White, Horace. *Money and Banking*, 4th ed. Boston: Ginn and Co., 1912.

Williamson, Jeffrey G. *Late Nineteenth-Century American Development*. Cambridge: Cambridge University Press, 1974.

Willis, H. Parker. *American Banking*. Chicago: La Salle Extension University, 1916.

Witham, W. S. Untitled address, *Proceedings of the American Bankers' Association*, 1898.

Woodward, C. Vann. *Origins of the New South, 1877–1913*. Baton Rouge: Louisiana State University Press, 1951.

Wright, Benjamin C. *Banking in California, 1849–1910*. San Francisco: H. S. Crocker Co., 1910.

Wright, Ivan. *Bank Credit and Agriculture*. New York: McGraw-Hill Book Company, 1922.

Wylie, James R. Untitled address, *Proceedings of the Michigan Bankers' Association*, 1901, pp. 36–39.

Yohe, William P., and Karnosky, Davis S. "Interest Rates and Price Level Changes," *Federal Reserve Bank of St. Louis Review*, LI (December 1969), pp. 19–36.

Zartman, Lester. *Investments of Life Insurance Companies*. New York: Henry Holt and Co., 1906.

Index

acceptances, 53–56; bank, 53–55; trade, 53–56, *see also* discounts: double-name paper. *See also* bills of exchange
agriculture, shift from to industry, 4
Alcorn, Edgar G., 248
American Bankers' Association, 57, 72, 82, 92, 196

bank note issue, *see* National Banking Acts: note issue provisions, profitability of note issue under
bankers' balances, 102–113, 132, 157; as use of surplus funds, 126; competitive market in New York for, 110–111, 264, 267; concentration in New York of, 95–99, 103, 104, 106–108, 112, 113n, 119–121, 148, 170, 236, *see also* pyramiding of reserves; defined, 105; growth of, 97, 105–107; opposition to interest payment on, 112–113, 264; rates on New York, 96–97, 250, 263–267; relationship to call loan market, 103–104, 118–119; *withdrawals*: during Panics, 119–120; seasonal, 136–137: traditional theory, 126–127, Goodhart theory, 127–128, estimates of, 134
Bankers' Magazine, 79, 112, 143, 183, 194, 264–265
banks and banking system, 236–238; American vs. British, 57, 62;

balance sheet entries: 46–47, 248–251; bonds for circulation, 248, 249; bonds for deposits, 248, 249; due from banks, 47, 154, 248–249, *see also* bankers' balances; due to banks, 47, *see also* bankers' balances; loans and discounts, 248, 250, 251; other stocks and bonds, 248, 250; clearings, 139n; credit departments, 72–73, 101; functions of, 6–7; growth of, 25, 89; portfolio diversification, 47–51, 88, 179–180; role in economic development of, 3; stock, interregional holdings of, 170–174, 237; structure and performance of, 7, 13, 236, 238. *See also* correspondent banking system; national banks; private banks; state banks
Barnett, George, 36, 43, 234
bill brokers, 41. *See also* commercial paper market: dealers
bills of exchange, 51–56; defined, 51; importance, 52–53; *kinds*: bank acceptances, 54; demand bills, 52; time bills, 52; trade acceptances, 53–54; 55–56; relation to real-bills doctrine, 60. *See also* checks
bills of lading, 63–64
Bolles, Albert S., 68
bonds, railroad, 50–51, 249–250

285

Friedman, Milton, 22n, 23, 26

Gallman, Robert E., 5n
Garfield, James, 33
Gerschenkron, Alexander, 62
Gibbons, J. S., 3
Gold Standard Act of 1900, 94,
218–220, 235, 241; effects of,
201, 219–220, 223–224, 228–
229;
 provisions of: capital re-
 quirements, 201, 218; note
 issue, 77, 218n
Goldfeld, Stephen, 24n
Goodhart, C.A.E., 127–137, 142,
146, 252, 254–255
Greef, Albert O., 175, 182, 191,
192, 193, 198
Greenbackers, 23n

Hazelwood, C. B., 177, 178
Hepburn, Alonzo B., 121
Hughes, Jonathan, 13

Importers and Traders' Bank of
New York, 72, 266
Indianapolis Monetary Commis-
sion, 11, 77n, 92–93, 94
inelasticity of the currency, 7,
22. *See also* national banking
system: criticisms of
institutional change hypothesis,
240; explained, 21, 199–200;
tested, 212–218
interbank borrowing, 102, 149–
165, 199, 237;
 concealment of: reasons,
 153–154; methods, 154–155;
 during Panics, 158–159; extent
 of, 155–157, 158n, 159; geo-
 graphical distribution, 159–
 162; importance to South,
 161–163; interest rates charged,
 150–151;

kinds: bills payable, 151,
152, overdrafts, 151–152;
rediscounting, 151, 152–153,
155;
seasonal patterns, 158
interest rates, *see* long-term inter-
est rates; short-term interest
rates
investment banking, 6, 37

Jonung, Lars, 23n

Keehn, Richard, 202n, 222
Kemmerer, E. J., 137, 138
Knox, John Jay, 7, 46
Kuhn and Loeb (investment
bankers), 41
Kuznets cycles 18n

labor force, shifts in distribution
of, 4, 207
Laughlin, J. Laurence, 71n, 89,
151
lawful money, 97, 98
legal tender, 76
life insurance companies, 6
liquidity, 48
loans, 61–70;
 country bank: characteris-
 tics, 66–68; differences in
 collateral for, 68–69; ma-
 turities, 67; size vs. city
 banks, 69–70;
 defined, 54;
 kinds: demand, 64n, 65n,
 66, 251n, 260–261, *see also*
 call loans; mortgage, 64;
 secured, 63; time, 64–65;
 unsecured, *see* discounts;
 maturity length, 61–62, 65;
 policy in England, 62; policy
 in Germany, 62
loans and discounts portfolio, 47,

54, 60, 67–69, 88, 250–251, 260
long-term interest rates, 13
long-term interregional capital market; institutions, 6; interest rate convergence in, 13; interregional flows, *see* financial flows, interregional

Macaulay, Frederick, 249, 250
market power hypothesis, 218–235, 240, 241; explained, 21, 200–201, 218; tested, 218–220
McAvoy, Walter, 197
McNabb, L. C., 85
Mellon, T. and Sons, 41
Mercantile Trust Co. of St. Louis, 168
Mints, Lloyd, 46
monetization, 23
money market, *see* New York: as national money market; short-term interregional capital market
money stock, 22
Money Trust, 110
monopoly power of local banks, 175, 180, 200, 211, 215–217, 220n; erosion by growth of state banks, 221–222, 232n, 233n, 235, 241, 243; influence on local interest rates, 221–222, 234–235; measure of, 209
Morgan, J. P., 6, 41
mortgage companies, 6
Moulton, H. G., 61, 62
mutual savings banks, 6
Myers, Margaret, 98, 113n, 120n, 187

National Banking Acts, 27–29, 36–38, 94–98, 153, 218, 233, 240; capital requirements, 28,

94; legal barriers to entry established by, 8, 21, 28–29, 94–95, 200, 208; limitation on loan size, 37, 45, 175; note issue provisions, 74–78; profitability of note issue under, 78; prohibition of branch banking, 90; prohibition of mortgage lending, 29, 45, 178, 200, 226, 237; purposes of 1863, 1864 Acts, 27, 74; regulations encouraging growth of state banks, 36–38, 66, 94–95, 226, 237, 241; reserve requirements, 45, 97–98; role in promoting a uniform currency, 74–75; role in reducing interregional interest rate differentials, 75, 170–171; tax on state bank notes, 27, 200; usury provisions, 80. *See also* Gold Standard Act of 1900; Resumption Act of 1875
national banks and banking system, 25–29, 238–240; as means of mobilizing and transferring capital, 123–124; balance sheet of, 47, 246; central reserve city, defined, 98n; country bank, defined, 98;
 criticisms of: 7, 11–12, 22n, 89, 94–95, 112–113, 118, 121, 236, 240; inadequacy in transferring capital, 11–12, 89; inelasticity of the currency, 7, 22n, 121; susceptibility to Panics, 7, 112–113, 118, 121, 236, 240, *see also* pyramiding of reserves;
 direct interregional lending under, 164–170, 199, 237; *growth of*: 25–26, 219, 223–224; as compared with state

impose, while his other works play—albeit in a pious, Habermasian, way—with at least the possibility of incommensurability rather than subsumption. In doing so, they allow painting to address the photographic surface rather than being restricted to simultaneously memorialising and anticipating it. Richter is by far the highest achieving practitioner of painting as itself something that can only be recalled (and then only through critique and demystification). But it is because of this that his approach is perhaps less helpful or exciting than are attitudes to and uses of contemporary images or surfaces that are not prepared to insist on painting as an exemplary form of production. Instead, they are engaged in a variety of quite impure approximations of its surface to any condition whatsoever that may address questions of movement and, in a related sense, recognisability—associated with those images or surfaces or their material incarnation. This would be painting that had more to do with the body and phenomena than with (an idea of) history and appearance as a system of already codified signs. It would almost certainly have to deinstitutionalise painting, giving it a number of starting points. Such work is everywhere, but one sees little of it in the museums, magazines, and galleries. An array of diverse practices, its unfashionability follows from its indifference to the idea that we know what painting is. It is that indifference that allows it to make painting encounter the surfaces that surround it and the subjectivity that invents itself through them.

Mondrian and Newman present themselves as transitional figures in the reordering of the subject, from a natural to a technological model, through painting considered as a practice involved primarily with the visual. Mondrian's last paintings were clearly about a kind of time that came from the semi-mechanised life and shape of Manhattan. Underneath or on top of this mechanisation is the poesis of mechanisation, the syncopated body offered by Jazz: Western music's time is reordered to foreground rhythm and repetition in a manner that reconciles the body to the industrial, from a starting point that is the opposite of the mechanical (it is interesting that Dave Hickey should recently have compared the current status of non-representational painting to that of Jazz.[5] The people who are interested in it know where to find it. No-one else gives a shit about it. Both have achieved the status of poetry, which deals with language at its most fundamental and is ignored by many people who would otherwise claim to be professionally involved with sign systems of all sorts).

I see much contemporary painting as an update of Mondrian's body and world. Both involve the relationship of the concept of immediacy to the persistently deferred present of the technological, which is no longer mechanical but ubiquitously electronic, and made of plastic. Painting is led to the question of time because of its foundation in spatiality—one can't have space without time, each necessary to the movement that unites them in one's experience of the work and on which each, as concepts, sheds a

confines of irreversibility in a zone where the reversible is not only permitted but obligatory: painting cannot do without it, either phenomenally or conceptually. Painting's historically acquired morphology as a skeleton with a skin may provide a clue to why the stretched canvas—and, by comparison with it, the unstretched canvas, the panel, the fresco and fresco-like—can persist as a place where the body may think itself—not as volume containing and occupying space but as surface and space. Similarly, its dependence on surface and support as a fundamental opposition—which means they can be collapsed into one another as well as held apart—physically reconstitutes the ideational or perceptual separation of the painting's space from that of its physical location. With the surface, a morphological parallelism allows painting to engage the three primary surfaces of the age: cinema, television and computer screens, as well as the absolutely blank surfaces that enclose nearly everything else in the late twentieth century. With film, the word 'frame' ceased to refer to what surrounded the picture and came to refer to the picture as a whole. The world in which painting takes place is nowadays one in which if you're not looking at a photographically generated image (photo, film, video, billboard) then you're probably looking at a surface that is impeccably blank and made out of plastic or something else that is plasticised, as are the metal exteriors of motor cars.

This is the sense in which it seems clear that contemporary non-representational painting contains many instances where one may say that what one is looking at is a handmade realisation of the idea of space made available, not in nature, but in technology. The space of painting has expanded or mutated to refer to the electronic as well as the natural, in a world where we now see nature from within technology rather than the other way around. This would be one reason why one would want to theorise the present as an epoch in which people want to live in photography, rather than as one that may somehow be known as having been photographed.[3] It would also be why it seems to me that, of the three approaches to photography in Richter's paintings, the non-representational paintings are the least successful because they require being turned into photographs before achieving their full effect. The other two—painting as photographic effect, as in the early landscape paintings, or painting as supplement to and reconstitution of photography, as in the *Baader-Meinhof* paintings (1988)—maintain a gap between the painted and the photographed that allows the painting itself to be the final resting point of the image it bears.[4] Richter's non-representational paintings exist fully only as photographs, in the same way that the catalogue for a Warhol show is always better than the works themselves, if the works in question are paintings. They represent, through rehearsing its fulfilment, the inherent teleology of that belief in productivism that seems to characterise Richter's (commemorative rather than frolicking) practice. They can never be seen except as surfaces awaiting transcription and the regime of legibility it will

I have suggested elsewhere that the art world's distaste for the visual as opposed to the verbal is a function of its fear of beauty and preference for that version of the sublime that may be assimilated to the condition of the discursive.[2] One may add to that the hostility towards Clement Greenberg, which has long been a *sine qua non* of membership in the seriousness club that runs the art world's museums, magazines and galleries and which causes painting to be held in contempt because he was interested in it. One may also add its correlative, the similarly obligatory adoration of Duchamp, who hated painting for reasons that demonstrate his inveterate academicism and failure to understand modernism, and who was as a result revived in the late 1960s in order to dispense with Clement the strong father. For twenty years, the idea of the readymade (and the Frankfurt Institute plus Foucault—actually, Foucault reborn as Adorno—discourse that has accumulated around it) has, *inter alia*, been used to fend off the adiscursive rather in the way that the cross is used in Dracula movies. When the visual appears, particularly in the form of painting, out comes the demystification fetish and we're safely back in a discursified real, free of the threat of phenomena rather than appearances. Or of appearance as anything other than the reappearance of a familiar sign. For some (for example, me), this has meant twenty years of stability (or stagnation) in the name of transgression, complete with an academy of instituted deinstitutionalisation, where the idea of being after modernism—whether as a result of having worked through it or of simply happening along afterwards, or, conceivably, both—is inseparable from that of being after painting. In the scheme proposed by the current administration of the recent past, postmodernism comes after modernism and is also beyond it, in the sense that we are more sophisticated than our parents because we have both learnt from them and found them out. And painting is that to which one may refer in all sorts of ways but may not actually do. It is only allowed to have *been*, and any use of its materials or conventions may only be seen as material reconvention, solely, one understands, for the purposes of an as it were empirical critique, of a now lost, or, more exactly, shunned, form. Thus, one may make work, and careers, out of painting as a critique of painting, where what is affirmed is the death of painting, but one is not supposed to make paintings with the straightforwardness that one might, say, make music, or even, Adorno notwithstanding, write poetry. (Which is to say that it is no longer enough that every thoroughly felt and thought work must implicitly be deeply critical. Now it has to be explicitly so, the thoroughly felt and thought part being as variable as it always was.)

Despite or, possibly, thanks to, its official redundancy, however, non-representational painting has continued to exfoliate and develop over the past ten years to the point where one would have to conclude that it is in great shape in a subterranean sort of way. *Despite* it, because it can only proceed by ignoring all the arguments against its continuing existence. *Thanks* to it, because, as a frivolous spectre, it can frolic beyond the sombre

NOTES ON BEING FRAMED BY A SURFACE (1998)
Jeremy Gilbert-Rolfe

Ten years ago, I wrote an essay about how non-representation, and especially non-representational painting, performed a kind of meaning-production that was beyond the scope of the art-critical establishment.[1] The intervening decade has been devoted to keeping the 1980s alive by artificial resuscitation, and the art world continues to be a place in which the visual is usually only an extension of the essentially verbal: one does not look at most contemporary art so much as one reads it, its visual form and appearance inflecting but not determining its content.

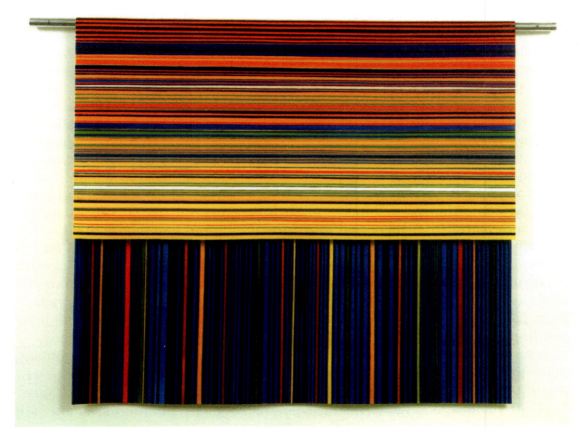

Figure 2 Linda Besemer, *Fold # 9: Section d'Or* 1998, Acrylic paint over aluminium rod, 122 × 183 cm, Courtesy Linda Besemer.

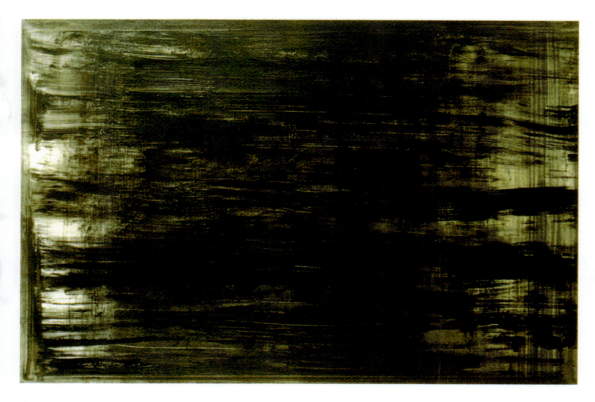

Figure 3 Nancy Haynes, *Molly's Soliloquy* 1991, Acrylic, oil on linen, 61 ×86 cm, Courtesy Nancy Haynes.

necessarily different light. Just as a lot of painting nowadays calls forth comparisons with the spatiality of the plastic surface or screen—continuous like skin or a photograph, but unlike painting's accumulation of layers—so too it tends to evoke the time of video. Whereas, Mondrian's late paintings, modular repetition and difference, perhaps call forth the parataxis of film. I have, for example, elsewhere compared and contrasted Nancy Haynes' *Molly's Soliloquy* (1991) to the capacity of electronic screens to rob form of substance, which they do by obviating materiality, and which painting may, as in this instance, realise in terms of its own, materially emphatic, spatiality, by bringing density into a maximal convergence with openness and lightness.[6]

In *Molly's Soliloquy*, time is both cancelled and intensified within the fluidity of the slowly accumulated marks that make up the surface. All the properties and qualities brought into view—the heaviness of one kind of paint as against the lightness of another, the thickness of heavy-gauge linen contrasted with the thin layer of paint spread across, and interrupted by it, the use of layers inextricable from one another because of their translucency, of bits of paint that sit on top of the surface in order that they may float in as

Figure 4 Gary Wilson, *Untitled (red/red)* 1997, Acrylic on canvas, 183 ×366 cm, Courtesy Anna Schwartz Gallery, Melbourne

well as on it—allow the space of painting to become a place for an encounter with time as reversibility, which is to say, as equilibrium. In Haynes, as in Mondrian, reversibility is how the body maintains itself through a kind of time, and I take both to show that the idea of immediacy becomes somehow oxymoronically bound up, in painting, with the at first sight contrary one of equilibrium. This is a question that, if examined, may help in developing further the relationship between the allegedly static arts and those of performance and electronic mediation.

To pass quickly from Mondrian to Newman is to go from New York's idea of New York to New York's idea of the countryside, and from there back to the cinema—in Newman's case, to Cinemascope. I have said elsewhere that I think Barnett Newman posited the conditions for a postmodern, post-human sublime, found in the technological, where he could still discover the sublime in nature.[7] Haynes may provide one confirmation of that premise; I have space here only to mention briefly two others, who are a bit younger. Made entirely out of plastic paint and detached from the wall, Linda Besemer's new paintings did not bring to my mind, when I first saw them, something that was not made out of plastic, as had been the case with some paintings of comparable facture that Ed Moses had made back in 1974. Besemer's work reminded one of plastic table cloths, Moses', of Navajo rugs or something like that, possibly suggesting a generation comfortable with a continuity with plastic to which an earlier one might have been comparably indifferent or, alternatively, hostile: the one eager to incorporate the look of

the late- or post-industrial into painting, the other to bend it towards a reference to the pre-industrial; the one, perhaps, concerned with the (ubiquitous) immediacy of the technologically mediated or originated, the other with an immediacy that has to be imagined or retrieved or otherwise found outside of the contemporary everyday.

Finally—moving from Haynes in Brooklyn, to Besemer in Los Angeles, to Melbourne—if one were to compare Gary Wilson's paintings with certain diptychs of the 1960s and 70s that they at first recall, one would find another version—of a more emphatic, or art-historically explicit sort—of the same theme. Because to compare his paintings with, say, Ellsworth Kelly is to look at the difference between the sources of colour as a surface that is also a space.[8] Not the material or physical sources—these are very close, hence the usefulness of the comparison. But the sources to be found in and as subjectivity seem very different. Through a surface detachable from its support—so that when Besemer makes them inseparable we see that as a problematisation of their irreducible difference—painting reconsiders, by realising it in terms that have nothing to do with it—and with no desire to reproduce or represent it—the zone of alienation between the human and the surfaces within and between which it tries to find its subjectivity, or, if you like, is invented by them. I think that's quite interesting. Whether one's audience found the contemporary condition of immediacy relevant would, however, depend on whether one was addressing the living or the dead.

NOTES

1. 'Non-representation in 1988: Meaning-Production beyond the Scope of the Pious', first given as a lecture at Cooper Union, New York, subsequently published in *Arts Magazine,* May 1988, and as Chapter 6 of *Beyond Piety, Critical Essays on the Visual Arts, 1986–1993,* Cambridge University Press (New York), 1995, pp. 53–74.

2. I develop this point in my 'Beauty and the Contemporary Sublime', in Bill Beckley and David Schapiro (eds), *Uncontrollable Beauty*, Allworth Press (New York), 1998, and at greater length in my *Das Schöne und das Erhabene von heute*, trans Almuth Cartens and Dagmar Demming, Merve Verlag (Berlin) 1996, a monograph developed from that essay and translated into English as *Beauty and the Contemporary Sublime* Allworth Press (New York), 1999.

3. For more on how all objects now aspire to the condition of the electronically photographic, and people to occupying it rather than, say, seeing themselves through it, see my 'Cabbages, Raspberries, and Video's Thin Brightness', *Art & Design* (May–June 1996), Special Issue on 'Painting in the Age of Artificial Intelligence', Guest-Editor David Moos, pp. 14–23; and 'Blankness as a Signifier', *Critical Inquiry,* XXIV, 1, Autumn 1997, pp. 159–175.

4. *Das Schöne,* op cit, pp. 41–48. I note, incidentally, that others—for example, Peter Osborne—see many more differences within Richter's practice than my description acknowledges, but these seem to me to be differences that preserve the same posture, or teleology.

5. In conversation with me, while I was writing this essay.

6. See 'Cabbages, etc', op cit. *Molly's Soliloquy* has been followed by paintings that in some respects address the idea or phenomenon of the screen more directly, including works made entirely out of paint that glows in the dark. I extend my discussion of the convergence, in Haynes, of painting with the idea, or other kind of influence or image, of the screen in 'Endspace: From a Real to an Absolute, Nancy Haynes' Paintings 1974–1998', *Nancy Haynes,* Gallerie von Bartha (Basel), 1998.

7. 'Beauty etc', op cit, pp. 42–46; *Das Schöne,* op cit, pp. 22–30.

8. See my 'Stephen Bram, Rose Nolan, Melinda Harper, Gary Wilson', Art Gallery of New South Wales Contemporary Projects (Sydney), 1998.

IAN DAVENPORT: MAKING AND SEEING MEANING (1998)
Andrew Wilson

The history of modernist abstract painting has often been defined through an attention to different spaces. The demands of an autonomous painting focus attention on the space of the painting alone. However, this autonomy can be punctured by an attention to the space in which the painting is seen by the viewer or, indeed, to the space in which (and through which) the painting is made. Each of these spaces provides the painting with quite distinct meanings that are formed, ultimately, between a painting's subject matter (what a painting is, in and of itself) and its content (other forms of meaning that might attach to the painting and be communicated by it).

Figure 5 Ian Davenport, *Untitled* 1988, Oil on canvas, 213 ×213 cm, © the artist, courtesy Galerie Limmer, Cologne and Galerie Haas, Berlin.

Late modernist painting, as it was understood by critics such as Clement Greenberg or Michael Fried, proposed the joining together of subject matter and content in such a way that the painting would be seen alone—isolated— within an experience of visuality. Such a way of looking—in Greenberg's phrasing, using 'art to call attention to art'—understood the painting solely as self-referential.[1] No other references, external to the painting, had any role to play in terms of the provision of meaning. For Greenberg, the significant meaning of a painting by Morris Louis could only be found in terms of its essentialist and historicist discourse on its own modernist condition. Furthermore, this was a discourse that was first and foremost 'seen', in which 'visual art should confine itself exclusively to what is given in visual experience, and make no reference to anything given in any other order of experience'.[2] In this context, the achievement of Jackson Pollock's painting was understood to be the creation of a spatial illusion constructed from a web of lines that had no figurative or extra-pictorial referential status whatsoever. For instance, Michael Fried wrote about Pollock (from the perspective of Post-painterly Abstraction) in just this way:

> Pollock has managed to free line not only from its function of representing objects in the world, but also from its task of describing or bounding shapes or figures, whether abstract or representational, on the surface of the canvas. In a painting such as *Number One* there is only a pictorial field so homogenous, overall and devoid both of recognisable objects and of abstract shapes that I want to call it *optical*, to distinguish it from the structured, essentially tactile pictorial field of previous modernist painting.[3]

Such a response to painting as this, in terms of visuality, presented the action of sight in a detached sense—as a looking without the act of looking— which might reveal a, more or less, aesthetic and formal value in that which was seen. This stood in stark contrast to Merleau-Ponty's understanding of sight, where the act of perception involves the beholder's interaction, bodily, within a space in which the object of focus could take its place. Merleau-Ponty wrote of a 'system of experience' and the act of seeing as something that is 'lived ... I am not the spectator, I am involved, and it is my involvement in a point of view which makes possible the finiteness of my perception and its opening out upon the complete world as a horizon of every perception'.[4] In this respect, the beholder becomes involved in an act of seeing in a tangible and almost haptic sense.

The primary demand made by Ian Davenport's painting is to a visual response, but although this is constructed in the context of an attachment to a largely modernist tradition of abstract painting, it repudiates a viewing (such as that proposed by Greenbergian modernism) that is closed off from its surroundings. The meaning that can be found within his painting is

created out of the meshing of certain traditions of abstract painting and qualities of involvement both onto and out from the painting. The awareness of space and the significance this has for the creation, as much as for the reception, of each work is crucial. A recent painting by Davenport, such as *Poured Painting: white, black, white* (1996), is seen simultaneously in a number of ways. There is the individual encounter with the surface of the painting, where meaning can be formed from sight as well as from the act of looking, in which our presence as we look at the painting becomes here a part of the painting. *Poured Painting: white, black, white* also takes its place in relation to a tradition of modernist painting and its process of self-criticism, just as meaning can be located in the rhetoric of each painting having been conceived as being part of the series of 'Poured Paintings'. Additionally, there is the way in which each painting (as much as each grouping of paintings) should be seen as part of a process of making—the result of a set of procedures—in which the method and order of fabrication can be traced through in the painting. Lastly, there is the way in which each painting takes its place both from and in the world. Although they are rigorously non-representational, Davenport's paintings suggest various sets of references between signs of nature and the signs of the city. Within this equation, meaning is not attached to each painting in a prescriptive way, in which the painting becomes either just about itself or just about something other than itself; instead, it occurs at the points at which all these different ways of seeing intersect.

Davenport's involvement in the ways in which material and process engender meaning could first be recognised when at Goldsmiths he transferred from the painting department to the sculpture department, where he was encouraged to give a different level of attention to the materials of painting and the ways in which they may be used. One of his earliest paintings from this date, *Paint Can* (1988), is a representation of a can of household paint, in which the paint used to paint it has been allowed to run and drip. The work rehearses a modernist tautology—a painting of paint that is also very much about paint itself (a pictorial, visual, material and conceptual image)—that has, in a way, continued to be reiterated in Davenport's paintings to this day. He followed this with a small series of paintings, 'Untitled Series' (1988), which amplified this in a pictorially more abstracted way. The surface of each painting contained a number of small ellipses. To draw each ellipse, Davenport would first dip the brush into a pot of paint, sited beneath the painting, and would then raise the brush to the canvas. Each time he did this, the brush, loaded with paint, would describe the gesture of making this repeated arm movement as paint dripped from the brush over the canvas before the brush itself could make contact to draw the ellipse. The ellipse itself was a more distant echo of the paint can, being an image of its top when seen in perspective, but the other aspects of these paintings—the repeated procedure, the balance between chance and control,

the manipulation of colour, the extension of a vocabulary of drawing and their tangible physicality and materiality allied to a lightness of touch—provided Davenport with a set of tools by which the canon of modernist painting could be reinvigorated within the terms and languages of the 1980s and 1990s. It is not only that, culturally, a pluralist attitude has become the norm over the last fifteen years. Davenport is representing painting and the phenomena of contemporary metropolitan life at the same time. His paintings offer us a new way to see the city, not through an appropriation of sign systems, but on a deeper level. In a sense, there is not so much difference between the experience of looking at a painting by Davenport and that of getting onto a tube train; it is this sort of recognition, not of an image (through a 'sign') but an activity (moving through space), that is significant here.

It is, to a degree, illuminating that Davenport, with his first paintings, should start by using a classic early modernist procedure in which abstraction is formed by the removal of recognisable, or decipherable, elements from an image by means of a process of progressive simplification. However, the immediate disappearance of the still-life image is here less important than the fact that the paintings that followed—all resolutely non-figurative—should have a direct connection to the stuffs of the world as phenomena. This is signalled in Davenport's painting, in one way, through his continued use of household paints and materials (his DIY brand of modernism), and through the tracing of gesture and process that refers as much to the process in a material way as it does in a bodily way, to unlock the situation that frames the process.

It is no accident then, that Davenport has been attracted to the work of artists who have used paint (or an equivalent for it) in ways that utilise the space of the studio and the application of paint in a sculptural sense in which the body's involvement in making the painting is given a primary role. In this respect, he has cited artists such as Yves Klein, Jackson Pollock and Richard Long, who, in different ways, have engaged with the idea of an abstract painting that was formed in areas quite apart from the purely optical. Pollock described his process in terms of his bodily involvement in the making of a painting that foregrounded its own materiality, so that

> I prefer to tack the unstretched canvas to the hard wall or floor. I need the resistance of a hard surface. On the floor I am more at ease. I feel nearer, more a part of the painting, since this way I can walk around it, work from the four sides and literally be *in* the painting ... I continue to get further away from the usual painter's tools ... I prefer sticks, trowels, knives and dripping fluid paint or a heavy impasto with sand, broken glass and other foreign matter added.[5]

In this way, Pollock's paintings contain not just a narrative of the process by which they were made (the order of paint application or the sorts of tools

used are often encrypted in each painting's surface), but also declare that narrative to be concerned with the spaces in which and by which the painting was formed, in terms of bodily movement around and into it (a point virtually ignored by Fried). Similarly, Yves Klein's 'Anthropometries' are so much more than just a record of a particular performance or event and extend the 'zone of immaterial sensibility' already consolidated in his 'monochrome propositions', as a bodying of space that was later to find its partial echo in the walk and splash pieces of Richard Long.

Since his introduction at Goldsmiths to a new way of thinking about what painting could be, Davenport has investigated the properties of paint, its relative fluidities and drying times, its covering capacity, its relative finish (matt, satin, gloss, vinyl) as well as the introduction of other materials (such as varnish). However, and unlike Pollock and Klein, Davenport's mark making—though it might embrace the appearance of chance—is not intuitively formed, but is instead highly structured and preordained (like the very different types of mark-making in the work of John Cage or Jasper Johns).

To these ends—the creation of chance-structure—Davenport has also explored different ways of bringing the paint to the surface. The earliest paintings, such as *Untitled* (1988), continued the procedure of *Paint Can* (1988) and were achieved by taking the paint from the can at the centre of the painting's base, and then releasing it onto the top of the canvas, from where it was allowed to fall down. This process leaves two trails: one that fans up, left to right, as the paint is brought to the canvas, and another as the paint falls down to cover the canvas. In later paintings, the paint was brought up to the top of the canvas from a point opposite to that of its release at the top, giving parallel vertical spills and drips. In others, Davenport also started to tilt the paintings so that he could control the runs of paint better. In contrast to this degree of control, a small group of paintings were made using electric fans to blow the paint across the surface of the canvas.

In 1990, Davenport started pouring puddles of paint onto the canvas, which would then be lifted up from the floor to create thick, broad runs. In the series 'Untitled Matt Black', pours of gloss and then matt paint are offset against a matt ground. By 1993, the method of pouring, as much as the resulting image, had become structurally more complex. Where before, the method had been a direct pour (whether from a watering can or straight from a tin) onto a flat canvas that was then tilted,[6] the newer paintings, such as *Poured Lines: cream, yellow, beige, dark blue, light blue* (1993), were already tilted when the paint was poured over them—as Richard Shone has described—within a tightly defined process:

A small scaffold is placed next to the canvas which is positioned at a slight angle to the vertical. The paint is poured from a vessel with an adjustable head that regulates the breadth of each pour. Strict time is

kept between the sequence of pours allowing the paint to find its way down and off the canvas, before it begins to meander or expire. Variations in timing establish the overall tempo of each work.[7]

By 1995, Davenport had started making larger pours. In *Poured Painting: white, black, white*, a coating of white gloss paint was applied to a 6-foot-square sheet of MDF board. After this layer had dried, the painting was laid out horizontally. The centre point of the painting was located and a quantity of black silk emulsion was poured. The paint moved out towards the edges but just before it reached that point, Davenport upended the MDF panel so that the pool of paint fell down towards, and over, the bottom edge of the painting. The painting, as it stood at this stage, described a black archway shape against a white ground. When the black paint had dried, the pouring process was repeated, but with white gloss again, the panel being upended just before the paint reached the edge of the black archway shape. The painting now describes a black arch on a white ground.

The development of Davenport's painting over the last ten years, in terms of the procedures and processes he has employed, has remained strikingly coherent. However, these processes and the paintings' material facts—the manner and order of application of different types of paint onto a support—do not, as I have already suggested, give the whole story in terms of a construction of meaning. The 'material facts' might be where meaning comes from, but they do not themselves provide the sole meaning of the resulting paintings. Davenport's paintings are not purely process paintings and our response to them is not purely optical. Michael Fried's understanding of Pollock's painting as 'optical' is now insupportable, as it ignores not only Pollock's interest in the action of myth and metaphor but, more significantly, also refuses to address the ramifications of a working practice that explicitly puts the paintings in the world.

Similarly, Davenport's paintings cannot be defined as singular objects. If the subject of his paintings is to be found as much in the nature of their structure as the result of processes and procedures that were carried out, and can be similarly defined by a referral to the physical manner in which the paintings have been made and the prosaic materials that they are made from, then the content of these paintings flows from and against our reception and perception of what, collectively, these structures and processes are and might imply. It is in this sense also that the notion of a purely optical response to the painting is undermined, and subject and content move apart.

In 1963, the American artist Brice Marden wrote about his paintings as being 'made in a highly subjective state within Spartan limitations'. In the early 1970s, he described his paintings as 'but sounding boards for a spirit' and in 1980 said, 'I accept nature as a reality; it's the best reference; it's what the painting's about'.[8] The trajectory of these admissions by Marden—their movement between subjectivity, rationality and the world that surrounds and

informs but is, crucially, not depicted in his paintings—perhaps gives an indication of what Davenport means when he writes that 'I don't say this painting looks like this or that, the whole painting might be about something, more likely a phenomenon than an object. But the meaning comes from the making'.[9] The 'phenomenon' that Davenport describes here is one that has split the subject matter of his painting from its content. In Davenport's hands, painting becomes about something other than just paint, without, at the same time, having to make recourse to a field of external reference (being 'like' something else), or to the construction of a painting as a representation of painting (being 'like' the history of its own making or the history of the making of other paintings).

Furthermore, Davenport's paintings display a seemingly effortless physicality through which we can see the drawn line of gesture and yet can find no trace of brushmark. The paintings are constructed in a very hands-on way (as photographs of Davenport at work in his studio show) but we are left, especially with the poured paintings, with something from which expression has been detached and taken away, just as the process he uses relies on a progressive and sequential layering and deliberate, even wilful, obscuring of what had been done before.

The meaning of each painting, in terms of a 'phenomenon', is of course a result of the making (but the 'meaning' is not the making itself), as much as it is to be found in Davenport's attention to repetition within the structure of each painting, to the conception of a series of paintings and in his reuse of tradition. The meaning can also be found in the way these 'events' can be ruptured by chance and the outside world and simply by the experiencing of the paintings in ways that are not purely optical. The 'phenomenon', here, can be uncovered from the paintings' place in the world and the way in which they are seen. In this respect, Norman Rosenthal, writing about Davenport's first solo exhibition, suggested that his paintings

> have within them extraordinary movement, sometimes capable of evoking particular elements—perhaps water or the wind. They might seem to resemble water reeds moving in the wind but equally they give rise to thoughts about the smoother surface beauty of industrial production, or yet again, in their energy, of sexual force.[10]

In writing this he was not saying that Davenport's paintings were pictures of water or wind, but that reference to such phenomena (or to the DIY store) was inescapable given the phenomena surrounding their own creation and reception and their connection to the everyday. The openness of such a reading of his paintings being determined and framed by the procedure and circumstances of their making.

What the beholder sees when looking at one of Davenport's recent poured paintings, is the result of much else besides a process that, itself, can

be little more than just a starting point. The process might be the painting's subject, but it is not its content, even though it frames the content. Ultimately, such paintings are not about pouring, but about seeing and experiencing a painting that has been formed from pouring. Everything about the recent poured paintings is determined by their human scale, which allows Davenport to handle them while he makes them and when completed, they enclose the beholder in sight of the painting. This is quite different from the iconicity found, for instance, in Robyn Denny's door paintings (or Gary Hume's, for that matter) where the presented image has a referential content that lies outside the painting and that similarly moves the focus of perception away from the painting towards something to which the painting can be likened. Similarly, the comparison that has been made between the work of Davenport and Ellsworth Kelly is revealing.[11] Although there is a similarity of shape to the pared-down forms and divisions in Kelly's work, these are forms that derive from, and are abstractions or simplifications of, observed nature. There is no such connection in Davenport's work.

The arch-shape in Davenport's poured paintings has no abstracted, metaphorical or representational purpose or meaning. It describes a prosaic layering of edges and a 'drawn' line that has not been drawn but poured. It also frames an experiential reading of these paintings in sight, to an extent that his other paintings do not have. This approach is emphasised in works such as *Poured Painting: blue, black, blue* (1996), where the arch shape emerges from the satin paint layer surrounding, and surrounded by, a large expanse of reflective gloss paint. This framing encourages the beholder to approach the painting as an object constructed out of sight, where perception is figured as the process that completes the painting. The beholder sees themselves looking, framed by an internal structuring that also points to the making of the painting. Furthermore, chance, here, becomes the painting. The 'something else' that forms the content of these paintings is located in the face-to-face contact with the painting, in which the beholder looks at an object that becomes an image or an appearance, just as a careful process gives way to something that cannot necessarily be controlled. In this instant, where subject and content move apart, the painting can be recognised not as a mute object, but as a collection of structures that connect to the space of the viewer as much as the space of the painting and the spaces through which it had been made.

NOTES

1. Clement Greenberg, 'Modernist Painting', in John O'Brian (ed), *Clement Greenberg, the collected essays and criticism* (vol 4: *Modernism with a Vengeance, 1957–1969*) Chicago University Press (Chicago), 1993, p. 86.
2. Ibid, p. 91.

3. Michael Fried, *Three American Painters*, Fogg Art Museum (Cambridge, Mass), 1965, p. 14.

4. Maurice Merleau-Ponty, *Phenomenology of Perception*, Routledge and Kegan Paul (London), 1962 p 304.

5. Jackson Pollock, 'My Painting ...', *Possibilities 1: Problems of Contemporary Art*, Wittenborn Schultz (New York), Winter 1947, p. 79.

6. See the sequence of photos by Henry Bond of Ian Davenport in the process of making *Untitled Matt Black* (1990), in Andrew Renton and Liam Gillick (eds), *Technique Anglaise, current trends in British Art*, Thames & Hudson/OOP (London), 1991, pp. 62–67.

7. Richard Shone, *Ian Davenport*, Waddington Galleries (London), 1993.

8. Brice Marden, 'Notes', 1963; 'Notes', 1971–2; 'Interview', 1980, in *Brice Marden: Paintings, Drawings and Prints 1975–80*, Whitechapel Art Gallery (London), 1981 pp. 54, 57.

9. Ian Davenport 'Notes', September 1989, in *The British Art Show 1990*, The South Bank Centre (London), 1990, p. 50.

10. Norman Rosenthal, *Ian Davenport*, Waddington Galleries (London), 1990.

11. Martin Maloney, *Ian Davenport*, Waddington Galleries (London), 1996: 'Consistently these paintings testify to the desire to try to make beautiful paintings. Delving into Albers (with Ellsworth Kelly not too far out of sight), Ian Davenport's DIY approach to modernism gives a new edge to the familiar'.

Ian Davenport in Conversation with David Ryan (1998)

David Ryan: Re-reading your *Notes on Painting* of 1989,[1] it's astonishing how relevant they are to your current production. What, if anything, do you feel has changed since you embarked on your first mature paintings?

Ian Davenport: I suppose I feel the paintings were mature even back then. It felt as though I'd discovered something very rich; something that I really wanted to investigate. Every time I explored a new series, it felt like it opened a new area, even though there might have been relatively modest shifts or changes within the range of procedures I was developing at that time. In one sense, that's what I still do now, and I guess that's why they're still relevant to me. I'm still dealing with chance, process, fluidity, control, materials—very simple, basic things. I didn't set out to explore such a progression intentionally; things just developed naturally. It's as much a surprise to me that I'm still dealing with similar concerns ten years on.

Figure 6 Ian Davenport, *Poured Line Painting* 1994, Household paint on canvas, 213 ×213 cm, © the artist, Collection Museum of Modern Art, Dallas; the Mary Margaret Munson Wilcox, Fund and gift of Mr. And Mrs Lennox, Lizzie and Dan Routman.

DR: It's interesting that you mapped those processes out with your *Notes,* which act as both a description of your activity and almost a 'score' for various actions.

ID: It was simply a means of achieving greater clarity, a way of focusing. Each series has enabled me to examine one aspect more precisely at a given point. I think I said in those original *Notes* something like, 'I always try to do very little, but a lot of it'—and this remains true.

DR: Yes, and one of the things I picked up on was this: 'I don't say this painting looks like this or that, the whole painting might be about something, more likely a 'phenomenon' than an object. But the meaning comes from the making'. What kind of 'phenomenon' did you have in mind here: paint, or something out there in the world?

ID: I think now, re-reading this, it remains a little too vague. I was trying to underline the procedural aspect of the work, discouraging a metaphorical reading or romantic associations. 'Phenomenon' is such a broad and also loaded word, so I doubt whether I would phrase it like that now.

DR: Phenomenon could also refer to gravity ...

ID: That's right, and I think that's a very sculptural approach in fact. I'm interested in making paintings that are sculptural—but not sculpture.

DR: One is almost tempted to say it's paint in its 'natural state', but that's not quite right either, is it?

ID: Well, I like that idea, but my approach remains highly controlled. So no, it isn't right. It's more a balance between the paint doing what it does and the controlled parameters that frame this activity.

DR: So you've implied that at the time of your *Notes,* you were trying to restrict this process of associative readings by focusing on the 'making as meaning'.

ID: Well, I would say 'redirect', rather than restrict or be totally prohibitive about it. But I also think that the individual elements that I'd adopted did have other connotations: how a drip or a flow of paint might allude to something natural, for example. The problem with this term, 'making as meaning', is that we enter the vast field of discussion of meaning *per se,* and to tie down what something means is always tricky. Carl Andre once suggested that, as far as he was concerned, his artworks were expressive but without any intended message. The meaning doesn't come from any other

message, but from the materials and the artist's articulation of those materials.

DR: This is quite a modernist approach, isn't it?

ID: Absolutely, and one that I don't think we should be too quick to reject. It's easy to forget that creating form, itself generates meaning.

DR: And such an approach informs the current paintings?

ID: The paintings are the result of a specific approach to the activity; they're placed on the floor, and already have a sprayed ground coat. Then, from the middle, I pour a liquid gloss paint until this nearly reaches the edges, at which point the painting is stood up, and the paint is allowed to flow down, forming an arch shape. After drying, this process of pouring is then repeated for a second layer, almost erasing the layer underneath it, leaving a very thin line, almost like an archway shape.

DR: What strikes me about these recent works, is the way in which these very clear, simple forms manage to traverse a wide range of art-historical references: Motherwell's 'Open Series', or some of Mangold's paintings spring to mind.

ID: Yes. Mangold, Kelly, Albers even ... I don't mind those associations. And of course, many different artists have informed the approaches I use, but such references are a by-product of the resulting 'image'. So it isn't ironic or about quotation, it's simply to do with the complex triggering of association that might be sparked by a focused, simple form. It also goes back to the idea that such severe restrictions can result in a kind of liberation—it opens up a whole world. Of course, the last thing I'm thinking of is to make work that looks like Kelly or Mangold, but I don't mind the fact that I'm touching on this history in some way, and through the processes that I use, re-inventing it for myself.

DR: Thinking about the fact that you work in series, do you see meaning as something that's accrued through repeated activity? Repetition is often cited as a means of eluding meaning, like the repetition of a word, or the serial production of manufacture.

ID: Again, this is a complex issue. I think, generally, repetition allows me to get into a particular problem, enabling me to perfect a technical quality, or whatever, whereby the more you repeat it, the more in control of it you become. But repetition also differs from particular series to series, and we're talking about a wide range of different works here. When I first started

making the paintings, the marks would be repeated in a grid form or from one side to the other. So repetition acted in a very rhythmical, digital way—almost like a machine. But if you're asking if I think that meaning is located within the repetitive act itself, then no, not for me. Then again, I can think of somebody that I admire, like Monet with the 'Haystacks'—a very simple, abstract form that acquires different depths and nuances with each repetition.

DR: Yes, whereby Monet constructs a sense of the general from different, particularised representations that articulate minute shifts of difference. We're also talking here about repetition as a vehicle for intensive variation.

ID: I'm always happier when you see more than one work in order for this experience to take place.

DR: As I mentioned earlier, repetition can also have the reverse effect: an emptying out of meaning. Kandinsky referred to this in *Concerning the Spiritual in Art*,[2] and it's also an important aspect of Eastern art.

ID: Well, I don't consider myself to be particularly Zen orientated, but perhaps that relates to what I was saying about the approach to perfecting a technique, which could be seen as a focus; as a clearing-away of imperfections or inessentials. In one sense, this is a kind of emptying out; slowly seeing the thing more clearly.

DR: Bernard Frize suggested to me the other day that painting gave him a specificity, a locality—the space, in a word, to be a realist dealing with real materiality. Is this something you can connect to?

ID: Yes, I think that's right. I like this encounter with the 'real thing'—this engagement with the materials. I've never thought of myself as an abstract artist, but simply one who's exploring the materiality of paint.

DR: The way you, or perhaps others, describe your work, it might be tempting to think of the youthful Stella—'What you see is what you see', or, 'The paint is as good as in the can'—etc. What differentiates you from such an approach?

ID: I like Stella, and I admire the way that approach attempted to de-mystify art-making. The way he dealt with composition, especially in the 'Black Paintings', the fact that they were pre-planned—worked out and then executed—interested me. I think also there's a human quality to those paintings: the wavering line within the arena of the canvas, etc, that often gets missed when they're discussed. So there are overlaps, and I wouldn't

rush to distance myself from such an approach. I think that today's material context is quite different, and therefore will generate a whole gamut of different meanings.

DR: How do you see the status of process in relation to the work?

ID: It's a tool; it's not the point of the paintings. It's an important point to make in relation to the final outcome, but I'm not a 'process artist' by any means. The point is the richness of the final outcome, which is intertwined with a set of procedures. So it's a balance between the two, rather than any particular stress on either aspect. It's also important to think about the objectivity of the marks—in that they don't come from any psychological sets of concerns. I don't have any attachment, in a direct way, to those marks; the process enables this distance. I'm interested in how Stella achieves this, and also Jasper Johns with his '0–9' series.

DR: Since you mention Johns, I'm also reminded of his practice of transferring a composition from one piece to another in order to allow himself to concentrate on something else, maybe the colour, or whatever. This is in line with a process-like approach to variation and repetition.

ID: Yes—I can see the use of that, absolutely. I think the use of chance in Johns is very interesting as well. To take the notion of 0–9 as a starting-point is a pretty dumb thing to do, but it results in a highly complex and unpredictable image. I like that. Johns was influenced by John Cage, who I'm also interested in. I remember reading Cage's 'Lecture on Nothing' from *Silence*,[3] whereby part of the text is structured in such a way as to make this structure experiential—so on one level, it's about nothing, but it's also about something. This too, enables that encounter with the 'real thing', with the materiality of the text; rather than writing about something outside of the text, the text becomes the vehicle for us to experience something.

DR: You just mentioned distance as being important. There tends to be a movement away from the brush as an implement—the recognisable brush-mark (albeit as a starting-point for the flow of paint)—in favour of other, more distanced tools.

ID: I think that's right. Actually, I feel it's important to question pre-givens—I like the idea of making a painting without any recognisable brushstroke. The distancing gives me more freedom to manipulate the materials; it is controlling, but without a brush; it's controlling the material at one remove.

DR: Martin Maloney[4] suggested that you're like a gymnast in terms of the attempt to improve technical manoeuvres, and you yourself have discussed a

Figure 7 Ian Davenport, *Poured Painting: blue, black, blue* 1998, Household gloss paint on medium density fibreboard 152 ×152 cm, © The artist, courtesy Waddington Galleires London, Photo: Prudence Cuming Associates Ltd.

sense of timing, or even tempo—a strict rhythm that's crucial to the work. Is this sense of tempo developed as you work your way into a series? How important is it that the paintings reflect this physicality as part of their own presence?

ID: Different series have different concerns. I think the paintings that required this sense of tempo were the 'Poured Line' series, which developed a sense of rhythm that had to be strictly kept during the process, and I think this is recoverable in the experience of these paintings. The recent ones, if we keep to a musical analogy, are more like floating, single chords, maybe. In terms of working method, the physicality of the two series requires a very different rhythm to be developed. The idea of relating this to the activity of a gymnast arose because, at the time I started making these paintings, I was

watching the Olympics and saw these divers doing somersaults or a flip or whatever, and doing it extremely elegantly, and they'll score one point. Then they'll go up and do something else very similar, just as elegant, and get a 'two'. And you think, what was the difference? Sometimes a very small change can make a big difference. I liked the connection of something that's outside of painting, outside of art even. And I certainly don't think of the works more in terms of modernist discourse than as DIY or more everyday things. That makes them less precious, but it also affects the process; I have to be very clear about what I'm doing each day. When I was doing the 'Poured Line' paintings, I set myself a day of the week for each colour—Monday: red, Tuesday: blue, Wednesday: green, etc. This would intensify the concentration; it would focus the work. It became almost like a diary. It was a way of marking time, in many ways. In the recent work, it's a sense of timing that's completely different— getting that precise point in time when to lift the painting.

DR: Is it important to think of the works in terms of manufacturing; almost an industrial model?

ID: Yes, definitely. I think that the idea of an industrial workshop can be traced right back to Titian or Bellini.

DR: Going back to the procedures of making, both Brice Marden and Sean Scully have stressed the importance of physicality and its corresponding sense of presence as almost being a key to their work. Scully has spoken in terms of the indexical marks of making: the traces of the physical process being almost like a 'footprint in the sand'. Likewise, Marden, with his emphasis on the unique limitations of the painter's body. On the one hand, this might conjure up something of your activity, but I presume the concern with distance situates it elsewhere?

ID: They are both artists who interest me. Yes, those issues are important for their work—I'm thinking of Marden's very precise relation of the scale of his work to his own body. While issues like this do concern me, I suppose I've developed a very hands-on, physical way of making my painting, for results that appear very hands-off and distanced from physical activity. It is contradictions like this that the work seems to feed on. So there is this relationship to the body, but it is more oblique than either Scully or Marden.

DR: It's also interesting how a painting can 'behave' quite differently from its physical components. Leo Bersani has written about paintings as a manifestation of a 'non-spatial order of being within the space they take over'[5]—suggesting that the spatial presence of a painting cannot be seen simply as the dimension of its physical limits, or of the space it occupies. I was wondering if this optical dimension was left to chance?

ID: Perhaps there are two different conceptions of space being touched on here: the literal space of the painting and the effect of the environment. I do attempt to control this to an extent—in the sense of making models of environments and paintings, etc, to work out those relationships. But, of course, such environmental factors are unpredictable. The viewing situation is crucial to the work.

DR: And it's interesting that this is often discussed in relation to the work. It's a notion of reflexivity—with the materials literally dealing with absorption and reflection. How much does this consciously inform the choices and decisions at the stages of making?

ID: Well, that is important to the whole process. Just on the level of colour choice, the darker colours will absorb light.

DR: Yes, some of the individual paintings do absorb the environment in this way, whilst others seem very self-enclosed, like a coloured intervention that cuts into the space of the room.

ID: It's strange the way some of the paintings operate almost like a mirror. It's very odd to see yourself as part of the image, in contrast to the opacity of some of the others, for example. This is something that interests me very much in the viewing process. I think the paintings also encourage movement around them physically—and that's another sculptural aspect, I suppose. In this sense, there isn't one ideal viewing position; you're invited to move around them, as you would an object in space.

DR: The reflective quality can also really disrupt the viewing of the painting as 'image'.

ID: Yes. I think the more reflective they are, the more *modern* they are, almost in a futuristic way. The viewer is so much more aware of the process of looking, of being part of the painting, almost.

DR: Is this another way of breaking down the classic autonomy of the modernist painting, the self-enclosed picture?

ID: It's another spin-off from the process and the materials; the way different sheens—gloss or matt—might behave, creating these diverse responses to the environment. But it's certainly something that fascinates me. Going back to the colours, though; these are very industrial. One of the reasons for this is that in England, you don't have access to really bright colour, apart from in the manufactured sense. So they will relate to cars and industrial lacquering with their particular surfaces and qualities. I think that's also why I referred

to them as 'coloured', rather than 'colourful'. The colour has a particular self-contained presence in some way, rather than any sort of free, chromatic play.

DR: Brian Muller has suggested that your work fits into the category of 'new modernism', a genre of 'post-postmodernism',[6] so to speak; a reaction against deconstructionist, iconographic, referential art of the 1980s and the early 90s. Thinking of your British contemporaries, a concern with representation, sometimes of the most abrasive sort, seems to be the order of the day, within painting itself as well. How do you, if at all, situate your work within this current climate?

ID: I think we should be wary of making any artificial distinction between abstraction and figuration. Individuals are more important.

DR: Well, yes, I would agree—this would be a rather archaic distinction. I was simply wondering whether there's some feeling of mutual purpose between some of your fellow painters of monochrome abstractions?

ID: There's no question of being part of a movement—'new modernism', for example. No artist in their right mind wants to be labelled. That's more a concern of critics and historians of art. And my connections are also with artists who wouldn't readily be critically connected with me: Gary Hume, for example. I feel that we've both learnt from each other's work in a very interesting and fruitful way.

DR: Finally, many of the American artists I've interviewed have suggested that the monochrome, or the field approach to abstraction, is a dead-end; that it invites perhaps too much nostalgia for the canonical achievements of classic modernism. Obviously, you would disagree with such a position?

ID: It's interesting that you say some of the American artists said this. I think this shows the weight of the Minimalist tradition and the broader history of abstract painting for American practitioners. Being an English painter allows me to be more free with that tradition, and to use it in my own way. I certainly don't feel we can say it's a dead-end. If you apply that logic, then in the same position forty or fifty years ago, I'm sure they would have said that a figurative approach was an impossible avenue to follow. The current scene shows that such a statement is nonsense; each generation looks at the past from a different perspective. Although I admire the great modernist figures, I don't feel they're sacrosanct, and that one cannot rethink their achievements. Someone is always going to do something that changes the situation, that goes against the prescribed view. As soon as someone says that you can't possibly do this or that 'today', then that, to me, is as good as an invitation to do it.

NOTES

1. *British Art Show 1990* , Hayward Gallery (London), 1990, p. 50.
2. Wassily Kandinsky, *Concerning the Spiritual in Art*, trans MTH Sadler, Dover (New York), 1977 p. 15
3. John Cage *Silence, Lectures and Writings*, Marion Boyars (London), 1961, pp. 109–126.
4. See Martin Maloney, *Ian Davenport*, Waddington Galleries (London), 1996.
5. Leo Bersani and Ulysse Dutoit, *The Arts of Impoverishment—Beckett, Rothko, Resmais,* Harvard University Press (Cambridge MA/London), 1993, p. 95.
6. See *Real Art*, texts by Brian Muller, Southampton City Art Gallery (Southampton), 1996.

LYDIA DONA: ARCHITECTURE OF ANXIETY (1995)
David Moos

I see painting as this molecule that is constantly in the process of its rupture. This is what my painting really is. It's this big molecule, this big map, this big urban construct, this void, this body, this skin.

<div align="right">Lydia Dona (1991)</div>

By linking architecture to anxiety, I expect two things: first, a better understanding of how the fabricated is fashioned along emotive or expressive urges; and second, a better grasp of how biomorphic constraints mediate their interface. The painting of Lydia Dona roots conceptions of the corporeal in visual tropes of contingency. The human body becomes a figment of contestation that must mediate between chemically fluid genetic codes and a cognisant agent forming culture, society, a world. The sole index becomes that

Figure 8 Lydia Dona, *Pyramids of Breakdown and the Tears for Cleopatra* 1994, Oil, acrylic and sign paint on canvas, 213 ×162 cm, Courtesy Galerie des Archives, Paris.

of scale, not a relative notion but rather the introduction, or induction, of an absolute scale, the scale of painting. Each of her paintings offers a scaling—where the mind must conceive separate yet simultaneous paradigms of its own purpose. From 'molecule' to 'urban construct', location of the human seeks a multi-tiered synthesis and, inevitably, a constantly shifting scale for itself.

For the practice of painting, this strategy has far-reaching implications. The active painting body that leaves clues to its corporeality depicted in paint (field, line, drip, dot, etc), is managed upon multiple plateaus of connotation, and in the process catches up all manner of demarcation that inscribes it with meaning. Historical, cultural, textual, social, libidinal, biological—'this big map' opens before us, posturing for invention, questing to be deciphered as we travel its trajectory, which is, we must remind ourselves, primarily artistic. Dona is engaged with the production of a painted space into which these separate lineages can be operated, their differences meshed, their likenesses decoded. Before treating the 'content' of her painting, which I assume can only be addressed once the painting's method has been engaged, let me remark upon the milieu in which her meanings are pictured and abstraction can be associated. This essay will attempt to preserve certain breaks or discontinuities within itself, to focus upon a topic, but leave it suspended as image. And perhaps this is a valid description of how Dona's painting functions—it is the posing of visualised questions. What kind of viewer is needed for abstract painting today; who will this person be, in which body, where?

In setting herself the goal of allowing painting, as a singular object, to commute through diverse connotational terrain, Dona phrases her task in a synthesising language. Abstraction in painting becomes a project that is pollinated by, and can profit from, allusion and intersection:

> Colour codes are both cosmetic and cosmic. Cultural codifications of the 'cosmetic bodies' of femininity and masculinity are both quoted and displaced to build a systematised degendered 'code', a third zone of schisms and multiplicities: the zone of techno-urban bodies. The ghostly painting of the ghosts of the body.[1]

Into this syntax, which speaks of 'build[ing]' and the construction of metropolitan 'zones'—adopting the voice of urban planner—the figure of the 'body' becomes the locus of meaning. For painting, despite the use of a novel descriptive vocabulary pregnant with technology's tongue, the site of confrontation remains that of the body. 'Cosmetic bodies', in the manner of cyborgs, are what the painter speaks about. Dona's 'techno-urban bodies' refer less to the act of painting than to the kind of consciousness required for approaching her work. Will the historical gestures of painting remain valid in a future that is capable, through the augmentation of cybernetics, of fabricating conscious bodies?

As our culture continues to evolve from a machine-based technological ethos into an information-based floorplate, the body's relationship to its environment is remapped—literally rewired from the outside in. As Paul Virilio observes of his 'telecity': 'Clearly the urbanisation of real time entails first of all the urbanisation of "one's own body"'. An ominous archetypical urban inhabitant is envisioned as the body is 'plugged into various interfaces (computer keyboards, cathode screens, and soon gloves or cyberclothing), prostheses that turn the over-equipped, healthy (or 'valid') individual into the virtual equivalent of the well-equipped invalid'.[2] Human mobility, that great enterprise of the post-war mechano-world, is over-mastered in the electro-information world by a merely localised motility. Planetary environments are distilled into the interactive home managed by a *terminal citizen*, whose immediate genetic predecessor is the 'motorised-handicapped'—able to control the domestic environment without undergoing physical displacement. The adaptations and retoolings required of the information age will remodel the environment (house, city, nation, cosmos) and the body (arms, implants, cells, chemicals), with both converging in the super-consciousness of cyberspace. Mediating the interface will be the human mind, in no prescribed location *per se*, but rather, situated at some crucial delta where flows of information—like rivers with tides—go out and come in.

Flows are more constant than the material world that expresses and embodies them.[3] In virtual reality, where technologies splice a human subject into a cybernetic circuit by putting the human sensorium in a direct feedback loop with computer data banks, flow becomes the operative concept: 'the flow of information within systems [i]s more determinative of identity than the materiality of physical structures. Plunging into the river of information implies recognising that you *are* the river'.[4] When equipped with Virilio's 'interactive prostheses', this plunge is taken 'physically', taking the body along with the mind.

In seeking a human model able to contribute vitally and reflect upon the conditions of culture, Gilles Deleuze discusses the place of the nomad. In the framework of the information age, which enables a globalising projection of presence, the paradigm recurs with particular potency. 'The nomad is not necessarily one who moves', Deleuze suggests. 'Some voyages take place *in situ*, are trips in intensity. Even historically, nomads are not necessarily those who move about like migrants. On the contrary, they do not move; nomads, they nevertheless stay in the same place and continually evade the codes of settled people'.[5] The notion of 'in situ' acquires magnified connotations within the context of the information environment, and this is especially true for abstract painting. Dona's work confines itself to the unmediated surface of canvas, restricting the flow of expression to paint alone. Passing through recognisable 'codes' of painting, the canvas surface becomes an arch-site where 'trips in intensity' are navigated. Voyages of mind are pictured by processes of paint that form a compound identity through a dense accumulation of references that can be multiply construed.

The painting of Dona speaks in two tongues, with two referential codes: the textual (Deleuze and Guattari) and the art historical (Duchampesque diagrams, Abstract Expressionist icons, Minimalist components). From this bivocality, Dona's own voice emerges, reconstructing these sources onto a plane of polyvocal visual parlance. Her paintings should not improperly be conceived as synthetic or pastiche-based—the now all-too familiar strategies of postmodernism—because with each application of an adopted source, a crucial adaptation occurs. Dona's painterly articulation of recognisable parts allows for her work to defend against mere emulative schemes of appropriation. Her strategy is that of posing visual questions through the display of emblematic origins. The cumulative image thus calls attention to its multiplicity as sources are 'reformulated or redefined according to the relevant context now: the question of postmodernism, the void, the decay, the breakdown'.[6] Her careful enunciation of hybridised imagery subverts the initially recognisable source or referent, questioning re-cognition in the presence of the virtual experience offered by the painting. 'Freedom of meaning', the literary critic Harold Bloom has argued, 'is wrested from combat, of meaning against meaning'.[7]

The first encounter with 'meaning' occurs between text and painting. Before describing the painting, let me cite the discernible source that frames the intention of meaning. Each line, each idea written in the following passage quoted from Deleuze and Guattari's A Thousand Plateaus finds its way analogically into the painting Anatomies Of Molecular Motors And The Segments Of No Beginnings Nor Ends (1994). The envisioned thoughts appear to narrate the painting's motives:

> There exists a nomadic absolute, as a local integration moving from part to part and constituting smooth space in an infinite succession of linkages and changes in direction. It is an absolute that is one with becoming itself, with process. It is the absolute of passage, which in nomad art merges with its manifestation. Here the absolute is local, precisely because place is not delimited.[8]

Nomad space—smooth space; close-range vision as opposed to long-range looking, haptic space as distinguished from optical space. To trace the integration of 'part to part' displayed in the painting, its 'process' of making must be retrieved. Stand near its surface, at about brush distance. Here the eye can seek the annexation of time, the segmented disparate time involved in its making. Process and time, painting and looking—each an interposing, mapping, mimicking.

We approach the painted image 'moving from part to part', gathering up likeness where we can find it. Match the upper corners, quadrants of the hazy machine diagrammings (Duchamp's now antiquated Coffee Mill (1911) cum Chocolate Grinder (1913) rotated, concatenated and multiplied), with the

triangular components of this same chalkboard-like demonstration. Unite the internal flowing parallel lines, follow them like vectors to the centre, and reverse the flow outwards to the rim of the ovoid, circulatory edges; the 'infinite succession of linkages and changes in direction'. Commence the linking, travel the walkways of line or begin bounding over the surface, watch how the image imbibes 'becoming itself, with process'. The blue drippings (Pollockesque) accumulating along the curved edges in the four corners, locally attain a manifest difference that is nevertheless linked through colour and application. Switch colours and move with the dripping to the interior, to the dangling, ebullient, frenetic green. Become the painter with your eyes and 'merge with its manifestation'; become embedded with how successive applications of distinguishable paint have arrived to refute priority of application; undermine difference in the effort to bind parts of the painting together.

Such multiple overlaying of processes aspires after the 'absolute [that] is local, precisely because place is not delimited'. The painting is a labyrinthine happening, an insistent subjectively governed eloquence that demands 'close-range' scrutiny by virtue of its intricacy. For example, a faint pencil-drawn grid is seen to structure the smoothness of black exposed at the lower left (a reference to Minimalism, perhaps the grids employed by Peter Eisenman). We read out the textual inscription as follows: 'The smooth is the continuous variation, continuous development of form; it is the fusion of harmony and melody in favour of the production of properly rhythmic values, *the pure act of the drawing of a diagonal across the vertical and the horizontal*'.[9]

With the appearance of the 'diagonal' as key signifier implicating the definition of 'smooth space' (as defined by Deleuze and Guatarri),[10] the painted image stands alluringly close to its antecedent text. Dona's composition is forcefully governed by a diagonal that cuts across—an irregular border line, transgressive, antithetical to the horizontal and vertical formula of the composition. The text supplies us with a pantheon of signifieds with which we can inscribe and suture the painterly signifiers. Furthermore, if our aim is to commit the art-historical heresy of reading artistic biography as skeleton key to image, the 'nomad' trope could superficially be sustained. As a transplanted person—from Eastern Europe, through Israel, via Germany to New York—Dona's individuality invites speculation, as say, nomadic, rhizometric; 'no mother tongue', 'never send down roots'.[11]

A common tendency in criticism when confronted by abstract painting, especially Dona's, is to rely upon the text, the ideally equipped Rosetta Stone of *A Thousand Plateaus*. Indeed, the ingenuity of the book is such that is declares itself to exist 'only though the outside and on the outside', in relation to other 'machines' (painting) of the world: 'We will ask what [our book] functions with, in connection with what other things it does or does not transmit, intensities in which other multiplicities than its own are

inserted or metamorphosed.'[12] With this model of infinitely connectable textuality, narrative potential blossoms. Indeed, this has been the norm in approaching Dona's painting. Under the aegis of polyvocal rhizometric, segmentary, aggregate analysis, recipes for how her work dramatises abstraction have been synthesised.[13] The method has a certain appeal, for it ceaselessly throws the signifying power of painting onto a pre-ordained horizon of linguistic certainty. Writing, as the medium within which criticism operates, actually welcomes this seduction of the textual.

In clearing a creative space both for the painting and its critical appreciation, however, we may stand close to Bloom, who has emphasised the critical act of 'misreading or misprision'[14] as emblematic of the position that poets (and artists) feel in relation to their predecessors:

> The strong reader, whose readings will matter to others as well as to himself, is thus placed in the dilemma of the revisionist, who wishes to find his own original relation to truth, whether in texts or in reality (which he treats as texts anyway) but also wishes to open received texts to his own sufferings, or what he wants to call the sufferings of history.[15]

Such insight anchors the relation of Dona's paintings to the textuality of Deleuze and Guattari. She reads as a 'strong reader', committing acts of wilful misprision in order to acknowledge simultaneously and swerve from the source. As her painting rhetoricises its compounded, adopted imagery, gleaned from art-historical sources, so too does she tropologically defend against strict emulation of Deleuze and Guattari. The clue occurs in her titles. Titles direct the movement of abstract painting, governing connotation. The title marks the point of entry through which the artist passes, and in this case affords for a dismantling of equivalence between text and image.

Dona's titles are acts of adjacency as much as revision. Curiously, the first letter of every word of all her titles is capitalised. Seemingly major words like 'Molecular' or 'Beginning' are brought into the same orbit as those minor connectors and prepositions such as 'And' or 'Of'. Why the constant capitalisation? The move is syntactical as much as grammatical, emulsifying the ingested vocabulary of Deleuze and Guattari, rewriting it in a supraconscious fashion,[16] welcoming other antecedents. We may think, for example, of Duchamp's string of capitals 'LHOOQ', which typo-telegraphically transmits the uttered contemporary voice cyclically onto history. The role of Dona's titles splinter or scatter their referential attachment to the image. They state that she is misreading her sources, recognising many lineages in order to branch out to assert her own. Supplying a mobile army of metaphors with which to scale the painting, the title operates as arch-clue producing an essential swerve from a theoretical orthodoxy.

Moreover, Deleuze and Guattari state that there will be 'no typographical, lexical or even syntactical cleverness' in their writing of

multiplicity.[17] But Dona's titles commit all three of these turns, veering close to Derrida's favourite territory. The task here is not to compose a venue of precedent, but rather to understand the inherent message encoded in this intentional, emphatic act of titling. Taken collectively, her titles speak of a fundamental dysfunction between text and image.

The problematics of properly merging the linguistic with the painterly begin at a very basic level. With colour alone, for example, we realise the disparity. 'Although semiologic approaches consider painting as a language', Julia Kristeva has remarked, 'they do not allow for an equivalent for colour within the elements of language identified by linguistics'.[18] Not by coincidence, colour emerges as perhaps *the* major signifying component of Dona's work. Colour overrides and specifies the tenor and intentionality of her formal gestures. The title of her recent exhibition—'Iodine Desire, Loss And Stain'—suggests that codes are merging, colouristically resonating through one another. 'The purple, pink, green and ultraviolet of the paintings', the artist writes in an accompanying statement, 'are high-toxic tones, chemical types, photo lab colours that provoké a disoriented and diffused gaze'. By virtue of sheer amplification, the colours seek to disassemble our vision of historical acuity, while also disfiguring the linguistic.

Giotto's frescos at Padua are the platform from which Kristeva articulates her insights about the role colour plays in painting. 'By overflowing, softening, dialecticising lines', she notes, 'colour emerges inevitably as a "device" by which painting gets away from identification of objects and therefore from realism'.[19] The kind of realism Kristeva is referring to is depictive, figurative, didactic—the subservience of painting to 'literal' appearances of the world. But realism, taken as veracity, can also be transcribed onto the text/painting paradigm. The text is *not* an image that can be realistically pictured. It offers possibilities, modalities, pathways, entries and exits into the culture and potentially onto the painting, but it cannot be used to deliver images. Imagery, and especially abstraction, is the preserve of the artist, of a tightly levered subjective, interpretive imagination. If we were to trace the contours of the text onto visualised abstraction, mimesis would become the conceptual content of painting. Colour is the topic and topology that defends against this move, resisting absorption and over-writing the textual.

One is referred instead to sources belonging to the history of painting, to prior imagery that is now articulated in unique colour. In *Pyramids Of Breakdown And The Tears For Cleopatra* (1994), the colour scheme is, indeed 'cosmic and cosmetic'—comprised of fuchsias, hot pink, powder blues, orange drips and fiery red enamel. It is Dona's only painting that explicitly and iconically makes use of the triangle as a primary shape governing her composition. Vibrating against two airy registers of blue we find the lacy, garishly coloured Pollockesque drip; a brood of cellular forms consigned to

demarcated side-zones; the maniacal painterly jumble of schematised machine parts; a pencil grid structuring the interior of form and the assertion/emergence of primary form posited as conduit, conductor. These components are the pillars upon which Dona's imagination interprets the task of painting. They imbricate Abstract Expressionist leitmotifs with Minimalist remnants and interpolated signs of the Duchampian diagram.

How, and to what end, does a contemporary artist utilise and inscribe such historically diverse sources? Consider the 'drip'. Pollock's infamous 'all-over drip' has been excised from its infinite grandeur, localised and reined in to become a sputtering filiation at the pinnacle of someone else's pyramid. The smooth, flowing labyrinth is now a competing assortment of mismatched colour clamouring like electric, spasmodic energy along the sides of an alien form. The method of application could not be more distant from Pollock's action-oriented improvisations that involved his body in rhythmic movements, achieving a utopian formal signature of gesture. As the sagging orange 'drip' at the upper-left reveals, Dona has applied her 'drips' to an upright canvas, not a canvas unrolled onto the floor *à la* Pollock. Her body does not gyrate around or step onto the canvas to deliver its drip, but instead, with a refined, meticulous, and almost effete hand, she dabs and then drops the paint onto her vertically posed canvas. There is no randomness, no sudden ejaculation of creative furore, only the close movement of the hand at work, curtailing and managing each local application. The methodical process is obviated by the pink placed at the two lower corners of the pyramid. In the back of our consciousness, when we see Dona's carefully constructed and calculated drips, we liken the process to restricted intentionalities now available through computer programmes—the ghost of the cyborg making its trace felt. This acute placement of the drip begins to formulate questions about how painting is able to generate an identity specific to its creator, pondering whether it will be possible for such an ideal trace of individuality to be programmatically mapped out, set into prescribed co-ordinates.

The sign of Pollock is the sign of a precursor, and it instructs that 'influence' be conceived along errant but definite lines—a misinterpretation: 'Influence, as I conceive it, means that there are *no* texts, but only relationships *between* texts'.[20] However Derridean or deconstructive this Bloomian assertion may sound,[21] it allows for positioning painting beyond the game of textual recovery or mere historical source-hunting. In valuing the drip in Dona's work, we ascertain how it has been transmuted. In addition to the process of application, there are material concerns. Where Pollock used combinations of oil and enamel to achieve a watery interaction, Dona focuses on enamel alone. Her drips are hardened, shiny and reflective because she exclusively uses car enamel. In all of her paintings (but especially in those where the dripping densely accumulates), the enamel becomes a surface in which we see a splintered, discontinuous reflection of ourselves looking at the painting. This reflection comes to meta-reflect upon Pollock's mythic painting

body, which lies dismembered, scattered peripherally as so many shards. We catch only glimpses, the polish of high-keyed toxic tones, each only capable of sustaining one facet of the refracted body—our's, Pollock's, her's. In this manner, the machinery of the contemporary electro-information body (process), the historical improvisational body of Abstract Expressionism (sign), and the now fractured body of the viewer (referent), all begin to collide.

Material associations subliminally slide across the surfaces of Dona's paintings, unleashing terse parables of contortion. Subversive duplicity is accomplished with Duchamp, who is catastrophised when we realise that on top of a fuchsia acrylic surface, Dona has painted out her Duchampian machinic parts in oil paint. Oil!—for an artist who ceased painting with the declaration that he could not stand the smell of oil paint and turpentine.

The title *Pyramids Of Breakdown And The Tears For Cleopatra* suggests as much, admonishing the thinking that demythologises Pollock and Duchamp and turns them over to Cleopatra's geometry. Trading in formal likeness, however, would commit precisely the project that abstraction and criticism must keep away from. Sourcework such as this is expected and predicted as the currency of our culture. It serves, however, few profound aims that the project of misinterpretation requires: 'Source study is wholly irrelevant here; we are dealing with primal words, but antithetical meanings, and an ephebe's best misinterpretations may well be of poems he has never read'. Indeed, to motivate the form of the triangle, we might face a more arcane, equally tenable precedent in order to propose a 'strong reading' of the painting.

We go to *Jericho* and to *Chartres*, to those atypically unmistakable paintings, vertical works that slope as they tower. These triangular paintings maintain a specific place in Barnett Newman's oeuvre. The format was new, a late-1960s reckoning with the philosophical tenets that had underpinned Newman's work; his insistence that painting deliver a sense of place, confer the impact of totality where the human self comes to recognise its individuality. Painting engendered for Newman the fundamental tasks and through the expunging of reference and representation the artist sought an originary experience where creation could flourish. 'The onlooker in front of my painting knows that he's there', Newman stated in 1965: 'To me, the sense of place not only has a mystery but has that sense of metaphysical fact'.[23]

In tackling the triangle, Newman shaped his aesthetic scheme along provocative lines, immolating mythologies and imploding accrued cultural histories. *Jericho* dramatises the pyramidal component of Newman's antecedent sculpture *Broken Obelisk* (1963–67),[24] subsuming Egyptian mysteries as geographical connotation masters the cultural. The matt-black substance of *Jericho* is bisected by a red vertical band, the off-balance total awareness of symmetry revealed to compose its potential obverse. What might this obverse be? What human topic could elude the grasp of painting that rose before us and declared itself to incarnate 'metaphysical fact'?

The topic of the self might suffice, if we are able to destructure and decompose its essence. *Pyramids Of Breakdown And The Tears For Cleopatra* inserts itself as this juncture, beginning to define a self in painting. The uninflected acrylic ground of the triangle—Newman's serene metaphysical surface—is now attacked by vigorous overpainting. Dona lays siege to the most refined Abstract Expressionist philosophies of the creative self. Cells crowd in upon the triangle, breaking through the fuchsia wall of the outer pyramid, pink cells feeding off or latching onto the interior pyramid. They hunger for plastic union with the isolated machinery inside the pyramid. The self becomes a 'breakdown' of essence in dissected terms—part biology, part chemistry, part pure machinery—as these topics (cyber-predicates) now overtly occupy the painter (creative self) in abstraction. The pyramid in Dona's figuration offers occasion to let the Duchampian machine madly proliferate, hieroglyphically to postpone hierarchy and rhetorically to muddy the 'high ambition' of Newman's metaphysic.

Contrary to her other titles, which designate processes without naming the components involved, this painting dictates the interior form (as pyramid) and instructs its historical reference (Egypt). The title names 'pyramids', but the painting physically delivers, as only it can, triangles. A dimensional play is engaged, a transposition crossing through the painting and equally through its figurative histories. We are forced to concoct a leap in dimensionality that takes into account the triangle/pyramid geometric schism. 'Cleopatra' emerges as the operative word requiring 'breakdown'. If we rewrite the name, we generate its essence: 'Clio', muse of history; 'patra', as in patrimonial, patron of origins. This word, a name, is preceded by that countermasculine expression of grief, the shedding of tears. Overt or guised, elusive or definable, the 'breakdown' of signification allows for identity to emerge. It takes on the master-trope of artistic incarnation, the trope of origins. The ethos of Abstract Expressionism, its sanctifying of a self-sufficient empowered creator, is now insurgently reinscribed by a contemporary woman artist who wholly reflects herself through the intention of her own gestures within an intrinsic paradigm.

According to Bloom, 'origins, poetic and human, not only rely upon tropes, but *are* tropes … Tropes or defences (for here rhetoric and psychology are a virtual identity) are the 'natural' language of the imagination in relation to all prior manifestations of imagination'.[25] With the phrase 'rhetoric and psychology are a virtual identity', parenthetically situated by Bloom, we evidently cross into Freudian territory. Mention of Bloom's name instantly conjures his theory of poetry as presented in *The Anxiety of Influence*. Beginning with the title, but continuing throughout his analysis, Bloom co-opts Freudian language in an effort to overcome its personalising implications. Although often misunderstood, the Bloomian 'anxiety' that a poet (or painter) feels in the face of his/her precursors is not something within him/her, it is not part of the psychic economy of a person,

but is rather manifest by the text or painting. The trope of misprision or misreading was never internal to a person but always the province of the artistic work itself: 'Every poem is a misinterpretation of a parent poem. A poem is not an *overcoming of anxiety, but is that anxiety*'[26] This artifactual definition, which Bloom frequently stresses, informs the position of Dona's paintings in relation to their sources.

Anxiety, conceived in counter-Freudian terms and divorced from the person of artist, is the consequence of a painting overcoming its precursors. The emblem of this quest in Dona's work emerges to be the 'Void'. In *Shadows of Annexation And The Voids Of Paradox* (1994) the interior ovoid space is emptied of vigorous presence. A stilled world, the void is evacuated of markings or painterly tracery, and is only traversed by the lone spectre of a diluted drip scaling the vertical height of form. Colour alone pulsates, a massive dilation of violet. There are no clues to orientation. Gravity has acted in more than one direction implying that fixity of place and orientation no longer predominate. Here, the space of painting is opened up, swept clear of iconic elements. The Duchampian machinery is sectioned off, relegated to subordinate blue rectangular zones. The drip-work is dangled only along the periphery of the oval, somehow prevented from spilling onto the serene field of violet. This pushing of the precursors to the marginal—shaping their existence around the oval, coupled with the peculiar colouration—masters a composition that evades absorption into historical streams of connotation, regardless of how we manage to stratify/destratify reference. Anxiety of departure becomes the essence of this form. Neither subject matter nor content, anxiety *is* the experience of this work.

Such is the space of abstract painting, a reality of visuality that must doubly contend against a century of overwrought artistic production and an increasingly abstract world. Dona heightens the task of painting by taking on explicit textual concerns—additional sources such as *A Thousand Plateaus*—that inform the kinds of associations we may integrate analogically. The play of reading text into image is precarious, and by choosing Bloom, I have tried to plot a course that stays close to poetry (a sister art of painting), rather than impulsively latching onto those ever-appealing, constantly proliferating language machines of contemporary critical theory.

In recognising its position in the culture of today, abstract painting strongly presents itself only when the necessity of looking becomes paramount. The subjectivity involved in its making shuttles artist and viewer over diverse terrain. Seductively, at times erotically, it moves through topical paradigms of connotation, each expressed through a situating of how to look. From an aerial vantage-point; with microscopic powers; in the scale of a brushstroke; at the poetic remove of self-contemplation—all of these modalities of sight validate an approach to Dona's painting. Her historical tropes escalate possibilities, throwing sight onto a metonymic temporal plane. The methodical time taken to draw the grid, the systematic timing of the

drip, and the smudgy diagrammatic sequence of Duchampian machine parts—each represent a separate making time, each a different historical site in time.[27] All issues implode to intersect on the surface of canvas, a subjective territory that welcomes analogy, yet continually denies an orthodoxy of interpretation.

To grasp the subjectivity of painting, one merely needs to measure Dona's distance from postmodernism as adeptly expressed by one of her contemporaries. Moira Dryer's work, which seems to trade in similar territory, assumes a vastly different material position. Dryer's painting unfolds across frequently separated or disparate surfaces, remarking upon the inadequacy of the single rectangle as format for painting. The painting surface may have holes punched into it, alien appendages (such as metal handles, aluminium implants), or might curvilinearly present irregularised frame edges. Such devices materially literalise—that is, visually illustrate—such concepts as the 'segmentary', 'assemblage', 'aggregate', to name some obvious concepts from Deleuze and Guattari. Recalling observations made earlier about the body, what kind of parallels can be drawn, now that the natural body, unmodified by technology, is displaced by a cybernetic construct consisting of body-plus-equipment-plus-computer-plus-simulation? Dona's work emphatically states that the canvas alone, freed from material paraphernalia, will generate all routes to meaning.

For over a decade now, Dona has conducted her discourse in painting with the traditional tools of the craft and has done so confined to the single canvas. Dona's is a brush-made world, one that the hand alone produces. Within these limitations, painting necessarily focuses intention. In compliance with the canvas, that inveterate surface of subjectivity and template of defined absolutes, we turn out towards the world, in towards ourselves. Maurice Blanchot, the magnificent scaler of night, whose thoughts about artistic creation haunt the ends of all critical inquiry, figures the dream onto itself: 'One seeks the original model, wanting to be referred to a point of departure, an initial revelation, but there is none. The dream is the likeness that refers eternally to likeness'.[28]

The text always allows us to speak about the painting, but that is all it can do. Whether this task restores or diminishes meaning, it is a different flow. Painting is never text; like the world, text is only commentary:

There are no individual statements, there never are. Every statement is the product of machinic assemblage, in other words of collective agents of enunciation (take 'collective agents' to mean not peoples or societies but multiplicities). The proper name (*nom propre*) does not designate an individual: it is on the contrary when the individual opens up to the multiplicities pervading him or her, at the outcome of most severe depersonalisation, that he or she acquires his or her true or proper

name. The proper name is the instantaneous apprehension of multiplicity.[29]

NOTES

1. Lydia Dona, statement accompanying the exhibition 'Iodine Desire, Loss And Stain', Galerie des Archives (Paris), April 1994.
2. Paul Virilio, 'The Third Interval: A Critical Transition', in Verena Andermatt Conley (ed), *Rethinking Technologies*, University of Minnesota Press (Minneapolis), 1993, pp. 4–5.
3. See for example Michel Serres, *Hermes: Literature, Science, Philosophy*, Josué V. Harari and David F. Bell (eds), Johns Hopkins University Press (Baltimore), 1982, pp. 71–83.
4. N. Katherine Hayles, 'The Seductions of Cyberspace', in *Rethinking Technologies*, op cit, p. 174.
5. Gilles Deleuze, 'Nomad Thought', in David B Allison (ed), *The New Nietzsche: Contemporary Styles of Interpretation*, MIT (Cambridge, MA), 1977, p. 149.
6. Lydia Dona, interview with Klaus Ottmann in *Journal of Contemporary Art*, vol 4, no 2, Fall/Winter 1991, p. 27.
7. Harold Bloom, 'The Breaking of Form', in *Deconstruction and Criticism*, The Seabury Press (New York), 1979, p. 5.
8. Gilles Deleuze and Félix Guattari, *A Thousand Plateaus: Capitalism and Schizophrenia*, trans Brian Massumi, University of Minnesota Press (Minneapolis), 1987, p. 494.
9. Ibid, p. 478 (my emphasis).
10. For a complete definition of smooth space and its ideological implications see Deleuze and Guattari, '1440: The Smooth and the Striated', Chapter 14 of *A Thousand Plateaus*, op cit, pp. 474–500.
11. Ibid, pp. 7, 23.
12. Ibid, p. 4.
13. In a recent catalogue essay, for example, Klaus Ottmann adopts the strategy of sheer quotation where approximately one quarter of his text is comprised of passages culled from Deleuze and Guattari; see Klaus Ottmann, *Lydia Dona*, Galerie Barbara Farber (Amsterdam), 1993. See also Maia Damianovic, 'Paradox View: New Paintings by Lydia Dona', *Artsmagazine*, vol. 63, no. 4, December 1989, pp. 70–73. In this article, the various section headings are direct textual lifts from *A Thousand Plateaus*.
14. Bloom, *A Map of Misreading*, Oxford University Press (Oxford), 1975, p. 3.
15. Ibid (my emphasis).
16. I use 'supraconscious' along lines that Roman Jakobson implied. The Slavic word *Zaumnyj* (supraconscious) alludes to the particular form of

poetry practised early this century by the Russian Futurists, notably Khlebnikov, which in its most drastic instances verges on total verbal delirium. 'Zaum' aspires to stand outside language and grammar in an effort to dismantle traditional meaning and produce significations predicated on the sudden impact of the trans-sense utterance. See, for example, Roman Jakobson, 'Supraconscious Turgenev', in Marshall Blonsky (ed), *On Signs,* Johns Hopkins University Press (Baltimore), 1985, pp. 302–307. A longer discussion of Lydia Dona's relationship to language could certainly benefit from the 'zaum' paradigm.

17. Deleuze and Guattari, *A Thousand Plateaus*, op cit, p. 6.
18. Julia Kristeva, 'Giotto's Joy', in Leon Roudiez (ed) *Desire in Language: A Semiotic Approach to Literature and Art*, trans A Jardine, T Gora, and L Roudiez, Columbia University Press (New York), 1980, p. 216.
19. Ibid, p. 231.
20. Bloom, *A Map of Misreadings,* op cit, p. 3.
21. Bloom himself measures his distance from deconstruction as follows: 'Nietzsche, according to Derrida, inaugurated the decentring that Freud, Heidegger, Lévi-Strauss and, most subversively, Derrida himself have accomplished in the Beulah-lands of Interpretation. Though I am myself an uneasy quester after lost meanings, I still conclude that I favour a kind of interpretation that seeks to restore and redress meaning, rather than primarily to deconstruct meaning. To de-idealise our vision of texts is a good, but a limited good'. See *A Map of Misreading*, op cit, p. 175. For commentary on Bloom's differences from Derrida and de Man, see Peter de Bolla, *Harold Bloom: Towards Historical Rhetorics*, Routledge (London), 1988, pp. 25–35, 105ff. Christopher Norris expresses ambivalence over Bloom's self-differentiation, but nevertheless writes that Bloom's argument, 'shrewdly undermines the deconstructionist position by insisting on the conflict of wills to expression behind the encounter of text with text. This struggle, he urges, must not be lost sight of in the undifferentiated merging or free play envisioned by Derridean deconstruction'. See Norris, *Deconstruction: Theory and Practice,* Routledge (London), 1982, 122ff.
22. Bloom, *The Anxiety of Influence: A Theory of Poetry,* Oxford University Press (Oxford), 1973, p. 70.
23. Barnett Newman, interview with David Sylvester, BBC (17 November 1965), reprinted and amended in John O'Neill, *Barnett Newman: Selected Writings and Interviews,* Knopf (New York), 1990, p. 257.
24. Newman distinguishes between the pyramid and the triangle, regarding one as form and the other as shape. The pyramid strictly belongs to the domain of sculpture and the triangle to painting. See Newman, 'Chartres and Jericho', in *ARTnews*, vol 68, no 2 April 1969, p. 29. Dona counters this formality, instructing that the triangles within her painting be conceived as pyramids.

25. Bloom, *A Map of Misreadings,* op cit, p. 69.
26. Bloom, *The Anxiety of Influence,* op cit, p. 94.
27. In the context of scaler analogies, one may recall Virilio's tracing of his trajectory of speed in this century, with the acceleration of instantaneous communication and supersonic travel, 'every city', Virilio notes, 'will exist in the same place—in time'. See Paul Virilio and Sylvère Lotringer, *Pure War,* trans Mark Polizotti, semiotext[e] (New York), 1983, p. 60.
28. Maurice Blanchot, *The Space of Literature,* trans Ann Smock University of Nebraska Press (Lincoln), 1982, p. 268.
29. Deleuze and Guattari, *A Thousand Plateaus,* op cit, p. 37.

Lydia Dona in Conversation with David Ryan (1996)

David Ryan: You've described your work as being strongly rooted in concepts, and I wondered if this was bound up with a literal definition of abstraction itself, with the conceptual framework that you construct relying on the absence of any empirical particular, the emphasis being on the conceptual model?

Lydia Dona: Well, that's one way of seeing it. But what I'm after, is more a philosophical place; a philosophical debate and site as well as the construction of a visual involvement with that site. So one doesn't exclude the other in that sense. What is also extremely important, is a certain type of build-up within this place or site where the concept is derived from a larger picture of an abstract model and the transformations within that occur through the particular permutations of that model, together with various 'contaminations' that will be the result of different environmental shifts. This puts the paintings into another kind of gamut of perception, experience and subjectivity.

Figure 9 Lydia Dona, *Architectural Phantasies and the Folds of the Drip* 1996, Oil, acrylic and sign paint on canvas, 168 ×152 cm, Collection Daimler-Benz AG, Germany.

DR: How do you see your work in relation to concepts like 'authenticity' and 'irony'—do they have any particular place within this conceptual schema?

LD: I think that the question of authenticity and the question of irony seem polarised here in a particular way. The polarisation is apparent and I'm not interested in either of them. In fact, I'm not interested in that either/or polarity at all. Rather, I'm interested in a whole different place in the triangle that leads elsewhere and where the question of synthesis can occur; because what has been our luggage with reference to the authentic is very particular, and, likewise, the ironic is always read in connection with cynicism, I would say. I have more interest in 'spreads' around the centrality of those concepts. If we want to take those concepts as centralised polarities, then what engages me more is the liquidity of the periphery in relation to those centralised polarities. So the authentic and the ironic, for me, are not focal places. The question is more a case of de-focalising these places; what Gilles Deleuze refers to as 'intermezzo'—a space that is much more about fluidity and infiltration, a mid-section in this particular site, where I want my work, the concepts, the contextuality of my work to refer and cut through.

DR: Outside of any notion of a dialectic?

LD: Yes, outside of the dialectic. In such a way it becomes an investigation of different kinds of fissures, or forms of opening and folding, and which also result in different time frames of 'present', reference and inter-subjectivity. The notion of synthesis that's raised here is different from the dialectical one.

DR: Going back to the kind of conceptual mapping that you initiate, this is actually very much reflected in your working method, which in fact is a 'gamut' of highly coded sign systems, isn't it?

LD: Right. Definitely, and I like that you bring that up because the materials that I work with are very important in connection with the type of metaphorical creation or parallelism of these ideas. I use a kind of enamel paint that's highly reflective and gives a shine back, and I'm interested in how this relates to the notion of the gaze, both theoretically and physically, experientially. It also holds certain connotations that relate to the body in other ways, in that this high gloss and high-key colour might imply lipstick or nail varnish; in such a way, particular paintings might make use of a certain violet or pink, evoking a bio-chemical registration of the body through technology. So this is highly coded and employs definitive, culturally coded systems. Also, certain materials such as acrylic paint—fast, quick drying—has a lot to do with the history of Minimalist and colour-field painting and this is a historicised type of material that I'm re-utilising to open up those sign systems. Then, of course, oil paint, which is 'traditional'

in a different kind of way, conjures up a whole history of representations, which I deform and distort and use in different systems of opacity and translucency that, in their own way, actually pervert a notion of photographic space or glass. So, it's almost like I take these materials from the system of painting and brush them against a system of environmental registration. In this way, we can think, 'if this was a building, then this particular area would have been glass, this would have been metal, this here, stone or chrome, etc'. In a way I want the paintings to be handmade, and their reference to real material to be very strong, but I don't want the traditionality of painting, you know, a bounded space utilising thick paint, a wrought impasto. On the contrary, I want them to be almost as though they were created out of liquid, and as if the liquid created its own frozen state.

DR: I think it's very interesting the way in which you utilise this layering process, which is concerned with signs and codes and their relationship to materiality, or the nature of the materials themselves.

LD: By the way, the enamel paint is called 'Sign Paint' [laughs]... 'Sign Paint—One Shot'—the idea of 'one-shot' is, in my mind, connected with physically moving—one-shot. It's also like 'drinking' the paint, or rather, that the canvas drinks it, soaking it up in one shot. And, of course, I'm interested in that system of absorption, the environment that absorbs, the painting that absorbs the body, the viewer that acts like a sponge.

DR: Yes, 'one-shot painting' … Ironically this also references Kenneth Noland. Wasn't that the term he used to describe his painting process?

LD: Ah yes—I hadn't made that connection.

DR: Going back to that idea of the sign, and in particular, the way that, in relatively recent theoretical positions, the relationship between the signifier/ signified has been articulated, are you in danger of re-grounding the signifier, in that you make the works 'point' to particular signifieds—ie this references this, this is a sign for this, etc? Given your interest in French theoretical positions, does this not contradict the kind of 'slippage' between signifier/signified, or the free play of the signifier that is dominant in much of this discourse?

LD: Well, that's a good question … To be honest, I'm not too sure. There are an incredible amount of loaded possibilities that exist within the readings themselves, and these in turn depend on the system of subjectivity and the viewer's own orientation within this. My work is ultimately open to a lot of variable interpretation and projection, and I enjoy that sense of communion that can exist between these variables. For example, a passage might seem to invoke microbiology or a sense of viral infiltration, yet you could also see

it as dots, simply dots within a pointillist approach; or on the other hand, it might be seen as connecting to a photographic field. So we might say that although something might seem linguistically grounded at the stage of making, it's the relationship to physicality that might create this 'slippage' as you called it. So it's this communion between the purely linguistic and the physical that can result in surprising reversals of identity, and I invite a situation of complex deciphering to take place. I don't really know anymore a lot of things besides the fact that the act of looking is as complicated as the act of painting; the gesture of looking is as complex ... the 'loaded' eye of the viewer is so contaminated to begin with, bringing so many references, interpretations, readings to the visual. You can also start asking yourself, 'what type of baggage is the viewer bringing to the visual anyway? How can we work with this contaminated look?' It's interesting that half our constructions are based on so-called mistakes anyway.

DR: So this notion of the 'viral' operates on many different levels—it's also a metaphor for the kind of transformations that occur at the level of the signifier so that they escape the seemingly rigid codifications that set them in motion. But isn't it safe to say that the work is programmatic in the way that these theoretical constellations are set up in the first place? And that the result is—and you may not like this term—deconstructive? I mean this in the classical Derridaean sense, with its emphasis on supplements, margins and 'undecideables'.

LD: Well, 'programmatic' is also a word we should discuss because there are so many transformations that occur in the work that I would not refer to it as a programmatic point of departure. It's a conceptual point of departure, and I think that distinction is important in that 'programmatic' implies simply a process of execution. I always say, in fact, that I consider myself a conceptual artist who makes sites, and my sites just happen to be paintings. I'm also very interested in film and film theory, architecture, literature, together with corresponding theories as well, of course, and there's a dialogue between all this and my work; they feed off each other. My paintings kind of get sucked out of other disciplines. More than ever, I'm interested in that place across the disciplinary options—that's where I feel I am today. I like to think of all this as an investment in a complex inter-connectedness between different circuitry—it's where these circuits are bordering on other circuits and feeding off other ones. So, architecture, literature, film, microbiology are all parallels, for me, of painting, but a painting that has to traverse these different sites. In this way, painting today shows the necessity for conceptualising its own deterritorialisation, and in this sense, it does have connections with a kind of deconstructive practice. Even though, in terms of its making, or its traces, it appears a re-territorialisation, in that the physicality of the drips—or whatever—map out a space.

DR: Yes, we often get a sense of the painting dismantling itself in front of our eyes, which is partly why I asked you about this notion of deconstruction. And not only is this articulated at the level of the conceptual schema, but it also seems physically ingrained in the work. Through, for example, the car engine diagrams that you use, which evoke a blueprint for a machine, one where you're not sure how to put it together or whether re-assembly is at all possible ...

LD: Have you seen those car manuals I use?

DR: No, actually I haven't.

LD: Here, I'll show you... [taking a car manual and leafing through it] and I don't drive! [laughs]. So for me, it's like driving into an inner depth of a car, which in turn is like an inner part of the brain. My original interest in them was in the fact that they were so fictional, and yet specific as models. I was very interested in Duchamp and interested in returning the readymade to painting itself, making the connection of the readymade return to a retinal gaze out of desire, and the complexity of desire and denial both appearing at the same time within this return. This pictorial re-inscription of the

Figure 10 Lydia Dona, *Photo-Labrynth, Ghosts in the Drips of Montage* 1997, Oil, acrylic and sign paint on canvas, 213 × 162 cm, Collection William Lehman Jr, Miami, Florida.

readymade was really a different 'place', and I think this emphasised the Deleuzian aspect of my work rather than, say, a Baudrillardian reading of the model: mine were machines of desire ...

DR: This, too, is Duchampian isn't it? Not just within the context of the ready-made but also *The Bride* ...[1]

LD: Exactly. Not just 'desiring machines' but also machines of desire, a mechanisation of the erotic that is Duchampian.

DR: You've mentioned in the past the notion of the dissolution of the viewer. You touched on this earlier, but could you elaborate on how important this concept is for the work?

LD: It's a very important aspect—the viewer dissolves, the object dissolves and what remains is a kind of loaded fusion ... I must sound absolutely nuts when I talk this way, but it's important for me to be clear about these things at a linguistic level as well. So, this results in a kind of dissolution at all stages. Recently, I've changed as regards how I view this, and I suppose every stage of my work adds another dimension, so maybe it's an expansion of this original concern. In the last few years I've been extremely engaged with architecture and the problems of the relationship of the body to this physical articulation of space. It's a notion of participation and it's the relationship between models of representation and result; also, how the building 'appears', and our occupancy, not only of the physical site, but also of these models. The question arises of how we target these issues, and one's connection to, or separation from, the building became important to me. And I saw a similar process happening in terms of the movies, with issues of expectation, engagement, or disengagement or disconnection, as absolutely integrated in the 'event' of the movie itself. I began to ask myself how painting might negotiate a similar conceptual parameter. How does painting enter into this relationship between its own embodiment and conceptual apparatus? Like the movie, you can't reduce it to its script or narrative plot or whatever; the painting is the result of edits or cuts. And if we talk of it as an abstraction, then it's an abstraction not simply in terms of an 'abstract image', but an abstraction that also obstructs, and this obstruction is one of a kind of delimitation; a delimitation of its physical limits resulting in an abstraction as a kind of, again a Deleuzian term, 'becoming'. So this obstruction is one that works against our places and expands, contracts, liquidates, cuts. And the sense of dissolving is a very important process for me as a way of addressing this notion of 'becoming'.

DR: Were you also interested in the Lacanian notions of the gaze? I'm thinking of Lacan's articulation of the logic of the gaze in 'What is a

picture?', where he describes the functioning of the scopic register of the image-screen as a geometrical intersection of the gaze of the 'I' and the gaze of the 'other'. Here, too, is a complex dissolution into image through desire, as Lacan says, 'the object a in the field of vision is the gaze'.[2]

LD: Yes, this interests me very much, but I would use this in my own way, to my own ends, and not Lacan's. And I have to say, and I think it's an important thing to say, that in the United States there has been a very strong resistance to painting involved directly with theoretical thought. In Europe, I guess there's more heritage of philosophical experimentation. So, in 1986 or 87, I became very interested in the writings of Gilles Deleuze and at that time I really didn't have a hell of a lot of possibilities to discuss it. America had discovered, of course, Baudrillard, and there was great emphasis on Foucault, on systems of power and on unmasking these, and this was reflected in the types of artwork that were then being made. Nobody was really interested in the neurotic, nervous, electrical wires that existed within these systems. I always felt that this was a more interesting place for me, both in terms of energy and in terms of a kind of poetics. There seemed to be a great difficulty to address this in the 80s. Now it seems more open, and I feel, with exhibiting regularly in Europe, more respect for a critical discourse that attempts to come to terms with these aspects.

DR: Going back to some of the ideas that we've just been discussing—the idea of conceptual models, the dissolution of object and viewer, etc—given these concerns, what is the status of the individual work, and where is the 'location' of the work?

LD: The location of the work is in the question itself.

DR: In that the work is actively engaged in seeking a location?

LD: Yes absolutely. It seeks a location. I'm really interested in the formative aspect of a location, not necessarily in permanency. Which is why I adopt the term 'becoming', and why it occupies an extremely important position within my work: 'becoming' in relation to location, to site, to sight, rather than the location of 'being' as a static place. So the location won't be found in one particular piece, nor even the whole conceptual gamut, because the entire enterprise is involved with 'becoming'. What does this really mean, to 'become'? It's a process that allows one to access constant inner mutation and growth, at the expense of one's own regular security systems, and permanent placement.

DR: On a more pragmatic or practical level, how does such an outlook inform the physical placement or siting of the work?

LD: It's interesting that you bring that up because I've been thinking about this issue just lately. It became a tormenting issue to make this division between, let's say, the intellectual concerns and what you call the 'pragmatic' situation of installing a show. I always felt that people wanted to see my paintings in the way they wanted to see them. Yet I felt I needed not only to present them with my paintings, but also with my 'hermeneutic', so to speak. I'm aware this doesn't close the situation down, and I don't want to, but I felt the need to use the entire space in a way that was compatible with this hermeneutic. So I want to put it in such a way that I recreate through the gallery an urban environment, and I want to have the tissue of the gallery parallel the tissue of the exteriority of the world. In this way, the paintings operate like doors, windows, mirrors or entrances, and also have a relationship with each other. This relationship is one of echoing, of reading across but also simultaneity. One of the things that film does, is to offer the potentiality of this simultaneous viewing; so there is, with the paintings, a kind of *mise-en-scène*.

DR: How does this *mise-en-scène* operate?

LD: Well, it's a sense of the viewer's vision splitting in some way; a splitting of vision and consciousness that moves across groupings and develops its own mechanisms of grasping, and yet these individual pieces also, at the end of the day, remain on their own. So fusion, and what I call environmental 'plot', are bound up with this *mise-en-scène*. I don't want these works to be seen simply as diptychs or triptychs; I want relations that go beyond this, and I refer to it as a kind of 'fusion'. The sense of building a narration, and then a corresponding deconstruction as the paintings are 'taken apart' by the act of looking is very important. That sense of entering and participation that I mentioned in connection with architecture or film is clear in connection with these large paintings with voids, these empty centres. It's a notion of entering the void that is both empty and full, and re-experimenting with its prediscursive possibilities of liquidity, ephemerality, and at the same time trying to have, or to evoke, a security system of stability around the edges. Yet there are also paintings that are sub-divided, dissected, almost scissored. When I put these works together, it's almost like an anatomical preoccupation that's present there.

DR: So this is a kind of total 'orchestration' of the relationship between the canvases in a series and the particularity of the environment itself?

LD: Yes, but not a formal one. I'll give you an example. Many of the 'void' paintings that I just mentioned make use of particular blues, and in fact my colour range generally has changed and accommodated blue much more. Now, its usage has its origins in three sources: firstly, the idea of the

architectural blueprint; secondly, the mythology of Yves Klein blue—deforming, distorting it and bringing it into a more synthetic, cerulean Hollywood artificial place. The third aspect is ink, you know, as in writing, but also for spreading and absorption. So, I can't just use a colour for no reason; I have to ask what the meanings are. I want a very loaded, intense codification and sensation of physicality coming from it. I see this as also being bound up with the question of 'how do I install this?'. People often think I'm involved with all kinds of decorative decisions, or that it's purely formal. Or, on the other hand, they see it as too philosophical, too complicated, like one has to read all those books in order to understand my paintings. In a way I'm happy that it creates a lot of nervousness—that's an important aspect of the viewing situation for me.

DR: Is this nervousness partly the result of the difficulty to locate, and the implementation of a logic of 'leakage', whereby one part of a painting mutates into another part? Or even the way you talk about the inter-disciplinarity of the work, which infers a liquidity of boundaries, of conceptual boundaries?

LD: Yes—I like that word, 'leakage', and use it a lot to describe the processes that I'm involved with. Interestingly enough, I was talking yesterday with somebody who designs software and is involved with this at MIT, and we were talking about how nothing is autonomous anymore, how everything is inter-disciplinary, and the addressee and the addresser are increasingly interchangeable. It strikes me that making paintings today is like any other discipline that we might invoke, whether it's scientific or whatever.

DR: What about your interest in architecture? Does this remain at a general level or are there particular examples or practices that interest you more than others?

LD: Well … I'm fascinated by the architecture of Peter Eisenman, of course, right? And this means the whole project, the thinking behind the project. There are other younger architects, such as Greg Lynn, whose work engages me very much. I'm interested in the general aerial view within urbanism and the expansion of urbanism and the various meanings this might hold for us today. You know—where are we? At the edge of the city? At the end of the city? What kind of transformation of time or space occurs between the two? In some ways, I translate this into form: ovals or circularity, entanglements, labyrinthine topologies or topographies. There is also an urban language that does reflect a general concern with architecture. Specifically though, a certain type of practice does engage me more than other types, and it's one where the visualisation of models and the realisation through materials is no longer traditional. Ultimately, it's an architecture of instability.

DR: Yes, I can really see parallels between your work and certain buildings that have critiqued the notions of interiority and exteriority, and even the whole idea of 'place'.

LD: Right. It's clearly visible, isn't it?

DR: We've already touched on the relationship of language to the project on one level, and I wanted to ask you about those extraordinary titles and how you see their function.

LD: The titles give context to the paintings, and give context to the project; the titles are, in themselves, a project. I see them rather like the diagrams: I see them as orbits, as an inter-textual plane that lies between the paintings, and I see them as a way to have a total plot or narrative that can connect, disconnect, reconnect and break down. A lot of my thought, I guess, can be linked to Surrealist poetry, maybe even right back to Mallarmé, and certainly to the Duchampian tradition that comes out of this. It has become important to the work because I never really liked titles; I never felt that they meant anything in any really effective sense, and on the other hand I didn't really find 'Untitled' of any use either. What I'm trying to do is something where the title falls apart to such a degree that it becomes untitled, but in a different sense.

DR: To what extent are the paintings informed by issues revolving around gender? In one statement, where you're discussing the codification of various elements in your painting, you imply reduction, or reductive processes as a kind of male preserve—a hallmark of male logocentric practice.

LD: Well, maybe I should qualify this. First of all, of course, there were a few women—Jo Baer, Agnes Martin—who were involved in a utilisation of a reductive model. But I then said that there was a tendency to use reductive models for a particular historical reason, to represent clarity and specificity. I wanted to build within models of complexity, and to use models of reductivity as one aspect, to re-use them, deform them even, in order to open them out. So the reduction doesn't occur through a process of elimination. I wrote a piece for *Artforum* on Mondrian, and I was really looking at why he had felt the need to narrow it down, and why he felt he had to practise all that restraint. I have to practise that same restraint, but within a larger concept of freedom, and in a way I have to practise them both. I have to practise the freedom and the restraint and the freedom to restrain within complexity. There is a certain type of reduction that occurs in my work, but not as a main focus—it doesn't occupy a centrality. I don't want to 'narrow' the world, but I do want to bring together certain things to look at, to examine. I also don't know about certain things, and this might determine what I examine. I

don't get emotionally attached to my own signatures, because I repeat elements and I re-utilise them over and over again and they're capable of generating new meanings in different contexts, of transforming their identity. But, going back to your question, the issue of gender in my work is a complex one. It's safe to say that there are certain processes at work—a 'feminisation', for example, of the 'masculine' gesture, where the splash is transformed into the drip. But this is not to valorise one over the other, necessarily. Somebody once said to me that they thought my work looked like it had been made by a man. I replied: 'not really—women drip', I said, 'and men splash', [laughs] but in another way you could say, 'yes'. I deal with the Pollock drip, but the painting stands vertical in production, and I drip it slowly with my hand and I have all these fans that blow them away. If there is a gendered space that's relevant to my work, then it's not to be found at either of the two polarities, which is why I've referred to it as a transsexual activity. Interaction, infiltration, fusion, one transforming into its other.

DR: Is there a danger that everything is marginalised and denied centrality, that there is an endless process of self-cancellation?

LD: No. Definitely not.

DR: Could we say, though, that painting as a practice, through such an activity, operates from the margins?

LD: But that is not a marginalisation. It's oblique, but it's not marginalised. It's a very different practice from, say, all-over painting. It appears from the sides coming into the centre, but that doesn't make it marginalised. In fact, we could argue that elements that were once marginalised take on a fleeting prominence in my paintings. Take some of these diagonal geometries— they're drawn in with stretcher bars, so the intervention of the stretcher bar emphasises this process of bringing things from the back to the front. But it's all to do with this diagonal, oblique look. It's not marginalised ... I'm not too sure of the correct word ... maybe there isn't one. If painting operates from the margins, then it's because we're in a relationship to them other than the usual, traditional one. I recently described my work as a 'spaceship that has just landed in space'; or we might say, a simulated architectural gestalt that has transformed a physical one.

NOTES

1. Marcel Duchamp, *The Bride Stripped Bare by Her Bachelors, Even* (also known as *Large Glass*), 1915–23.
2. Jacques Lacan, 'What is a Picture?', in *The Four Fundamentals of Psycho-Analysis*, WW Norton (New York), 1981, p. 105.

A COMPLEX SPECTACLE, STAGED WITH CAREFUL ATTENTION TO DETAIL: AN ESSAY ON THE ART OF GÜNTHER FÖRG (1995)

Max Wechsler

> *Great actors have always shocked their public*
> *first they went behind its back*
> *luring it into*
> *the historical trap*
> *the intellectual trap*
> *the emotional trap*
> *and then they shocked it*
> *The actor's greatest enemy is his public*
> *And knowing it will improve his performance*
> *…*
> *against his public*
> *against human rights—understand?*

Thomas Bernhard, *Minetti*

Figure 11 Günther Förg, *Untitled* 1994, Acrylic on canvas, 220 ×150 cm, Courtesy Galerie, Bärbel Grässlin, Frankfurt.

It is, of course, absurd, but this unrelenting, highly prolific production of works of art reminds me more and more of the excess and exuberance of the Baroque. And I did not first have to visit Günther Förg's brilliantly staged exhibition of several sculptures and two paintings in the Baroque Orangerie at Herrenhausen for this idea to enter my mind. I am not referring to the Baroque in a strict formal or stylistic sense, but rather to a 'Baroque' attitude; that is to say, to an approach characterised by a high degree of artificiality and artistry with a melancholic undertone. Whilst this is a complex, daringly intellectual approach, it is one that addresses, by reason of its spectacular, extravagant character, our elementary senses and hence also our scope of thinking and understanding within perception itself. It is a crazy world—the spectacle of a provisional end of time, which, precisely through its confusion of perspectives, can function again and again as the starting point for new processes of reduction and substantialisation, whilst at all times remaining a strict criterion.

I have made reference on other occasions to the grandeur with which Förg stages his exhibitions and to the importance he attaches to the integration of his individual works into the given scenario of the exhibition room. This site-oriented, almost installation-minded approach to the presentation of works in the gallery seems in Förg's case to assume more than normal significance. In adopting this approach, Förg relativises the direct effect and significance of each individual work and at the same time broadens its scope of interpretation by placing it in the staged context of a larger set of meanings. The theatrical moment in the presentation of Förg's art is therefore not only confined to its formal aspects. On the contrary, it must be seen as a method of presentation that affords Förg a much broader scope, enabling him to exercise a very direct and calculated influence on the reception of his work in all its complexity of detail and shades of meaning. If we were to continue the theatrical analogy, we could even go so far as to consider the entire scenario as a theatrical performance in which a whole spectrum of different positions is represented in dramatic or epic manner and through a diversity of means of expression, thereby not only developing the reality of the play from the interaction of its individual aspects, but also influencing its interpretation. The play that Förg puts on more frequently than all others deals with a theme that has been chewed over time and time again and still hasn't been properly digested, is the complex theme of modernism and its uncontrolled dissolution into postmodernism. It is without doubt a demanding play and the performing of it may not at any cost be fluffed. After all, it is being performed on a stage that has meanwhile become an important platform for elaborate theoretical debate, not least on basic philosophical and moral principles. At all events, we are venturing onto very tricky ground here.

However, if we continue the Baroque analogy, it becomes increasingly obvious that Förg is not aiming to go into reverse and bring about a

'counter-reformatory' restoration of modernism, as could be said of Gerhard Merz, for example. Nor does he intend to set new 'absolutist' standards. His programmatic aim is rather a paradoxically 'provocative exorcism'—as Egon Friedell so aptly put it—which replaces one evil with another. He is not, of course, concerned with refuting the doctrines of modernism and with answering, either rightly or wrongly, all the questions that this may raise. The salient point is that a way must be found to preserve these questions as questions, and to think them through in the hope that they will lead to other, further-reaching questions. In short, it is necessary to examine the vitality and alarm potential of a promise that, in the final analysis, has yet to be redeemed and, in the case of modernism, is not least politically explosive, too. In other words, Förg is concerned with preserving the field of art as one in which he can still work. Basically, the problem outlined here is not a new one, for in all times of radical change, artists have been concerned not just with waving a sentimental farewell to all the inevitably affected mannerisms of what must now be allowed to die a beautiful death, but rather with drawing new energy from the existing, highly developed 'state of the art', energy that could possibly lead at one and the same time to the very heights and the very depths—in the vortex of the Baroque, for example.

Around the time when Förg decided to 'go his own way' as an artist, Neo-Expressionism, with its naive craving for images, was all the rage. And it was in its wake that both the art trade and the entertainment industry began to produce some odd quirks, too. Although in this respect Förg's decision certainly went against the grain, it did not constitute a professed counter movement, for Förg had no truck with ideologies, no matter how they were motivated by postmodernist attitudes. Förg's approach was not just more extensive, it was daring, too, for he resolved to question given historical and contemporary positions in an openly conducted field analysis—which was as clear-sighted as it was light-headed—and the field in question was that all too verifiable one in which art is put into actual practice. Thus, with this enormously ambitious project, Förg assumes an indisputable presence that is not infrequently construed as polemical, especially as he readily enters, with due fervour and intrepidity, that keen competition for market shares and positions of power that is so typical of the contemporary art scene.

One of the particularly fascinating things about Förg's work is the fact that, despite all rational opposition, he again and again produces groups of works that, on the one hand, constitute a spontaneous, situation-related statement of his own position and, on the other, clearly reflect both the tradition *and* the present state of art. Everything seems to have been inferred from something; everything seems to be argued from the premise that the artist's work must be understood essentially as a reaction to, and as a running commentary on, existing works, including, of course, his own. The way in which Förg consciously comes to terms with existing and new works

of art manifests itself—and this is both the special and the irritating thing about it—with a visual perspicacity and wit, completely bare of qualifying irony, which surprises us again and again. This discourse between works of art neither takes the form of copying in the traditional sense, nor the form of paraphrase in the classical sense—though Förg can on occasion instil into the viewer that same thrill of recognition that we feel when looking at one of the paraphrasing works of Picasso—and it certainly has nothing to do with postmodernist *appropriation*. In Förg's case, it is rather as though he is applying the grammar and vocabulary of the language of art to the structures inherent both in the intuitive process of creation and in the material itself in order to verify their essence and potential. And it is from this that the special quality of the enterprise develops, for here, both the analysis and the commentary take place on the same non-discursive level as the observed object. Here, the process of perception is immediate, that is to say, reflection is direct and not reported, whereby Förg's remarkably radical approach immediately calls to mind the method used by Jean-Luc Godard, Förg's often-evoked mentor and brother in spirit. Though I have used the analogy of the theatre with reference to Förg's exhibitions, the analogy of the cinema still holds good when it comes to describing Förg's actual works.

Förg's observations and reflections on art also have a certain affinity with those impassive *narrateurs* in the genre of the *nouveau roman* which, in reaching beyond the realm of absurdity, seeks to discover the reality of the world as such, as a neutral fact, as it were. However, this elevated neutrality cannot be regarded as anything but a theoretical postulate, for in the practical reality of having to come to terms with his subject matter, the artist must necessarily take up a position. This is manifest not least, for example, in Förg's obviously interested and pert choice of models and references, comprising, as they do, a somewhat disparate gathering of such pioneers of modernism as Mies van der Rohe, Piet Mondrian and Barnett Newman, as well as figures like Blinky Palermo, whose uncommon oeuvre already reflects the positions just mentioned, and also Georg Baselitz and Per Kirkeby, who are of interest to Förg primarily as *peintres-sculpteurs*—and, last but not least, an antique cast of folds providing food for a contemporary rethink. The accomplishments of these models are now the focus of attention, serving at one and the same time as points of orientation and objects of resistance. And, as in all father-son relationships, Förg rebels against these father-figures, attempting to push them off their sacred pedestals, whilst at the same time obviously holding them in high esteem—for why else would he bother himself with them?—and wishing that he, too, could be at least as good. And when he stands on their shoulders, he is definitely not doing it just for the sake of a better view, but rather because he is seeking that very shakiness that is associated with such a high and insecure vantage point. Be that as it may, what is of decisive importance here is the fact that Förg has chosen to come to terms with art within the medium of art, to deal with

artistic questions through artistic means. We must not, however, overlook the fact that the answering of these questions on a practical, formal level brings a further dimension into play, namely that of the content and/or meaning, both of the models and of the work itself, which the resultant form now conveys. This dimension of content and meaning contributes essentially, though well below the surface, to an ideal situation in which traditional positions now become provocative questions of contemporary significance.

In coming to terms with the oeuvre of Günther Förg, one is forever confronted with a world of contradictions and ambiguities. These not only result from the multitude of media used by the artist and from the dramatically ingenious staging of his work in exhibitions, but also, and in particular, have their origin in the very character of the exhibited works and motifs. Though it may sometimes seem so at first glance, straightforwardness is not in fact a characteristic of Förg's work, despite his apparently systematic approach. Even Förg's interrogative reflections on art are only one aspect of his work, for as they progress, they develop an intrinsic dynamism that can drive the work process further and further away from its original starting point. By logically following through an observed formal principle, artistic gesture or creative theme, Förg not only allows his work to develop a quality all its own, but also brings into play, quite involuntarily, problems and potential solutions that themselves result from the work process and which in turn lead to unexpected ramifications that can be traced through every stage in the work process. In so doing, it would be possible, for example, to demonstrate how Förg's painting not only tends towards abstraction but also resolutely seeks to avoid all representational forms. Maybe he is merely concerned here with avoiding the problems posed by figure-ground relationships, or perhaps it is a strategic means of avoiding any concretion of form in order to fill the surface with an idea of space, using the simplest means possible.

The aforementioned ramifications do of course include Förg's practice of transferring formal principles from one medium to another. Take, for example, Förg's use of representational photography, which, initially serves purely as the basis for the formal composition of the work, but then, as the work progresses, serves Förg as a means of linking the aesthetic questions posed by the work with the philosophical questions posed by the photograph, thereby achieving a strong emotional effect. Then there is the extensive interaction between painting and sculpture—the translation, for example, of mural painting into watercolour, and the translation of the experiences gained thereby into the bronze reliefs and the stelae, the soft modulations of which are vaguely reminiscent of the surface structures of Bernini's grip of the hand on human flesh. These evocations of corporeality can be traced all the way through Förg's work to the blocks exhibited in the Orangerie at Herrenhausen. Indeed, it is here that they find expression in an extreme form. What was a flowing element in the case of the bronze reliefs and

sculptures has here become static. The angular form and the horizontal and vertical linearity of the surface structure have, as it were, become an independent manifestation. In other words, the support has turned into a huge, seemingly archaic block, the sculptural quality of which is now essentially one of mass or volume. This impression is further underlined by the presentation of the smaller blocks, which are not placed on pedestals like sculptures, but are displayed on tables in groups of two. This form of presentation lends them a model-like character and is undoubtedly meant to be interpreted as a reference to the fact that Förg is still working on this project—the idea of a 'monument of surface' is evidently still being pursued. With the sculptural effect now diminished—if one can indeed say this in the face of such monumentality—the paintings on the walls involuntarily gain in weight. However, these gigantic formats, covered with a network of savagely executed vertical and horizontal strokes of varying density, quickly resume a dialogue with the surfaces of the blocks, and in so doing draw our attention to their potential as a painting medium. And then the imagination jumps from the plaster crust back to the paintings, which, due to the length of the room and the resultant possibility of viewing them from many different angles, suddenly make us faintly aware of a fine relief. A complex spectacle indeed, but it is precisely this complexity, this ambiguity, which is typical of Förg's work. The process of reflection produces a concrete result, which subsequently presents itself as an autonomous, debatable assertion in the artistic process. And here it is not just the originally questioned positions that are open to debate, for Förg's own treatment of them gives rise itself to a further pressing complexity of questions. And these questions must be answered before the artist—forever in a rush—complicates them still further and places them in a completely new light at his next exhibition.

Günter Förg in Conversation with David Ryan (1997)

David Ryan: Thinking back to the monochromatic paintings of the mid to late 1970s, you seem to have developed an aesthetic that contradicted many of the concerns of your contemporaries—the growing tendency towards 'Das Neue Wilden'[1] at that time, for example. Was this a conscious attempt to re-affirm an abstract tradition?

Günter Förg: I started the monochromatic paintings when I was still studying at the Academy in Munich and this continued to be a concern until the early 80s, at which point I stopped painting and did other things. I felt increasingly drawn to photography at that time and almost exclusively concentrated on this, sometimes combining these works with wall paintings. Later in the 80s I came back to painting, so it came full circle; in fact, some recent paintings again reference these monochromes, so I guess that shows

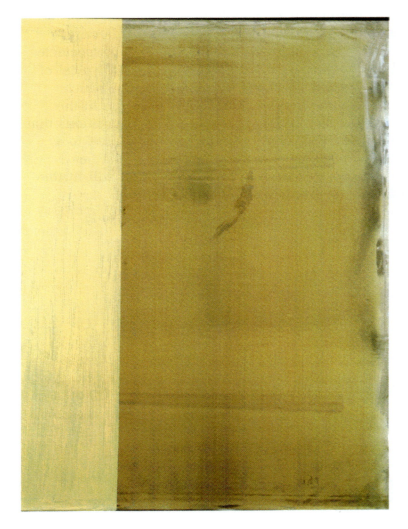

Figure 12 Gunther Förg, *Untitled* 1992, Acrylic on lead on wood, 150 ×100 cm, Courtesy Galerie Bärbel Grässlin, Frankfurt.

that they were an important starting point. The original monochromes explored different materials—wood, metals: lead, copper, etc—to see how this changed the feel of them. I've also made sculptures—freestanding bronze sculptures—so together with the photography you can see that it's an expansive approach to materials; this is important. As for the figurative thing, you know, older artists have always informed what I do; somebody like Munch is incredibly important to me, and he is of course a figurative painter. So you could use all this to question whether it was an 'abstract' statement I was making, even back then. What I admire in Munch and other painters can lead to a 'free' abstract statement. In my own paintings you might sense a figure—but it is not explicitly a figure. Or another example is the series of 'masks' that depict human heads—but these are not portraits, not specific, they're reduced to some kind of essence; so on one level you could call this 'abstract' too.

DR: So it wasn't a reaction against that Expressionist brand of German painting that was surfacing at that time: mythological, and figurative in a direct sense?

GF: Well, that wasn't so strong at the Academy at that time; in Berlin, yes. And, of course, I admired the work of somebody like Baselitz very much, but he, too, seems more complex. I mean he doesn't simply fit into that genre of 'Wild Painting'. Some of the works might appear completely abstract and the motif is often disrupted—the device of turning it around etc—so although it might be a figurative painting, you can see it in an abstract way. Baselitz's handling of the materials, traditional though they may be, have certainly affected my own approach and some of the colour-field paintings I did in the 1980s attempt to explore a contradictory clarity of form with an Expressionist handling.

DR: Going back to the monochromes, how important was the example of Blinky Palermo or Richter?

GF: I think Richter is a good painter for sure; his influence for me comes and goes. Palermo was important for me as a student but only so much as Ryman or Kelly; Palermo has a lot to do with Kelly's work.

DR: What differentiates your own monochrome from these examples I've just cited is, for me, the amazing sensation of depth in these works; the colour would appear to suggest this.

GF: Yes … it's a question of the choice of the materials. Actually, the earlier work was often made only in one step. I often used the particular choice of material to get this deep thing—this feeling of depth.

DR: Many painters of your generation came to painting through a process of reappraisal, as a means of escaping what, for many, had become the cul-de-sac of Conceptual art. Are there any crossovers here? Would it be wrong to see your approach as a conceptual approach to painting?

GF: Can you do this? Painting as concept? Somebody like Robert Ryman maybe comes close to this, whereby the parameters are laid out—only vertical strokes on this particular ground or whatever. But painting should give satisfaction and with pure concepts, you don't get this satisfaction.

DR: Even with Ryman you could say this?

GF: No, because Ryman has the concept to begin with, for sure, but the end result always goes beyond: it's always more than its starting point because of its physical manifestation—because it is a painting. There's also a sensibility, a sensuality. If you only have the concept and maybe, yes, you do a really good job with this concept, it will, however, never have the fullness of sensibility that good painting will have. Really, painting should be sexy. It should be sensual. These are things that will always escape the concept. I think painting is a resilient practice; if you look through the history of painting, it doesn't change so much and we always see it in the present. It is still *now*.

DR: Richter might also be an example of a painter having a strong conceptual base. He often denies this, I know, but ...

GF: Well, if you take the candle still-life paintings by Richter, I mean, there are so many stories there: it's a painting that contains references to the history of the practice—both in the way its painted and on a symbolic level— the candle as both life and death, etc.

DR: Are you suggesting this gets in the way?

GF: No... well... I suppose that depends on the painter; it depends how well you do it. One painter might paint a car and it's banal, another might do it and it's a revelation. Warhol is an interesting example here. I think he was a good painter, a *painter* in fact. I say this because of his mixture of photography and the object. In German, we differentiate between this and the process of painting; in the German language painting is what you do with a brush only. In Warhol, the choice of the colour, the form, the image, is very sophisticated, as is his use of methods such as silkscreen, which is used in a very painterly way.

DR: You may have already touched on this, but it has often been remarked that your work situates itself, or at least has done in the past, somewhere between Judd and Baselitz.

GF: Yes ... it's a crazy thing to do in some ways. But it's in answer to those people who suggest that no way can you do that—you know, a dogmatic attitude: if you take a Judd box, no way can it be painted by Baselitz. I want to refute this kind of attitude. It's not mixing it exactly, but finding the freedom to synthesise things. I mentioned Munch earlier, the kind of freedom that we get from his very late work is astonis hing. He needed objects, a room or a figure, but the work isn't about these at all; it's about how can you go with painting to the edge... what is possible in painting. It's a free place that he found here. And it doesn't matter whether the subject is a tree or a figure, the painting goes beyond the subject.

DR: So that notion of synthesis is extremely important?

GF: Yes. It is.

DR: It stops things being boxed off?

GF: Well, I don't use it like Sherrie Levine for example—to reduce something. I don't pick up a detail of a painting and re-do it; I'm not interested in that.

DR: The use of materials often seems very specific as you've already said—in your work of the late 80s, early 90s—metals: copper, lead, leaf on wood etc. What attracted you to such materials?

GF: I like very much the qualities of lead—the surface, the heaviness. Some of the paintings were completely painted, and you only experience the lead at the edges. This gives the painting a very heavy feeling—it gives the colour a different density and weight. In other works, the materials would be explicitly visible as grounds. I like to react on things, with the normal canvas you often have to kill the ground, give it something to react against. With the metals you already have something—its scratches, scrapes ...

DR: A history almost ...

GF: I'm not so interested in history in this way.

DR: Well, more of a personality ...

GF: Yes, it already has a presence. Sometimes, I would leave the lead in the rain and you would get these amazing oxidised grounds, quite beautiful. Not much had to be done on these works—the smallest intervention only sometimes. But I wouldn't be interested in painting such grounds, I mean that would be too much. [laughs]

DR: These interventions on a ground create a tension, and you would often appear to exploit this conflict within your work.

GF: Yes.

DR: Going back to Baselitz, we might say that Baselitz re-affirmed certain traditional approaches to painting and with this, repositioned certain traditional qualities of that practice. This seems important to you as well.

GF: Very much so, yes.

DR: I was wondering in relation to this—and thinking about the concerns of 'classical' modernist abstract painting, with its attempt to construct an objective 'language'—whether you see yourself as utilising this seemingly objective language and refiguring it in such a way as to inflect it with the individual and the subjective once more? To refigure it with an Expressionist accent, so to speak?

GR: Yes, you could say this. But on the other hand, there are always mistakes made, in terms of practice and also critical reception. We inevitably see the works of the first half of the century in a very different way. We have more distance and we can see the works from a more pluralistic vantage point. We can go beyond the rhetoric of much of the modernist manifestos.

DR: It's ironic that you've often been cited as a 'painter's painter' and yet you have a diverse approach to material: wall paintings, photography, bronze sculptures, etc. What are the advantages of negotiating this wide range?

GF: For me, it's a means of concentrating, of allowing my time to be used to its maximum. I travel a lot, I have studios in different locations, so it helps me to focus on one specific thing at a time; so then I switch from one medium to another, from, say, painting to photography. I think if there's a key to all this diversity, then it's architecture. That is the thread that holds all these things together. The literal space of architecture is shared with the wall paintings, the subject of the photographs is often this sense of space.

DR: Yes, and in the grid paintings, we often sense an exploration of internal/external spaces, where the space in one painting is reversed in another.

GF: They share this with the photos of windows—of real windows. Often they look out onto nothing. They too have an ambiguity as regards the orientation of the space. This is a good example of how these works can feed into one another—the painting as a window, which has its basis in some of these photos.

Figure 13 Günther Förg, *Rusakov Club* 1995, Black and white photograph, 100 ×150 cm (unframed), 120 ×170 cm (framed), Courtesy Galerie Bärbel Grässlin, Frankfurt.

DR: Following on from that, I'm intrigued by the way you've combined very formal abstraction with photos that are often seemingly informal or intimate in their feel. Frequently, they include portraits of women—like that series that includes a woman drying her hair. How did they come about?

GF: There are several ways of viewing it. I mixed them up actually—they weren't all portraits, some were architecture, etc. You could view it as a kind of Expressionistic handwriting, or functioning as a relief, a construction of space. It's not a question of disturbing one space, it becomes something else ... or rather, I want within my own activity for it not to become boring—I have to surprise myself. The connection is viewing the photograph as an almost sculptural relief. The scale gives it an architectural dimension; they're readable as being beyond portrait scale. It's like a close-up—the same with the architecture—in fact I see them both as a kind of architectural photograph. Yet they can also be seen in an emotional way, Expressionistic even. If we think of the way we should look at classical photography, then it should be sharp, focused, the right angle or depth of field, etc. That is one criterion for architectural photography that my work does not follow.

DR: Yes, I'm always interested in that relationship between very different surfaces and contrasting levels or means of representation. In one sense, that's what you're describing here, but do you accept this as a kind of friction, a collision, or do you see it more as a situation of seeking a common ground between these differences?

GF: More the latter, I would say. Yes, a common ground between these different means. But that doesn't rule out the exploration of contrast—it's a situation where these differences need each other. I'll give an example. I had some pieces in a large mixed show in Berlin recently and I didn't have time to go to the opening. It was only photo pieces I sent there. I asked a friend how it looked and he said, 'Good … but they made the mistake of putting your pieces in the photo section'. I could see that this could easily be a recipe for disaster, simply viewing them with photographs amongst photographs. These pieces belong with painting; then it works well and you get some kind of 'kick' and they make sense as images.

DR: So you're looking for those continuities that reveal themselves through a particular contrast?

GF: Yes. The photo works, as I said earlier, function more like a relief—like a sculptural element. They have a particular sense of size and scale and a relationship is figured to your own body in space; it's a very tactile thing. In painting, you don't have this so much. In ordinary photographs, you don't necessarily read them in this way. An object of course has it more. So my photo-works negotiate this displacement of object and space: represented space and actual space.

DR: You've already touched on the deliberate referencing of the work of other artists, and this is quite striking. We might sense Ernst Wilhelm Nay, Baselitz or the Americans such as Newman, Rothko or Still, and we often experience strange combinations within the one picture; combinations that border on recognitions. Do you exploit this at the level of a dialogue between unlikely participants?

GF: Well, to an extent. I think if we take a broader perspective we could say that, fundamentally, as soon as we engage with painting, we have the same problems that faced those at the beginning of the century or even before: problems around colour, form, composition. For example, with Clyfford Still, I'm still extremely interested in how he articulates the relationship between one field and the next. Or the 'zip' of Newman—we could make those 'zips' technically better, but that's not the point, of course. Newman uses this 'disturbed' quality of the bleed in a specific way. So I'm often interested in

how these particular solutions can be refigured. I've made sculptures that reference 'zips', or paintings that explore quite jagged fields.

DR: But do these operate at the level of quotation? I think that these contradictory 'languages' can be quite violently contrasted.

GF: Well, normally it's not encouraged to put two things together. And let me put it like this—as I said earlier, I'm not interested in doing a Sherrie Levine, if you talk about quotation. I was once in a discussion at the Museum of Modern Art, New York, it was a discussion about the artist's hand. Sherrie was there, Jenny Holzer and Alan McCollum. All of these people were talking from the perspective of critique of originality, of not doing their own work, and literally having assistants produce the work. I looked around and thought, 'What the hell am I doing here—why have I been invited?'. These were dead issues for me even then. I asked Sherrie, 'What is the point of all this? What do you actually mean by this? Do you want to have the same experience as the photographer or painter fifty years ago?' And she said, 'Yes ... the same'.

DR: Well, it's an impossibility for one thing.

GF: Right. You can't possibly transport yourself back to another environment or time in this way. What does the Depression or Black Friday mean to us today? Something very different from if we were actually living through it.

DR: But to be fair, didn't Sherrie Levine see this gap between the original and its re-framing as a poetic space, rather than a cold conceptual strategy or a literal stepping into the shoes of the appropriated object?

GF: Can you have it both ways? Well, maybe she was not in a good mood that day we spoke! [laughs]

DR: In connection with some of these issues, I was wondering about the more recent grid paintings, which reference urban planning and modernist architecture, and also the corresponding photo-pieces of classic modernist architecture. It has been suggested that there is an ambivalence being articulated here about those achievements: 'ambivalence' in the sense that you are fascinated by high modernism yet also urged to critique it?

GF: No, I have nothing whatsoever against this architecture; on the contrary, I'm interested and absorbed by it. I'm not critical in this way.

DR: But it has often been read like this.

GF: That's a mistake, really a mistake. It's origins lie in a photo that I took in Italy of a building that was built by the Fascist party and someone wrote about the work that it was very critical because the columns were not vertical ... [laughs] My work has more to do with photography as an emotional vehicle, more like what Rodchenko did, rather than a simple-minded critique.

DR: An emotional response to the articulation of space that the architecture might set up?

GF: Yes. I generally respond because I think it is really good architecture. It's mostly architecture from the 20s to the 40s, so it does fit into the framework of classic Modernism, and many of the recent ones are Soviet buildings from the 20s.

DR: But this notion of critique would seem to be a problem with recent criticism, in that it *has* to be a critique or nothing at all.

GF: For sure. This is an unhelpful attitude I think; it's a problem with art writing. On another level, I suppose more recently the status of photos has changed—some photographs have been collected together in book formats. I'm working on architectural photos from Moscow and Prague for book projects.

DR: How would you differentiate these book photographs?

GF: Not at all in the taking of the photos; I don't let that get in the way. It's more a sense of how they're organised in the book format—a question of different presentation.

DR: Thinking about your output overall, one thing that strikes me is the tendency towards ruptures or breaks, rather than smooth or developmental continuity, to the point where one series might deliberately negate, or travesty even, the concerns of the preceding ones. I'm thinking here of the way the beautiful surface, or the beautiful brushstroke gets replaced by something really quite different.

GF: Yes, in the grid paintings you often don't get a brush stroke: the surface is scratched into or you don't get a sense of the mark starting or finishing on the canvas, so it sets up a different kind of surface. I think it's important to do these breaks when the time is right. The reception of the work is always behind, so it hardly ever is perceived in the right sense or it is seen in the sense that if you change too much, then it can't be truthful or authentic

work. This is nonsense of course; change is a central and key issue for an artist, I think.

DR: You've just described how one series might contradict another, but what about this notion of almost self-parody that you set up, where the form of one series is treated in a caricatured, almost self-mocking way?

GF: Yes, I have humour.

DR: It seems to be aimed at the high seriousness of, say, someone like Richter, with his statement, 'painting as a moral act'.

GF: Well, Richter is of a different generation. I think there seemed to be more of a contradiction between abstract and figurative modes of painting for that generation. When a painter crossed over from one to the other then it was perceived almost like they were a 'liar'. Of course, we don't have to view it like this today at all.

DR: Following on from this, how would your work connect with somebody like the late Martin Kippenberger, for instance, where 'attitude', rather than mode or style or even 'quality' in the conventional sense, was all-important?

GF: I like Kippenberger's work a lot, and we were good friends, but I think it depends on the kind of structures you use, the kind of structures that you're drawn towards. He found a particular way of utilising that natural humour and wit. Actually, I was just reading the last interview with him, and the interviewer asks him about his attitudes, why he was so 'loud', etc, and he said, 'Oh, that was kindergarten—now I'm serious'. [laughs] I myself have chosen another way; perhaps I interpret this 'attitude' in another sense. The sense of break or rupture in the work is important for me—you know, you study artists you admire, then you have to make a break with them and then, of course, once you've established a reputation then you must fight with this, go against this. If you become too satisfied, then it's over. In one sense, what I'm describing is the normal way of an artist: you struggle to find your position, you then get shows, you have to deal with the marketplace and the critical context for your work and fight your position in all this, then the reputation brings other problems—your reputation can kill you. If you were simply to make stripe paintings all your career then it would become complacent. With the Americans, Newman or Rothko, then it's different—they came to it very late and we're talking about mature careers of only about twenty years.

DR: Do you see the market now as too dominant or simply a reality that we, as artists, must accept and work with its structures?

GF: I think it's a reality. I thought maybe after the 80s, that the situation might change, but it's still the same situation, except that it is not so strong as back then. Maybe young artists should change their strategy and not accept it, but they want it the same I think. Even those who play the game of pretending to be outside the system can only do so with it—and in that sense it's a kind of foreplay before finally becoming fully embraced by the system of the market. It all gets encompassed by the galleries, by the big museum shows. The look of the work changes but the system doesn't.

NOTES

1. This term refers to the Neo-Expressionist painters who appeared to dominate the German art scene in the late 1970s, and particularly applied to artists such as Salome, Bernd Zimmer, Rainer Fetting et al.

RULES AND THEIR EXCEPTIONS (1999)
Guy Tosatto

*Many birds (the parrot, the humming-bird, the bird of paradise) and a lot
of crustaceans in the sea are free beauties themselves and belong to no
object determined by concepts as to its purpose, but we like them freely
and on their own account. Thus designs* à la greque, *the foliage on
borders or on wallpaper, etc, mean nothing on their own: they represent
nothing, no object under a determinate concept, and are free beauties.
What we call fantasias in music (namely, music without a topic), indeed
all music not set to words, may also be included in the same class.*

Immanuel Kant, *Critique of Judgement*

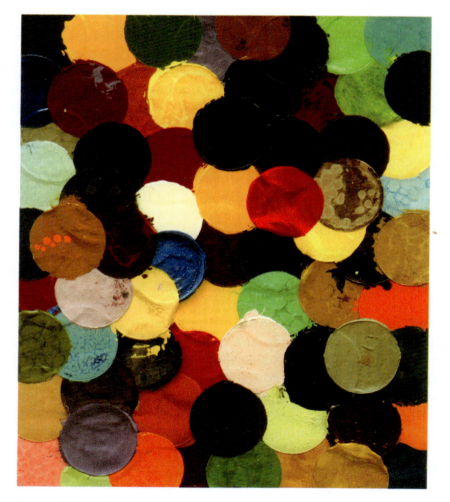

Figure 14 Bernard Frize, *Suite Segond* 1980, Lacquer alkyd urethane on canvas, 55 ×46 cm,
Courtesy Frith Street Gallery, London.

Use only the finest of brushes—the famous *traînard* utilised by marine painters to sketch the halyards and shrouds on ships' masts—in short, a brush destined only to paint lines; establish no rule except those dictated by chance, no finality but the total, mechanical covering of the surface of the canvas: these were the options taken by Bernard Frize when he began his first series of paintings in 1976. From the outset, he asserted an attitude of resolute withdrawal from the act of painting, and consequently, from painting itself. The brush selected is the most modest, least *artistic* of brushes. It permits nothing but that for which it was conceived: tracing lines. A tool more than an instrument, it leaves room for no expression, or at least no personal inflection. In the artist's hand it constitutes a stinging critique of the *classical brush*, the painter's privileged instrument, the symbol of his virtuosity.

By this initial choice—less anecdotal than it may seem—the artist gave a precise, imperious indication of the position he intended to uphold in his relation to painting. For as you will have guessed, Frize is anything but naive. His choice to approach artistic creation *at odd angles*, through the detours of trivial or inappropriate tools, and through singular or random procedures, is grounded in a profound knowledge of Western art history and its modern developments. Only after having measured the stakes, the failures as well as the successes, did he decide to approach painting in the spirit of his great predecessors, Wladyslaw Strzeminski or Andy Warhol, through a relationship of distancing that affects the activity of the painter no less than the status of the painted object (that is, the easel picture). Thus, one must consider the choice of the *traînard* in its metaphorical dimension. This rather derisory brush constitutes the illustration of an activity judged derisory—just as the pictures offer themselves to the gaze as the direct reflection of the application of a technique: *painting with the traînard*. The artist, here, counts for hardly more than the executor of a mechanical activity that could be carried out by another; the work is only the result of basic procedures, a kind of playing patience, at best a craftsman's *tour de force*. A resolutely modest attitude in sum, which, for this reader of *Ecclesiastes* anyway, suggests a pessimistic vision of the place and the status of art, as well as the place and status of the artist in contemporary society. It may lead one to think that Frize's early paintings, in their emblematic dimension, are to be envisaged as so many vanities.

This mistrust toward the traditional modes of painting—which an artist of the preceding generation, Sigmar Polke, had also expressed—finds one of its most perfect illustrations in a series of works from 1980, entitled *Suite Segond*. The procedure is simple, even simpler than in the *traînard* paintings: it is just a matter of stripping off the film of dried paint from the surface of pots left open to the air, then gluing these films directly onto the canvas so as to cover it entirely. No more brush, no more painter: the paint offers its skin, the pots offer their form, and the artist allows himself only the arrangement of these paint-forms on the canvas. *Almost* ready-made

paintings, signalling the *almost* total effacement of the painter before a self-generating painting. Though the demonstration is striking, one must obviously not neglect the interstices of meaning slipped surreptitiously into this parable of painting's meaninglessness: we can glimpse them in the two *almosts*. For although the painter finds the films of paint already made, his activity nonetheless begins with the preparatory choice of the colours and the form of the paint pots. Similarly, when he applies the films to the canvas, a multitude of events occur, such as the wrinkling of the skins, their drips, their overlaps, in short, the alchemy of an as yet unfixed material providing the painter with an instant's space of intervention.

This procedure would be developed in the early 1990s with a series of paintings entitled *Suite*. In this case, a mix of several differently coloured kinds of paint is left to dry in a quadrangular basin. The artist then removes the dried surface film, which he places on the canvas. He reiterates this operation, layer after layer, until nothing remains. The process produces series of pictures of various lengths, depending on the quantity of paint employed; they present the different states, the different strata, of the same block of pictorial material. It is a fascinating, troubling vision, these metamorphoses of matter: we are the spectators of a mystery, and the artist, in his absolute withdrawal, becomes the go-between who guides us beyond the opacity of painting, towards what is *behind* or *after* it. Perhaps he has attained a definitive distance between himself and the act of painting. Indeed, his activity is reduced to its most simple expression. And yet in the closest proximity to matter, to its secret organisation, to its subterranean chemistry, he casts light on a new dimension of painting's reality.

These works have sometimes been compared with Gerhard Richter's *Abstrakten Bildern*, on the basis of formal parallels. Such a comparison obviously misses the specificity of both. For not only does their nature prove radically different—a film of matter for one, a thick impasto for the other—but their procedures are opposite. For Richter, the metamorphoses of painting are only accessible at the price of a wilful fashioning and an accumulation of layers of colour. This activity is part of a quest that nourishes the romantic vision of its author and culminates in the elaboration of new icons, a dazzling synthesis of painting. Scepticism prevails for Frize, leading him to unveil the artifices of painting, peeling them away like an onion … No metaphysics of matter underlies this approach; for him, painting in itself is only paint. What Frize ultimately gives us is an *image* of abstract painting, whereas Richter offers abstract painting in its most classical dimension; the former, like Duchamp, situates himself in the break from a certain art history, whereas the latter enters into a dialogue with a tradition.

To invoke the question of images in this body of work is also to enquire into the artist's attitude toward them. And though one quickly observes that abstract motifs indisputably predominate, particularly with the famous friezes, the appearance here and there of figurative images should not be

underestimated, like the ambivalence of certain supposedly 'abstract' paintings. Let us be clear from the outset: one finds no representation in the traditional sense in the work of Bernard Frize. On the other hand, it does include a large group of reproductions of objects and things. Between representation and reproduction there is an important nuance, which suggests, here again, the distance that the artist seeks to maintain between himself and painting. The first incursion of images into his work is exemplary in this respect. It occurs in a series carried out in 1979, with a decorator's tool, the *roulor*, which allows one to reproduce motifs such as flowers, fruit, toys, etc—just like wallpaper. Through repeated applications of this tool, the artist saturates the surface of the canvas until he has created an almost abstract composition with the superimposition of the motif. From very close up, the motifs can still be made out; from afar they blend together and a vibrant surface of interlacing colours appears. As one sees here, the frontier between abstraction and figuration reveals itself to be quite permeable, and in the context of this delicately ironic demonstration, their strict opposition seems to refer to debates of another era. But in this series it is the very use of images that proves significant. Of course these previously made motifs bring the ready-made to mind once again, but the aim is elsewhere; it primarily concerns the status of the image in painting. It is clear that for the artist, every painted image cannot help but refer back to painting, to its modes of constitution, to its procedures of elaboration, but never to an exterior reality, that of the visible world. Here again, scepticism is the rule. If the artist offers us images, he seeks above all to show us their mendacious nature: the image, the ultimate lure of painting. Thus, the use he makes of image always reveals itself as iconoclastic. Consider the occasional imaged series of the 1980s, such as the *Natures mortes* or the *Articles*. Each time, the image is placed in an antagonistic relation to the painting that includes it: the inadequation of colours and forms, of figure and ground, the mimetic contamination of the support medium by the subject, or of the subject by the format ... Iconoclasm at work: such is the definition of Frize's relation to images, which he puts on trial so as to stigmatise the permanent gap he maintains between them and himself. It is a gap that tends to shrink when the images no longer constitute this interpretative and arbitrary projection of the visible world onto the canvas-screen, but instead are born of the order—or disorder—of painting itself. This is particularly the case in several series of paintings from the early 1990s, which, although their titles are various (*Equivalent, Oreillers, Cinq vues dans un carré, Romi* ...), all spring from the same procedure: an unmixable solution of ink and acrylic is spread over a canvas freshly coated with resin. The result is of confusing beauty: beyond the simple trace of the brush's passage, in the effusive materials, in the more or less controlled flows, sumptuous seascapes or forest scenes appear, calling to mind the figurative stones of Tuscany, Chinese paintings of the great periods, or the shadowy, fantastic inks of Victor Hugo. Evocations and not representations, these images emerge from the pictorial matter and constitute

the reflection of our imaginary, of our capacity to *see* the mark of someone's thinking, the transcription of someone's vision, in an artefact that is merely the fruit of chance. Thus, the artist holds out a mirror, in which, to be sure, we catch a glimpse of his taste for complex and ambiguous configurations, but in which we can above all measure the anthropomorphic nature of our own gaze, as well as its cultural dimension. The gap, the distance that Frize insists on maintaining with respect to artistic creation, is thus betrayed in his attitude towards it, which some might judge off-hand or even cynical, whereas in fact it is nothing but the translation of his humour: a humour concerning both himself and his activity. Avoiding all emphasis, cultivating a certain lightness: for him these seem to be the conditions necessary to the development of his work. Playfulness, malice, irony, are so many mainsprings allowing him to keep his *distance* from painting: and, as we have seen, it is with the use of inappropriate tools, with the diversion of craft or industrial techniques, with the systematic accident (the paint pots left open) that he finds a way to put a halt to the shortfalls of an all-too codified activity. The choice of certain themes also proves significant: from the glazed ceramic pots likening the painter's activity to the potter's, to the friezes undertaken during his stay in Rome, causing visitors to exclaim: 'Frize paints friezes!'. Finally, the titles too share in this logic that oscillates from irony to tomfoolery: from *Suite Segond*, after Louis Segond, the Calvinist translator of the Bible, to *Romi, Vony, Mona* and *Vick*, the code names of the train lines in the Paris inter-urban rail system, by way of *Sous le soleil*, a scanachrome reproducing a select collection of bare breasts. Humour, of course, is often a mask for modesty. For Frize, this modesty concerns the exercise of painting above all; and sometimes, when the need to paint is not imperious, it leads him to prefer the observation of the clouds or the amused contemplation of the depths of a coffee cup,

Since the mid-1980s, Frize's paintings have presented a smooth, glossy, glazed, flat aspect, like that of waxed canvas. Their surface forms a screen and maintains painting beyond this frontier, like the glass of a mirror. In doing so, it keeps us at a distance. Thus, the gaze comes up inexorably against this transparent veil, letting us guess the inaccessible splendours that are always to be found *behind* it: there, where the perceived image is embodied. Once again, it is the artist's deliberate will to retain for his painting the posture of withdrawal that he himself maintains with respect to it—a characteristic whose immediate effect is to further whet the spectator's desire to pierce the mystery of these works. A desire perpetually disappointed and rekindled.

The impossibility of understanding exactly where to situate the pictorial event one is seeing is complemented by an inability to fathom its procedures of fabrication: the question *how is it made?* For here, as well, the mystery remains, and the indication of the materials used hardly suffices to dispel it. Read the list of materials instead: 'water-based paint and primer on canvas, alkyd-urethane lacquer on canvas, crackling varnish and oil on canvas ... ' The same holds for the geometric configurations favoured by the painter in recent years, whose

simplicity, indeed obviousness, continues to intrigue, to surprise, to disconcert; and hence to question us as to the underlays and overlays of a given grid, the beginning and end of a given frieze, the top and bottom of a given view into a square ... All these perturbing elements act to capture the attention, entrap the gaze, and lead the viewer to enquire both into the reality of the images he sees and into the validity of his own perception.

Nonetheless, if the works are haloed with an aura of mystery, this is neither the design nor the will of the artist, but rather the product of two combined factors: on the one hand, the distancing carried out by Frize in his paintings; and on the other, our desire to reach the totality of his works, a desire stimulated, needless to say, by the extraordinary beauty of some of them. In short, the mystery resides in this space created in between the painting and the spectator; a space where the latter's imaginary can unfold. Two series, one of them older (the carved-out paintings) and the other more recent—paintings such as *Lime* (1998) or *Mile* (1998)—provide the dimensions of this space, its polarity. The former are made of several layers of differently coloured paint, which, once dry, are carved out with a cutter. At each incision appear the stratified films of paint. Here, the artist plunges us into the very heart of the pictorial material, even as we witness a dismemberment of the painted surface. The second group of works is realised with a hard roller on rough-grained canvas. The numerous coats of paint applied to the canvas impregnate the grains to the detriment of the ground, with its finer weave. Thus, the painting seen from the front appears lightly coloured, while the view from an angle—or rather, in profile—reveals a dazzling colour spectrum. With these works, painting is situated *flush with the canvas* and no longer in the depth of the material, in its powdery dimension: in short, the painting appears when one steps away from it! Two opposite movements, then, one leading to the very heart of the pictorial matter—a feeling redoubled by the appearance of these works, which recall some swarming mass of cells seen under a microscope—and the other pushing us to take a step back, indeed, to adopt a peripheral position in the face of the painting. From the close-up view to an enforced distance, in the back-and-forth movement of the work's materiality and its mere appearance, we perceive the oscillation of this space, its beat, its amplitude. A contradictory, paradoxical space, it feeds desire even while frustrating it, offers painting to the gaze even while pulling it away from the view, exposes the work of the painter even while formulating enigmas. An important share of the fascination exercised by these works no doubt resides in this capacity limpidly to state the reality of the painting, and at the same time, to illustrate so clearly all that escapes the understanding, all that can neither be analysed nor demonstrated. Let's simply call it the mystery of art.

As already indicated, one of Frize's favourite themes is the frieze. Friezes of all kinds and in all forms, carried out with a single wide paintbrush or a bouquet of artist's brushes, covering the entire canvas with dense material or

standing out against the neutral ground of the painting, letting it breathe freely and easily. An abstract motif par excellence, the frieze refers only to itself, to what it presents: a play of lines, simple or complex, sharp or diffuse, monochrome or multicoloured. With his friezes, the artist once again speaks only of painting, of its possibilities and gaps, of its successes and failures—he speaks, or rather, with his consistent posture of withdrawal, he *lets these things be said*. For if he holds the brush, he nonetheless prepares all the conditions so that the painting can carry itself out: in short, realise itself. Thus, the failures are sometimes more convincing than the successes, the gaps more pertinent than the gains. It's a surprising ethics of art, decreeing rules that contain only exceptions. The artist's mastery, art's freedom: here is a paradox that Frize resolves through the extremely close attention he brings to every element, every stage of the painting's elaboration, but also through his total availability where the *realisation* of the painting is concerned. The motif of the frieze, in particular, gives him this possibility to play with procedures and *to let painting play*. Kant, in his attempt at a definition of beauty, classifies the frieze in the category of 'free beauty' (*pulchritudo vaga*), a beauty released from the necessity to refer to anything but itself. The motif exists by itself and for itself, and its beauty is nothing but the result of this complete autonomy with regard to anything it might signify.

Is this not, finally, Frize's attempt: to express, to fulfil this *free beauty*? An attempt that cannot support itself on anything but the position of withdrawal that he has adopted from his very beginnings. And, if we prolong this reasoning, could we not see the frieze as the privileged metaphor of the artist—with the homonym turning the motif into a signature? It signifies what might be taken as his definition of painting: a group of objective givens submitted to the laws of chance. A conception in the form of a Mallarméan morale, where the painter prefers not tragedy but irony, not drama but play.

Bernard Frize in Conversation with David Ryan (1997)

David Ryan: I was wondering about the status of the image in your earlier work in the 1980s, which function rather like painted 'found objects' or even found *objets d'art*. Was this a conscious attempt to re-inscribe a Duchampian approach within the medium of painting itself?

Bernard Frize: Well, no, not really. I wasn't so interested in what is said to be Duchamp's issue … it was so fashionable. Everybody was involved with referencing Duchamp and it seemed a good enough reason to avoid it. In the 80s, the use of the idea of readymade became over-familiar and predictable. I wanted to find another way. I felt it was important to do so.

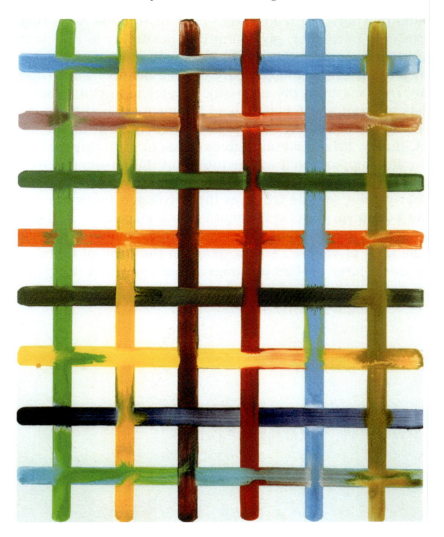

Figure 15 Bernard Frize, *Goutte d'Eau* 1997, Acrylic and resin on canvas, 146 ×114 cm, Courtesy Frith Street Gallery, London.

DR: During this period, there seems almost no distinction between those works that focus on or centralise a recognisable image and those seemingly involved with an investigation of a self-reflecting materiality or 'autonomous' picture making. Did you make any differentiation between those approaches at the time? Why did the latter approach become a singular preoccupation?

BF: No, you're quite right, I didn't make any distinction between these different paintings. I see them both as representation—both attempt to result in a representation. What is called 'abstraction' became the main course of my work.

DR: *Suite Segond* of the 1980s, where you constructed a painting from the dried skins from paint tins, is often cited as an important piece. Was this the first piece to embrace a chance-oriented process or system?

BF: I did paintings with a roller before and also paintings where I laid on more than fifty layers of paint, which I notched in order to see all the colours. I also did some other works where the result, the image, was unpredictable. I think I've been interested in utilising different processes for some time, but not simply at the level of 'process painting'. Do you know the story of the *Suite Segond*? I'd just finished drawing a picture on a new canvas and all that was left to do was to lay on the colours. As I was reaching for the tins of paint, I felt guilty; I wished I wasn't so untidy and hadn't forgotten to put the lids back on. Of course the paint had dried. I had to grab a knife and cut around what had become a sort of skin. To get rid of it, I dumped it on a near-by canvas. I did that for the next tin, and in fact for all of them. It was handy because, although one side of the circle was dry, the other wasn't. So the paint stuck easily to the canvas. I tried to choose as many colours as possible. And I was amazed to see my drawing being completed, when I was merely laying down paint. I was developing techniques that were adaptable according to the circumstances.

DR: In what way?

BF: Well, you know, I had a job and painted at weekends—literally a Sunday painter, and this obviously restricted me in some ways.

DR: Is this why you have sometimes substituted the word 'necessity' for 'chance'? Could you elaborate on this distinction?

BF: I don't complain about painting with dry tins of paint. Why not use chance as luck? It has always been clear to me that I had to use the quality of the paint, the function of the tools (the kind of brushes, the grain of the canvas, etc) as materials that defined paths to follow. Each gesture became

specific, each solution, particular. I was surprised and interested that from these restraints, results could still be hazardous.

DR: I was recently reading a lecture by the composer Morton Feldman, where he was making a distinction between himself and Pierre Boulez, 'Who', said Feldman, 'is not interested in how a piece sounds, only in how it is made. No painter would talk like that'.[1] How interested are you in the finished piece, the 'look' of a painting? If your processes are an attempt to abolish taste in many ways, what makes a particular end-product acceptable or unacceptable?

BF: It's interesting, because in many ways I almost work blind: I engage processes that often do not require me to look. In some of the large paintings, I have someone who is literally directing me to follow the drawing. As another example, when I use a certain resin, the final colour is not perceivable during the process of making. Having said this, of course, I am interested to know what I've done. Let's say that, generally speaking, I like works that require a second look; when at second sight, things are not emptied. So to get back to the point, I operate between the two: processes are raised, then I lose a certain control and the surprise provoked is the sign of a complexity that pleases me and makes me *desirous*.

DR: As a means to an end?

BF: Process, as a thing in itself, is certainly not interesting for me. I like to figure out strategies. I like to get excited by the desire to make a painting and to look at it like one related to my body of work.

DR: The work also seems to site itself somewhere between improvisation and system.

BF: Yes, that's true. I would suggest a kind of informal system—one can change one's mind.

DR: Feldman also often discussed the relationship between the idea (or concept) and the nature of materials. For him, the notion of having an idea divorced from the material was a contradiction in terms, the starting point always being the nature of the materials themselves, an idea being 'sparked', if he was lucky, by working his way into a piece with direct engagement with materiality. Does such an approach square with yours in any way? I'm thinking here of the fact that you once suggested the paintings painted themselves?

BF: I agree with Feldman here, for sure. That was what I called 'necessity'. You know, this relationship is defined legally too. I once saw some ceramic

plates with coloured circles, identical to the *Suite Segond*. Naturally, I sought legal advice on this matter, and the lawyer told me that no patent could be given to an idea, but to a technique or a material. An idea does not exist without its materiality. I also can't think outside of the specificity of materials. Most of the time, I have ideas coming to me through the particular use of a material.

DR: This brings to mind Tony Godfrey's question in his short text of 1994,[2] 'Is Frize an extreme materialist or is there something over and above the material and the process?'

BF: Perhaps it is not for me to say. Tony Godfrey should look at the paintings again.

DR: To take the musical analogies further—and I hope you don't mind this direction …

BF: No, not at all. It's interesting.

DR: … it might be said that Feldman's mentor, John Cage, is more relevant to your concerns. I'm thinking of the elaborate stage-managing of chance operations in relation to the 'event' of performance, and the concern with an ego-less position; also with his analogy of photographic processes in relation to indeterminacy. Cage suggested that he gave the means to take a photograph, but that it was the performer who took the photograph via a camera that he himself has given instructions to construct. Your work does not provide us with a camera, but does present us with a 'photographic evidence', so to speak. In many ways, because the artist is his or her own performer, the process is reversed—we, as viewers, are perhaps invited to reconstruct the specific device (the 'camera') that enabled the 'event' (painting) to take place. Is such a reading at all relevant to your own analogies with painting as a photographic process?

BF: I'm very interested in these thoughts. I think, generally, that there is a very strong connection between photography and the history of painting—which operates on many different levels. It would be silly to think only in terms of pictorialism, talking about photography or mimeticism, in thinking about referential painting. Rosalind Krauss has written on Impressionist drawing and the impact of photography, and shows very clearly how it affected the process of painting and monoprint.

DR: But I was thinking more in terms of this 'stage management' of so-called chance that we get in Cage's work and its link with the resulting aural image, and also the workshop techniques of a camera obscura. Both these

models of producing 'images', for want of a better word, might have a peculiar, oblique crossover with your approach.

BF: Yes, maybe. That is certainly an aspect. But it's messier. There are so many ways for chance to happen. There is this analogy with the photograph, the techniques of processing. The relationship between contact, exposure and surface is strong. I like to think of the paintings almost as a kind of 'slice', and a Polaroid might also have this sense of being peeled, a slice of paint and time.

DR: The British painter, Ian Davenport, suggested that he develops an idea of tempo while working, that the method he adopted might suggest a particular rhythm of working. Is this the case with you also?

BF: No. I don't think really in those terms of a specific tempo. To me, a painting has to be done quickly to be able to show its process, to be clear, without tricks. I don't like the mess of painting; it has to be done most of the time in one go—otherwise, I get bored. Ironically, working out the process and figuring out all the preparations for a painting take longer than the actual act itself.

DR: You've suggested a kind of ego-less goal to the paintings, another reason why Cage's approach to chance springs to mind.

BF: Yes, it is an important factor. There is a huge difference, in terms of work, between the artist seeing themself as a God-like creator or simply processing the world. Obviously there are social and political issues that inform both these positions.

DR: I'll come back to that point, perhaps, later. On a more formal level, there seems to be a kind of 'perverted' all-overness to some of the more recent paintings, indeed, earlier paintings as well, whereby traces of gestures become emblematic, yet symmetrical. How important is the example of colour field painting or non-relational painting of the 60s?

BF: Chance and non-composition are two strategies to avoid an ego position in painting. Geometrical composition, the principal of the series, automatism, non-relationality, etc, all these are attempts in the same direction. One aspect of the colour-field painter's work is dealing with it, the other one is the sublime, and I'm far from it.

DR: Was Morris Louis important to you?

BF: I like some aspect of his work: the 'Veils' for instance. I also sensed Greenberg somewhere around in the background and this immediately put me off. I don't like Greenberg's ideology.

DR: And Stella?

BF: No. I never got the chance to be interested in Stella—even the 'Black Paintings'. I never liked the way he changed the rules of the game as he went along, you know, to suddenly assert shaped canvases and literal space. What did all that really mean and where did it go? We all know the limitations of the rectangle of the canvas, and it is a convention. To make the shaped canvas an issue the way he did was not interesting to me and in retrospect, it seems a strange contradiction. Kelly, Warhol, Sol LeWitt, however, are of interest to me, more than Stella or Louis. Kelly is a very interesting artist, the early work he produced in France, with its own exploration of chance, is extremely valuable and underrated. You know, you mentioned John Cage, an interesting figure for sure, but also connected with Duchamp. People think, 'Chance equals Duchamp' (especially because Duchamp, most of the time, is considered as attempting to bring about the end of painting). There is another tradition that goes right back to Jean Arp, with the torn papers from the years 1916 to 1919, and I think Kelly's work is linked to that. If we discuss chance, then I would link my approach firmly within this 'tradition', rather than the Duchampian one. We can also speak about important figures outside of America and artists of the younger generation.

DR: Richter cited the importance of non-relational painting and having spoken to some of his students, it's easy to see that this formed a core of his teaching. I'm surprised in one sense that you're so dismissive of early Stella, given your concern with symmetrical articulation.

BF: Well, Stella's work bores me. I'm much more happy in relation to artists with whom I can discuss all that without dogmatism. Painting is always referential. From Günther Umberg, Marthe Wery or Adrian Schiess to Lisa Milroy, to David Reed, Klaus Merkel and so on, we all find solutions that inform our work now. Concerning symmetrical articulation, many of these forms you're talking about have found sources. The manoeuvres in some paintings are influenced by ornamental or other ways to divide a surface. *Pacifique* from 1991 is determined by all the moves of the knight on a chess board, and I found the figure in a book about mathematics. Of course, I don't like to tell it, to spell it out; it would be ambiguous to see it as important. It's enough to say I did not want to invent a drawing, I needed a pattern.

DR: It suffices that these routes look pre-determined?

BF: Exactly. I wished to use a bunch of brushes, each with one colour, to follow the drawing, to divide the surface. The fact that the brushes were gathered in a bunch and mixing up the colours *in situ*, avoids any choice

concerning the result. As I was trying to reproduce the pattern, the surface was wet so the colours were blurring. The pattern was getting destroyed. This found drawing allowed me to point out many kinds of paradoxes. Inventing the drawing would have been very formal.

DR: To what extent is your project concerned with a conscious de-familiarisation of all the formal components of painting?

BF: What do you mean by 'de-familiarisation'?

DR: Well, I'm thinking of the way that the formal elements of the paintings are somehow made strange; they're arrested from simply being 'placeable' within a tradition, like, say, the one we've just been discussing. This makes them less comfortable, less easily 'read' in some ways.

BF: [silence]

DR: Perhaps I should give an example—again, a kind of de-familiarisation. Wittgenstein, in his *Remarks on Colour*, examines the nature of our language system in relationship to his physical experience of colour. He looks at the inconsistencies of concepts such as light, dark, transparent, etc, and asks, what if we had a completely different 'language game' in relation to the manifestation of colour?[3]

BF: Yes, it's an interesting thought. It points to the complexity of colour in the face of any attempt to grasp it with language—or the inverse. In terms of my own painting, I wanted a multi-coloured, chromatic situation to avoid choice. Once you do something in art, it seems that it becomes a trademark: Ryman's white or Reinhardt's black. I wanted something different—for painting to hold as many colours as possible; such a proposition is not always realisable. But it became a specific problem that many of the paintings deal with 'how can I get as many colours as possible in one brushstroke?' A painting, like *Goutte d'Eau* (1997), has a chromatic system whereby each bar's grid is a two-coloured line but is painted with one brushstroke.

DR: You've mentioned your due to writers like Lewis Carroll or Lawrence Sterne. What about somebody like Samuel Beckett? He springs to mind for several reasons. I'm thinking here of the crab-like, seemingly inwardly turning manoeuvres of gesture trails on the canvas in relation to some of Beckett's textual reflexivity. Also, the apparent anxiety of something that fails to signify: that is blank, empty. As Beckett said, 'To be an artist is to fail, as no other dare fail'.[4] Can you connect with this or do you see it as an over-dramatisation of the situation?

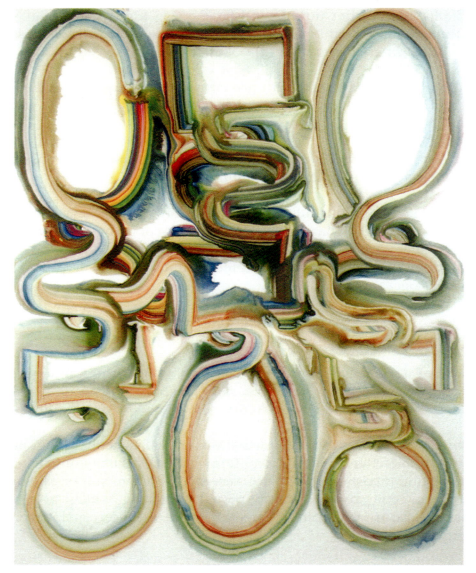

Figure 16 Bernard Frize, *Taunus* 1997, Acrylic and resin on canvas, 234 ×190 cm, Courtesy Frith Street Gallery, London.

BF: No, I could agree with this statement. I think he's right. I always forget about my desire, that's why I always do it again. But you know, Beckett is very trendy at the moment. It's fashionable to quote him to legitimise every practice.

DR: Really? I didn't realise he was so fashionable right now. But I think, on another level, surely it's wrong to allow fashion to overtly colour our relationship to such an obviously interesting figure?

BF: Yes, I understand what you mean. I have found his work very interesting for a long time and especially the later work he made for television, like *Quad* (1982), with its non-verbal and spatial choreography.

DR: Like your work, concerned with pre-determined routes, mapping out a space in a particular way?

BF: But what I was getting at earlier, was this legitimisation of painting by something else. I think there are many artificial discourses built up and quite frankly, writing and painting are something different.

DR: Finally—and I think this follows on from what you were saying just now—you once alluded to Barnett Newman in the context of a rapport of faith with the medium of painting, one that is lost at present. What has replaced faith and rapport? How do you feel painting—if we can be media-specific at all—operates today?

BF: Well, I think I was referring to a particular interview between Newman and Rosenberg, where a political stance is discussed ...

DR: Yes, where Newman, in response to a question about the ultimate meaning of his paintings, says something like 'the downfall—or the end of—all totalitarianism and monopoly capitalism ...'

BF: Yes, he says—and this is an important nuance—if Rosenberg and people like him could understand his work, all forms of totalitarianism and capitalism wouldn't exist. I'm much too sceptical to argue such a statement, but, as such, we could give it a second thought. After all, what's interesting is to understand how art produced in a given context reaches a point where it becomes universal.

NOTES

1. Morton Feldman, in Walter Zimmermann (ed) *Essays*, Beginner Press (Cologne), 1985, p. 47.
2. Tony Godfrey, *Chance, Choice and Irony*, Todd Gallery and John Hansard Gallery, University of Southampton (Southampton), 1994, p. 22.
3. See Ludwig Wittgenstein, *Remarks on Colour*, Blackwell (London), 1977.
4. Samuel Beckett, *Three Dialogues in Disjecta: Miscellaneous Writings and a Dramatic Fragment*, ed Ruby Cohn, Grove (New York), 1984, p. 145.

MARY HEILMANN'S EMBODIED GRIDS (1990)
David Joselit

Streaked with red and yellow, colours of courage and cowardice. Alfred Corn, 'Synecdoche'

I recently found myself intrigued by David Lynch's new movie Blue Velvet. The imagery was taken from many different periods, and that eclecticism was what made the film so provocative for me; there was no clear period, no consistent style of house or clothing, language or even colour. Mary Heilmann

In 1978, Mary Heilmann made a painting entitled *The End.* In this large, horizontal canvas a red square is suspended on the left side of a yellow field. Except for its left edge, which defines the border of the canvas, the red square is engulfed by a rich, yolky expanse (whose particular hue is the

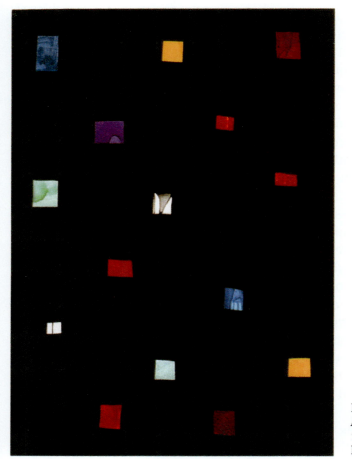

Figure 17 Mary Heilmann, *Gaieté Parisienne* 1983, Oil on canvas, 152 ×107 cm, Courtesy American Fine Arts Co., New York.

result of yellow painted over red). This virtually agonistic juxtaposition of red and engulfing yellow evokes a whole catalogue of possible associations, many of which are suggested in Alfred Corn's poem 'Synecdoche':

> Red the best colour for taillights? Yellow, for cabs? ...
> the sunset, like some gaudy, impressive
> Dessert, peach and raspberry ...
> Night before last upstairs in that bar
> yellow tablecloth
> runes in red neon ...
> this cloth plaid in the colours of blood and jaundice ...
> Streaked with red and yellow, colours of courage and Cowardice.[1]

Corn's lyrical series of reds and yellows does not exhaust the possible connotations of their combination in Heilmann's painting, especially the more vulgar or commercial allusions, like the striking suggestion of the red and yellow packaging of Kodak film.

Within the simple structure of her Minimalist-inspired geometric compositions, Heilmann loads her paintings with an extravagant array of possible meanings—from the lyrical, to the crass and vulgar—through her use of keyed up, often unexpected combinations of colour. A series of pink and black paintings of 1979 instantly recalls New Wave fashion of the late 1970s, but the pinks also inevitably suggest a frilly little-girl innocence (which itself was an ironic or 'appropriated' source for sophisticated fashion). *Serape* of 1983 not only clearly identifies the Minimalist grid with Mexican folk blankets, but through a choice of lush colours ranging from earthy reds to high-key yellow and seductive pinks suggests romantic sunsets and travel adventure, as well as darker hallucinogenic experiences such as the drunkenness and disorientation experienced by the protagonist of *Under the Volcano*.[2]

Heilmann's use of colour establishes a productive—a virtually literary— excess within her simple geometric forms. The supposed universality—or impartiality—of the square or rectangle is freighted with a wide array of associations ranging from everyday visual experiences like packaging, fashion, and folk art, to emotionally charged reflections on courage and cowardice, codes of femininity, and psychic destruction or disorientation. Like *Blue Velvet*, the David Lynch film she admires, Heilmann's allusions belong to 'no clear period, no consistent style of house or clothing, language or even colour'. Later in the same interview she adds, 'What I am looking for in my work is that it have a sense of time and place; current time and place; past time and place; future time and place—each painting to evoke memory and premonition at once'.[3]

This ambition—to bend the past into the future—is strikingly reminiscent of Frederic Jameson's formulation of postmodern pastiche. In his landmark

article 'Postmodernism and Consumer Society', Jameson discusses the postmodern in terms of two related concepts: pastiche and schizophrenia. In contrast to parody, he says, which mimics the conventions of an accepted norm, pastiche arises in the absence of any universal canon:

> Pastiche is, like parody, the imitation of a peculiar or unique style, the wearing of a stylistic mask, speech in a dead language: but it is a neutral practice of such mimicry, without parody's ulterior motive, without the satirical impulse, without laughter, without that still latent feeling that there exists something *normal* compared to which what is being imitated is rather comic.[4]

Jameson illustrates his point by discussing nostalgia films as a primary example of what he calls 'pastiche'. In such films, a historical period is evoked not in an accurate documentary presentation but rather through a combination of motifs and conventions of the past, largely redefined by the attitudes of the present. The result can be exactly what Heilmann describes as her goal: 'a sense of time and place; current time and place; past time and place; future time and place ... to evoke memory and premonition at once'. Jameson notes this collapse of present, past and future in his discussion of the popular film *Star Wars*, which he sees as a form of 'nostalgia film invading and colonising even those movies today which have contemporary [or future] settings'. According to his analysis, *Star Wars* refers nostalgically to adventure serials like *Buck Rogers* of the 1930s, 40s and 50s:

> *Star Wars*, far from being a pointless satire of such now dead forms, satisfies a deep (might I even say repressed?) longing to experience them again: it is a complex object in which on some first level children and adolescents can take the adventures straight, while the adult public is able to gratify a deeper and more properly nostalgic desire to return to that older period.[5]

This formulation is resonant of Heilmann's use of colour. The pink and black canvases of the 1970s, for instance, may refer *both* to nihilistic trends in fashion and to nostalgia for 'innocent' childhood femininity. Perhaps more importantly, the paintings hold these two apparently contradictory desires in equilibrium, allowing complex relationships to develop between them.

In the absence of an accepted canon of abstract art—either Abstract Expressionism or colour field painting—several artists of the 1980s who make abstract paintings have engaged in some form of pastiche. Philip Taaffe, for example, has combined motifs from earlier modern artists with forms drawn from architectural decoration in a self-consciously outdated 'mechanical' process of linocut printmaking. Heilmann's approach to the problem has been different, and unique. Instead of evoking current, past and

present time and place through a series of 'appropriated' images and motifs, she has accomplished this temporal and spatial collapse largely through evocative combinations of colour. Her unexpectedly sweet, violent, or kitschy colours establish a specific world of associations that Jameson might call nostalgic. In spite of its susceptibility to multiple meanings, however, Heilmann's colouristic vocabulary is not undisciplined: it relies on an explicit process of suppression, or repression, for its power. The explosive visuality of her paintings, their contradiction and excess, are channelled into the regular and regulating figure of the grid, one of the fundamental geometric elements of modernism (and postmodernism).

In her 1978 essay 'Grids', Rosalind Krauss explores what she calls, in the structuralist sense, the mythic quality of the grid, its capacity to express or incorporate both material reality and the spiritual:

> In the cultist space of modern art, the grid serves not only as emblem but also as myth. For like all myths, it deals with paradox or contradiction not by dissolving the paradox or resolving the contradiction, but by covering them over so that they seem (but only seem) to go away. The grid's mythic power is that it makes us able to think we are dealing with materialism (or sometimes science, or logic) while at the same time it provides us with a release into belief (or illusion, or fiction).[6]

The contradiction that Krauss recognises in the grid has been presented by Michel Foucault as a central condition of modernity itself. Fundamental to his description of the modern episteme is the concept of modern man as an empirico-transcendental doublet:

> This is why modern thought has been unable to avoid ... searching for the locus of a discourse that would be neither of the order of reduction nor of the order of promise: a discourse whose tension would keep separate the empirical and the transcendental, while being directed at both.[7]

Krauss' interpretation of the grid as a mythic resolution of the material and the spritual closely mirrors Foucault's broader description of modern thought as that which engages—attempts to resolve—the split between the empirical and the transcendental.

In twentieth-century painters Krauss notes a continuum of strategies towards the grid, ranging from the fully abstract (ie Larry Poons and Agnes Martin) to the more concrete (as in the work of Jasper Johns or Andy Warhol, where the grid is used to organise material drawn from the world).[8] Thomas Crow recently argued that Warhol's images of Marilyn Monroe, Elizabeth Taylor and Jackie Kennedy, as well as the *Disaster* paintings of the

early 1960s, were suffused with a poignant violence and mourning. Following this, it is possible to view the grid both as a means of conveying material reality (the repetition in Warhol's pictures, Crow says, might be understood 'to suggest the grim predictability, day after day, of more events with an identical outcome, the levelling sameness with which real, not symbolic, death erupts in our experience') and as a heightening of emotional pitch (just as, as Crow has put it, 'one can see Warhol's repetition of the photographic image within the pictorial field as increasing rather than numbing the viewer's sensitivity to it').[9]

The grid—as that which embodies and masks the contradiction between the material and the spiritual—has not lost its potency for postmodern artists. Rather, the terms of its contradiction have shifted in the direction of what Krauss calls the concrete. Warhol's work of the 1960s was an important early moment in this shift. Instead of emptying the grid of all but its purified or spiritualised essence, Warhol filled it with a repetitive, jarring parade of sex and death. Similarly, Heilmann loads the rationality of the grid not with references to the transcendental, but, as Warhol did, with evocative fragments of the everyday, particularly objects that are considered feminine, or the products or props of 'women's work'. Her grids refer to weaving, dresses, fans, tablecloths, and serapes. They allude not to the grandly spiritual, but to the reality of domestic life, and to the fantasy of film.

Heilmann's grids also refer to the body. In her works, geometric structures are engulfed by paint as though by flesh. The surfaces of her canvas are built up from several layers of medium, resulting in either a translucent depth, almost like skin, or a watery transparency reminiscent of body fluids. These layered surfaces—typically riddled with drips or small cracks as evidence of slow accumulation—often hide, or engulf, the geometric structure beneath. *Rosebud* (1983) for instance, is composed of a nearly regular field of red points on a white field, but the experience of the painting obscures this order. What is more immediately striking is the quality of the lurid, dripping, red rosebuds themselves. Less than flowers, they resemble bloody wounds or even body openings (in slang 'rosebud' can mean asshole). In this painting, the grid is imagined not as a geometrically perfect *a priori* structure, but rather as a simultaneously seductive and repulsive transformation of the body into grid, or the grid into body.

Heilmann has developed a broad array of techniques for dissolving, engulfing, or fracturing the grid. In many paintings, the taut, stiffened figure of geometry is relaxed into a watery substance that flows. *The Green Spiral* of 1988 is both a wave and a labyrinth—or a wave as a labyrinth. In several recent paintings, such as *Del Mar* (1989), she has used a colour inescapably reminiscent of South Atlantic or Caribbean waters. In describing rectilinear forms with this romantic blue, she inserts a subversive seed of doubt as to the eternal or universal stability of geometry, creating lines, squares, and rectangles that would *dissolve* or disperse were they not restrained by the

borders of the canvas. *Gaieté Parisienne* (1983), like *Rosebud*, is structured as a field of points, but the points are more like windows or sources of coloured light within a black void. The stability of the grid is dissolved into light, a medium with no substance. In *Chartreuse* (1988), as in *Gaieté Parisienne*, the painting is structured around a void, but whereas *Gaieté Parisienne* is what Krauss might call 'centrifugal' in its implied extension beyond the edges of the canvas,[10] the void in *Chartreuse* is centripetal: it occupies, or rather evacuates, the centre of the painting. Heilmann literally establishes a centripetal dynamic, as though the touchingly ordinary colours and geometric forms on the periphery of the painting are sucked into the gaping 'absence' at its centre.

Lifeline, of 1989, combines Heilmann's strategies of fracturing the grid, transposing it into a fluid or flowing substance, and disorienting the body. Like many of her recent works, this painting is executed on a shifted or stepped canvas that appears alternately as a slipped rectangle or as two overlapping squares. The entire figure is bisected by a diagonal, which defines two sectors: the lower dark blue, the upper white. The 'square' on the top left is divided by two perpendicular lines, like a gun sight, into four equal quadrants. What appears superficially to be a clever hard-edge abstraction, however, masks a very different visceral experience. Whereas the orthogonal 'gun sight' reinforces the rationality of the gaze and its susceptibility to measurement and deadly accuracy, the diagonally defined blue 'sea' establishes an alternative horizon, which is more skewed and intimate, implying not the gaze of control but the disoriented and helpless (or pleasurably amorphous) position of swimming or, considering both the violence of the diagonal rotation and the work's title, of drowning. The blue 'water' in *Lifeline* flows out of the painting, out of the fractured grid. It renders the crisp accuracy of the orthogonal dry, solid, and impotent. Shooting is displaced by drowning.

In his theoretical writings, as well as in his paintings, Piet Mondrian repeatedly argued for a stiffening or straightening of line (of the grid):

> The taut line without colour ... may be the most desirable appearance for abstract expression; however, colour is necessary for *abstract-real* expression ...
> If, in the morphoplastic, the boundaries of form are established by *closed line* (contour), then they must be tensed to *straight line* ...
> For in the metropolis nature is already tensed, ordered by the human spirit. ...
> This breaking of form had to be replaced by the *intensification of form to the straight line* [a criticism of Cubism's fragmentary quality].[11]

For Mondrian, as for other modernist and postmodernist practitioners of the 'mythic grid', the grid's purest form lay in tenseness, tautness and straightness. It was through this strict, straight perpendicularity—or what he

called 'pure relationship'—that Mondrian believed spirituality would enter the empirical, mathematical structure of the grid. And it is precisely this stiffness that Heilmann seeks to dissolve. This is particularly poignant in the series of paintings, including *M* (for Mondrian?), in which she has adopted Mondrian's vocabulary of primary colours and black lines. In these works she relaxes the 'master's' orthogonal structure through her labyrinthine black line, executed by hand, and her watery areas of colour.

For Mondrian, as for a host of subsequent artists ranging from Ad Reinhardt to Agnes Martin or Robert Ryman, the grid achieved spirituality through a reduction to its essence. Heilmann has imagined, and resolved, the grid's contradiction between the empirical/material and the transcendental/spiritual in a different way. Like Warhol and other postmodern artists, she has resisted purifying the rational matrix of lines in order to achieve a perfect abstract spirituality; instead, she has filled it—almost to the breaking point—with allusions to the domestic everyday world and to an intense and palpable presence of the body. What was stiff and otherworldly has become flowing and intimate. The dynamic she dramatises recalls Klaus Theweleit's description, in his study *Male Fantasies*, of Fascist soldiers' fear of femininity and desire:

> I [have] described the way in which soldier males freeze up, become icicles in the face of erotic femininity. We saw that it isn't enough simply to view this as a defence against the threat of castration; by reacting in that way, in fact, the man holds himself together as an entity, a body with fixed boundaries. Contact with erotic women would make him cease to exist in that form. Now, when we ask how that man keeps the threat of the Red flood of revolution away from his body, we find the same movement of stiffening, of closing himself off to form a 'discrete entity'. He defends himself with a kind of sustained erection of his whole body, of whole cities, of whole troop units.[12]

Mary Heilmann fills the 'sustained erection' of the modernist grid with an imagery of flowing fluids, flesh and allusions to gaily coloured fabrics, dresses, or fans.

NOTES

1. Alfred Corn, 'Synecdoche', in *A Call in the Midst of the Crowd*, Penguin Books (New York), 1978, pp. 9–10.
2. In conversation with the author, Mary Heilmann made allusions to the pink and black of New Wave fashion, as well as to the various associations of the serape paintings, including their resonance with Malcolm Lowry's *Under the Volcano* (1947).
3. Mary Heilmann, interviewed by Lilly Wei, 'Talking Abstract', *Art in America*, July 1987, p. 88.

4. Frederic Jameson, 'Postmodernism and Consumer Culture', in Hal Foster (ed),*The Anti-Aesthetic: Essays on Postmodern Culture*, Washington Bay Press (Port Townsend), 1983, p. 114.

5. Ibid, pp. 116, 117.

6. Rosalind E Krauss, 'Grids' (1978), in *The Originality of the Avant-Garde and Other Modernist Myths*, MIT Press (Cambridge MA/London), 1985, p. 12.

7. Michel Foucault, *The Order of Things: An Archaeology of the Human Sciences*, Vintage Books (New York), 1973, p. 320.

8. In discussion with the author, Heilmann evaluated various post-war incarnations of the grid as inspiration for, or counterpoints of, her own work. She particularly mentioned Andy Warhol's capacity to fill the grid with powerful emotions. The linking of Warhol's grid to hers is indebted to this conversation with the artist.

9. Thomas Crow, 'Saturday Disasters: Trace and Reference in Early Warhol', *Art in America*, May 1987, p. 135.

10. In 'Grids', Krauss uses the example of Mondrian to develop an opposition between centrifugal, or outward-directed, abstraction and the inner-directed centripetal. She notes that, like many abstract artists, he used both strategies.

11. Piet Mondrian, 'The New Plastic in Painting' (1917), in Harry Holtzman and Martin S James (ed and trans), *The New Art—The New Life: The Collected Writings of Piet Mondrian*, GK Hall (Boston), 1986, pp. 36, 38, 59, 64.

12. Klaus Theweleit, *Male Fantasies*, vol 1, *Women, Floods, Bodies, History*, trans Stephen Conway in collaboration with Erica Carter and Chris Turner, University of Minnesota Press (Minneapolis), 1987, p. 244.

Mary Heilmann in Conversation with David Ryan (1996)

David Ryan: Do you feel uncomfortable with the term 'abstraction' in connection with your work? Many painters today, I think, feel the term limiting and unhelpful in many ways, maybe because it seemingly contradicts possibilities for representation in the fullest sense of that word.

Mary Heilmann: Well … I don't feel so uncomfortable with 'abstraction'. It's just that we have to do a lot more talking around it in order to properly define what we do.

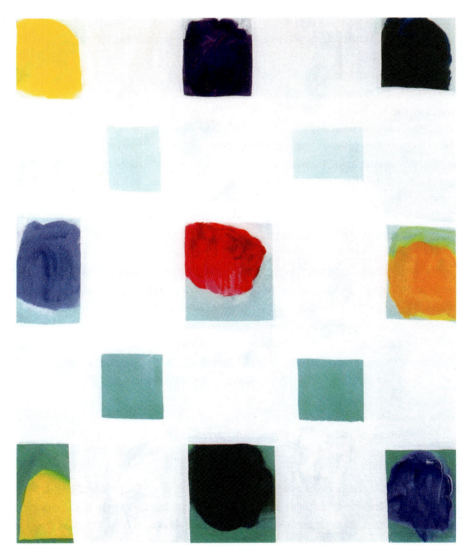

Figure 18 Mary Heilmann, *Lucy* 1997, Oil on canvas, 102 ×81 cm, Courtesy, American Fine Arts Co., New York.

DR: In the past, you've suggested the term 'geometric' as a clearer way of describing your activity ... as being more specific to the work.

MH: Right. Although I think we use these words as conveniences, they do serve a purpose. Usually, you know, when somebody like the guy in the gas station, or my brother, asks me about what I do, I say, 'I do oil paintings that are abstract, and that means that it is not really a picture *of* anything specifically in an outwardly obvious way, but sometimes when you look at it, references to the everyday reveal themselves and with more looking, they get stronger'. I think people get that, you know. I think we do know the difference between, say, a realistic painting and one that is 'abstract'; so, for that reason it's still a useful word, at least for a marker.

DR: You once mentioned that when you started painting, you treated each painting as an 'object'.

MH: That's right. Because when I was at school, I studied sculpture and when I first came to New York, I started doing sculpture and nobody really seemed engaged with painting. I was involved with people who were initiating early performance art, music, and also sculptors. To try to find my own voice, to do something original, at least in my immediate environment, I turned to doing painting in order to separate myself off from the others, but I still saw myself within that continuum of sculpture.

DR: Was the notion of process prevalent at that time?

MH: Sure. In sculpture certainly ... more than painting. Although people like Ryman were working of course, and Ryman was really about deconstructing the materials of picture making. And I was, too, though not really deconstructing, in my case because I didn't come from a painting background. I was constructing the materials of painting from naiveté. As an undergraduate, I was a literature major, and as a graduate student I was a sculptor, so I had to find a way into painting from scratch in many ways.

DR: You also maintained a physical connection, in a sculptural sense, with the primacy of materials—many of the earlier paintings are made directly with the hand.

MH: That's right, like finger painting—almost like a child's painting in fact. Also, I worked with the stretcher frame and made paintings where the image was at the back of the canvas, the cross of the stretcher bars. And I made pieces where I would peel acrylic paint off a glassy surface, or maybe an oil surface and then re-apply it to the canvas. It was really like doing sculpture with the materials of painting.

DR: Going back to this notion of the object: was it the idea of making an autonomous work or was it more a notion whereby this object/painting might also connect with, say, other objects in the real world?

MH: Certainly now, I'm interested in a situation whereby a painting will connect with the architecture of the room, and also the objects that a person might come across in the space of that room; it becomes a kind of 'conversation' between these elements. I might add that this takes on a domestic feel: it's about the kind of objects one might have in the home, and this feeds into the ceramic work I've been doing recently. Also, I have a new house in the country and I'm beginning to work out there. In fact the whole home will eventually become the studio, so the work will really end up 'speaking' to the home as part of the practice. I feel quite comfortable with this, as it brings together long-standing interests. There is so much happening with this now as well; Jorge Pardo is doing a house project in Los Angeles. He's building the house that will contain his decor-inflected pieces, and Richard Prince, he did a house piece a couple of years ago. But, going back to your question, I'm trying to think about whether earlier on this was such a concern. I think it's really the last five years or so that it's become so important. Having said that, the earlier shaped canvases were also about similar concerns to an extent—that's what really showed me that the drawing of the edge of the canvas, which uses the wall as part of the subject, can in fact embrace a larger conception of the work's 'world'.

DR: Thinking about your hands-on approach to form, de Kooning once made a marvellous analogy between painting and the construction of a clay sphere, made without rulers or callipers or such instruments—so it's done completely by eye—the creation of a perfect sphere. So long as you avoided the measuring instruments, who's to say it's a perfect sphere? One day it looks right, the next a little flat on one side, the day after, someone comes round and says 'it's a little lumpy over here' and so on. This delicate balance of addition and subtraction, together with the idea that you never know for sure that it's 'right', fascinated de Kooning. Such an image for me also conjures up the very plastic approach to geometry that your work possesses.

MH: Yeah? Great! Well, in a sense that whole approach to intuitive balance is important. In designing the composition of my paintings, I effect a process of cutting up the rectangle in several different ways at once: firstly, by means of grid structures with their almost anti-compositional overtones, and also in the more fractured sense that we've just been talking about. So on one level, I've managed to avoid the problem of composition, but when we think, say, of these diptychs and multi-panelled pieces in relation to the articulation of the whole space, then a kind of composition re-emerges in a different way, and one can think of Japanese flower arranging—which is both disciplined and intuitive—in relation to all this. What has also been very significant is

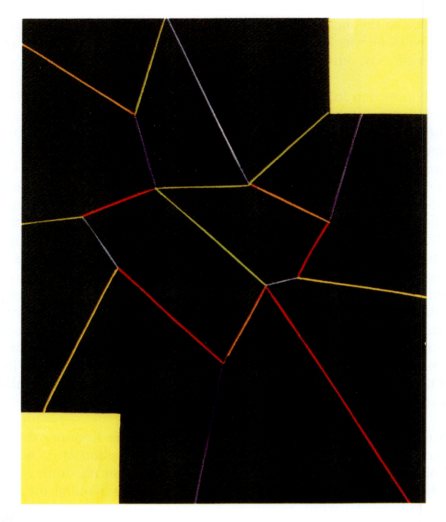

Figure 19 Mary Heilmann, *Au Go Go, The Painting* 1997, Oil on canvas, 127 ×102 cm,
Courtesy American Fine Arts Co., New York.

doing shows with other people, where different artists' works speak to each
other. That's become a very exciting part of the practice.

DR: Has all this made you reflect more specifically on the active participation
of the viewer?

MH: Completely—as equal in importance to the discrete objects themselves.
When you get those kinds of group shows where pictures are just put on the
wall one after the other, and the sculpture is stuck on the floor—I just hate
those. Similarly, I've often gone into collectors' houses and they'll have
everything on show in their house, filling every inch of the space, and I

always thought it looked so awful—very hard to see the work. I could never figure out the logic of this; it seemed so arbitrary. But for me, that's why this sense of 'arranging' is so crucial and also intuitive: very subjective kinds of criticism are brought into play here. You'll say, 'this works and that doesn't', etc. In fact, making installations is very close to doing decor—all that 'bad' stuff that was not considered as serious.

DR: How do you think about scale in relation to these ideas around installation?

MH: Of course, scale is affected by the room that the work is made in, and then the exhibits are designed in accordance with the room where they're going. So if I'm going to have a show somewhere, I'll familiarise myself with that space and reflect on the relationship to the scale of the work in the studio.

DR: Going back to the notion of composition, or placing, you once said that you liked playing with form 'like a kid playing with building blocks'.[1] Is that interest in very basic formal manoeuvres still relevant?

MH: Well, this is even important for those installational concerns I was just mentioning, that sense of arranging: it must never look fussed over or too obvious, so in that sense you could say that if it didn't really look like a kid stacking blocks, then it's wrong. Of course, really, it's much more complex than that and there's more behind it, but there's a lot to be said for that simplicity, and as you can see, my approach to form is still pretty basic. Actually, line has become more important to me in some of these paintings— and a freehand line rather than masked. Over in that painting [pointing to a work] you can see a kind of 'baroque' motif sneaking in; I like that sense of line, and how it travels across the surface.

DR: A sense of time seems very important for your paintings and I wondered whether you consciously set this up and if so, how?

MH: You mean a kind of compressed time and memory?

DR: Yes. It's a complex issue, I know, and there are many ways of looking at this, but thinking about the object/painting in relation to these ideas throws up certain contrasting approaches: the object might be a catalyst, a springboard for a flow of memories—we can think of Proust's madeleine as such an object—or the reverse: the memory in search of an object that might act as a container for such memories, which holds them in such a way that they are translated into a concrete experience for someone else. Is that compatible with your approach?

MH: Yeah, I like that. They are certainly about memory, and they also have these titles that help to cue the memory, in which the viewer is invited to reflect on the relationship between this verbal framing and the visual experience of the work. In this way it's a kind of translation with this inter-personal thing going on. I like to think of painting as 'imploded', whereby this chunk of matter can contain many different layers, a kind of compression of experience. The painting behind you is called *Like Sleep* and knowing this you probably experience the painting differently. Actually, I've started putting their titles on the side of them, so they're literally inscribed physically, and I guess it's only one step to writing the title on the surface, and I've considered this.

DR: Wasn't it Robert Motherwell who felt he 'painted with titles', considering the verbal element as being as intrinsic a part of the painting materials as pigment or canvas?

MH: Actually, he's not one of my favourites, probably because of the verbal thing coming before the fact. I feel that the memory, or the imaging of the memory, is not so deep with Motherwell as it is with some people. But he wrote on them sometimes, didn't he? All those *Je t'aime* paintings ... That's something good though: I'm probably going to start doing that ... if I can get away with it without being too hokey! [laughs]

DR: You've often spoken of a relationship between your work and other media: film, television. Is this still a positive relationship for you?

MH: Sure. That's the great thing about painting. It's funny, though, I'm not so interested in the movies at present. Now, my obsession is with music. I teach also, and I like to talk about non-objective or abstract painting using the analogy of song, because songs often tell incredibly complex and sometimes long stories utilising very few words. The music, as the aural imagery, is a big part of this, setting the scene and structuring the narrative. On another level, there is a dialogue going back and forth between the visual arts and music very much right now, with people trying to figure out how to make good music videos, and the visuals are part of the whole package. Also guys like David Bowie and Brian Eno both do artwork, and many current bands went to art school. People like David Byrne studied art originally too. Currently, I'm particularly interested in 'world music' and how this has affected rock and pop recently.

DR: What interests you about world music?

MH: I like the fact that it's colonialism going backwards. I mean, geographically there's so much more interplay, and with the social

complexity of the metropolitan centres, there's a process of the colonised colonising the colonisers, to the point where the so-called first-world culture is no longer owned or dominated by a white middle class, and that's very exciting. In our country, this has resulted in an empowering of what was an underclass. You only have to see how white youths are partaking in, and imitating codes that are laid down for them and are culturally hybrid, so to speak. And the other thing is that through music, art and culture in general, it's all being envisioned in clothes, style and colour, etc. So world music celebrates, for me, this increasingly complex situation, reflecting a more nomadic cultural orientation.

DR: I'd like to go back to your point about using song structure as an analogy for painting. How does this relate to your own work?

MH: I think about a painting being like a song, in that a painting will have different elements to it that add up to something like a story, or at least a narrational structure. One of the elements would be the title, which is the verbal aspect that can 'frame' the other elements. These might include a sense of light, particular culturally encoded colour combinations and actual physical layers and shapes, which you could also pick apart, rather like a puzzle.

DR: So this is a 'narrative' level—the process, how it is made, this tells its own story?

MH: Sure. What you did first, second etc, and so, if a critic or student or art-lover or whoever, would simply look and reflect on the experience of the painting, perhaps even simply describing this experience, saying what's there, they would, ultimately, come up with the meaning of the piece. For them, that is; this is of course relative. But such a process is not so different from taking apart a poem, or analysing a poem, and arriving at a sense of meaning.

DR: Towards the end of the text that accompanied your 'Greatest Hits' show at the Pat Hearn Gallery a few years ago, the inference was that you were concerned with particular formal outlooks and re-examining them from a more gender-specific perspective. We could think, for example, of Donald Judd's work and the kinds of discourse that attached itself to it—notions of universality, distance, etc, together with his own terminology for the work: the 'pure power' or 'pure presence' of the object. Such terminology would be unacceptable in some ways today, and many artists involved with a formalist approach might stress a more reflective, subjective, resonant mode. We might perhaps invoke Shirley Kaneda's term, 'the feminisation of formalism'. Are you sympathetic to such a reading of your own work in this light, do you subscribe to a gender-specific position?

MH: Yeah, well ... it's something that's fun to talk around, because you could go to a Judd piece now, and analyse the experience of that work, take it apart, and describe it as being a very reflective and feminine, intuitive and engaged work, not monolithic, solid, powerful, self-contained at all. It's funny, because Judd's work is very domestic: he made furniture, he made his whole home/work base an encampment in Texas and took great pleasure and care in viewing the works in relation to each other and the architectural environment, with a very postmodern kind of attitude, which he would have ultimately denied, I think; but it was there. It wasn't in his personality, certainly not. But then the whole thing is complex, which is why I see this 'gender' discussion as interesting only for conversational purposes. To go back to Judd and say it's 'feminine': it isn't really, literally, it's just from the perspective of a new point of view. You could equally powerfully and deeply speak of it in his terms. Both positions are 'true', so to speak.

DR: In one sense, we're also talking about how an artist might relate to certain traditions within the genre of abstraction, and how these might be re-figured. Much has been written about the seemingly endless repetition of the 'emblems' of abstraction—the tradition of monochrome painting, the grid, etc, and more recently, appropriational strategies as a re-figuring of the past. How do you view your own positioning within the continuum of tradition?

MH: Well, I think my work does speak to the history of art, and more specifically, to the history of modern art. There are elements of appropriation: maybe the titles or colour, references to other paintings etc, but these are not used as 'strategy', but rather as part of the whole process. I like to think that each piece has my own work inside of it but also my experience of the whole of art history. In this way, I think time is relevant again, a kind of compressed time. As I said earlier, all this experience can be sucked into one chunk of matter. Painting can offer this, and it's a new way of taking apart time, of thinking about time.

DR: What is your relationship to theory?

MH: I think theory—or rather the writings of the great thinkers who have provocatively attempted to describe the nature of our reality—I think we can use these ideas in our lives, not just our art. It can become part of it, like, say, music does. Sometimes, I find I recognise my own thoughts in these ideas, after the fact. For example, when I was writing on film and sentimentality, I didn't know Frederic Jameson's marvellous essay on the same subject, where he says sentimentality can be a route to true sentiment. I'd said much the same thing in my own way. I often read things after I've thought about issues that I recognise as part of my own thought processes, or

through the general 'buzz'. In this way, I see theory simply as part of popular culture—ironically, I guess.

DR: Finally, what is your perception of contemporary painting?

MH: Well ... when I switched over from sculpture to painting, I really did believe that painting was dead, that it was finished, in some ways that enabled me to do what I did. That would be around 1969. Thinking back to my student days, none of the interesting people did painting; they were involved with performance art, 'happenings' or Conceptual art. But what happened was that this process of 'destroying' painting, of taking it apart, really re-energised it, and has 'eaten' all of that material and used it to make new work, which is often unashamedly visually gorgeous, and manages to do something powerful and moving with something that can hang on a wall. And it can be very popular: the imagery, the touch, the colour, it can reflect popular taste, fashion, etc, so it's not dead at all. Now many interesting students are doing painting.

DR: It's interesting that you say when you started painting, you were also convinced it was dead. Was this a kind of playing around with the remnants of a dead language?

MH: Yes. And I felt it was a very perverse thing to turn to, for me, at that time. It was really denigrated by the people that I associated with, like Carl Andre and Robert Smithson. Smithson ... I remember having provocative discussions with him about certain painters just to see what he'd say. I remember us having a conversation about David Hockney, and he said, 'I can't believe I'm even talking about David Hockney'. [laughs]

DR: And Andre?

MH: Yeah ... I can't remember anything specific ... He was just generally contentious. [laughs] The other person, though, who I had conversations with, was Joseph Kosuth, who of course was really *anti*. I would try and provoke him, playfully. I used to suggest he take up painting in his spare time, and for a long time after, we didn't speak. [laughs].

NOTES

1. See Lilly Wei, 'Talking Abstract', *Art in America*, no 88, July 1987.

THE RELATION OF INTERRUPTION: RECENT WORK OF SHIRLEY KANEDA (1998)
Andrew Benjamin

What does abstraction figure? With this question, both the content and the address of abstraction are staged. Content has to be understood as the deployed presence of paint; deployed in a particular form or series of forms rather than another. The address of abstraction is the reference that any work is going to have to the already present history of abstraction. The latter is neither monolithic nor does it admit of an essential determination. The address of abstraction is the staging of a relation to history that works as an immaterial presence within the materiality of the work's work. Materiality is not just the content. Materiality is painting—materiality as painting refers to the way in which the matter of painting works the relationship between content and address within the frame.

Figure 20 Shirley Kaneda, *Dual Singularities* 1998, Oil, acrylic on canvas, 206 ×157 cm, Courtesy Feigen Contemporary, New York. Photo: John Berens.

Responding to the opening question has to involve two determinations that are necessarily interrelated. As a beginning, this necessity has to be retained. The two determinations are generality and particularity. Generality is the address. Particularity is the content. Nonetheless, the particular is neither an example nor an instance of the general. While setting this position in place demands a more complex argument than can be offered here, it remains that were they to be either examples or instances then such a conception of the particular, or of the instance, would depend upon the possibility of attributing an essential quality to abstraction such that that quality—identified and thus stated—could then be instanced in the work. In the place of this possibility—and thus recognising that what is at work here is a philosophical conception of the artwork, which, while operating in terms of the reception of the generic refuses to attribute to the generic an essence—a different relationship between work and genre has to be found. Allowing for a response to this problem does not merely involve the relationship between content and address, it necessitates a formulation of that relation eschewing generic determination enacted on the level of content and thus resisting the operation of the essence on the level of address. It is this latter position that has to be developed.

Developing it demands a turn from the essence to the particular. It is, however, a turn that cannot be located within the determining confines of an either/or. The turn to the particular has to allow for materiality—the specific presence of the object—and the immaterial. Immateriality is neither a transcendental force nor does it have a directly transcendent quality. Immateriality is an ontological description of the interplay of history and genre. (Within philosophical writing on the artwork, history is the confined presence of that interrelationship.) There is a twofold complication that enters at this point.

The first is that this move from the either/or entails that the only possible object of study is the *object* and thus its particularity. The latter needs to be understood in terms of the object's presence and therefore in terms of how it works as an art object. Within the confines of this argument, materiality becomes indistinguishable from the work of the object as a work. The particular, nonetheless, stages, by virtue of its particularity, its own relations to the presence of the history of which it forms a part. That staging is the ineliminable copresence of the material and the immaterial that occasions the work.

The second complicating factor is that it is the relationship between the material and the immaterial that defines the site of judgement. What complicates this set-up is that while interpretation has to allow for invention, it is also the case that interpretation is constrained to respond to the demand of the work. The site of that demand is provided by that which occasions the work and thus that which allows judgement to take place. Judgement, while always particular—insofar as it has to address the work's particularity—

concerns the relationship between the content and the address. And yet, however, even though that relationship delimits the site of judgement, what has to be incorporated is that which makes judgement possible. That possibility has to be defined in terms of repetition. In other words, content will always have to be judged. What this means is that particularity only allows for judgement to the extent that it is understood as a particular repetition. The interpretive question therefore inevitably pertains to the nature of the repetition. Not only does this reinforce the ineliminability of having to operate on the level of particularity, it obviates, at the same time, any reduction of particularity to a particular moment within a supposedly more general catalogue of examples. The exemplar yields to particularity. Examples return however they are defined by the work's internality rather than being determined by that which is external to the work's own self-productive activity.

Here, the works in question—recent paintings by Shirley Kaneda—are demanding. They operate in terms of a specific staging of the relationship between figure and ground. Their demand sets the scene for interpretation. Rather than taking the conditions of interpretation to the work, the work itself must be viewed as staging the condition for interpretation. In operating in terms of the insistence of the object and thus with the materiality of the work, interpretation cannot escape the necessity of description. Here, it is vital to note that the insistence is on description and not on illustration or exemplification.

The convention of the figure-ground relation works to provide a particular setting for interpretation. Within the conventions of painting that deploy both landscape and figure, the convention of figure-ground allows for an interpretation dictated by the identification of icons, symbols and other modalities of representation. The figure can be read in its relation to the setting—the ground—in which it is given. The figure-ground allows for a propriety both temporal and interpretive to be given to the figure. The setting carries the figure into the interpretive domain. Abstraction already begins to work against that which is demanded by the retained primacy of the figure-ground relation. Indeed, this distancing is not unique to abstraction since it is also present in Cézanne's later landscapes. Within them the application of paint and the continual sectioning and ordering of the frame's work—again the reference is to materiality construed as the work's activity—occurs such that they continually disrupt the drawing of any easy distinction to be established between figure and ground. The constant return to Mont Sainte-Victoire provides the location in which this disturbance could be traced. With the majority of these works, paint continually constructs figure-ground relations. With these paintings, relation rather than being taken literally, emerges as the interpretive problem.

It should not be thought that abstraction involves the necessary overcoming of the figure-ground relation. In fact the retention of that relation

within certain strains of abstraction provides, a way of escaping the strict hold of figure, not by resisting it, but by giving it an abstract quality. It is in this sense therefore that it becomes possible to present the figure within abstraction. And, in this context, abstraction means the presentation of figure outside any automatic identification with a pre-existent form. Figure exists as an abstraction. What is retained is the place of figure even if that figure is an abstraction of an identifiable form. Maintaining the structuring force of the figure-ground relation is to hold the space of representation in place. As such, abstraction comes to be defined by the negation of figure. The reiteration of the place of representation, and thus the definition by negation, opens up the possibility of a conception of abstraction that is not structured by the figure-ground relation and thus would involve a different reiteration within the address of abstraction.

It is in these precise terms that it becomes possible to situate the demands of Kaneda's recent work. Four paintings from 1998 set the scene in which the consequences of this demand can be worked out; two will be considered here: *Uncertain Doubts* and *Repressed Resilience*. While these works differ, they share along with other recent works such as *Dual Singularities* and *Disloyal Devotion*, an important affinity. Identifying that affinity is not to argue that each work has a similarity of intent defined in relation to a single project. Rather, the affinity has another source. In this context, the possibility of recognising any affinity is defined by the way in which each particular frame works. Once it can be argued that the space of representation no longer delimits—positively or negatively—the work's work, then, at that point, it becomes necessary to redescribe the activity being framed. The difficulty in finding the requisite concepts and categories within which to provide the definition defines, in the first instance, the nature of the demand presented by these works.

The force of the figure-ground relation is that it delimited the work's internal space in terms of a grid; not a grid understood as formal presentation of the work, but a grid that would allow the detail of the space of representation to be presented, since the grid allowed for an elongation in which depth would have been occasioned by a repositioning of the grid's lines in order to introduce the spacing necessary for representation. In the case of abstraction, depth need not have necessitated the introduction of the lengthening process necessary for perspective; nonetheless, the presence of figure-ground relation brings with it a depth that can be mapped. Here, in Kaneda's work, the affinity between the paintings is provided by the eschewing of both depth and surface. In the place of the grid demanding the abeyance of the figure-ground relation, it is the centrality of a relation that can be provisionally described as one that holds between figures. Such a description needs clarification. What necessitates clarification is the way in which the 'between' functions. What happens to the nature of figure once it is freed from having been inscribed within the relation figure-ground? Rather than there

being any straightforward resolution to the question in painting—connection arising as a problem once the narrative power of the figurative is absent—both relation and connectivity remain, though now as sites of investigation.

A question arises at this point: what does it mean for a painting to be a site of investigation? Perhaps this could be redescribed such that what is being examined is the capacity of art to examine and therefore to sustain a question. Any attempt to answer these problems has to begin with the recognition that neither examining, investigating nor holding to a conception of work as given by the question, pertain to painting having either a didactic or heuristic force. And yet to argue that examination and investigation are no more than painting's self-evaluation or self-justification is to overlook that what is being staged by that conception of work does not seek to give abstraction's address an essential quality. Self-evaluation or self-justification if taken as the literal enactment of a singular project would ground art's work—the productive and thus workful quality of art—within terms set by a repetition of the same. With Kaneda's work, what is being staged is not this form of repetition. Within her paintings, something else and thus something more singular is at work. The site of that work is this dissociation from the figure-ground relation enacted via the work's project of working with relation and connection.

Investigation and examination operate without that pre-given delimitation that would have been provided by securing the figure in relation to the ground and thus also in its differentiation from the ground (clearly the definition of one in relation to the other must also work reciprocally). Given the impossibility, therefore, of recourse either to depth or to the retention of a conception of surface as generated by the opposition to a depth—no matter how minor the presence of that depth may be—the question of connection and relation come to be posed. However, their being posed now takes place within the abeyance of that conception of universality and of singularity that accounts for any particularity by construing it as always already in relation to the universal. Here, what is at work is the insistence of the particular. This insistence marks the presence of the work. Moreover, in just the same way, the possibility of figure-figure relations demands a reworking of figure, rather than its mere acceptance as the other to 'ground'. Particular, once distanced from its place with the particular/universal relation, demands a reconsideration of particularity. This is, in part, the project of Kaneda's recent work. There is therefore a type of self-inscription in which her paintings stage the possibility of the particular—now understood as the singular—by investigating and thus enacting their own singularity.

In *Uncertain Doubts*, lines and sections overlap. The chess board, the over-layering of brush strokes reinforcing the activity of work and thus of the work as an activity, are not integrated into the frame such that they are then taken to appear in it. Appearing demands its ground and in so doing turns the appearance into a figure. (Here, figure would depend upon its being

Figure 21 Shirley Kaneda, *Uncertain Doubts* 1998, Oil, acrylic on linen, Courtesy Feigen, Contemporary, New York. Photo: John Berens.

positioned and held in place by the retained centrality of the ground.) In this instance, the differing elements that appear are the work. The question of their relation is once more the issue. Again, the presence of differing elements—differing yet all painted—still precludes the simple description of an elemental juxtaposition. In the place of mere relation and therefore mere connection, the paintings work and continue to work via an exploration of relation by making the actual connections—the moments when the elements

either interact or overlap—productive by their allowing for what was noted above as exploration and investigation. What this means is that Kaneda's work utilises points of disassociation and differentiation. Rather than being posited, they have the capacity to inform.

The utility of the interplay of differentiation and forms of connection has to be thought of in terms of interruption. Interruption is linked to the location of identity within the frame and thus of the transformation of the figure in the move from the figure-ground relation towards a relation of figures. In *Uncertain Doubts*, one of the ways in which the identity of the differing elements whose work comprises the work occurs is via interruption. The interruption works to construct the particular. And yet, while interruption figures, it is not absolute. When it occurs, what is retained— retained precisely because it is posed by the work's operation and thus by the literal application of paint—is the question of the relation established by the interruption. It is thus that interruption differs from simple juxtaposition. The move away from what could be described as the simple countering of one element with or by another is reworked a number of times. Before moving to the overlapping already mentioned, it is important to stay with the distinction between juxtaposition and interruption.

In the middle of *Uncertain Doubts*, above the band of white, is itself a complex interruption, because of its demand that time figure here, since it is neither straightforwardly addition nor subtraction—there are two series of lines. The first has been interrupted by this dramatisation of painting's time. The lines are themselves interrupted—or they interrupt—another set of lines. Moving from one stage to the next is to move between elements constituted by interruption. And yet, precisely because this is not a simple activity, the question of relation insists. Further evidence of the intricacy of this situation stems from the problem of distinguishing between the singular and the plural. While there are lines—hence the plural—the interruption constitutes each set as a group and thus as having a certain singularity. Once again, there is an irreducible complexity, because of the necessity of having to maintain the presence—the anoriginal presence—of both the singular and the plural. The complexity of this set-up reinforces both, the impossibility of simple differentiation thereby maintaining the primordiality of relation.

The demand posed by the work of relation is clear from the different sets of lines in the top-middle of the work. The difference between them brings definition, colour and symmetry into consideration. It would be in terms of these differences that a beginning could be made in explaining the internal make up of the areas delimited by interruption. However, the line that interrupts—and in interrupting becomes constitutive of particularity—is not itself present. There is not a line as such. A border is present. And yet rather than being a line with depth and thus with its own specificity, it is simply an interruption. Despite the force of this interruption, the question of the relation between the lines and thus between the delimited areas cannot

be precluded. The lines are viewed, and thus the delimited areas are viewed, one in relation to the other—note again the need to maintain the copresence of the plural and the singular—in terms of a discontinuous continuity. And yet, if that were all that was the case—ie, if all that was being staged were that relation—then the painting would be didactic. The power of the work resides in its using those points of interruption and thus discontinuous relation as themselves being productive. They are sites of exploration. In the above case, it has to do with the investigation of a line that has no depth and yet which works to interrupt.

At other moments in the painting, relations are investigated. The refusal of literal juxtaposition is the refusal of both collage and the simple addition of bands of colour; one played out next to the other. Neither collage nor stripes, and yet the negative definition is pointless. The force of the position emerges in the presence of 'stripes' and the presence of different elements, precisely because their presence is not a simple one, and the way in which they are present demands that the question of the relation between the different components be posed. Indeed, it could be argued that it is in terms of that relation—the relation demanded by interruption—that the work insists on being understood.

In another recent work, *Repressed Resilience*, the problem of relation and thus the distancing of juxtaposition are staged with similar precision. This work introduces an important addition. Rather than relation and thus the use of interconnection as productive only occurring within one frame, there are two frames. Nonetheless, it is not as though a frame has been added. Nor is it that the work comprises, in any unproblematic sense, a diptych. To begin with, this work is both frames. From the start, therefore, the question of relation is at work. Moreover, disruption or interruption are literally present insofar as the works, while hanging close to each other, either do not touch, or need not touch. They are separate. And yet that separation, the moment it is announced, is, as a defining and permanent characteristic, also effaced. The work is both and both occur at the same time. It is this moment—the self-identical moment—which, in holding the work in place, in allowing the display of the constitutive element to insist at one time, ruins its own self-identity by being that which occasions a complex and irreducible event demanding a temporality of complexity. What enables this to happen is that the frames repeat content. This occurs within different strategies of painting. Examples are necessary: the repeated presence of the reddish tracings of painting's work is neither an addition nor a subtraction, blocks whose designs may differ from one frame to the other, but eschew and nonetheless pose the same problem of relation and thereby recall the transformation of figure once it moves from its position within the figure-ground relation.

Each of these examples is the presentation of this painting's own engagement with the question of singularity. It is an engagement articulated in terms of a sustained preoccupation with interruption and connection and

thus the relation between figures. Furthermore, these examples, precisely because they are not exemplary of anything other than the work's work, become the presentation of content. However, that content, once again, in this context, the presentation of the singular articulated in terms of an investigation of relation and interruption, is at the same time that which begins to allow for an analysis of the relationship between the work's work and the address of abstraction. The latter cannot be reduced to material presence but is always that which is addressed by the work in order that the work maintain—or attempt to maintain—its own singular status. It is for this reason that it constitutes the site of judgement.

Part of painting's work can become an engagement with that which makes a specific painting singular. The affinity that marks out Shirley Kaneda's recent works is that they demonstrate the capacity of painting to pursue the question of painting's singularity. Judgement may decree that despite the attempt to sustain singularity, works may simply fail to realise that end. Kaneda's work, here via its continual use of interruption and relation, of holding both in play at once, sustaining both by a specific use of painting and internal design, investigates the conditions of the singular in painting by presenting work that maintains singularity. Her work therefore affirms the possibility of painting to work as painting on the condition that as work it presents itself in terms of its own particularity.

Shirley Kaneda in Conversation with David Ryan (1996)

David Ryan: You were invited by Valerie Jaudon to participate in the show 'Conceptual Abstraction' at Sidney Janis (New York) in 1991. Did you feel that this term provides any useful inroads into the position of the work included in that show, which has often been grouped together under various terms, such as 'New Abstraction', etc? And do you think it is appropriate to your own activity?

Shirley Kaneda: Well, the title was not really accurate in terms of the abstract painters brought together in that show, with the exception of David Diao, whose work is conceptual and abstract, and painting at the same time. Everyone else wouldn't fit so easily into that category. Of course, one can propose that abstract painting can be associated with a conceptual framework, and obviously that was the idea behind the show. But the term 'Conceptual Abstraction' is not only inaccurate; I would say it doesn't really serve abstract painting in the end, and I think it would be misleading to view my paintings in this light. There are, however, new sensibilities that

Figure 22 Shirley Kaneda, *Repressed Resilience* 1998, Oil, acylic on linen, 295 ×157 cm, Courtesy Feigen Contemporary, New York. Photo: John Berens.

signalled a renewal of the practice of abstract painting, which was what the show had intended to reveal.

DR: How important was appropriational abstraction in the 1980s for you?

SK: For me, it wasn't important. Some people may have thought that my work had some appropriational approaches, but that's more a by-product of the processes that I've implemented. If it looked appropriational, this was not intentional. Speaking for myself, I feel that appropriation is not an interesting proposition.

DR: Your earlier paintings often made use of bi-partite structures, divided between left and right, which invited a comparative mode of looking—we might get a relationship between forms that suggests a particular reading of fluidity on one side, and solidity on the other. Does this articulation of 'difference' go beyond the formal?

SK: Oh, absolutely. It's a method to invoke those ideas that deal with inconsistencies and paradoxes. I want the paintings to enable a reflection of such ideas as the desirability for consistency, obviously not literally, but provoked through the visual play within the painting, so that they go beyond the given visual information and operate on the level of the metaphorical.

DR: Where did the forms originate from in the earlier work; what are the sources?

SK: Actually, not from anything. One can name certain elements like circles, lines and so on, but the more 'organic' shapes are from wanting a non-standard geometry, so that they're stretched from the basic ovals, circles, etc. And they get more complicated, resulting in the shapes becoming more difficult to identify.

DR: So they're like hybrid geometries. It's also the irony of something becoming 'quasi' organic from basic geometrical procedures.

SK: They also take on the form of something seemingly specific. Someone once related them to emblems or insignias—my earlier work was often related to heraldic design ... which I don't mind ... but again, this was a by-product, not an intent.

DR: This is interesting at the level of almost a game-playing with recognition. With heraldic design, recognition might even be a matter of life and death in the context of battle or war. But on another level, you've intimated an indeterminacy built into these forms and an acceptance of various interpretations: is this a correct assumption?

SK: Definitely. It opens up the space of a painting for me in order to produce a more reflexive work. I had to bring into play more complex shapes. And not only were they complex in themselves, but also in terms of the relationships of those shapes together with texture, pattern and so on. It was an examination of what a particular painting could hold in terms of difference and complexity.

DR: The recent work seems to explore a more disruptive overall fragmentation, rather than the bi-partite differentiation, and it results in a kind of spatial disorientation, whereby one opening of form seems to fold onto another. Andrew Benjamin suggested a possible reading of the new work as a loss or lack of 'ground'—I'm understanding him both literally and philosophically here—that your work, 'eschews any necessity of retaining a determining ground'.[1]

SK: Yes, I think that's accurate because they're made up of parts, and they are, by and large, disparate elements. And yet they have to co-exist on the same picture plane, defying a figure-ground reading even though the figure-ground might initially seem to be the 'logic' of the painting. My intention is to deny that rationality within the work. In a way it's all 'groundless'—we're left simply with a bunch of elements of their material and visual relationships. It's these effects that supply the material for their interpretation. And those material relationships that exist in the real world but cannot be seen are replicated in my work in order to make them visible.

DR: I was thinking about this in relation to Adorno in the *Aesthetic Theory*, where he writes about montage, which he describes in terms of ruptures, allowing the life-world to invade or flood into the work of art in order, as he says, to 'Shock people into realising just how dubious any organic unity really was'. I'm interested in how you allow something of this sensation, while it tends to fold back onto the work itself: the rupture is a kind of reflexive one, so to speak. This might be linked to Adorno's dissatisfaction with the polarised extremes of montage and Constructivism, the latter of which he said 'rattled badly', because of its anti-subjective drive. Your work might be seen to engage with some of these problematics, and could in fact, be viewed with Adorno's ideal address to the work of art: 'Nothing in you, no part of you is unimportant'.[2] I just wondered about these relationships within your work: the opening out, folding back in, etc. Does Adorno's political reading of form have any resonance for you?

SK: Absolutely. The play of these different shapes or elements is one of complex interrelation. We may momentarily have the illusion of having grasped an element and its location, but this is soon 'broken', and ultimately it's impossible to locate them within a fixed area. And this kind of activity in

my work is close to Adorno's idea of a work of art, in that it's always destroying what is, or working towards freeing it, so it can reshape itself. Though the elements look to be montaged, nothing loses its identity to the whole in my work, in that unity is dependent on those parts, or as I think Adorno says, 'must include that which resisted integration'. This is a crucial aspect of my work, as the whole tends to produce a false universal, in which the parts are not given equal credit, but are only there to serve the construct of the whole. My paintings frame a moment in a continuum, in that all the elements in the painting can be imagined to continue outside the work. What interests me about this, is how such fragments can take on the appearance of self-enclosure in such moments. So it's not that I don't believe in the principle of unity, quite the contrary. I just don't believe in the pretence of a harmonious unity where the parts become sacrificed for the sake of it.

My problem then is, how can we have a whole that doesn't negate, and is faithful to those parts that make it whole, and which doesn't produce an illusion of unity but an actual one. I try to dispel the notion of hierarchy between the whole and the parts: they're equally important and one can't have one without the other.

I guess I have to agree with Adorno again in terms of form and content, and its relationship to politics. My work is certainly not political, but its content can be seen as a resistance to oppression and dominance; and so in that sense, it can be seen as being sympathetic to a political reading. I'm still idealistic in that I think of art or painting as a place to produce those values that can be useful for us. Of course, this is predicated on the fact that the work is not literary, so it's on a metaphorical level.

DR: Following on from the idea of fragmentation in relation to a ground, this obviously could be seen to connect with certain psychoanalytic notions. I'm thinking particularly of the kind of language Lacan sometimes used with reference to the unconscious, where he conjures up an image of total discontinuity as opposed to the 'mirage' of the unified one: 'The experience of the unconscious is the one of the split, of the stroke, of rupture ... Where is the background? Is it absent? No. Rupture, split, the stroke of the opening makes absence emerge—just as the cry does not stand out against a background of silence, but on the contrary makes the silence emerge as silence.'[3] I'm quoting out of context of course, but that would seem very relevant to your approach. It could also be a description of your recent work,[4] with its ... well, maybe it's too strong a word, but a kind of violence, in terms of cutting, splitting, opening?

SK: That's interesting. [laughs] Certainly the concept of the 'Real' in Lacan's terms is similar, in the way that the elements in my work just seem to exist alongside each other, because the work resists language and its interpretation. I know that there's an aggressive side to my work, but I think that, more than referring to the unconscious as you've suggested, the important issue for me is

'difference'. For example, there's an aggression and at the same time, something that is 'beautiful'. But these appear to be in conflict, because they're treated separately, and yet at the same time they require one another in order to identify themselves. I guess what I think about consciously in relation to my working process is how these identities interplay as a model of the Real, not the Symbolic. Without getting too psychoanalytical about it, what I want to imagine is a state that exists before we have the Symbolic.

DR: How do you see the function of these patternistic devices within painting?

SK: It's two-fold. Going back to the notion of politics, what induces me to structure clashing and differing patterns and processes, is so that they may partially reflect the present dialogue that has evolved around cultural ideals. I hope my work can reflect the fact that, within the social as a whole, the existing hierarchies are becoming more fluid. So where we used to think of social structures as singular, we now see them as being more pluralistic or, in a funny way, more democratic, because of their diversity. On the other hand, the notion of the decorative is such a loaded concept, which has been shunned by most painters, except for pattern and decoration painters of the 1970s and, more specifically, Philip Taafe. Painters are almost paranoid about their work being seen in some decorative manner. But I also think there's a difference between the decorative and decoration: the decorative is a quality and decoration is an embellishment. I think abstract painting has to deal with this—not to 'put it to rest' and leave the notion of the decorative behind, but so that it can become part of the vocabulary of abstract painting. I think it's one of the most relevant aspects of abstract painting. Most abstract painting of any significance being done at present incorporates this notion of the decorative— whether knowingly or not—Stella, Polke, Lasker and especially Richter. It's really something that we needn't deny: I'd like to emphasise it and make it part of painting. I think this opens up the supposedly closed system of abstract painting's subjects and aesthetics.

DR: How does this square with certain classic modernist views of the decorative? Greenberg, for example?

SK: I think he said, 'The decorative haunted modernism, like Communism haunted democracy'. Or something like that. The difference is that modernist painters associated the decorative with the idea of the backdrop—like wallpaper—because it haunts the 'field' of abstract painting. For me, and for other current abstract painters, painting is no longer a metaphor of the field.

DR: Several artists I've interviewed have spoken of the need to reconnect abstract painting with the everyday: David Reed or Mary Heilmann, for

example, particularly in their approach to colour. Is this an important issue for you too?

SK: I think some of us recognise that abstract painting isn't out there on its own, occupying a space that's always self-referential and self-perpetuating, and nothing else. One of the ways to reconnect abstract painting with the arena of the real, is to make direct reference to the world of everyday experience, maybe through an approach of structural relationships. Having said this, what also must be stressed here, is that abstract paintings are in themselves 'real': they don't refer to other things. Just because they don't have mimetic or referential quality doesn't mean they're any less relevant. So for me, I don't have any specific relationships that I'd like to emphasise—like fashion or what's happening on the street, or commodification. So abstract painting, while it can be absorbed into the life-world, can't be dissolved by its losing its identity.

DR: That's one of the quandaries of modernism, isn't it? That idea of resistance to being swallowed whole by a voracious consumer culture?

SK: But it participates in this consumer culture. One doesn't have to compromise or make works specifically for consumption. I think there's room to make challenging works that can have criticality, while being part of our culture, which is based on capital. Bruce Nauman is a good example of an artist like that. Another notion of resistance with abstract painting, is that it has its own identity, as with everything else, and it shouldn't be in competition with other media that are closer to the real world—like video and installation—just because they draw on, and engage directly in its representation.

DR: Does this also mean actively drawing on these media in some way? For example, the optical patterns in this painting [pointing to a work] might be seen in terms of a video or computer-screen image—a hint of a kind of virtual space?

SK: In my case, I'm engaged simply with the nature of processes.

DR: Does it bother you that I read it in this way?

SK: Not at all, but it's a by-product; it wasn't an intentional component. It can reflect technology, and I'm open to these references that seem to spin off my approach to painting's processes.

DR: Could you say something about these processes themselves?

SK: I approach these generically, so to speak. For example, many of the areas will be worked on the floor. I won't use a brush but manipulate the paint through lifting one side of the canvas and letting it flow—and so on. In other places, I use a palette knife in a particular way. Each of these approaches may be referencing different modes of painting. One can think of stripe painting or Abstract Expressionism, but obviously not exactly or directly; it's simply a loose reference to those means. I certainly feel that many processes or approaches within abstract painting's history were prematurely abandoned, or at least worked through very quickly, and then dropped. And for me, it's interesting to go back and find out what can be useful, and through this kind of historical awareness, use abstract painting to maintain itself as a discipline. By using these means again, it can construct new meanings and bring the new into some kind of relationship with its past and traditions, as opposed to this perpetual striving for the new and displacement. By constantly rearranging and redressing painting's means, the new gets elucidated.

DR: You mentioned this when we talked last evening: that any engagement with abstract painting is also an engagement with its history.

SK: I think it's impossible to deny or ignore painting's history, because painting is a closed system. In other words, we know the material and structural limitations, but this doesn't mean that it's incapable of discovering something that we haven't seen before, whether that's fulfilled by contextualising its history. This doesn't simply mean dressing up the old to look new, but how we see the past through the context of the present can open up something useful to us. There's no such thing as discovering something totally new from scratch. Even the old chicken-and-egg conundrum—the which came first—something was there to begin with. There is always in our culture a propensity for the new. While I have no problems with the new, I think that when there are so many interdisciplinary approaches, each discipline is basically in danger of losing itself. The problem is how we can maintain these different disciplines while allowing for an interdisciplinary approach. Otherwise, there's erosion with nothing left to fall back on. For this reason, I think abstract painting is in one of the better situations, not only to retain its grounding but at the same time, to acquire new ones.

DR: So your position would be one of accepting the new as having its own presence, as well as containing a whole shoring up of the past, and this can be used positively?

SK: I think so. In a way, I feel similarly towards philosophical and critical thought. You don't have Lacan without Freud, or Derrida without Kant. Of course it sounds dialectical, but isn't that how art came into being?

DR: How important are such theoretical concerns in direct relation to the practice of your paintings?

SK: I'm of the school that believes that it would be very difficult to divorce theory from the practice of abstract painting. And I know that it's not a popular idea in that this was, and still is, the criticism of abstract painting: that it relied so heavily on theory. Whenever there is any theory that is complex, there's a mistrust, or it's thought pretentious, because those associations are not fixed. I feel that abstract painting is on the one hand a physical and aesthetic act and on the other, a reflective one; and you can't really have one without the other. Otherwise it's really in danger of ending up as decoration. Even if it has a strong theoretical or intellectual content, this doesn't necessarily mean it has to be textual. For my part, I'm interested in getting the structure and material to operate on a metaphorical level, where the painting leads the viewer to ideas rather than demonstrating or illustrating them.

DR: The term, 'feminisation of formalism' has been associated with your work. How do you see this now?

SK: I think I used that term in an interview with David Pagel, conducted for *Tema Celeste*. It's a rather strong term in retrospect. The idea of the feminine, for me, has to do with a notion of not being singular. In particular, modernist abstract painting was singular and had a monolithic approach, particularly with respect to formalism. So when I used that term, what I meant was that there was a way of thinking about formalism that's not 'neo' formalist, but perhaps 'post' formalist. So I attempted to deal with a kind of polyvocal situation and argued that it cannot be reduced to a singularity. In reality, present contemporary abstract painting consists of many different voices; and the reason why it's impossible to have a movement anymore— one that can be singularly identified—is that there are so many different approaches and it's difficult to make any hierarchical conditions to say, 'this is better than that'. The criteria for making hierarchical decisions can no longer be construed in the singular, with all the corresponding authority that this implies. In fact, I think there is no space for movements anymore, any singular visual style. I think we're past that time. There are similarities and corresponding concerns, but always realised differently.

DR: Many of the other artists I've interviewed have emphasised the importance of place, of location and installation, in relation to their work, not just on a physical or formal level, but also in the way this informs or constructs meaning. Do you see your painting as functioning in an integral way? Or is the interrelationship of pieces an issue?

SK: In a show that I had in 1994, I played with those ideas a little. I think the reason why many artists are interested in this 'playing' with the environment is because art's autonomy was made so much of that they now want to articulate its conditions, the terms of its independence, so to speak. On the one hand, the paintings are complete in themselves, at least in my case let's say. On the other hand, rather than the idea of peeping through a window onto the other side, the opposite is what we want to see right now: the notion that paintings are actually looking in to our space and we become part of the scenario. It's like the window is kind of facing the other way, not the wall.

DR: Yes. Julia Kristeva describes something like this when discussing the Giotto frescoes in *Giotto's Joy*, where she talks about the central viewpoint not being in any particular fresco, but rather the site of the viewer within the architectural setting.[5]

SK: Right, exactly. That's a kind of pre-perspectival situation that she's describing there and it's interesting that abstract painting can reconnect this. This concern with installation, which as you say is a growing concern, is to constantly offer up fresh viewing situations by consciously negotiating the relationship between paintings: what faces what, the height, spacing, etc. It's that changeability of the viewing situation that affects the way we look and think about it—that is the goal here.

DR: Finally, how do you feel about the climate for making paintings today? Without asking you to crystal-ball-gaze too much, do you feel the present situation is a healthy one, particularly in connection with a sense of future practice or development?

SK: Well I'm optimistic, but on the other hand, you have to be realistic … and I don't think these are good times for painting. We were talking earlier about the multiple styles that constitute contemporary painting, and while this is in many ways great, it also creates confusion and such a situation has delivered a glut of abstract painting, much of which is not interesting. So, all this gets tied up with the whole genre of 'abstract painting' and lessens its impact. It often seems extremely difficult, although vital and necessary, to develop clear criteria as to what might constitute successful work within the genre at this point in time. The other thing is, of course, the problematic relationship between painting and the market place and the whole critical, curatorial apparatus. It's obviously easier to sell paintings than massive installations; and many galleries have fallen back on painting for purely economic reasons, which is misleading. There are very few writers or curators who will write on abstract painting. And it's amazing how so many younger critics are historical amnesiacs, you know; they don't understand

how painting has changed and they don't really want to take the time to understand. It's easier to pretend you're viewing media with no historical precedent, as it is also easier to engage with images that are more literary. With painting, the viewing takes much longer and while painting is attempting to be in 'synch' with its present times, the audience passes by with a clipped attention span. What you have to realise is that painting has a temporal space, and the average viewer probably doesn't want to spend a long time looking at it or thinking about it. There's a sensuous quality in my work that hopefully switches on this exchange, to ignite an interest with the physical that can engage the viewer, which can lead to other thoughts about the real world, metaphorically. For me, it's important to find ways to switch this process on, but I think the most dangerous thing is to force this contact by representing something too literally in abstract painting, so that the viewer thinks he or she has got the meaning. For example, you mentioned the TV screen earlier. If this was an end in itself, then it becomes the kind of signification that leads nowhere.

DR: Yes. Somebody like Gerhard Richter has been grossly misread in this way—by many painters too—as producing the blurred or technological ambience of the TV or video screen. And this can easily become simply a mannerism. Another point that might be relevant to what you were saying earlier, is Adorno's observation, writing in the late 1960s, that abstract painting was still a site for radical practice, despite the growing number of paintings appearing in hotel lobbies and lounges.[6]

SK: That's what formalist abstraction ended up doing: creating a third and fourth generation of artists who just reproduced those premises and processes. With all the questioning of old values, going on in the 1960s, it was also a crucial moment in terms of painting—a defining one. Since then, everything has been in reaction to painting. It was all in relationship to the notion that abstract painting had degenerated into decoration from the point of view of the Conceptualists. This idea can't sustain or rationalise the glut of other objects anymore, and what we need to do is re-evaluate that moment in a more pertinent light. One could almost say that everything since then has been reactionary. Art can't just be a reaction, and one of the great problems of our time is that much of the work being produced is simply a commentary or critique, which ultimately doesn't do much for the category of art. Adorno was against the 'real', ie representational works of art, so he was a staunch believer in the abstract. As far as abstract painting being a radical site is concerned: it's no more or less than other art forms. It's certainly capable of being radical only if the audience can understand that the terms of painting have changed. Painting's terms are always evolving, which I think is abstract painting's unique strength.

NOTES

1. Andrew Benjamin, *What is Abstraction?*, Academy Editions (London), 1996, p. 49.
2. Theodor Adorno, *Aesthetic Theory*, Routledge & Kegan Paul (London/New York), 1986, pp. 222–5.
3. Jaques Lacan, 'The Freudian Unconscious and Ours' in *The Four Fundamental Concepts of Psycho-Analysis*, Norton (New York), 1981, p. 26.
4. The work of 1995–6.
5. See Julia Kristeva, 'Giotto's Joy', in Leon Roudiez (ed) *Desire in Language: a Semiotic Approach to Art and Literature*, trans A Jardine, T Gora, L Roudiez, Blackwell (London), 1980.
6. Adorno, op cit.

PAINTING IN DOUBLE NEGATIVE: JONATHAN LASKER (1992)
Joseph Mashek

To make paintings capable, for good reason, of being taken as vacant or exhausted abstractions—paintings prepared to handle underestimation as to 'authenticity'; paintings that without being simplistically ironic are at once hyperdecorative and ultra-intellectual—what a tall order!

Maybe a painting by Jonathan Lasker ought to be something of a cultural embarrassment. How glibly we speak before it of 'postmodernity', while it is hardly a generation since a distinguished old-master art historian could get away with claiming that Manet 'pursued ... [his] lesson in a direction that involved spiritual impoverishment'[1]—a statement that may be more right than Charles Sterling could have comprehended, though it would take a modernist to know. Even Bataille said that Manet 'sounded the death-knell of rhetorical eloquence in painting', hardly hinting at his articulation of a whole new eloquence.[2] But for Baudelaire to have famously written to Manet 'You are only the first in the decrepitude of your art'[3] now sounds like

Figure 23 Jonathan Lasker, *Romantic Gulf* 1981, Oil on Canvas, 156 ×76 cm, Collection the artist, courtesy Sperone Westwater, New York.

sheer poetry. Having followed Lasker's work enthusiastically since the early 1980s, I can see how squares might hate it even as revisionists rejected it for a buffered yet undeniable commitment to abstraction—as those mesmerised by the 'economy of signs' show such small patience with what seventeenth-century French theory called the specific 'oeconomie' of the single painting.

Allow me, then, to begin art-historically, as neither party will want to do that job. There is apparent in Lasker's work a certain High Disneyesque mode of surface display that is itself adumbrated in turn-of-the century Symbolism. I think, for instance, of the rubbery, kitsch-unforgettable shadows in the 'Ave Maria' sequence of *Fantasia* (1941) as anticipated by shadows shifting across tree trunks and figures in Maurice Denis' *Procession Under the Trees* (1892), not to mention, as equally Laskeresque, jigsaw shifts of hatching with biomorphic zones in, say, Armand Séguin's engraving *A Summer's Day* (1894). Equally relevant to Lasker are would-be folksy images by Charles Filiger (who was admired by Alfred Jarry and André Breton), such as a study of a child kneeling at prayer—Lasker's basic repertory includes comparably 'bent' forms—marked vertically from thigh up, horizontally below. True, Lasker's Symbolism never quite keeps a straight face, but that doesn't mean it's only a joke: wit does require that at least two terms be entertained in the mind at once, even if that is too much to expect of most citizens of the art world now. At the same time, 'people' are already 'talking about' our own *fin-de-siècle*, where Lasker has *been* for some years. Because Lasker's art assumes a kind of engineered disengagement, I notice under its sway that Filiger's devoted critic Charles Chassé found in that artist's work *beaucoup de mécanisme.*[4]

In a wider cultural history, Lasker's characteristically detached, feeling-at-a-distance approach to painting—half 'Look, no hands', half 'Don't blame me'—also recalls 1900 as a moment of newly extreme technological detachment, what with the first atomising, Seuratesque 'data processing' not only of the telegraph but, especially, of the player piano, the latter particularly fascinating today as paleodigital. Scott Joplin (1868–1917) saw his original piano rags pirated in his own day, with nervous breakdowns to show for it; Joshua Rifkin's deft revival of the rags as art music only gave white America occasion for another massive effacement: Joplin is now the anonymous soundtrack composer of *The Sting* (1973). As to the piano rolls themselves—those punch-cardlike records of note sequences disencumbered of Joplin's, Rifkin's, or anybody else's heart and soul—it would be interesting to speculate, in light of Lasker's specially detached abstraction, on whether pianola music constitutes an Aristotelian representation in the sense of a rendering or *rendition* (which is to say, a *mimesis*) at all. With Lasker, it is as if we got to hear Joplin live and it turned out he had worked extra hard to sound just like a pianola.

As to heavy, turnpike modernism before and after 1900: how about Manet's own *The Ham*, with its dashlike patterned wallpaper(?) background; or even, for the sangfroid of the mint-green diagonal bands of its copper

balustrade, not to mention the stripe effect of its shutter slats, the famous *Balcony*, of 1868? Curiously, not even in postmodernism is it easy to shake off Manet as the great progenitor. (For a surprising adumbration of David Salle, check out Manet's 1874 *Monet Painting in His Studio*). But the rather videoesque striated grilles of many Lasker paintings also recall a kind of horizontal hatching used in the Synthetic Cubist paintings of Picasso, either as borrowed from the structural givens of a pair of shutters (*Window*, 1921) or as an imposed structural differentiation (*Table with a Cup*, 1922)—though I must contain myself here because nobody now wants to bother about such things.

In light of Lasker, I also notice, in earlier American modernism, a telling likeness, overriding the two painters' discrete preoccupations, between a characteristic 'leathern' facture in the art of Marsden Hartley and the almost outrageously untransmuted materiality of Lasker's paint-job, with its reverse naturalism—like some decorative sycamore bark made in rubbery plastic in Taiwan, or pigment as margarine rather than 'buttery'. I am thinking, for instance, of Hartley's *West Brookville, Maine* (1939), where a heavy, solid, patchwork of painterly stucco quartered in zones of rough strips renders spruce logs as felled, parallel and evenly stacked, plus regularly spaced trees still standing and about to be cut. Artist for artist, one might even find pertinent to Lasker's way of painting Hartley's personalist tender-toughness, except that Lasker's equivalent is critically *an*aesthetic.

Looking so switched-off, Lasker's work shows unexpected structural affinities with that aspect of Abstract Expressionism that was knowingly Euro-Surreal. For instance, as a kind of *basso* supporting a melodic 'figuration', his striated patches recall images by Baziotes, such as the milky *Jungle*, of 1951. What a difference of attitude, however: it is as if Lasker laid down a thin ground of, as it were, non-fat milk, and then went and put the heavy cream back on top of that. Significantly, *vis-à-vis* French-style modernism, the two-step process makes not for intensification or rarefaction but for the opposite—an almost chemical materialism, synthetic in the common sense even if also, differently, of Synthetism. Equally synthetic in the popular sense are his arch or lurid colours—which a student of mine, to Lasker's delight, once contemptuously characterised as deriving from 'the K-Mart School of Colour Painting'.

One afternoon in the spring of 1985, I think, when Peter Nagy was in Boston and I invited him to make a double-time sweep through the Fogg, Peter pointed out the remarkably Lasker-like fusing and flat overlay of motifs in Motherwell's *Wall Painting* (1950), in which it is as if Motherwell had sought to de-apply the graphicism of Matisse's *Jazz* collages—those forms in bikinis—in paint. Motherwell's work is obviously more homogenised and sedate than Lasker's. Yet in a more Beat, saxophonic way, Lasker makes pink look 'cool'. Tellingly, even his graphic sense evokes the sophisticated post-war style of the designer Paul Rand, including 'intellectual' book jackets, in the 1950s. Lasker's paintings are altogether abstract—more purely, in fact,

than they seem if you are still looking for signs of Renaissance picture structure—only they do not parade their abstraction. His is as it were a special kind of third-stream, postmodern jazz-quartet sensibility.

A limply flat painting by Lasker from 1978, *5 of Spades*, evokes early Lichtenstein or Warhol even more than a famous trope of early modernist critique. Actually, James Laver, discussing playing cards in a precocious 1948 article 'Good Bad Painting', observed that it was in fact only in the nineteenth century that playing-card designs underwent their, to us, conventional doubling, with two reversible tops, which suggests that we should be careful not to assume that before a certain point in the 1800s a reference to cards implies the antipictorialism of a reversible design.[5] Now, the playing-card trope for Post-Impressionist flatness, including Courbet's rather redneck insult to the *Olympia*, is by now too boring to rehearse, except that, via Cézanne and Cubism, and in analogy with chess as a cerebral theme, its abstract connotation of gaming may lead into that different cliché, of art as play.

Let me interject a point from an insightful early modern aesthetician who nowadays never even has the honour of being hit-listed in anti-modernist purges, Vernon Lee. Reviewing then new German 'empathy' theory at the turn of the century, she reached the point of suggesting that decoration itself 'might be explained as a parasitic excrescence of play upon work'. This was a challenge not only to the Romantic poet Schiller's idea of play as creative freedom but also to Herbert Spencer's notion of art as surplus energy discharged in free play. However, 'freedom', according to Lee, 'is not the aim of the artistic process, but its necessary condition, since we do not act freely in order to take pleasure in freedom, but please ourselves because we happen to be free to do so'.[6] Considering Lee's reversal helps me to understand something I before only sensed: how some of the wit in Lasker's paintings depends on their looking stubbornly belaboured even as they look so well-groomed. How ruthlessly, come to think of it, Lasker handles the decorative hanging-out, again and again, of the almost-the-same, hardly spontaneous cadenzas and 'ornamentation'.

One painting by Lasker from 1987, *Fashionable Obscurity*, has a purple, 'high-key' field, like a colour in a yuppie sportswear catalogue for jocks of no team. Onto this is applied, or rather, into it is more or less inlaid, an array of broad, strugglingly hand-drawn vertical stripes of mudlike ochre. Stripes and field alike are overlaid interruptively by twin amorphous white patches striped vertically with black, each of which is further overlaid by a linear, signlike motif in red—a pointless hieroglyph something like a fusion of the 'heart' and 'spade' of playing cards. (Giving two instances of the same red motif on differently shaped but similarly striped white patches, side by side, recalls Rauschenberg's anti-Expressionist self-simulation in closely doubling painterly quirks from *Factum I* over into *Factum II*, both of 1957.) Here, too, as elsewhere, Lasker juxtaposes two different *kinds* of colour, as different as

attitudes, one tending toward the gorgeous and the at least caricaturally feminine and the other toward a dumb *profondo* look that by rights should be caricaturally masculine, the latter playing as if den pieces to the boudoir air of the former, or, by a stretch, Baroque to their Rococo.

By 'belaboured' I mean also to imply *driven*, in the sense of Artaud's *The Theatre and Its Double* (1938)—this in spite of Jean Baudrillard's attempt to swallow up Artaud, Pac-Man-like, assuming him as a mere 'referential' of what he wrote. Take the idea of *'matter as revelation,* suddenly dispersed in signs to teach us the metaphysical identity of concrete and abstract and to teach us this *in gestures made to last'.*[7] Thanks probably to the cult of Baudrillard, the pop-intellectual Marshall McLuhan of the 1980s, there is a current, wrongheaded sense of a 'double' as some kind of deracinated simulacrum, as if, in Lasker's case, the works were nothing more than stand-ins for abstract paintings. This is simply not what Artaud termed 'the double', which is anything but inert. A snatch or two from Artaud in gear shows how unsuitable to any ironically distanced posture his 'double' ought to be (his definitive example being the Balinese theatre): 'As if waves of matter were tumbling over each other, dashing their crests into the deep and flying from all sides of the horizon to be enclosed in one minute portion of tremor and trance—to cover the void of fear'.[8] Copying the words down, I began to think of the following in respect to a threat of anxious immobility in Lasker's, in one sense switched-off, in another quite brazen, icings of paint: 'A chaotic boiling, full of recognisable particles and at moments strangely orderly, crackles in this effervescence of painted rhythms in which the many fermatas unceasingly make their entrance like a well-calculated silence'.[9] It's the fermatas that really do it, by analogy with the blatant gaps in Lasker's structures; but the nearly swooningly far-fetched overall conviction counts too.

It cannot have escaped Lasker that his own work, however *smart*, is much less simplistic and shows rather less 'attitude' than fashion dictates. He seems to paint out of suave disgust with the way things are, perhaps with disgust for the pseudo-radical philistines' antipathy toward painting. Thus I see his work not as an empty, ill-defined 'double' for painting, that is, as part of current bourgeois anti-art voodoo, but as a true 'treble' to that false 'double', or better—as the German translator of the original version of this essay gave it, in 1987 (though who, here, could be expected to know about church music)—as a kind of 'descant', gliding up an octave above its given basis.

Lasker's barky, stuccolike facture, *an*esthetised as it is, does manage to affirm painting. Baudrillard generalises with dumbfounding crudity in his remarks on 'The Stucco Angel' (welcome to the 1980s), but his slapdash insult to historical truth takes on interest before Lasker's heavy, stuccoish impastos. 'Stucco exorcises the unlikely confusion of matter into a single new substance, and is prestigious theatrically because [it] is itself a representative [ie, representational?] substance, a mirror of all the others.'[10] Here is at least the flavour, let's say, of Lasker's kind of significance. But while Baudrillard's

cynicism as to the possibility of sublimating (negligible) matter into (appreciable) immaterial effect conveniently sweeps a great deal of worthy art, old and new, out of the way, in today's circumstances—including by now even debasements of Baudrillard!—even blasphemous anti-painting has sufficiently to entail *painting per se* to count.

I keep speaking of Baudrillard, against my will. If only he conveyed a sense that his brutalisation of Artaud, whose thought was no delicate bloom, had been *sportif*, we could thank him for cleverly driving us back to the original 'double' that got marginalised before 'margins' themselves became so *hot*. Certainly the Artaudian double is no coy postmodern tap-dance. When, under the heading 'An Affective Athleticism', Artaud calls on the actor (read artist) 'to make use of his emotions as a wrestler makes use of his muscles', seeing 'the human being as a Double, like the Ka of the Egyptian mummies, like a perpetual spectre from which the affective powers radiate', he calls for unnervingly vivid affect (not *none*), for 'virtues which are not those of an image but carry a material sense'.[11] Far from implying business as usual, this seems to indicate a toughened, materialised version of dramatic 'image'. I now find myself dwelling on Artaud, in turn; but he heads me into the special 'double', or double-negation of the simple, mistaken double, in Lasker's art.

An actor, or artist, should be like a wrestler? What can this mean right now, with even *that* debased? You don't have to be Barthes to see that there is an art world as blaspheming of its own classic equivalent, not only as profiteering, as the world of 'pro' wrestling, as I have written elsewhere. If Lasker's appliqués of disjunct forms are at all like the shadow puppets or the body-ornamented dancers of Artaud's East Indies (already admired by Derain among the Fauves), haven't the similar ballet tights with wild arabesque designs of Nijinsky lately resurfaced with Artaudian underclass outrageousness in the figured tights of Ravishing Rude Rick, of the World Wrestling Federation (an operation so *purely* commercial that, like Jeff Koons, it simply self-advertises)? Some would see Lasker that way, and enthusiastically; but then, for his double-negation of painting, I see him instead as more like an Arthur Craven, the boxer who rates as a Dadaist, but only because he *really did box*. While I'd hate in effect to hand over Lasker to the French, the Artaudian aspect of his work isn't unrelated to the Artauderie of that great anti-painter whose art is very much *real painting*, Jean Dubuffet, either.

Contemporaneous with *The Theatre and Its Double*, with its wittily defensive imputation to a painting by Lucas van Leyden of 'metaphysical' ideals ('I am sorry to use this word, but it is their name'[12]), was the famous lecture by Heidegger, 'The Establishment by Metaphysics of the Modern World Picture' (1938), published as 'The Age of the World Picture' (and supplemented in *Holzwege*, 1952). Here, the philosopher maintains not that a new, Cartesian world-picture replaced a premodern one, but rather that the Cartesian method uniquely affected the very representability of the world as such. This 'modern' world-picture being (or having been?) *the* world-picture,

the very condition of appearing altogether new 'is peculiar to the world that has become picture'. The picturability, as such, of the world, Heidegger sees as essentially modern; and the very word 'picture' (*Bild*) 'now means the structured image (*Gebild*) that is the creature of man's producing'.[13] The very understanding of its coming into being is tinged by a sense that almost from its first comprehensibility the world-picture would have to dissipate.

Is it rash to find here, half a century later, some inevitable 'postmodernity' implicit in modernity itself, or is that a thought only an amateur could get away with? Clearly, Jonathan Lasker dallies with mechanisms of *de*piction already subverted in a century of modern painting: a now almost pointlessly imagic drawing-in-paint; stripes dopily adrift from their mates in a more air-headed than atmospheric field; loose parts from the old Erector Set of perspective. Some of us have been quite happy that the preposterous old picturability has been defunct since about 1910, so why should we feel any disappointment on that score? And if we never wanted to buy into the puritan postmodernists' interminable funeral for painting, well, we can admire how Lasker manages to concoct representations of our present, not altogether unfortunately unpicturable, condition. 'No age lets itself be done away with by a negating decree', says Heidegger, adding—as with so much art today—'Negation only throws the negator off the path'.[14] Heidegger also says that 'What belongs properly to the essence of the picture is ... system'; and 'Where the world becomes picture, the system ... comes to dominance', though 'where the system is in the ascendancy, the possibility always exists also of its degenerating into the superficiality of a system that has merely been fabricated and pieced together'.[15] This integral doubt in the artifice of picturing *at all* seems to me rather like what Lasker negotiates in his art. Lasker's painting is no mere postmodernist documentation of the disenfranchised means and mechanics of representation; neither is it anti-modernist by simple 'negating decree'.

Here, in the 1952 appendices that Heidegger added to his 'World-Picture' essay, it seems that 'the melting down of the self-consummating essence of the modern age', which in context is practically to say of picturability itself, 'into the self-evident, is being accomplished'. To my eyes, Lasker reflects this condition with a practically Nietzschean hilarity. Nietzschean in its own right is the way, for Heidegger, the collapse has to occur in order for there to be 'fertile soil for Being to be in question in an original way'; hence, 'Only there where the consummation of the modern age attains the heedlessness [or better, recklessness (*Rücksichtslosigkeit*)] that is its peculiar greatness is future history being prepared'.[16]

To be sensitive to the tremors in the foundations beneath us is perhaps almost to be condemned to a dandyish exclusivity. If only the crumbling of the world-picture meant simply the final downfall of academicised representation in painting, we could simply cheer. By now, more has been crumbling than representational, or even modernist abstract, art. Lasker's

reckless, *rücksichtlosige* images might be said to consist of shards of the modern world-picture, yet he still manages to paint them with a saving delight in painting. Of course, to the new Calvinist radicals, beyond the pale even of so-called Neo-Geo, so naughty an intimacy with paint almost calls for the pillory and stocks. But in his own way, Lasker is as critical as any. In a published statement, he noticeably refrains from prevailing nihilism in explaining that it is painting's very 'capacity to present the viewer with both a fictive experience and an actual experience simultaneously' that allows it to 'examine the very mechanism of fiction' and the way we invest meaning in its 'random graphic marks'.[17] Even in its dandyism, Lasker's art is strong on *def*ence: it is as if it were unwilling to 'play ball' without putting up a fight.

Despite the risk of dandyism of *appreciation*, my thoughts on Lasker seem to be spiralling outward. Collins' and Milazzo's piquantly crafty suggestion that Lasker's 'strife' between figure and ground might be likened to 'the social phenomenon of "class struggle"' calls the attention of irony to art's shared frontier with social life.[18] Somewhere between the large world of the class struggle and the little world of a single painting is the art world, where, as the sociologist Levin Schücking could write more than four decades ago, 'one can become a success only if, following the American device, one "gets talked about"'. And Schücking seems quite relevant to Lasker where he explores the sociology of traditional high-class taste as anti-individualistic and accustomed to think in types: 'The complete exposure of the life of the emotions, like all that is ruthless in expression, is ... bound to be unattractive ... It is always revealing things that must at all costs be suppressed'.[19] Lasker, I think, deals with such deep-seated detachment just enough for his wilful *an*aestheticism to be manifest as an 'isometric' strength. It is the bad-taste part, then, that begins to seem more than dandyish or indulgent, given that upper-class types, conditioned by concern with inheritance, consign art to a decorative place in their scheme of life and tend to be repelled by eccentricity; then again, 'Repulsion wears off. Unconscious compromises are made between earlier ideals and that which is constantly seen or heard'. In other words, as Schücking quotes Max Lieberman as saying, 'Take the picture away, or I shall begin to like it'.[20]

It is hardly as a mere child of his age that I admire Lasker in his art—certainly not in the sense that 'the children of this world are in their generation wiser than the children of light' (Luke 16:8). Yes, Lasker's art is this-worldly instead of 'transcendental', but its very wit must be good for the spirit too. 'You have as much laughter as you have faith', it has been said. Oscar Wilde? No, Luther.[21]

NOTES

1. Charles Sterling, *Still Life Painting from Antiquity to the Twentieth Century* (1952), trans James Emmons (revised edition), (New York), 1981, p. 122.

2. Georges Bataille, *Manet* (1955), trans Austryn Wainhouse and James Emmons (New York), 1983, p. 92. Bataille is here addressing 'that elegant thinness of the pictorial image, that flat transparency which sounded the death-knell of rhetorical eloquence in painting'. *à la* the famous playing-card trope. There is a critical duplicity in his text, however, because by this point, the reader has already been coaxed repeatedly to concede that *all* rhetoric or eloquence goes by the boards with Manet: eg, 'Every strain of eloquence, feigned or genuine, is done away with'. (p. 48) So in some sense, any remark beginning 'His eloquence, needless to say, had nothing in common with the turgid ...' (p. 72) must be bankrupt before the thought is complete.

3. As quoted in Sterling, *Still Life*, op cit, p. 123; cf Bataille, *Manet*, op cit, p. 42.

4. Charles Chassé, *Le Mouvement symboliste dans l'art du XIXe siècle* (Paris), 1947, p. 114.

5. James Laver, 'Good Bad Art', *The Studio*, CXXXVI, October 1948, p. 667. Laver was also fascinated, as it happens, by a Victorian propensity to 'cement fragments of broken porcelain' all over *objets d'art*.

6. Vernon Lee (pseud of Violet Paget), 'Recent Aesthetics', *The Quarterly Review*, CXCIX, April 1904, p. 198 .

7. Antonin Artaud, *The Theater and Its Double*, trans Mary Caroline Richards (New York), 1958, p. 59 (emphases in original).

8. Ibid, p. 65.

9. Ibid, p. 61.

10. Jean Baudrillard, *Simulations*, trans P. Foss, P. Patton, and P. Beitchman (New York), 1983, p. 88.

11. Artaud, *Theatre*, op cit, pp. 134–35.

12. Ibid, p. 36.

13. Martin Heidegger, 'The Age of the World Picture', in William Lovitt (ed and trans), *The Question Concerning Technology and Other Essays* (New York), 1977, pp. 115–54, and fn 18 (ed) on Heidegger's word *Gebild*.

14. Ibid, p. 138.

15. Ibid, p. 141.

16. Ibid, p. 153; in the original, Heidegger, *Holzwege,* 4th ed, (Frankfurt), 1963, p. 103.

17. Jonathan Lasker, '"Nature Study", "Idiot Savant", "Ascension"', *Effects: Magazine for New Art Theory,* no. 3, Winter 1986.

18. Tricia Collins and Richard Milazzo, 'Tropical Codes', *Kunstforum International*, no 83, March–May 1986, pp. 308–37.

19. Levin L Schücking, *The Sociology of Literary Taste*, International Library of Sociology and Social Reconstruction (New York), 1945, p. 63.

20. Ibid, p. 61.

21. Martin Luther, from a Latin commentary on Psalm 126.

Jonathan Lasker in conversation with David Ryan (1997)

David Ryan: Jonathan, in the past you've been rather critical of the blanket term, 'abstraction', suggesting that it implies, 'A negative [condition], namely the absence of image, rather than a positive position.'[1] How do you now view the complex relationship between a concept of abstraction and image making?

Jonathan Lasker: In a way, I really don't think of my paintings as abstract. There are very clear pictorial references in my work. Maybe you can say that they're 'abstract pictures', because they use the means of abstraction in order to engage the picture plane as just that—a plane for picturing to happen. What my paintings are trying to arrive at is a situation whereby a series of pictorial events can be construed, and yet at the same time one can look at that painting as being very literal in the abstract sense. So I don't think 'abstraction' is a totally negative term; that was too harsh a judgement. What I was probably thinking of when I made this statement, was a condition that might be seen to be bound up

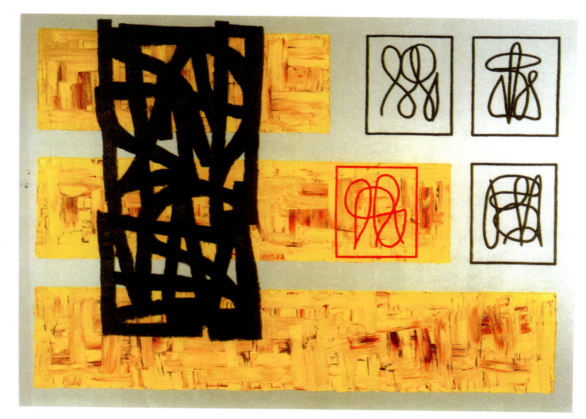

Figure 24 Jonathan Lasker, *The Value of Pictures* 1993, Oil on Canvas, 244 ×335 cm. Reproduced with permission of the High Museum, Atlanta, GA,USA; purchased with funds from Alfred Austell Thornton, in memory of Leila Austell Thornton and Albert Edward Thornton, Sr, Sarah Miller Venable and William Hoyt Venable. Courtesy Sperone Westwater, New York.

with late modernism, whereby the 'picture' is no longer present, and what is asserted is a sense of what's real about the thing that you're looking at. In current painting, you can have both things happening at the same time. You can arrive at a picture that's more 'aware' of itself literally.

DR: Does this create a more congenial framework for playing with pictorial metaphor?

JL: Yes. Definitely. I think when you're looking at my paintings it's clear that you will think of, or relate to, other things in the real world outside of the picture. Yet you're also very aware that you're looking at a painting: at a process of making and the physical elements of paint, which is one of the conditions of abstraction.

DR: Your work has also been seen in the context of a kind of picturing of the processes of the mind itself.

JL: That's true. I'd like to think that these paintings throw the viewer back onto themselves, that they view themselves viewing the picture. And that they're aware of how they're construing a picture, construing random marks to be a picture—which is what painting actually is—mark-making construed as a picture. This process—and it's a two-way thing because it leads back to intention—will be consciously reflected upon, I hope, by the viewer. Painting can essentially mediate this relationship between a picture as a thing and also engage a reflection on the consciousness of the viewer and maker. I see these works as being very much about painting primarily, and then maybe about abstraction secondarily, which in some ways is reflected in the fact that I'm interested in a broad range of current painting: anything from current realism to abstraction.

DR: You've always spoken very positively about the medium of painting in a climate that is often hostile and depreciating.

JL: Right. Well, of course, there has been a long standing argument against painting throughout the century. I've personally always asserted that in fact it's one of the most interesting media currently, because of this capacity to engage illusionism, or rather a mediated image, something that doesn't actually exist, and at the same time to present a very actual experience. It's a dialectical situation. In this way, painting presents these two tendencies very clearly, whereas other media do not. In most films for example, you're really not aware of the cinematic process, you go straight 'through' the medium into the illusion. The image that is presented in painting, I'd like to think of as an 'ethical' image, which can have a very strong moral grounding force. This is very important today, I feel.

DR: Leading on from this notion of an 'ethical image', in the catalogue *Cultural Promiscuity*, you wrote about the 'hyper-real' conditions of culture today—'The irreality of contemporary culture is supported by and in complicity with a bankrupt economy'.[2] I was wondering how, as a cultural producer, you see the most effective way of dealing with this?

JL: If that is the cultural moment, that doesn't mean that everybody, culturally at that moment, is working within the same paradigm. You can also be working against that culture, while at the same time recognising that it's prevalent, and I think painting has the capacity to do that. My own painting does engage in some of the irreality that's around us. I'd like to think that it both engages with, and is mutually critical of this cultural moment. My paintings are critical in two different directions: they're critical of any easy assumption about meaning, and on the other hand they're critical of a very decadent approach to a culture without meaning, or without the possibility of meaning. So they cut both ways in that sense.

DR: Was the acceptance of this hyper-real situation more prevalent in your earlier paintings? I'm thinking here of some works that were painted in the early 1980s that referred to a particular chain of motels.

JL: Right. The *Motel Series*—thirteen paintings made in 1981. They were all quasi mass-produced works as though for a motel chain; an imaginary motel chain. The important question for me, though, was how would I manufacture such paintings as my own, and be aware that their destination would be the motel chain or the discount store? I was dealing with this idea of a kind of stereotypical production and yet at the same time these works deal with very real painting issues. So I think a lot of the dialogue that informs the later work is in those paintings, but maybe transposed in a different way. They are still, so to speak, conflicted about these issues. I don't necessarily think it's a situation where something is 'corrupted', more a question of engagement. Lets say I think you can get your hands dirty. The ivory-tower approach to culture is very false. The idea of the cultural producer always working outside of the social moment and in a manner that is 'pure', is a false notion. If you're going to deal with the issues and problems of the world in which you live, then I think you have to engage directly and get your hands dirty.

DR: So you feel painting can have this double edge?

JL: It can; I think if it's the artist's intent, yes. If it isn't, then the work is lost. For me this is an extremely important dimension of painting. So much of Pop art was about this issue.

DR: The small maquettes that precede the larger works are exemplary

telephone-pad doodles, but they're also very carefully framed: they give no sense of overflow. I wondered if you could say something about control, self-consciousness, and on the other side of the coin, perhaps a relationship to the Surrealist notion of tapping into the unconscious through utilising the scrawl of the knotted gesture?

JL: Well, it is a subconscious moment. I'm not interested in travelling deeply into my interior in these paintings, but through the maquettes, they touch on a subconscious moment or impulse. For me, again, this is a play around a duality. The paintings explore an awareness of themselves—a consciousness with what I like to think of as that moment that can be represented by a half-way stage between consciousness and the unconscious, like when you're just waking from a dream. It's a fine line between these states, and the doodles do have frames, boundaries; they're contained. So really, where these two states hit against each other, is in the complete process itself, whereby the small works are scrawled out in that manner. But when it comes to the paintings themselves, they're very consciously traced, always with the same sized brush so the execution is very clean.

DR: Yes, that's interesting: this idea of using a process that, for want of a better word, conventionalises this relationship. On one level, of course, it could be argued that we only have access to the unconscious through convention. I'm thinking here of Pollock's psychoanalytic drawings produced for the Jungian analyst, Dr Henderson, who felt that Pollock was articulating unconscious tensions through the 'language' of another artist, namely Picasso and specifically Guernica.

JL: We all go back and forth between origination and convention. It's a reality that we couldn't exist in the world without those conventions, yet at the same time, there has to be some extemporisation. I'm not too sure how original as human beings we can be, and how much of it is acting out universal patterns. I certainly don't have an answer for that, but in a way I'm directly involved with the investigation of what that is. These forms do play on certain conventional notions of what could be seen as archetypically abstract means of expression; unconscious forms presented in a manner that we now may see as being somewhat conventional. At the same time, though, when they reappear in my own work—each and every time these conventional aspects appear—they're rendered in a way that is unfamiliar, or at least, I've never seen them rendered in this way before. You could, for example, say that maybe a particular element has some of the qualities of a gestural passage from a de Kooning painting. If you really look at it, though, de Kooning certainly wouldn't have painted it in that manner. Some of these forms are 'typical', subliminal, biomorphic forms that one might find in early Abstract Expressionism—Baziotes for example—but, of course, also very

Figure 25 Jonathan Lasker, *Nearly Soul* 1996, Oil on Canvas, 229 ×305 cm, Private collection, courtesy Sperone Westwater, New York.

different, through the rendering and the whole process itself. At all times there's the question of our relationship to convention. Maybe we're all the same on one level, and then there's the fact that we do reinvent ourselves, and yet there are also original points of expression. You mentioned the *Motel Series* earlier; they were about these concerns as well in an odd way, because they addressed the issue of myself tracing my own identity through a couple of layers of convention. They were based on my own paintings, yet they were palette-knifed in that Ecole de Paris kind of style—the kind of thing that you would find in a motel chain. And this style owed something to the rise of Abstract Expressionism in America. So here I was trying to negotiate, or trace myself through a commercial convention and also a couple of layers of art history, and still arrive at something that was my own image. So it's also a question of asking where the identity really is—and finding it.

DR: Through ruthlessly pursuing convention, you can arrive at something that's other than convention?

JL: Absolutely. You can see this clearly just from observing how different people will approach the same tasks—handwriting analysis is a simple example, but even, say, cleaning a bathroom tile—it won't be done in the same way. Actually, it's remarkable how much invention goes into our lives, and perhaps these days it's easy to forget that, the emphasis being on convention.

DR: Thinking about your affinity with Abstract Expressionism, and especially Franz Kline, who has been mentioned in connection with your work both by you and by others, it's interesting to think about Kline's own relationship to scale. According to Elaine de Kooning, Kline constantly produced tiny ink drawings while still a figurative painter, and it was the experience of seeing one of these small, calligraphic drawings blown up on a monumental scale through a friend's Bell-Opticon, that the abstractions were seriously begun.

JL: In a way that's interesting, because Kline had to manufacture himself; he had to 'design' himself, and his 'tag' as an Abstract Expressionist, so to speak. He came later to abstraction than the others, that's true, and felt the need to reinvent himself in this direction. As a result, I think, he produced what I've previously referred to as some of the most 'cogent images' of Abstract Expressionism: the starkness, the black and white, the concentration. In Kline we find perhaps a similar juxtaposition of informality and self-awareness, self-consciousness, through this process. The definition of his expression is extremely powerful—a very absolute expression, yet at the same time possessing nuance in a highly controlled manner.

DR: In many ways though, your work could be seen as critique of Abstract Expressionism, in that you process the move from the unknown to the known and vice versa in a very deliberate manner.

JL: It's not a critique; really it's not. I think of it more as an analysis. The word 'critique' is used rather too broadly and consistently in contemporary culture. Analysis is a much more healthy relationship, I feel. So it's analytical, yet very respectful of what these artists created and accomplished. Each moment in culture has its own thing to say, and while I respect those artists immensely, I have no intention of wanting to be one of them today; this certainly is not an attractive notion. The idea of the past is that it's a stepping-stone to the future, so that particular moment has passed, but through analysis we can clear a space for something that might have a connection but is different, is 'new'. Otherwise, it tends to be a crude deconstruction, which is more often than not simply a negation. On its healthiest level, deconstruction can be analytical and function as a building block, but it has generally occupied a negative position.

DR: I want to go back to something we've already touched on to a degree,

which is the 'notational' aspects of your painting. You used this term to describe what interested you about eighteenth-century Mannerist painting, Magnasco for example. What is the connection with your work?

JL: It's very relevant to my own work. Much Mannerist painting explores notation in this pictorial sense. In any kind of picture, one is of course using a notational system, which the viewer then receives. In Mannerist works, the notational system becomes heightened, by manner or gesture. The gesture takes on an independent life of its own through the highlighting or emphasis of its characteristics. The pictorial components become more isolated and, ontologically, they come into their own. That intrigues me a lot, because in my own painting, each and every element of notation, suggesting a figure against a ground, can be taken as part of an entire picture. Yet at the same time, it very much has its own separate existence in the work—sometimes physically separate, in the sense that you feel the paint is being placed upon the canvas in a certain and very specific way. Notation stands in for something else and yet as a 'note', it is its own thing; and this is, again, a dialectical relationship that interests me.

DR: It's interesting thinking of this as a kind of unravelling in many ways. And something similar happens in relation to the scale of your paintings. A friend of mine who saw the pieces at the Hayward Gallery in London,[3] said to me that he felt the scale was all wrong. This seems to me, however, a crucial aspect of your project; that through the processes you utilise, we experience a very different relationship between image/scale/size, and this might also be related to what Gary Stephan referred to as 'homeless representation',[4] in connection with his own work. Does this strike any resonance with your approach?

JL: It does in a way ... that is true ... These forms or shapes I create are, on a certain level, a little bit 'vagrant'. They are kind of homeless, and they also could reappear in almost any other picture; but that is not to say that their appearance in a picture is arbitrary. That's a mistake many people make when looking at my paintings. Because they see one thing placed against another thing that is contrary to it, they think this placement is arbitrary. The placement of these forms is actually very specific. One thing is intended to contradict something else in a particular manner, so the relationships are very important. At the same time, I'm working with a fixed vocabulary of forms, which sometimes can appear in very different contexts in order to create these different relationships. So in a sense, these forms are kind of homeless. They don't necessarily 'belong' in a traditional sense to the picture; they're visiting there. In the past, I've referred to them as almost being like 'cultural tourists', going from one location to another, and visiting that space,

trying it out as a natural environment for themselves, seeing what it would be like to exist in that environment.

As regards the scale, there can be a sense of the figures being over-large, and an odd relationship to the ground as 'place'. At all points, the paintings are at the same scale. If I do a small painting, maybe $2 \times 2\,^1/_2$ feet, then the image will appear as large as on a much bigger painting; so the elements in relationship can appear overly large.

DR: So there's a kind of double-take with the scale; it disorientates a sense of size.

JL: Right. Things are trying to find their place, but they can't quite. The scale is actually as it would be if you think of them as figure representations. It's actually the placement that disorientates, I think.

DR: What about the process of doubling and mirroring that informs your work?

JL: The doubling tends to explore the reproducibility of these initial psychic moments, where you take the original impulse and then it becomes mediated. In some of my paintings, I've taken this automatic mark-making, and then reproduced it by tracing, using this 'cottage-industry' mode of reproduction. In many ways, I'm trying to situate an authentic psychological expression within the cultural moment, which perhaps demands mediation. But what I'm saying is that we can have this authentic experience and expression in that manner, and that this can be produced and mediated within the same painting. So in some ways, it shows how the culture is disallowing our own identity. And in a sense, the whole thing of multiplicity in contemporary culture is severely damaging to our perception of ourselves as 'original human beings', or as having a sense of original identity. In certain ways, these paintings deal with the moment of that frustration; they deal with that conflict.

DR: So it seems quite a moral positioning in many ways.

JL: Well, I feel that's extremely important in terms of an artist's relationship to the dominant cultural experience: I think ultimately it is a moral one.

DR: I was wondering about this position in relationship to certain traditional modernist notions. This was extremely important for abstraction at one point in time: a striving for unity, wholeness, where this goes beyond the formal and suggests a kind of ontological position; a realisation of integrated self for both object and viewer. This too could be a kind of moral approach to form.

What is suggested to you by the replacement of this model in much contemporary abstraction with fragmentation, complexity, contradiction, doublings, disunity?

JL: Well, as I've said, my paintings are dialectical; there's no question about that. The object functions almost as a discourse. The audience or participant's relationship to a discursive situation is a thought process, and likewise the viewer's relationship to my work is more of a thought process. What you're referring to in modernism, is this thing where the painting is more or less an object presenting itself to the viewer, who is also more or less an object.

DR: But both realise themselves within that moment?

JL: Well, as much as a thing can realise 'itself'. There is no selfhood for a thing.

DR: The identity of the thing is realised through the viewing process, so that an analogy with selfhood can be made.

JL: The viewer confirms the thing's existence. As such, there's a confirmation. But it all happens on the part of the viewer. The viewer recognises the object, and the object gives the viewer a stationary point to 'be' in relation to the object.

DR: The 'destination' of this notion of the object's 'identity' is situated within this idealised viewing situation ...

JL: Right, and the two things go back and forth. Well ... what we're describing is a situation where the pictorial gets deflated. My interests are much more, as I've said, pictorial, but the viewer does get a chance to step back and also have a relationship with isolated events in the painting. So he or she will relate to particular 'things' in relation to other 'things'. These are events that are existing in actual space—sort of mutually confirming each other as such—so the idea of a negative notion of fragmentation doesn't really hold with my paintings. The viewer is the most active participant within this dialectic. In terms of a relationship with, or rather an analogy with, a notion of self, I have to say I'm very optimistic about notions of the self, because obviously we need them in order to construe any social concept. Yet at the same time, there are deep and serious questions about them, and I feel that my paintings do attempt to address these issues. On another level, I think it's interesting that painting has become discursive. I mean Minimalism didn't really have a discourse—it had supporting literature, and a critical context, but in itself wasn't actually discursive.

DR: You mean issues were not somehow pictorially present?

JL: Right. It was literal and ... well, an empty vessel. I'm not denigrating Minimalism here, but I think it's a more recent thing that contemporary painting has been able to take on more confrontational issues. And in an actual and a less literary way—I'm thinking here of the way critics project onto something that is empty of discourse in itself—current painting visually takes much more responsibility for the construction of particular meanings or the initiation of its own discursive issues.

DR: Do you see your paintings as operating within a system of 'language' that you set up, or is it rather 'languages' in the plural?

JL: That's a good question ... I think ... language, rather than the plural, which would suggest more a question of crossing cultural boundaries, which does happen to an extent, but ultimately only to a limited extent. They do stay within a tradition of Western history and culture, but this in itself is explored on different levels, I think. Let me say that I don't want to get too literal about the paintings operating as a language. There are things that happen on a pictorial level that always defeat language. Language, of course, defeats itself ultimately, because linguistic cognition is limited.

DR: Language springs to mind in relation to your paintings for a variety of reasons, though. Many of the things we've been talking about could be related here: the idea of convention and invention, the notion of dualities and particularly 'difference', so important to the structuralist proposition of language.

JL: There is that, I suppose. As well as a very actual, literal experience that goes outside of language, which is the idea of being in front of the thing at the moment, and experiencing how it's actually happening in front of you. Where this notion of a relationship to language is relevant, is during the process of making. Certainly here you could point to patterns of language at the operational level.

DR: Another structuralist notion of how language functions that might be relevant to the kinds of experience offered up by your paintings, is the idea of a relationship between an abstract totality of language that can never be experienced perceptually. It's only in the individual utterance that we 'experience' language. There's something of this in the way that you approach form, and the way you were talking earlier about a kind of endless, potential recombination of forms, and this might also lead to a reflection on what is actually present and absent.

JL: Yes, this is a valid point: I guess you could formulate parallels. I do, however, feel that it's important for painting that it operates on a level of visual phenomena, and then afterwards one infers the meaning of that phenomena in a literal manner, if literality is at all necessary.

DR: But there can be fruitful convergences with theory that might help us reflect upon that phenomena, as long as it isn't forced?

JL: Yes, exactly. Any painting that becomes an illustration of theory would, to my mind, be very much compromised.

DR: But these chance convergences can occur. For example, I can think of Derrida's deconstruction of presence, where he favours the indeterminacy of writing over the (illusory) 'grounded' authority of speech. Surely this could be relevant—after the fact I'm sure—to the way in which you displace the 'authentic' gesture of the maquettes in the larger works?

JL: Actually, I'm not interested in deconstruction, but much more in a situation of reconstruction. These paintings accept the fact that, currently, meaning has been deeply deflated, yet at the same time, I'm interested in engaging possibilities for meaning. The questions to ask are: how can we begin to reconstruct meaning? How does one find relevant meaning within certain forms? How do they begin to have significance for us again and what are those meanings? What is the resonance of that experience? And try to build back up from that, so once again we can recompose an abstraction that posits an overall meaning. I think that's the point in history that we are in right now. If Derrida is implying that the spoken utterance is always seemingly a subjective prejudice, then on a certain level, that prejudice, for me, is a correct one. It's the only way that we can proceed to construct meaning. Personally, I feel that after going through all the analytical processes of deconstruction, we're going to fall back on the fact that there is a meaningful core to human consciousness, and that in order to communicate, we have to accept certain 'constructions'. On that level, I'm optimistic about arriving at meaning, but I think it will be at that point when we've gone beyond the kind of dispersal of meaning that deconstruction favours. Much contemporary theory is operating from a level of rather poor faith, and ultimately, in culture, and also socially—I think this is very important too—it is now crucial that people start to reinvent their culture with some level of faith. Whether this is an intellectual position, is debatable, but certainly it's a creative one. And that's a very important thing to realise: that creativity is an act of faith. So what we think is not only how we construe things, but it's also what we wish to believe, and that's how we construct thought in the first place. I certainly think it's a difficult point in history that we occupy. And those people who are simply emphasising this

are not false in that belief, but it's a moment for, if anything, a more heroic approach, rather than a demoralised one.

NOTES

1. Demetrio Paparoni, interview with Jonathan Lasker, *Tema Celeste Art Magazine*, no 32, Autumn 1991.
2. Collins & Milazzo in conversation with Jonathan Lasker, *Cultural Promiscuity*, a catalogue of 13 studies (Rome), 1989.
3. 'Unbound: Possibilities in Painting', Hayward Gallery, London, 1994.
4. Stephan was paraphrasing Clement Greenberg with this term (in conversation with the author, New York, May 1996).

FABIAN MARCACCIO: TENTS OF WAR (1997)
Carlos Basualdo

Time and space here have no order; all things are seen from many directions, in fragments and segments, and are interrupted at any point. Yasumi Akihito, *Photography as an I Novel.*

How can we define the experience of an activity that excludes the very concept of rest? Or rather, the model, paradoxically immobile, of such

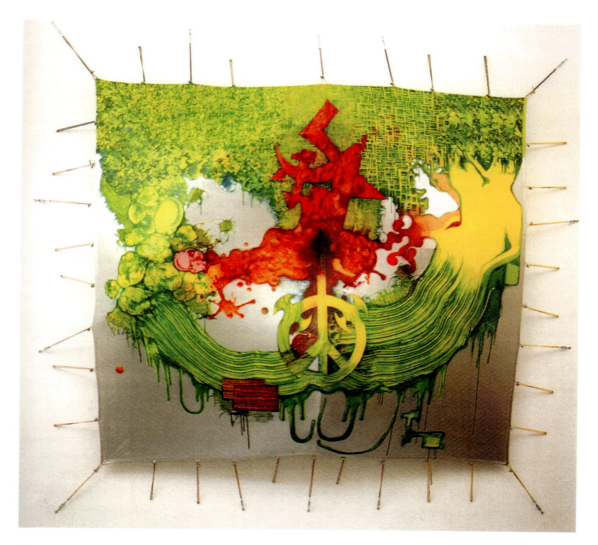

Figure 26 Fabian Marcaccio, *New Juvenile #1* 1996, Water and oil-base paint on canvas, copper tubing and nylon ropes, 267 ×295 ×51 cm, Courtesy Gorney Bravin + Lee, New York. Photo: John Bessler.

frenzy? In these paintings everything seems to be unstable: the background jumps to the surface, tentatively takes hold of the wall, contradicts the marks that a precarious and clumsily hidden structure leaves on the canvas. Canvas, background, support, structure, motif and brushstrokes all furiously assume a false kind of predominance, with everything struggling frenetically, and above all, against itself. If Fabian Marcaccio's painting were described in terms of the grammatical structures of language—a parallelism whose effectiveness I shall examine below, then in the phrases that make up his works, there are only verbs, or rather, all the elementary particles of this synthetic language have been simultaneously activated: conjunctions and articles transformed into verbs, pronouns and nouns all verbalised.

It is easy to conclude that such a project could not be carried out in linear terms, and would have, on the contrary, to be developed through the integration of divergent experiences—which would reflect the polymorphism of a work that ranges from wall installations to schematic drawings and photographs.

All this happens, and has been happening, in a work whose curiously logical development extends over the last eight years. Indeed, the first paintings of this period date from 1988 and since then, Marcaccio seems to have been bent on modelling pictorial practice, which in the first instance led him to mediate it and consider it in analytical terms. I use the word 'mediation' to signify his use of printmaking to depict the basic elements that constitute modern painting—hence the analytical component of his work. The object is to separate fragments of the whole, which would result from considering a virtual picture with a virtual development within a virtual whole.[1] The metaphor here is more than valid: if that imaginary picture were a body, Marcaccio would be examining it like a forensic scientist. Thus, the first pictures of his series could be likened to the representation of experiments of a surgical kind; a brushstroke is isolated, which is communicated with an ornament, the texture of a background is injected in the wall of the room, and so on. There was a kind of delirious taxonomy in the series entitled *Cases of double and multiple take*, which Marcaccio undertook at the same time as his paintings over a period of almost five years—a supposedly infinite catalogue of drawings, which constituted a dictionary of exceptions, and which was related to the latter only indirectly, as if they were 'false relatives'.

There was, therefore, from the beginning, an analytical intention—which was almost perversely surgical, coupled with an emphatic attempt to avoid any aspect that might be assimilated to a pictorial gesture, anything that might in one way or another evoke the idea of presence, itself inseparably linked in the history of modern painting to the concept of expression. It is precisely this that seems to account for the insistent use of mechanical printing techniques related to printmaking, and more recently, photography, in his work. In the pieces done between 1988 and 1994, the application of paint appeared to have a sarcastic reference through the deposit on the

canvas of silicon marks—fantastic schemas of some eventual brushstroke—or
through the rough line of thick brushstrokes of oil on a fragment of
sackcloth leaning against the rest of the picture surface. These
brushstrokes—the surface colour of which, rarely homogeneous, contradicted
the meaning itself of the movement associated with gestuality—functioned as
a silent and parodic indication of the impossibility of conceiving of pictorial
practice in terms of presence. Both procedures were used to emphasise
Marcaccio's rejection of any relationship between his project and the various
Expressionisms. These brushstrokes, with their histrionic falseness, referred
to the brushstrokes printed on the canvas as their authentic counterpart:
what was true was what was absent. In his recent pictures, the appearance
of silicones or the thick grooves of oil has been replaced by a vicious register
of correction and retouching. The 'paint' marks that can be detected on the
canvas are now intended to give slight emphasis to certain dramatic aspects
of the work. They are undoubtedly a kind of impatient make-up, which gives
a nervous kind of movement to the surface of the pictures, heightening the
sensation of stability that seems to underlie them. The relationship between
the techniques derived from printmaking and painting in these works can no
longer be seen in terms of a simple opposition, but rather as an attempt to
construct an inexpressible level between both procedures, to integrate them
within a paradoxical contamination of the one by the other.

In the early works from the series, the artist attempted to compose
phrases with fragments of elements normally associated in formal analyses
with modern painting and, in particular, Abstract Expressionism: background,
brushstroke, dripping, frame and so on. Marcaccio worked on this version of
abstraction like an autistic translator, making the frame into brushstroke, the
background into dripping and the dripping into ornament. It is not necessary
to point out the subversive potential of such a practice in the context in
which it was conceived and executed: the restrictive tradition of North
American painting, through the normalising vision of Greenbergian
formalism. In this sense, a model of artistic experience that would savagely
decode this corpus, transforming it into a corpse animated by everything that,
in its constitution, should be suppressed, would without doubt prove
liberating. Like a guffaw of laughter, Marcaccio's painting had the violent
passion provoked by the emergence of what had been suppressed, in this
case, a kind of mocking of the concept of presence—of expression—which
paradoxically came from informalism and a peculiar abstract variant of a
certain Magrittian Surrealism. If Greenbergian formalism could be seen as
the repressive conscience of modern art, then Marcaccio's work would be
constituted on the basis of its failed acts: the accidental and incomplete
remembrance of the tradition of post-war European painting and what, in the
words of the artist, could be called 'bad Latin American painting'.

While this distortion of the alphabet evident in the early works in the
series was sufficiently aggressive in its internal structure and critical range,

the recent works cannot be classified as other than purely violent. First, the autistic phrase, and now, the ecstatic representation of a continuous activity, the verbalisation of dead times, the conjunctive tissue of the phrase. To get a clear idea of the effect produced by these works, one would have to think of a prayer in which there was no silence between the words. The terms of this phrase would be indicated from one to another, meaning would circulate in all directions and the visual result would be similar to the meticulous description of an internal explosion, the implosion of any guarantee of meaning. An example is *New Juvenile # 2* (1996), a work from the 'tent' series (clearly related in various ways to the *Parangolés* of Helio Oiticica), in which the canvas no longer rests on straight wooden stretchers but appears stretched taut over a wall with a series of mountain-climbing ropes around its perimeter, and which are prolonged through metallic tensors that are in turn fixed on the surface of the wall. The canvas does not lie straight on the wall but exerts pressure on a metallic structure, made of soldered copper tubes placed against the wall, which the artist designs separately for each work. The overall impression is that of finding oneself being a disturbing parasite on the traditional form of painting, an amorphous body whose surface has been transformed into a kind of topological model. The irregular relief of the 'tent' in turn contradicts and strengthens the capricious and volcanic narrative of its surface, contrasting with the centripetal thrust of two curved brushstrokes, which, in the middle of the canvas, give rise to a cancerous proliferation of ambiguous signs: an explosion of bubbles, or the column of smoke left by an explosion, a hybrid between the 1970s symbol of peace and the gothic heraldry of heavy rock, and a star whose points evoke the incomplete segments of a swastika and a sickle with its hammer. Furthermore, the green background merges at times with the confused image of an exalted multitude, the entire scene embroidered with elementary particles from the language that Marcaccio had previously isolated from the body of an expressive abstraction—from background to brushstrokes, and from the latter towards the frame, and so on.

In *Time Ad for Paint* (1996), the 'theatre of operations' consists of making violently explicit the symbiotic relationship between painting and advertising, the reverse of which condemns the art object to the order of merchandise. In this work, a number of unequivocal references to mass culture co-exist: there is a kind of fragmentation of the advertising sign that can be ambiguously read in relation to the tradition of geometrical abstraction, an almost stratospheric agglomeration of symbols whose changing contours point to the possibility of a process of endless mutual exchange, and the already characteristic mottled background, which, in a careful reading, proves to be the image of a multitudinous group of people. At first sight, it seems a simple narrative: the placard that becomes brushstroke that becomes a bloody spoliation and an agglomeration of emblems emptied of any meaning. The setting is a musty background of

green bubbles, which seem almost to rise up, like some gaseous emanation, out of the broadened fabric of the canvas, and which in turn have become an expectant multitude. The apprehension of the work is furthermore conditioned by the displacement of the spectator around it, since the canvas once again appears taught and distorted by a complex system of mountain-climbing ropes, tensors arranged irregularly on the wall, and the structure of copper tubes that articulates the spatial syncopation of the images. In its altered emphasis and its discontinuous nervousness, *Time Ad for Paint* sees the symbiosis between painting and advertising as pure variation belonging to the order of parasitical relations. The correspondence is immediate, since both advertising and modern painting co-exist in their symbolic existence as pure surface—at least as regards the dictum of the North American formalist logic. In this work, Marcaccio temporalises the surface by submitting it to a topographical process, which thus denies the flat quality of the elements which it at the same time extends over the surface. The figurative references enhance this effect, the result of which is the composition of a series of unresolvable oppositions: the immediacy of the surface contrasts with the historical density of the emblems whose temporal solidity is both negated by the structural instability to which they are subject and by the simulated ephemerality of the fragment of advertisement. And although there is nothing in the work that might refer to critical distancing, a violence can be detected that may be properly described as mimetic, almost a passage towards an act—but an act understood in its twofold meaning of action and acting at the same time.

However, because of their linear nature, descriptions such as those given above can only deeply betray the experience of the work, which is less that of a delirious narrative than of a pure creaking, as if the gears of a language were forced to drag themselves against one another, preventing any kind of articulation and ordered sliding of their parts, denying in the final analysis any possibility of one-way meaning. The pictorial phrase appears decomposed into a myriad number of contradictory elements, like the paths of a crossroads that capriciously point in one direction or another: literalness and ideology in this setting are but facets of the same amorphous aggregate in a permanent process of crystallisation. If all the relations between the members of the social fabric were overloaded with meaning up to the limit, the resulting effect would be practically the same as that created by the paintings on the spectator. This is the reason why Marcaccio's paintings can perhaps be interpreted as a model, in line with the modern tradition, but by insisting on enacting within its structure something that it would otherwise merely represent, the model in turn becomes an event of that something whose thought it encourages.[2] In *New Juvenile # 2*, as in a game of chess carried out simultaneously at various levels, each 'move' can go in at least two directions, which may in turn be opposed or complementary: the background is an indistinguishable mass of persons, the signs are both literal

and ideological elements, the explosion is a narrative process and at the same time an integral part of the composition.

It was noted earlier that these new paintings appear to the spectator like theatres of some strange violence, since the objective is no longer that of achieving a liberating explosion—as in the case of the works from 1988-1994, but a continuous distortion, the image of a background noise that suddenly moves to the foreground and fully occupies the spectator's field of vision. But the appearance of this violence in modern pictorial practice is anything but situational and a marginal history of painting might well be based on an identification of the works in which this facet appears. One example would be Jackson Pollock's drippings, another—perhaps in response to the former, the incisions of Lucio Fontana. There is violence in the distorted and monstrous women of de Kooning, as, in an opposite sense, in the strict simplifications of Malevich. In some cases, the violence is literal—the incision—and in others it appears in the marks left by a violent act, as in Pollock; and finally, it might be said that modern painting as a whole is an act of violence against a specific system of rules to standardise practice (and here we would have once again to quote the names of all the previous artists, and add to the list a rosary of missing names). Thus, the cold, mediatised and troublesome violence of Marcaccio's pictures remains within the circle of a tradition of rupture, which usually goes under the name of modernity. It is clear that the objective, once again, is not to make paintings worthy of the name, to make paintings into a phrase that cannot be translated into the language that apparently lies at its origin, to have nothing to do with that language, not through oblivion (Robert Ryman) but through the exacerbation of the processes of signification. Thus Marcaccio has recourse in his search for significant structures to superimpose on his bastardised version of the language of abstract painting to such things as advertising, television, computers, and all other systems saturated by images.

But it is not enough to establish the relationship linking Marcaccio's work with modern painting; it is also necessary to establish as a counterpoint an important differentiation, which identifies the singularity of the work. Whether in the case of Fontana, Malevich or Barnett Newmann, the type of operation through which the violence is exercised—literal or metaphorical—on the conventional nature of painting is the same: an extreme gesture of simplification. In the case of Marcaccio, however, the violence is the product of excess, it is a pure excess, which is cornered and cannot escape the weight of its signifying nature; it cannot cease declaring, although what it declares is above all the same act of declamation. The simplification that characterised the early modern artists seemed anchored in the confidence provided by a search for essences; Marcaccio's recent work, on the other hand, consists of an interminable accumulation of senseless suspicions. The distance between the one kind of procedure and the other is the same that might be said to exist between a specific and precise act and a continuous

activity in the process of expansion, between, perhaps, a discrete series of armed conflict and an underground, subliminal and generalised war.

NOTES

1. Here, too, this is a specifically mediated experience: the virtual body would not become an organic totality, apprehensible in an immediate way, but rather an image projected on the basis of the analysis made of modern painting by North American formalism (Clement Greenberg, Michael Fried, etc). It could be said that Marcaccio does not dissect a body but rather what, in itself, is already an 'exquisite corpse'.

2. The term 'event' has been used by Marcaccio himself to refer to his paintings on several occasions. From the context in which it appears, Marcaccio is trying to contrast this concept with one of simple presentation, naturally linked to the idea of presence. The 'event' would be the occurrence of a mixed and deferred instance of presentation in which the model (the work) would become partially activated in relation to the presence of the spectator, without this activity being in itself self-sufficient. The objective would, of course, be to affect the audience, but in an incomplete way: the effect that the works would produce in the spectator would necessarily be subordinated to a linguistic apprehension of the works. The evocation is undoubtedly that of a mixed instance of aesthetic experience in which affection and rational apprehension would not be initially divorced.

Fabian Marcaccio in Conversation with David Ryan (1996/7)

David Ryan: How useful is the term 'abstraction' to you? Do you find it relevant to your practice? Would you class yourself as an 'abstract' painter?

Fabian Marcaccio: I'm more interested in seeing the work as having abstract roots rather than being abstract *per se*. I'm coming from a tradition of abstraction, whereas other artists' work might be rooted in a realist, photographic, conceptual or literal tradition. It is of course difficult to define what is abstract, especially when we're now faced with abstractions of abstracts, a kind of meta-abstraction. I suggest that my work is best seen as a

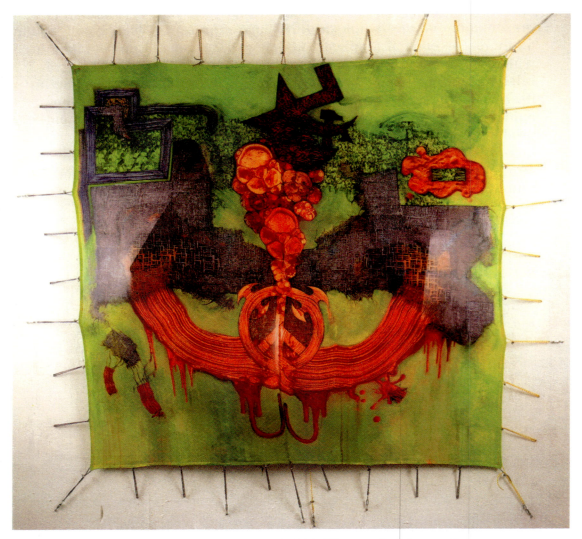

Figure 27 Fabian Marcaccio, *New Juvenile #2* 1996, Water and oil-base paint on canvas, copper tubing and nylon ropes, 305 ×305 ×36 cm, Courtesy Gorney Bravin + Lee, New York.

complex or expanded abstraction; one that confronts and absorbs these other traditions, and at the same time leaves behind the space of traditional abstraction. It's important for me to examine and play with the idea of how abstraction continually reworks its own material. This is partly because traditional abstraction didn't go deep enough, in terms of a play with a new notion of internalised abstraction, almost in the way a 'para-language' might operate; whereas photography, throughout the century, functioned in a journalistic sense in relation to so-called reality and therefore dictated the operational terms of classical abstraction. It is now in a different situation. Present photography is becoming much more of an abstract practice in the pejorative sense of the word, because of the technology of digitalisation. Photoshop, in particular, transforms it into an electronic farce. If we take another of those traditions that I've just mentioned—the Conceptual—then we can see that this favours a particular framework for viewing ideas; one that is particularly time-bound—the 1970s, when it was believed that ideas escaped commodification. Right now, an idea like the Internet is more expensive than the value of a feudal castle. Painting, especially abstract painting, because of its experience with dealing with structures, can cut between different modes and achieve a more interesting relationship with contemporary realities.

DR: So, you see the approach of contemporary abstraction as a pluralistic one?

FM: Yes, the notion of expanded abstraction embraces these other modes.

DR: In the past, you've suggested that the term 'paradoxical network' is fundamental to your project.[1] Could you elaborate?

FM: Well, thinking back to when I started out, and what I wanted to put together, there had to be a basic starting point; so I started rejecting the structure of the grid, because I thought this was one of the hallmarks of abstraction's self-alienation. I also rejected the idea of flatness together with classical or conventional compositional approaches. I knew I had to destroy these elements for myself, and my starting point was, in fact, to re-analyse the space of collage as a route for abstraction. Collage is a more contaminated and dispersed space, and it was quite a loose place to start … lousy, even [laughs]. But there was a heterogeneity that was important to me as a base, so I rejected all those other ways of organisation for painting in favour of a mode that also transcended collage—a collage that will understand itself as a new 'coherent' thing. Something more advanced than simple collage, where one is not aware of the cuts or fragmentation usually associated with that particular mode of working. Later on, I used the term 'Paintants' as an empowered version of painting not connected with the usual

limitations suggested by the pictorial. The notion of 'paradoxical networks' follows from this, in that collage is an extensive and heterogeneous system, and yet I would describe my work as an intensive and cohesive practice. It is really a new alignment of stuff coming from collage.

DR: How important are ideas from scientific theory? Obviously there are links here, not only in the sense of how you've just been discussing the 'matter' of painting, but also how DNA, genetics etc might be mapped onto the tactics of generating form in the work. These issues would appear to inform some of your thinking. Is this simply a chance overlap?

FM: In the beginning, I used the idea of an 'altered genetics' of painting, but I didn't mean to be scientific; my take on it was more poetic. I used these references in some early titles, but also pointed to another domain: namely, the notion of the 'altered', or the mere possibility of contemporary 'otherness'. I thought that the more diverse things that connected with the work, the better. Classical abstraction worked to disconnect from it all. I'm working from the perspective to present it as a connective matter, to find where the tissues lie. As for the notion of genetics, we find it everywhere, and on different cultural levels right now; it has been absorbed, and perhaps we don't need the scientific angle to grasp it.

DR: The work is extremely synthetic as you've already mentioned, and one might even say artificial.

FM: Yes, extremely artificial. Artificiality, for me, is not a pejorative term like in the 1980s, where it was associated with ideas around the commodity. I'm trying to define a positive relationship to artificiality, and I'm interested in how you can alter pictorial matter to get something new out of it. Early on, I was interested in putting together compounds of pictorial matter that were indistinguishable from their sources, and extremely unstable. Going back to genetics, the notion of genetic mapping and its particular usage is related to this. In another way, the artificiality associated with my work could be traced back to the fact that it's not only a 'bastardised' use of painting—for example, figure-ground in painting—but also of focus-unfocus in photography, multiple scale-diagrams from topography, and amplification-sampling from advertising.

DR: Following on from this, the sensation of mutation seems a very prevalent trope that is explored in the work. And this can be taken to an extreme—I remember seeing a work in Vienna at the Secession, where one part of the piece seemed almost violently broken off from its 'parent' form.[2] How pre-planned are such events—does it come out of the process, or is it designed at the initial stages?

FM: Well, I like this rupture at the level of materiality, medium and content, but at the same time, it's a process of healing. It's interesting that you refer to it as a 'mutational' quality; as regards the planning—it is both—sometimes pre-planned, or it happens while the work is in the making, depending on the individual piece. One of the reasons for this is that I want the work to go beyond self-consciousness, as if the pictorial tissues are self-producing. It is as though all re-painting or painting occurs through a post-consciousness. In my early work, the ruptures are more pronounced, because I wanted to achieve a highly complex resolution with a totally incongruous set of materials. This is something that still continues to interest me and I still explore it, but this mutational quality in the present work is at the level of content. My work always deals with support and image as well as a kind of information overload. For example, if we look at the recent 'paintants', like the piece you mentioned in the Secession show in Vienna, we will see that the materials are much smoother than in my earlier work—you enter it as an iconographic painting, but as you try and make sense of it, it mutates into a kind of photograph with indexical information—and then, at the same time, it looks like another thing altogether, like an advertisement or propaganda, perhaps even a three-dimensional cartography. So it is this excess of transmission that interests me here—the figural, signs, abstract matter, structure and so on.

DR: Yes, we have this kind of fluid situation at the micro as well as the macro level in your work. In the sense that it's difficult to grasp any of the elements singularly: they fold into neighbouring forms or other elements. Even down to the material support in the earlier work—in the sense that the stretcher bars seem to imitate (although imitate seems to suggest a cause and effect that the work also denies) brushstrokes—they too seem to be mutating into a kind of figural activity.

FM: Yes, but more than a notion of imitation, I'm thinking of a kind of feedback—where the framing structure behaves as an image, the pictorial behaves as structure, signs behave as organic matter, etc. 'Framing' then flows on every level instead of just to the edges as in conventional painting.

DR: I was quite struck by the fact that, in the earlier work, the stretcher-frames themselves are highly crafted in one sense.

FM: They were carved—and this is something that I've moved away from in recent works. In connection with these carvings, I tried to use a new type of procedure of 'casting' wood. It's this same 'cast wood' that is utilised in the production of new furniture. But this was too expensive, so in the end, I settled for a modest carving. Now I'm using copper pipes like a plumber or a banner maker; I feel more comfortable with these structures and the possibilities they bring.

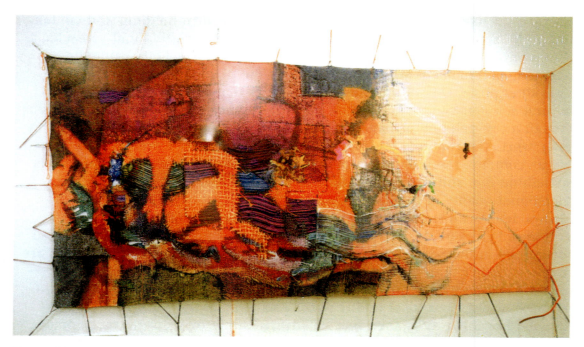

Figure 28 Fabian Marcaccio, *Compress Paintant* 1998, Water and oil-base paint, silicon gel and polyoptics on canvas, plastic mesh and copper tubing and nylon ropes, 244 ×427 ×30 cm, Courtesy Gorney Bravin + Lee, New York. Photo: John Bessler.

DR: Do you think you'll go back to the carved, elaborate frame supports?

FM: These new pieces are getting more elaborate than the former, so I don't feel I need to, at least, not at the moment. The spatial possibilities of these new structures are richer—they're lighter, and they embody the temporary nature of a tent structure. They give a sense of rudimentary architecture—a sense of the ephemeral, the nomadic, and the often disempowered feelings associated with a trailer park or shanty town—in confrontation with the rigid, oppressive, late-modernist structures of corporate architecture. This brings us back to the idea of collage: the shanty town or trailer park is the ultimate consummation of social collage. But this has nothing to do with the rather ridiculous notions of 'nomadism' that accompanied the Transavantgarde of the 1980s.

DR: You are arguing for it in a more philosophical sense?

FM: I think of my approach as empirical—you know, this is exemplified in the space we're talking in right now. Here we are on the Lower Eastside, which is a good example of this: all these different pockets of culture function both within institutional structures and outside of them, so that the

social fabric is never static and it creates more fluid structures and gestures than well-off neighbourhoods—it's a hit-and-run type of structure that's also echoed in the tent-paintings that I make. This results in real trans-subjective gestures instead of those subjective gestures that relate, say, to abstract expressionism. These trans-subjective gestures are massive affects or communal gestures.

DR: The recent work explicitly picks up on some of these ideas. The earlier work seems to turn inside out the gesture of Abstract Expressionism. Here, I'm reminded of the composer Pierre Boulez's description of his work as a fixed or contained explosion. Almost the obverse is true of your works, in that they're barely contained implosions.

FM: I like that—and I don't need to add anything to it.

DR: The new work seems to pick up on this notion of what you've described as the 'massive affect' of a kind of communal gesture, and you mentioned power. The paintings are inscribed with all the visible signs of the darker side of communal power with barely transformed hammer and sickles or swastikas lurking here and there; these are readable insignias …

FM: This is a recent development, but in my view, it intimately continues a relationship with more abstract elements that occurred earlier on. It's the exploration of signs that have multiple levels. I don't necessarily think in negative or positive terms about them—I don't think it's possible to abolish ideology, as painters in the 1960s and 70s might have believed. After the Cold War, we observe the spread of micro-ideological activities, and I'm trying to work around this, together with some other notions like internalised Fascism, or economic terrorism. Rather than questioning whether it's possible to surpass ideology—and here I'm thinking of Gerhard Richter's concerns, which unfortunately can lead to other traps like nostalgia—we have to find ways of taking it on board, at the level of the micro, and the complex. As an example of a changed situation, we only have to compare the unified demands and ideological frames of the student demonstrations in May 68, in contrast with the diverse and contradictory agendas at the recent demonstrations at the UN.

DR: That's interesting. There's an essay by Derrida on Nietzsche called 'Otobiographies', where he talks about the 'double programming' of any text: that it can be appropriated by the left or the right, and that the text, almost genetically again, will contain the blueprints for these future destinations; that Nietzsche the radical and Nietzsche the Fascist are somehow part of this double programming.[3] In connection with this, a friend of mine used the example of a court case, where the same piece of security video was being

used by the defence and the prosecution! I would have thought this kind of simultaneous play and cancellation of opposites would be relevant to these highly loaded insignias melting into one another and vice versa?

FM: Of course, that's actually an interesting concept. But I don't think in terms of a cancellation of opposites, rather, at closer inspection we can see that there's a residual piece of information that comes out of this supposed cancellation in favour of one side. In a more general sense, in relation to what you just said, Fascism perhaps became internalised in certain communities, while, on the other hand, ideas of Socialism have become a luxury—and this is important because the development of Socialism has an intimate relationship with the advent of abstraction and I think the remaking of abstraction will bring a rethinking of new forms of Socialism in opposition to this neo-liberal world.

DR: I'm also interested in these crowd scenes that ebb in and out of a seemingly purely textural activity. Like the signs of power or ideology, these might be seen to stand in for the communal, for a mass audience, not only in connection with the latter, but also with painting or art itself. We can think of the great idealist hopes of modernism here; are you inscribing a sense of loss?

FM: If I am using these things, then it's for spectators to think such things as you've just said. What's interesting for me is the operation that forces this easy sense of loss—there's a reverse logic or common sense going around that thinks abstract painting cannot be popular or political, or whatever. In many ways the work addresses this issue, and I ask myself, what is the loss? Who is capitalising with this sense of loss? In regard to this, you have to understand my work in relation to a kind of peripheral, Third World modernism, and this carries with it a constant artistic and social crisis: a notion of anthropophagy instead of appropriation, contaminated abstraction rather than pure abstraction.

I think there's a flow from the realm of abstract painting to the real. This paradox is central to painting with abstract roots because within abstraction there's always the adventure of some kind of structuralism, unlike photography, which can mostly be confined to the reportage of the literal, or in the end, with advertising. I think it's crucial that art avoids this journalistic sense, but that it also avoids an easy formalist approach. Painting can, in fact, devour this aforementioned problem because its very nature is transformal. It is not a question of imitating other media, but of absorbing them while retaining its own enigmatic quality. We can work with these beliefs not in a nostalgic way, but by seeking moments of truth or relative truth, as a constant negotiation with the real—different from the kind of negotiation that prevails in the world of economics.

DR: You once suggested, some years ago now, that you were involved in creating a kind of lexicon of forms that you 'warehoused'.[4] I was talking to Jonathan Lasker about his similar approach to this and its relationship to linguistic permutations and operations; how important is this for you?

FM: Well, I think this is misleading. I like to think of painting as being at a late stage. There can be an overwhelming feeling that everything is codified. However, contrary to this, my idea was to analyse something that looked like an 'a-b-c', only to show a totally new situation. When painting entered into a reductive mode, it was easy to identify it coherently, and it was clear what was within the boundaries of the language and what was outside of it. Flatness was in, and deep space was out; there was no way out of this. But when you enter a situation of what I call 'complex painting', this changes dramatically. My road into this was to develop pictorial compounds that would act with each other in the form of unpredictable networks. What you call a 'lexicon' is, for me, a multiplicity of empirical reminders, in the form of notes, rather than setting up a system of forms that I would recycle forever. It is the other side of reductionism, like a means of developing an active map—yes, like having a model or a map, and yet at the same time an action or event that inspires it, both dissolving each other ultimately. I think these notes are different from quotations or appropriations. The idea of pure originality is an absolutist way of thinking, just as the notion of pure quotation, like Neo-Geo, is totally sterile.

DR: I'm intrigued by the characteristic use of colour—the greens, violets, oranges. How do you see this as functioning?

FM: The colour works for me in a disjunctive way. The truth is that whatever convention is used in terms of colour, it becomes a limitation in some way: the modernists' use of primary colours for example, or even the colours of the decor and fashion of the day. There is a secondary quality that interests me: if I think of using yellow, I will use an extremely light green instead; rather than red, I'll use an unstable orange, and instead of blue, I'll often use an ambiguous turquoise. This creates a more shifting situation. I also work with white, which functions more like a movie screen than an empty canvas, but I try not to dogmatise it. I could say more about colour from a less technical angle; I tend to use less aristocratic, less refined colour.

DR: On one level, it seems artificial to isolate colour in this way, doesn't it?

FM: Sure. I work to produce a sense of colour that comes from artificiality and moves toward the natural, instead of pre-industrial earth colours. I always use the example that the Impressionists could only achieve the natural effects of the landscape-related colours because they used industrially

readymade artificial colours. Before their time, there were no manufactured synthetic colours.

There is an artificiality that has long invaded our sense of the natural. For example, you might have a tomato that has been picked too early, and in order to make it marketable, artificial colour is added. The natural is constantly being reinvented according to consumer expectations. It is no longer necessary to paint a still life, because it exists out there in reality: it has already been fabricated by industry, like the colour in the tomato, or the wax varnish on an apple. It's like Warhol once said—the interesting phenomenon wasn't so much how art was being commercialised, but how Western commerce had become artistic. The artificial is always related to our constructed notion of the natural.

DR: You mentioned earlier a kind of empirical experiencing of theory. I know that in the past you've been extremely interested in ideas coming out of Deleuze and Guattari; is this adoption of theoretical positions still important, or was it simply a springboard?

FM: I think this is problematic in many ways. There's a pejorative way of seeing the relationship between painting, philosophy and other realms. It's one thing to write or read philosophy and another to make paintings—that is, making paintings as pictorial matter let's say, rather than to pathetically illustrate ideas. For me, it's important to expand the corpus of painting in pictorial means in order to avoid an illustrative approach. There is no other way. During the 1980s, the relationship to theory became a caricature—art became a vessel to carry theoretical views. My use of theory is a much more relaxed one, and I feel that I use it in an organic way as I develop my own terms of theoretical reference. At the same time, I share my sympathies with certain philosophical ideas because I believe there's no way to separate the production of art, thoughts or things—they all come together.

DR: On a more general note, how do you see the status of current abstract painting?

FM: Saying 'abstract' is rather like saying 'philately': it reduces it to a crude category, which is why I suggest my work has roots in abstraction rather than being abstract. I've been in many shows that attempt to define abstraction and they fail to do so. This is because the world is connective, and if abstraction doesn't recognise this, then it creates its own ghetto, its own end. The more important thing is to make art that really engages with the world. So, abstraction as a beginning is interesting and not abstraction as an end in itself.

NOTES

1. Raphæl Rubenstein, 'Abstraction in a Changing Environment', *Art in America*, October 1994, p. 108.
2. 'Transformal', Wiener Secession, Vienna, 1996.
3. Jacques Derrida, 'Otobiographies' in *The Ear of the Other: Otobiography, Transference, Translation*, University of Nebraska (Lincoln/London), 1985.
4. Rubenstein, 'Abstraction', op cit, p. 108.

HARD BLISS: THE INDISPENSABLE THOMAS NOZKOWSKI (1997)
Peter Schjeldahl

Thomas Nozkowski's small, tough, inexhaustible paintings inhabit the art history of the last two decades like half-submerged rocks in a stream. That is, they are right in the flow, but they hardly go with it. They don't go anywhere. They endure, transfixed and transfixing, as if they had always existed and always will. They don't affect the current much. Anything adrift on the stream glides around them, unbothered. Only from a removed point of view does their presence fully register. One observes a separation of waters and perhaps a delayed effect: the little snarl of an eddy where the split current reunites unevenly.

There is a poetry to eddies. An eddy suggests a little reluctance or sullen compunction in a stream, an itch to flow sideways or backwards for a

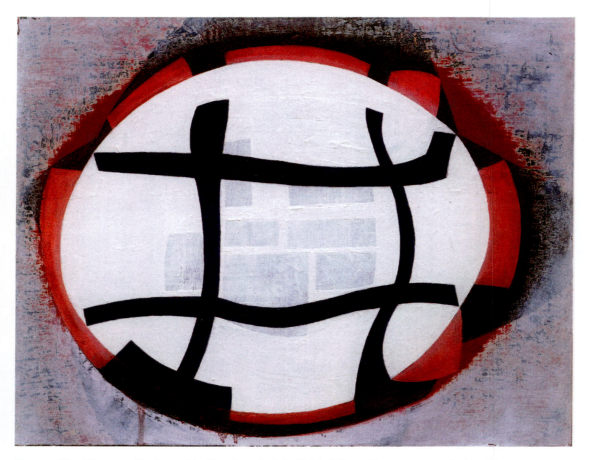

Figure 29 Thomas Nozkowski, *Untitled (7–84)* 1996, Oil on linen on panel, 41 ×51 cm, Collection The Hirshhorn Museum and Sculpture Garden, Smithsonian Institution, Gift of Anthony T Podesta, 1996 Washington DC. Photo: Lee Stalsworth.

change, or to take a break from flowing at all. It recalls a sensation of exercising critical intelligence, which constantly produces resistances and exceptions—principled misgivings—to the development of any idea.

I reach for a natural analogy to introduce Nozkowski's work because nothing artificial—no theory of aesthetic plumbing, say, predicting the output of spiritual pipes and faucets—will do for this art's obduracy. Looking at Nozkowski's paintings, I feel up against something that, while intensely sophisticated and subtle in form, is primitive in essence. It is a thing that survives. To continue to exist as itself is its first and last priority. The torrent of contemporary art's dominant styles cannot sweep it away or even budge it. Thus: rocks in a stream.

Nozkowski's paintings won't supplement anybody's art education. More likely, they will mess it up, though rather precisely. They introduce opacity and confusion into what you may think you know of painting's recent history and present uses. They are stumbles or stutters in educated aesthetic response. Meanwhile, they please, ruggedly. They are not decorative. They pose dilemmas—scandals, in a way—for the eye, challenging vision to account for them. The harder, more searchingly and sceptically, even antagonistically, you look at them, the better they get. This is not true of most art, which signals a certain point for the eye to break off scrutiny and surrender to a melting embrace, a clinch of taste or other conventional romance.

People who love Nozkowski's work, and there are many of us, tend to be a laconic, cagey bunch. We have no party line, no flag of a consensus opinion to salute together. We are often surprised to encounter each other and cautious if not downright wary, doubting the cogency of each other's or—if the other projects confidence—our own, judgement. Nozkowski's art operates at a psychological depth that feels irrational, asocial, and personal to oneself. When someone presumes to agree with me on that level, I find myself suspecting that one, if not both, of us must misunderstand what we are talking about.

Though possessed of no signature style, Nozkowski's paintings aren't exactly styleless. They advance infinite styles, one per picture. Each work is *sui generis*, as if it entered the world alone to bear the burden of art for everybody forever. It is not a fragment of Nozkowski's art. Fractal-like, it is the whole. This makes viewing any very large group of Nozkowskis a notably eventful, exciting and gruelling occupation.

Imagine traversing a jungle and coming upon tribes, each with a sharply different culture and language. You stay long enough to become communicative with one tribe. Then, at the next bend in the river, you must start all over again. Nozkowski's work is all one place: Nozkowskiland. You know where you are. But when you try to grasp the region's shape, it becomes like Pascal's definition of the universe: its centre everywhere, its circumference nowhere.

Nozkowski's deployment of staggeringly various painterly techniques and tropes beggars formal analysis, which functions by identifying patterns of

repetition and resemblance. Every detail of a Nozkowski feels ad hoc, thus unrepeatable, and resembles nothing but itself. To grapple with specificities of shape, colour, or execution in this work is like trying to catch a thrown beachball while holding a beachball. Each aspect is a total handful. I find that clearly remembering a given Nozkowski is almost impossible. Looking at one, we are continually just beginning to look, engaged in the freshness and puzzlement of a first glance endlessly.

Two great artists of the past insistently come to my mind when I reflect on Nozkowski: Paul Cézanne and Edward Hopper. Think of what those two, so hugely different in so many ways, have in common. For me, Cézanne and Hopper share a quality of fierce artistic passion shadowed by bottomless scepticism about the understanding capacity of other minds. A sort of despair of human connection informs Cézanne's selfless concentration on his petite sensation (all of existence reconstituted brushstroke by brushstroke) and Hopper's excruciating architectonics of solitude (hopelessness of communication communicated exactly). With melancholy rapture, each sustains a determination to perform art in the teeth of its certain defeat.

Anyone honest who regularly attempts anything without the services of a scoreboard or other bottom line incurs terrible moments of futility, when further effort appears meaningless. The best suffer most. The best writers know most acutely that words fail, as do the best photographers that the camera lies. Most of us recoil with a shudder from such recognitions, resuming a condition of blind faith in our undertakings that let us go on. It is with a touch of fear, then, that we confront the unallayed consciousness of a Cézanne, Hopper, or Nozkowski. And it is with glad humility, at last, that we accept such figures as mentors in courage.

How do I derive these thoughts from a lot of quirky, gawky, eclectic little abstract paintings? Somewhat as an oyster forms a pearl, by reacting to an irritant over an extended time. It is not for want of trying that I have failed to dismiss, reduce, explain away, or otherwise expel the provocation of Nozkowski's art from my experience. Give it a try yourself. Set out to discern how any given Nozkowski is bad or silly. Knock yourself out. The painting will be bouncing up at the bell long after you are prostrate in your corner.

Oysters? Boxing? Yes, I mix metaphors, leaping from one angle of thought on Nozkowski to another. This is the effect on intelligence of something that yields nothing to logic. Logic is an affair of parts. Nozkowski provides only hermetic wholes. 'At its best', he has said, 'art is a closed system'. Take it or leave it. Taking it, one has imaginative recourse to other closed systems. Nothing that a Nozkowski reminds you of can be either incorrect or definitive. As with intelligence itself, you may use this art indefinitely without ever using it up.

For the record, Nozkowski testifies that each of his pictures crystallises a personal memory, usually the visual trace of a place he has been. To possess that memory, you would have to be him. (Its accuracy is a matter of

professional integrity, no direct concern of ours.) Being yourself, you are bound to associate freely, summoning meanings from your own depths that are commensurate to the work's pitch of gravity, finesse, and humour. You may do this repeatedly, coming to the painting in the present tense that is its eternal address. We have different selves at different times.

Why would one submit to a lonely experience at once so refractory and so open-ended? I hope it is obvious. For those who don't immediately grasp the point of it, the exercise is apt to remain pointless. This art rewards precisely the effort that it demands. It is art less as Matissean armchair than as stationary bicycle for the eye and mind. Feel the burn. It will do you good.

Tom Nozkowski in Conversation with David Ryan (1997)

David Ryan: Your work is well known for its intimacy, with its centralisation of silhouetted motifs and a corresponding psychological engagement with the viewer, which has often been remarked upon. Has it always dealt with these issues?

Thomas Nozkowski: Well actually, no. I went to art school in New York in the 1960s and after this I made extremely large paintings that were systems based. So there were paintings of dashes, paintings of dots, etc—things covered with marks in a regular sort of way. Now one day, I realised that what I liked in these large, complex, systematic paintings, was when 'things' would appear; 'images' would appear by default. This was residual and accidental to the system in question, but it was the thing that engaged me most. One day, it just hit me that maybe I was using these systems as a way

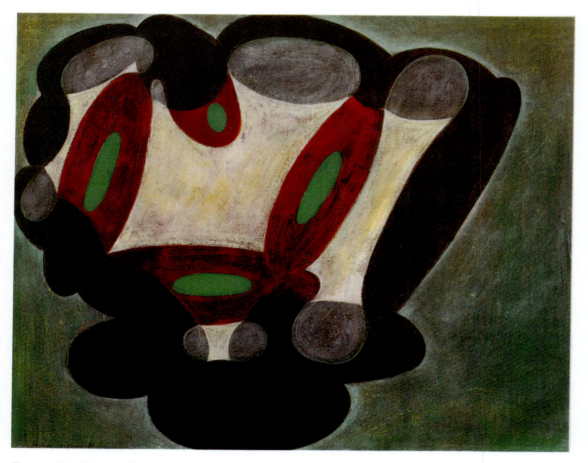

Figure 30 Thomas Nozkowski, *Untitled (7–38)* 1994, Oil on canvasboard, 41 ×51 cm, Collection Clifford Diver, Lewes MD.

of avoiding responsibility, and that if I was interested in image-making, then I should make images as directly as I possibly could. At the same time, I was involved in politics, and in my politics I wanted things to be as clear and honest as possible, so it seemed necessary to change my procedure.

DR: With what kind of politics were you involved?

TN: Radical politics: race, Vietnam, sexuality. Because of the political thing, I wanted to stop doing large paintings; somehow, I wanted to do paintings that fitted into 'normal' rooms: paintings that weren't appropriate to bank lobbies, and which would look 'useless' in the institutions. I now have another argument with this idea, but at the time it seemed relevant and I started working with this 16 × 20 inch format.

DR: Did this almost improvisatory approach to form immediately follow suit with this process of scaling down?

TN: Actually, at the same time I had a little bit of success as a sculptor, and this is quite odd because I really loved painting and the sculpture was just something else I did. But the 1970s weren't a very good time for painting. I'd have collectors come around and I'd show them some paintings—maybe like this one over here, [pointing to a work] and I remember in particular one famous museum guy, who said, 'Oh, very nice. Did your psychiatrist tell you to work like this?' [laughs] At that moment, painting was supposed to be gigantic, monochromatic and with as little incident as possible.

DR: So it was a kind of image-painting that you developed from this time?

TN: Yes, it was. I try to work in some way from reality, from something in the real world, literally anything. I try to make it as difficult a problem for myself as I can. You know, maybe, to do a painting about our conversation right now. What is the most visual aspect of this moment? I like thinking in this way: to think about memory visually. I try as hard as I can to find unconventional ways of seeing the physical world. So the source of the spark could be anything—a book I've read, or something I've seen—but the process is a visual one of constant translation. To work at a painting, and when it's done, to know why you wanted to make it in the first place: that is important to me. Painting can make things clearer in this way; you know: '*now* I know why I wanted to do that'.

DR: Would certain things be more of a trigger for such a situation than others?

TN: Probably, but that speaks to our individuality, doesn't it? Why do *you* look at *this* and *I* look at *that*? And, of course, it all changes over time as

well. When I first started working in this way, like a lot of young artists, the sources often came from other paintings—older paintings like Pisanello, or Titian or whoever—asking, 'why do you really love this painting? What is it? How does it work?'

DR: In the form of using a detail or fragment from the painting?

TN: At first, it would have to be—I needed to have something to grab on to. But I'll give you an example: one specific painting that was important to me, Pisanello's *The Vision of St. Eustace* [mid-fifteenth century] in the National Gallery, London. I saw it 'in the flesh' and ... well, every artist has these moments when you see something and you know everything about the painting: why it was painted, how it was painted, etc. You feel you know every inch of the painting. I did a number of things to try and get what was there—to paint the narrative, paint the colour, paint the shapes—and to attempt to find where the power of the painting really resided. It wasn't such a leap from doing this to using my own starting points in the world, and my own life in fact.

DR: It's interesting that you don't title any of the work, even though there is this emphasis on a source. Do you see the paintings as ultimately resistant to words, if that is at all possible?

TN: Well, I'd certainly like them to be. And, you know, I did start off titling them, but they then immediately became conundrums—you know, how did this guy get from *Brown Cow* to *this*? I think it's hopeless for people to get the full meaning of practically anything. You look at a High Renaissance painting, which appears crystal clear, and it's just impenetrable ... The longer you look, the stranger all the artist's choices appear. We don't really know what was meant. But what you do get is a believable machine that is capable of running independently of its intended meaning. The logic of the structures of the painting may remind a viewer of an order that he senses in the visual world. Sometimes, the flavour of a specific instance is readable. It happens often enough that I'm not surprised by it. What is important, though, is that the viewer sees this as more than just an arbitrary game. As I get older, however, the meanings tend to get more conflated, and I think it's more difficult to get what the painting is 'about'—for me as much as for other people.

DR: So you've become less sure of painting as a direct vehicle for the transmission of particular meanings, or feelings or whatever?

TN: They feel increasingly impenetrable and, strangely enough, the part that people might 'recognise' or immediately latch onto, is often the least

interesting thing about the painting. Somebody recently recognised an Oriental motif as a source for a painting … It was there, sure, but its identification isn't terribly interesting or important. All of this high-concept stuff in art—politics now, systematic painting then, my ideas about using the real world—all these ideas mean very little. The one goal is to make pictures that are rich, dense and interesting to look at. What irritates me about much political art is that it's not very interesting politics, it's not, generally, a sophisticated analysis. It's more like reporting on a particular political position. With painting, we have one of the most sophisticated tools that civilisation has managed to come up with. We've got five hundred years of oil painting and twenty thousand years of image-making that we can draw upon and use. I often think that it's just silly that people don't pick up on this as a tool, which can result in something quite profound; something full of beauty.

DR: If you use history as a tool, is it also a situation of confronting that history, an active and critical engagement, without wanting to dramatise the situation?

TN: You don't let the tool take over. I mean, there's a big difference between using history and connoisseurship. I like art that sees history as a kind of menu of options: permissions to reach for something new. Why I believe in abstraction, is that I feel it increases the potential of painting. The history of abstract painting is just beginning, I'm convinced of that. You could argue that, within the tradition of flat image-making, abstraction is the dominant force, with all those 'despised' modes of pattern-making: the Byzantine, non-Western traditions, and also medieval, religious art, etc. And we could even go so far as to suggest that Western art after 1400 is really an aberration: a blip, a mistake in the history of abstraction. Then again, we talk about 'abstraction' so casually, often without really thinking it through. I think the situation of abstraction is wide open—it shouldn't be some narrow definition. There's so much that can be done and will be done.

DR: You mean that abstract painting shouldn't be bound by the baggage of rule-based conventionality like, for example, the Greenbergian-inspired dogmas of the 1960s? In this context, it's interesting that your painting conjures up a kind of constant invention and singularity.

TN: Yes, well, that's through working with a source in mind. It focuses and gives a specificity.

DR: The play with figure-ground relationships would also appear to be a characteristic.

TN: Well, I think one could say that it's my weakness as much as a strength. Half of my education was from ex-Bauhaus people and so there was a lot of silly colour theory and a lot of figure-ground stuff that was floated around at that time, and this does pop up in the work. The better part of my education was, however, by Abstract Expressionist painters. The critic, Saul Ostrow, once had a very funny line: he said he thought I was doing 'Abstract Expressionism in slow motion'—this pleased me very much.

DR: Yes. It does seem to catch something of the paintings and something of the method.

TN: I work on these things over a long period of time, often over a period of many years, until they're resolved and reach some kind of 'conclusion'. And I don't tinker, you know. Each time they get back on the easel, they're scraped down or a fresh wash of colour is laid over the whole thing. So pretty much what you see is the last work I did on it—totally, that is. I very rarely go back merely to 'correct' or adjust a colour or whatever; it's generally a total reworking.

DR: Is the colour also rooted in a particular perceptual memory?

TN: Colour is very strange. I think it doesn't play as large a part in our visual memory as most of us believe. Maybe we're suffering from some kind of hangover from Post-Impressionism. I find it disturbingly imprecise. It's nice to use, though, to separate one shape from another ... [laughs] I think I'm pretty casual about colour. Sometimes it does have connections to the source; sometimes it's more arbitrary.

DR: I was looking at a painting of yours only the other day and I particularly enjoyed the colour: it glowed. Yet the colour was incredibly muted, murky almost, if each form were taken separately. And yet despite this, there was a subtle activation overall. This suggested a very conscious control, far from casual in fact.

TN: When I first started making imagistic paintings, they were, originally, way back, on a much larger scale; very large in fact. I remember thinking about initial decisions—like, say, the colour of a ground—'blue', I thought, 'I'll paint it blue'. And it would take me three fucking days to get it down. And just as you're almost done covering it, you'll think to yourself, 'Y'know, this looks like shit'. And it'd take three more days to get rid of it. Now, working much smaller, I can put something down as capriciously as I like and wipe it off immediately if it doesn't work. I'll try anything. Through serendipity, I can come up with all kinds of things I couldn't have come up with intellectually.

DR: How does this acceptance of the 'serendipity' of the painting process square itself with the notion of addressing a specific source?

TN: It's a little schizophrenic, but I like to let the two aspects, accident and intention, bounce off each other. I try not to be continually conscious of the source throughout the work on a particular piece; at a certain stage, I try to put it aside and just pursue the logic of the paint. You have to ask—does this actually end up speaking to the source? I'm sure there's a level of subconscious interaction that's almost like free association. But the goal is to make a good painting, and it's almost like the painting will demand its own terms. There's always this discrepancy between something figured in the imagination and how it will act physically. You take a particular yellow—you might have one in mind—and you put it down on the canvas and it doesn't do what you intended. Or a shape might not function in actuality the way you thought. You might shift it around; take a bit off here or there. One thing is for sure though: I couldn't have imagined these things from the start, working without a subject.

There's a marvellous essay by Robert Graves, called 'Food for Centaurs', where he begins by quoting Alexander Pope, who says something to the effect that what is great about poetry, is these wonderful, unanswered questions that abound: what songs did the sirens sing to Ulysses? What food did the centaurs eat? etc, and the fact is that you can never answer them or catch them. Graves says that Pope has got it exactly wrong: what is great about poetry is that you *can* answer those questions if you apply yourself as hard as you can. You can come up with satisfying answers, and answers that speak coherently to what the question was. I like that argument. Likewise, in painting, I'm intrigued by questions that seem, at first glance, almost unanswerable in that medium: how do you do a painting of a newspaper story, a song, or something ephemeral, like a particular moment or whatever?

DR: How would you actually go about working on such material and enable the source to inform a painting?

TN: I'll give you an example. My last show, as both an experiment and a challenge, attempted to make a kind of an autobiography.[1] I thought it might be interesting to organise it spatially. I've spent my entire life in the Hudson Valley. Everything important in my life has happened in a hundred mile stretch between my studio in Lower Manhattan and my house in upstate New York. I divided that distance into twenty parts—five mile increments—and tried to come up with a painting for each step ... kind of a crazy idea, but I wanted to try it. So each painting spoke to my past in a specific way, and I attempted to paint about things I knew or had heard about directly. It was a very interesting experience. Half the paintings were terrific ... [laughs] the other half were okay too.

But to go back to your question, I don't like to describe or outline how a source might relate to a painting; it becomes too verbal, too descriptive and confuses the whole thing. Just to give you an idea, though: one image starts with an apple tossed into a fire, the white flesh swelling in the heat and breaking through the tight, red skin. Then it gets conflated with a Polish Eagle … then the whole thing takes on a sort of landscape scale. That's how it begins, but before it's done, twenty other things get shoe-horned into it. That's one of the reasons why I don't like to identify the sources for the audience, because so many ideas cross your mind; you're working towards one specific point, but so many things might be referenced from many different angles.

DR: Did you want this group of paintings to be read as a narrative, almost sequentially?

TN: No. Absolutely not. I just wanted to generate twenty interesting paintings. End of story.

DR: But you did say 'related' pieces. Do you ever encourage interaction between paintings through particular hangings, getting a sense of ensemble from the works?

TN: No. In fact, that approach drives me nuts. In the past I've been encouraged to do this and I think it's dreadful—it looks awful. I want these pictures to stand on their own. In fact, I want as little interaction between them as possible. Because these pictures are smaller by contemporary standards, people often want to join them together and see them in groups. People still tend to confuse size with importance. But here we are, ending up talking about size again. There are so many issues that the paintings address other than this … I remember seeing—around 1975, I think it was—a show of Ray Parker's work, a very interesting artist actually. And there was a painting here that was about 35 feet long—35 feet! It was as though it was saying, 'Call yourself a collector? Collect *this*!' It was this situation I wanted to get away from, which I felt was both gross and absurd. You know, nobody spends as much time looking at our work as we do; no matter how much someone supports or admires us. Whether it's the people who write about us, or whatever, they're not going to put in anything near the thousands and thousands of hours we spend staring at these things in our studios, trying to figure them out and to get to know them. I figured that getting them into a domestic environment where somebody might encounter them every day, where their presence could be slowly experienced, then this might give them the chance of being seen closer to the way I see them.

DR: As you said earlier, this was a political decision, and it's an interesting reversal of the tendency towards the mural-sized picture in the late 1940s, again a political act.

TN: Sure. It's different politics; more anarchistic and individualistic. Nothing to do with the State or the collective in that way.

DR: It's a kind of micro politics, perhaps, in your case, where a certain type of openness is sought after: where the painting becomes liberated by the source and, at the same time, unfettered by certain conventional paradigms. There is a sense in much contemporary abstract painting that certain taboos have been lifted. That's why I think your work has, for me, echoes of experiments in abstraction that have largely been forgotten: early Russian abstraction, for example the Ender family, or Rozanova, maybe even some German painting of the immediate post-war period. We could say here that some interesting artists were cast aside by a relentless mainstream. Your work recuperates some of those quirky approaches to space and form.

TN: Yes. You know, I don't mind my work having these echoes or looking like somebody else's work—I should be so lucky, right? But what might separate me from some of my brother and sister abstractionists is a denial of irony. I've always sought to cut the theory to a minimum and knock the ironic, or the distanced approach. I want to suggest that if you can imagine something, you can act on it. I'll give you an example. When I was making systematic work, I remember doing two paintings—both dashes and dots, and red, yellow, blue— great colour idea, yeah? [laughs] I did one in a detached manner, on auto-pilot, you know, music playing etc; the other, with something in mind. The latter was so much more successful, so much more energised as an image, that I've been working this way ever since. You know, if we think of people making work outside of the 'profession'—whether it's criminals, the mentally ill, naive painters or whoever—these people haven't spent years studying painting as a craft, yet can come up with results that are startling and sophisticated in a visual way. And the reason is crystal clear: it's because they don't do things without having a reason for doing them.

DR: This reminds me of Arnold Schoenberg, who differentiated between his music as a crafted discipline, and his paintings as pure, emotional response, direct and unschooled.

TN: Beautiful paintings, wonderful paintings ... I saw them at the Modern some years ago.

DR: He could have actually taken lessons from some of the most illustrious of his contemporaries: Kandinsky, Kokoschka etc, but declined.

TN: Didn't want to screw it up, yeah? Well, there's something to be said for that. I mean, on another level, if we look more broadly at the present situation, then I think abstractionists are not getting much support from the

institutions; but the painters are out there. This might be a good thing, because the institutions are so debased at present—I don't think they're catching what is really interesting in contemporary art. It's not their fault, really. They need clear ideas, heroic figures, slogans. Look how Abstract Expressionism gets boiled down to five or six names, when what was so extraordinary about the movement, was its depth. It was a real milieu. The issue today is personal freedom—maybe it always is—and how do you measure its success or failure?

I remember when Richard Serra started making sculpture: the thrown lead pieces, the scatter pieces, the felt ones, and you thought, wow!, this guy is acting like he's inventing sculpture. And in a way, he was. Now, I think a lot of painters act like they're inventing painting, and I think that's great. It's a free enough moment to do this.

NOTES

1. Max Protetch Gallery, New York, 1995.

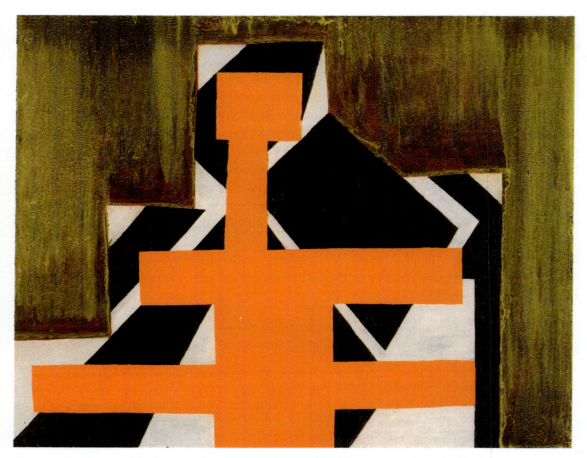

Figure 31 Thomas Nozkowski, *Untitled (6–100)* 1990, Oil on canvasboard, 41 ×51 cm, Collection Max Protetch, New York.

BETWEEN THE BED AND THE BRUSHSTROKE: READING THE PAINTINGS OF DAVID REED (1995)

Arthur C Danto

In an interview with the artist Stephen Ellis, which took place around 1990, David Reed expressed the wish that his works become 'an integral part of life, not separated in museums or galleries'. And he added 'Paintings belong where they can be part of normal life, seen in private moments of reverie'. In *Two Bedrooms in San Francisco* (1992), a text so uncharacteristic of what we would suppose an abstract painter might compose that it is difficult to reconcile its authorship with the kind of responses one might at first glance imagine that his works were designed to arouse, Reed recalls a conversation with one of his mentors, Nicholas Wilder, in which he said, surprisingly, that 'My ambition in life was to be a bedroom painter'. This confession, remarkable for someone tempered in the atmosphere of the New York art

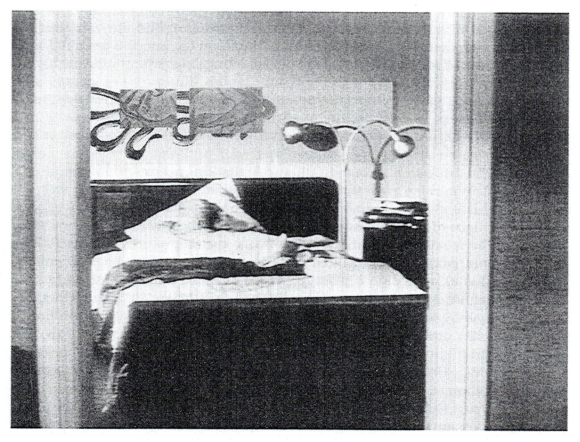

Figure 32 David Reed, *'Madeleine' in Scottie's Bedroom* (frame still from *Vertigo*, Alfred Hitchcock, Universal Pictures, 1958, with *#310* (1991-2), Oil and alkyd on Linen, 66 ×290 cm) 1991-2, Video still.

world, where it was the standard ambition of artists to dominate space and sensibility, was elicited by Wilder's observation—he was among other things an art dealer and in a position to know such things—that the paintings of the California artist, John McLaughlin, were 'bedroom paintings'. He meant that although people would buy a work by McLaughlin to hang in their living rooms, 'They would move the painting to their bedroom where they could live with it more intimately'. Most paintings, one supposes, are bought to hang in the living room, which is that part of the household designed for 'company', and typically furnished with objects that reflect upon the owner's taste, judgement, and material means. A 'living-room painting' is regarded as important, and meant to be displayed for the admiration of others. A painting is transferred to the bedroom when its importance is personal, and it has become an object of private meaning and intimate associations.

The museum is the living room of the community, where the latter's proudest possessions are on public display. It is a space, moreover, defined by the interests of the art world as a social institution: its occupants are, by right, critics and curators, conservators and docents, students writing papers for their class in art appreciation or visitors pausing to read the wall label. In the semiology of human spaces, the distance between it and the bedroom is almost astronomical. The critic has no legitimate entry into the personal and intimate space of the bedroom, where the painting might be the last thing we see before the lights are turned off and the first thing we see upon waking, where it watches over the act of love and the site of loneliness, and where it can press its meaning upon our consciousness with the mute insistence of a dream, an object precisely, in Reed's words, of intimacy and reverie.

So the first question to face in attempting to discuss an exhibition of Reed's work in a museum setting is this: how is he to reconcile such an event with his ambitions? What is a bedroom painter to do in the unforgiving impersonal light of museum space? With a gallery show, there is always the possibility that someone can, as the somewhat gushing expression goes, 'fall in love' with a painting with which, resources allowing, one can enter into as dear and familiar a relationship as one cares to have, bearing it off to one's bedroom for purposes of intimate scrutiny and private joy. But museum space is the chill public territory that belongs by right to—the critic, the curator, the conservator and the docent, enemies of intimacy all. Reed solves this problem with a kind of imaginative brilliance, by transforming the museum into a bedroom. He does this at the Kölnische Kunstverein by placing a bed in the exhibition, a component in an intricate installation, the purpose of which is in part to imply the relationship that the visitor is to have with the paintings to be encountered. One of Reed's paintings hangs over the bed, as if to say: 'Experience these works as you would if they were your bedroom paintings. Experience them as occasions of intimacy and reverie'.

But the meaning of the installation is more complex than this, and

merits a moment's attention before we go on to experience the other works in the exhibition in the spirit of 'bedroom paintings'. For it gives us an entry into the working of this artist's mind, which should help us when we endeavour to enter into relationships of intimacy with his more characteristic works. It is a kind of key to a rare artistic intelligence. The installation is visible from a bus stop outside the Kunstverein, through the museum's glass wall. Someone might pause before it, wondering what a bedroom is doing in the museum, which is scheduled to be showing an exhibition of paintings. One of the paintings, curiously, is on a wall behind the bed, but there is also a television set, which is showing a somewhat dated film, very much as if the Occupant were watching a tape or even a rerun. The film itself is famous: it is Alfred Hitchcock's 1958 masterpiece, *Vertigo*, which suggests that the Occupant not only has fine taste in paintings—He or She after all has a Reed in the bedroom!—but serious taste in film as well. By comparison with these testimonials to taste and discrimination, the bed seems nondescript, as if the Occupant paid no great attention to the furniture. It was not fine furniture at all, but looks as if it had been purchased second hand from a yard sale, or even from a Salvation Army resale shop. It looks like standard mass-produced furniture from perhaps the 1930s or even the 1920s. It could have been purchased years ago as a 'bedroom suite' by a young married couple without a lot of money—perhaps the Occupant's parents! Or it could have been bought as part of a job lot of furniture for a hotel with no aspirations to luxury. So there is a minor tension between the three components of the installation. And the installation itself then becomes an object of reverie in its own right, a small but instructive exemplification of the way in which one is to engage with the paintings that lie ahead, where one will be asked to notice and to resolve such dissonances, and relate them to life.

The reverie deepens when one remarks that the same bed exists within the film and without it—in the illusory space of the film as well as in the real space of the installation. The bed exists as bed and as film image—it has, as the old philosophers used to say, both objective and formal reality. Formally, it exists in the real space of the museum, like the television set or the painting, considered as physical object. Inside the film it is the bed on which *Vertigo*'s attractive female lead, Judy, sleeps and makes love. In the interview with Stephen Ellis, Reed talks about the problem of the artist being inside and outside as he makes the work: 'Part of me would identify with the painting, as if I were inside it working through the forms. Another part of me would stay outside and watch what was happening'. I would hardly suggest that the inside-outside status of the bed is a metaphor for the inside-outside posture of the artist relative to the work being made. But inside-outside clearly plays an important role in Reed's thought about art, and at the very least, the question arises in the viewer's mind as to whether *it is the very same bed*. The beds look exactly alike. Did the artist somehow get hold of the very bed Hitchcock used in his film?

This, in truth, replicates the situation in the film, where the hapless hero, Scottie, has to solve the problem of whether Judy, who looks too much like the woman Madeleine not to be her, really is identical with the latter, whom he has every reason to believe is dead. At the very least, the film is about illusion, appearance, reality, and identity, which are questions that arise with Reed's paintings all the time. In fact, the relationship between the bed in the installation and the bed in the film is as philosophically complex as is the relationship between the contents of the mind and of the external world, but curiously reversed. The bed in the film is the real one, the three-dimensional one in the museum space is the imitation. It is not even a real headboard! Reed cut a piece of plywood to the same shape and painted it the same green colour. Just because you can see and touch it does not make it real! Reality is here what is in the work of art—in this instance in the illusory space of the great film.

Reed cared enough about what was in and what was outside *Vertigo* to have made an expedition of pilgrimage to the sites Hitchcock appropriated for the film. Indeed, he went so far as to fulfil his ambition of becoming a bedroom painter by putting one of his own paintings in Judy's bedroom through exploiting the technologies of 'special effects'. If one were knowledgeable about Reed's work, one might wonder, seeing the still, how a painting from the 1990s should have found its way into a film of the 1950s. Or one might wonder if by some wild coincidence there was a painting in that bedroom that looks as much like a painting of David Reed's as Judy looks like 'Madeleine' (which is different from the way in which 'Madeleine' looks like Madeleine). Remember that the dark plot of the film pivots on the fact that the same actress, Kim Novak, plays two women whom the hero has every reason—except the evidence of his eyes—to believe different, since one of them he saw 'with his own eyes' (so much for the evidence of his eyes) fall to her death. So the identical painting, reversing the situation with the headboard, is real outside the film (and there you see it in the installation), and unreal as part of the bedroom in the film. *Vertigo*, Reed says, is intended to teach us to be critical of our illusions. In the bedroom scene in the film clip, the pivotal illusion falls away. Judy presents herself to her lover as Madeleine—or rather as 'Madeleine', since she had earlier deceived her lover by pretending to be the woman he 'saw' fall to her death. He now knows who she is and who she is not. As we know, the revelation of truth does not lead to the happiness it promises. The film also teaches us not to press our illusions too fiercely, that perhaps, as TS Eliot says, 'Man cannot bear very much reality'. There is a knowledge that can be dangerous to have if we recklessly replace our illusions with it. The bedroom is the space of such illusions and of fantasies. The bedroom painting might, as a condition for our intimacy with it, demand that we not press our interpretations with too much fervour. Reverie, perhaps, rather than analysis, is the appropriate mode. The scene with Kim Novak appears and reappears on the installation's television

set, over and over, every few minutes, like a repeated warning. It is the moment of truth and of danger. It underscores the difference between the bedroom and the world, between dream and danger.

Let us now look at the final component in the installation, the painting itself, in its two modalities, inside and outside the film, as a bedroom painting—since a painting in a bedroom—and as a museum painting, on view, as it were, as part of the installation. In the original scene, as shot by Hitchcock, there was a nondescript still-life, all too typical, alas, of bedroom pictures—the kind of bedroom picture that makes Reed's wish to be a 'bedroom painter' so piquant and odd. What we usually find in bedrooms are tepid still lifes, vapid landscapes, by-the-yard abstractions, reproductions of Rococo prints, or maybe photographs of a parent, a lover, children, or the Occupant's wedding day in which She looks radiant in tulle and He looks resolute and desperate in black. *# 328*, 1990–1993, is, like all of Reed's paintings, a fiercely energised work, equal in its intensity, I suppose, to the revelation in that tremendous scene in Judy's bedroom when the veils are lowered (symbolised by the change of clothing) and the Truth revealed. Moments of Truth belong in the bullring, and are associated with death and ordeal: they shatter the delicate atmosphere of the bedroom, in which fantasies coil and uncoil in the imagination. If there is the equivalence between the painting and the moment of revelation in the film, then Reed is not someone whose paintings one altogether welcomes into the bedroom, since they would destroy or distort through invasion of that private space. It would be like bringing into the bedroom someone who looked kind of attractive at a party but turns out to be the Angel of Annunciation or some even more terrifying being. All those Marys in all those Annunciations who shrink from the burden of their destiny collectively warn us to be careful what we welcome into the space of reverie and intimacy! The painting Reed has insinuated into Judy's bedroom transforms the bedroom into some more frightening space than even Hitchcock could have intended, as it transforms Judy into some bearer of terrible news disguised in an act of intimacy and trust. Whatever the message of the film, the message of the painting in-and-out of the film is: take all necessary precautions when you replace the bland decorative pictures, whose normal habitat is the bedroom, for a museum painting that aspires to be a bedroom painting. You may not want to have to deal with all that power in so intimate a space. The museum has enough contrary energy perhaps to be able to contain it.

328 could, in the spirit of intimate reverie, be an abstract presentation of an Annunciation. There are two components: a heavy lashing brushstroke to the left, and, confined within a dark rectangle, an undulating, serpentine form, shaped by the action of some kind of blade moved through wet pigment. The brushstroke echoes the pastel colours of the bedroom in the film, as if the angel attempted to disguise its fierceness, to 'blend in', as it were. The undulation in a square space could, to protract the fantasy,

correspond to the action within the womb, as though the contractions of the portentous birth had already begun in the body's darkness—as though the annunciation of the birth coincided with the action announced. There could be a reference to the pastel-and-dark of *Vertigo* itself, as Reed recalls the contrasts in the film: 'When the hero is deceived by the girl he is following, the scenes are all in flat, pastel colours. When he's pulled into the reality of the situation, the screen is crossed with black and white diagonals'. Pastel, then, is the colour of illusion, black the colour of reality. The painting dissolves into an allegory of the world within the bedroom and the world outside. What has happened to the Angel in this interpretation? The Angel has itself dissolved into an emblem of fantasy and deception. But the dark contractions of the womb are real. The painting could enact the way in which we fantasise in the act of love, which may nonetheless have real-world consequences in the body's moist darkness.

I offer this not as an interpretation of # *328*, but as an example of a reverie, loosely underwritten by the visual text of the work, of the kind one might have if the bedroom were one's own and the painting an occasion for a certain reverie. It would be a reverie informed by the history of art, the structure of a specific film, the knowledge of love, the language of colours, the possibilities of form. And I offer it moreover as a paradigm for thinking of the works in this show. One must be bold, not hesitating to ascribe narratives and symbols and human meanings to these powerfully expressive works. The writer Roland Barthes distinguished two kinds of texts: those we read as readers, and those we read as writers. 'The goals of literary work ... is to make the reader no longer a consumer, but a producer of the text.' It would be better to say: there are two ways of reading texts, as consumers and as producers, and the same is true of painterly texts. To address a painting as a consumer is to be concerned with matters of art-historical truth and possibility with questions of formalism. This is the mode of 'reading' that belongs to the museum—to the critic, the curator, the conservator, the docent. To read as a producer, as I have done, belongs to the bedroom. It is to open oneself up to the interpretative possibilities of the painting, and to make it one's own. To achieve paintings that aspire to enlist the viewer as a co-producer is what it means to be a bedroom painter. Most of us—most paintings for that matter—exist somewhere between the bed and the brushstroke—to use a phrase certain to awaken memories in my reader that I shall not further clarify.

After writing the last paragraph above, I opened Barthes' marvellous book *S/Z*, just to check my memory. I noticed, for the first time, that there is a frontispiece, which spreads across two pages. I do not know who did the painting—it could have been Correggio, but it could have been a nineteenth-century artist. In any case, it shows two figures, an angel to the left, and a sleeping nude figure, somewhat androgynous, to the right. I say 'angel' advisedly, since it could be insisted that it is Cupid. For it looks, in gesture

and expression, exactly like the angel in Bernini's *St Theresa*. The reclining figure could hardly be St Theresa, but he/she (*S/Z*) is having a passionate dream in the dark interior of the soul, the outward sign of which is a luminosity where (I suppose) the Angel has thrust its arrow. To read this painting from the perspective of the museum would be to identify the painter, date the work, identify the figure, nail down the action. To read it from the perspective of the bedroom is to see it as a realistic version of the same tensions we find in # *328*, and indeed through many of Reed's paintings. Continuing to view things from the perspective of the bedroom, I take the fortuitous discovery of this overlooked image in an otherwise familiar text as an assurance that I am on the right track.

* * *

After reading this essay, David Reed phoned to identify the painter of the frontispiece. It is Anne-Louis Girodet de Roucy—or Girodet-Trioson, as he called himself—a student of Jacques-Louis David, and an influence on the young Romantics. The painting itself is *The Sleep of Endymion* (1793). Reed said he had been studying it just last summer at the Louvre. I count that a further confirmation.

David Reed in Conversation with David Ryan (1996/7)

David Ryan: Given the fact that illusion operates on so many different levels in your work, is 'abstract' the best way to describe it?

David Reed: I often think that it isn't. In relation to my work, 'abstract' is a conventional word that has lost much of its meaning. I've tried to think of other words and haven't been able to. Jeremy Gilbert-Rolfe uses 'non-representational' rather than 'abstract'. In certain ways, that's better, but can also be misleading. Illusion makes the marks in my paintings seem at times to be representations of themselves. I don't know the right word. I wish I did. I've been in too many shows called 'Abstract ...' [laughs]

DR: You once described the Grand Canyon as the 'source and home of American Painting'.[1] What was vital about your connection with the desert landscape in the early stages of your career, and do you identify residues of these concerns in your present work?

DRd: I went to the Southwest to explore the meanings I'd found in Abstract Expressionist paintings, especially Pollock and Newman. I connected their work to the sense of vast, unlimited space in the desert. I lived near Monument Valley to paint the landscape there.

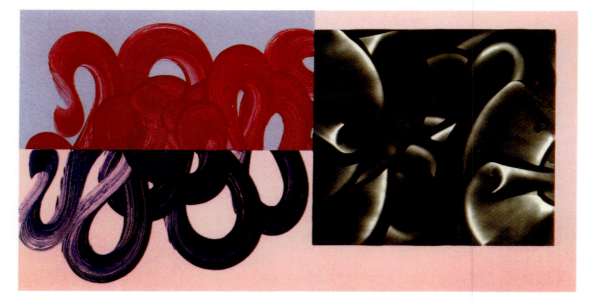

Figure 33 David Reed, # *328* 1990-3, Oil and alkyd on linen, 74 × 142 cm, Private collection, Cologne, courtesy Galerie Rolf Ricke, Cologne. Photo: Dennis Cowley.

DR: And these paintings were representational and painted 'on site' in a conventional way?

DRd: Yes, they were, although they didn't look much like landscapes. The local Navajos felt sorry for me. They thought I was hopelessly incompetent, attempting a conventional representation of the landscape and failing.

DR: But it was a representation of the sense of space, presumably, through the contact with the landscape?

DRd: Right, that's what I was trying to do. I wanted that feeling of space when you're someplace that can't be located, that's too big, that can't be contained; has no limits. At the time, I thought I was there to investigate painting. I didn't realise until later how much I'd been influenced by Western movies, the romance of the Western desert and hero. Jackson Pollock worked as a trail guide at the Grand Canyon, and from the photos I've seen, he certainly also had a cowboy fantasy [laughs]. That space I was painting is huge, but is ultimately isolating because it's so unified and so separate from us. John Wayne in *The Searchers*, like the hero in most Westerns, walks off alone into the desert. When I was painting, I kept imagining ways to break open the space to see what would leak out. In *The Searchers*, I love the scene behind the cave when John Wayne is cut open with a knife to remove an Indian arrow he's been shot with, because it represents the breaking open of his image as well as the space.

DR: Your work from the late 1970s to around 1980 has been described as exploring a more Minimal aesthetic.

DRd: I used to think that those paintings were connected to Minimalism, but now I feel that they're connected to Postminimalism: the work of Eva Hesse, Robert Smithson, Richard Serra, Keith Sonnier, Mel Bochner, Barry Le Va, Jo Baer. These artists broke down Minimalism using direct processes of gesture and the physical properties of their materials, especially effects of gravity. My paintings from the mid 1970s were especially related to work like Richard Serra's thrown lead pieces. I wanted a direct sense of process through the gestures in my paintings as well as a sense of gravity as another force distorting the gestures. I was fascinated by Barry Le Va's work, which created a sense of a narrative through simple physical actions. At the time, people told me: 'It can't be done in painting. In the frame everything is different'. They were right that it was different. In painting, physical properties become theatrical, create illusions. In the 1970s in New York, Post-Minimalism was a club, used to beat painters over the head. My friends would say: 'You've got to quit painting and use other materials'. They felt that I was hopelessly naive. About five years ago, I taught with Barry Le Va at Skowhegan. After

my slide talk to the students he came up and said that our work had so much in common. Well, I was very touched. Just because I worked in a different medium didn't mean I had to have different concerns. One should be loyal to ideas, or obsession, or dreams. Not to a medium.

DR: That's very interesting. I never made the connection before, but its immediately translatable for me: the relationship between your repetitive brushstroke paintings of the 1970s and, say, Serra or Le Va.

DRd: Before Postminimalism, every avant-garde movement had a 'painting wing'. Minimalism had Mangold, Marden, Martin, Ryman, but with Postminimalism there was no painting wing. Some of the artists had done paintings before and there was a sense that they were combining painting and sculpture in their work. That's when this idea that painting was outmoded and old-fashioned really took hold. There was a great deal of rhetoric that had to do with physicality and materiality, the literal quality of the work. With painting, you don't have this; once you put a mark on a surface it becomes an illusion, a theatrical production. That put people off, but I felt that the same things that could be accomplished in the actual room could be accomplished on the stage of painting.

DR: In the 1980s, your work certainly seemed to proclaim this sense of theatricality with an increased flamboyance of colour and gesture. Other commentators have linked this directly to the influence of Baroque painting. Did you use it to rethink your work, or had it always been an interest?

DRd: I was interested in the Baroque from my college days. I had a wonderful teacher, Bill Midgette, who talked about Rubens and the Carracci in a way that got me involved.

DR: Did your interest in this work relate in any way to Frank Stella's call for a reconsideration of an engagement with deep space and illusion as outlined in his Harvard lectures in the mid 1980s, again using Baroque and Mannerist work as an example?

DRd: I was recently in a public discussion in Baltimore with Stella on the relationship of contemporary and Baroque art, as part of a show, *Going for Baroque*, curated by Lisa Corrin.[2] There was no common ground in our discussion. I'm critical of the views he put forward in his lectures at Harvard and suspicious of his approach to history, finding it overly formal. He singles out Caravaggio at the expense of many other interesting artists. Also, I find the solution he proposes for contemporary painting, the very literal building of physical space out from the wall, to be extremely limiting. I don't think 'space' of this kind is an important issue right now. Finding an equivalent for

'space' is much more relevant and interesting. My experience in Baltimore, working inside the museum on colour studies from specific Baroque paintings, taught me that I shouldn't take any formal structures of space or light directly from Baroque painting. When I did, it just looked terrible in my paintings. I could use some similar colour, but the light and space had to be completely reworked in my own way. I couldn't use any direct formal influence or inspiration. I'm afraid that now when I look back, I think my involvement with the Baroque was a way of avoiding some of the hard questions facing contemporary painting. Looking back at historical painting can be a kind of ... well, a way of avoiding tensions and finding a comfortable place. I am very wary of it now, as much as I love Baroque work and feel inspired by it.

DR: On another level, though, Baroque painting can also fragment the viewer's experience. I'm thinking of the ceilings, for example, where it's difficult to obtain an overall view or focus: the whole is construed conceptually rather that perceptually from a series of very different vantage points.

DRd: Yes. The fragmentation of the viewing experience—that's a possible link. But I think this experience has to be approached now in a different way. I've often had fantasies of a painting that one could never see whole from any one viewpoint. I like the idea that it would have to be put together mentally as well as the fact that if there is a 'whole' then it has to be fought for, that it takes a while to get there. But now the perception of the whole needs to be broken more than just physically.

DR: This kind of fragmentation also reminds me of what the French philosopher—Buci-Glucksman? ...

DRd: Ah yes, Christine Buci-Glucksman, yes, I know her writing.

DR: ... What she called a kind of Baroque or rather 'ocular madness': a kind of simulated craziness, or a shattering of the 'self' through such fragmented Baroque viewing experiences, again, a kind of uncontained space. I wondered if this related in any way to what you call 'the Fantastic' in relation to your work?

DRd: I love her idea. The desert sky had that effect on me. It's strange. The excess of the Baroque and the emptiness of the desert can have the same effect.
　　I'm glad that you bring up the Fantastic. When asked about philosophical categories in connection to my work, I have to say that Beauty doesn't interest me. The Sublime is a more difficult question because I love

Abstract Expressionist painting, but my work isn't involved with this kind of Sublime. Instead, my work's category is the Uncanny or the Fantastic. In this category, one can't tell what is physical and what is an illusion; the two become merged. One goes back and forth between interpretations: has the hero been acted upon by supernatural forces, or has there been a series of unfamiliar, but ultimately explainable, physical coincidences. I like that in the end you can never tell which explanation is correct. Kafka and Poe, two of my favourite authors, fit into this category. In the Sublime you're involved with a sense of presence. In the Fantastic, there's a loss of presence, something is missing. This feeling is true of my work. When viewing an Abstract Expressionist painting, I stand still, close to the painting where I feel located. The painting gives me a sense of place, of where I am. My paintings are best seen while moving. For my show at the Kunstverein in Cologne, the best view was from the tram-crossing outside, in front of the building. One saw the paintings move by through the windows. [laughs] My paintings are not about being located.

DR: These thoughts are interesting in relation to some of Frederic Jameson's ideas around a postmodern sublime: where he says gone is the idea of the individual self, testing its limits against the expanse of nature. And we might also think of the void of your desert experience here—that this has been replaced by a kind of placelessness, and free-floating, ungrounded experiences rather like the highs and lows of the drug user, no longer locatable in any coherent construction of the 'self'.

DRd: The goal of the Abstract Expressionists was, I think, to strengthen a sense of the self as you stood in front of the painting. I'm afraid my paintings do the opposite. They question the self, and make us aware how much more fluid a sense of self is now. For better or worse, I feel that I have several possible selves or my 'self' is changeable. From watching films, we're so expert at identifying with various characters. We move and transform through these indentifications.

DR: Your use of colour seems to owe a debt to the painters of the Baroque that we mentioned earlier, certainly in terms of the strong light/dark contrasts. How do you approach colour—is it based on specific memories, or is it governed by more internal relationships?

DRd: When I first came to New York, Greenbergian formalist painting was very strong. Their theory of colour was to eliminate contrasts of value and colour temperature so that hue contrast would become stronger. This denied a lot of the emotional possibilities of colour. I wanted instead a kind of painting that could keep as many of the qualities of colour as possible in strong contrast. In my paintings, I use extreme contrasts of hue, value,

temperature. Only intensity remains constant and unifies the light: Technicolor painting. And I wanted to use specific colours and pairs of colours that would refer to both popular culture and high culture. I was never interested in purity. A certain red/green relationship, for example, might refer to Delacroix as well as to the colours used in swimsuits. This complex use of colour references is one of the beautiful possibilities in contemporary painting. We've become much more sophisticated now in our awareness of colour. Is the TV scene black and white because it is an old show? Because it's a documentary? Because it's information provided in a documentary style? What colour is that passing car: that flash reflecting in the sun? Look at that detergent bottle! Newly invented pigments are all around us. Lately, I've become interested in the new colours in comic books. Because the colours are now printed using a computer, they can be much more specific with tone and gradation. They employ blurred edges and other effects impossible until now. It's fantastic stuff, very sophisticated. Painters should use the new pigments and define the meanings associated with these new colours. But we have to act fast, otherwise the comic book colourists are going to define the colours for us.

DR: Is there also a danger that we almost get blinded by this explosion of colour: the more it surrounds us, the less we 'see' it?

DRd: No. I think it's a wonderful challenge to come to terms with colour and to give it meaning. I find it exciting, and the wilder and more extreme the colour, the more I like it. Lately, I've been using interference and iridescent colour in my paintings. Wary of this, I stupidly put it off for a long time, and as I started, I just kept thinking to myself: 'If you can use regular paint *or* iridescent paint, why not choose iridescent? Why not?' Painting has to compete against the colour we see on luminous screens. We have to accept the challenge.

DR: I want to go back to two points you've already touched on. Firstly, the 'effect' of fragmentation and disunity on the viewer. I wondered if you could say more about the way a painting can specifically 'address' the viewer. This has again been discussed in relation to your work through Baroque painting. Secondly, you mentioned earlier a kind of absence of presence in your work. In this context, I'm intrigued by the way the brushstroke functions in your work: both distanced and elusive in the way in which the marks are generally difficult to trace back to any stable origin.

DRd: On the first point, Baroque paintings initially engage us spatially and then make us uncomfortable because of the actions in the narrative reaching into our space. In Guericino's *The Delocking of Samson* at the Metropolitan Museum, a wounded naked man is about to break out of the painting into our space. It's a violent image, threatening to the viewer. Caravaggio's

Concert is in the same room: a guitar player faces us, singing a love song, tears welling up in his eyes. We are in the position of the boy's 'patron', who is about to leave with someone else. Caravaggio, in a self portrait in the background, turns to look, aware of the injustice. The singer will be left alone, hurt, rejected. We are in the place of the exploiter, an uncomfortable and ambiguous position. Over and over again in Baroque painting, an initial spatial engagement creates in the viewer an unusual and uncomfortable relation to the image. I hope my paintings also have this effect on a viewer, but they have to do it differently. Since my paintings aren't figurative or narrative, I can't use these devices in the same way. But I do hope that my paintings are aggressive in the space, and ask the viewer to choose to take part in another kind of narrative. Mieke Bal has written about my paintings being second-person narratives. I hope a viewer will have this kind of involvement. I often think of my paintings as projections from a viewer. I guess this is why I'm so obsessed with vampires and their lack of reflection in a mirror. What part of us reflects from our projection? What part doesn't?

All of this relates to your second point. Yes, my paintings have quite a distanced effect. The marks are isolated, removed from the maker, and it may not be easy to identify with them. I hope that eventually the viewer will be able to identify through colour. This feeling of overcoming an obstacle is extremely important to me. It's a choice to become involved. I'm very mistrustful, now, of easy entries into painting, especially through tactile materials, and tactile material gestures. I feel these entries are accompanied by a sense of nostalgia for defined times. In Cubist paintings, the planes inside the painting always refer to the wall behind the painting. It's taken for granted that the wall is a real and solid referent. Now, when a painting is on the wall, there's no sense of, or guarantee of, that reality. Paintings now hang on a wall as if floating on a screen, as if hanging over a TV set. The wall is still there physically, but it is also an idea, a desire for a certain social interaction, a page from a book. Some painters have physically broken out of the frame, not like the Baroque painters through illusion, but materially and literally. I want to break out mentally. The edge of the painting is still there physically, as the wall is, but it's also not there at all.

DR: Has the whole issue of virtual space had an effect here?

DRd: I think it has had a tremendous effect on all of us. We see the world in a different way. What is real and what isn't? Usually, it's not very clear.

DR: When I talked to Jonathan Lasker the other day, he spoke about the need to ground the viewer, as I interpreted it, in quite a moral way. It's interesting that you seem to be saying the opposite here: you're quite happy with the free-floating, disembodied experience with all its anti-humanist overtones?

DRd: I have tremendous admiration for Jonathan's paintings and feel our work has a lot in common. When we talk about this issue, we come at it from different sides, but I'd like to think that we end up in a similar place. My paintings are very physical, but I emphasise this other quality, and his paintings are so bound up with the mental that he emphasises the physical. Both of our work is a combination of the two.

Painting has a rich and varied humanist history as well as the ability, because of its sensitivity, to transform itself and mutate into something different. Painting is so impure, so corruptible. For a long time it had a parasitic relationship with Christianity. Painting would be completely different without this relationship, as would the Christian religion. Now there's a chance for just as rich a relationship with technology. In many ways, it could be a similar relationship: focusing on forces beyond the human and how to understand them through the humanity of painting.

DR: You've mentioned that a sense of presence in your paintings is a strange, or even uncanny sensation rather than a straightforward one, and, in the past, you've also used the term 'presentness' as representing an important dimension in the work. Firstly, how do you define 'presentness' in relation to presence? And secondly, how does this differ from the modernist use of that word? Here, I'm thinking of Michael Fried's usage in his *Art and Objecthood*.[3]

DRd: There is a kind of anti-presence in my work. Something is missing, not there. When I first realised this, it completely unnerved me. I couldn't accept it. It wasn't something that I wanted. I admire the Abstract Expressionists; how can I have ended up in a position that is so antithetical to theirs? Likewise, the photographic connotations. David Carrier saw this before I did and I was at first resistant. Only when I saw that a photographic effect kept recurring in different ways did I accept that it was somehow part of my work. It was not something I willed consciously to happen.

I think of presentness as being different from presence. Presentness is immediacy. People talk about illusion as though it deals with space, while I think it deals more with time, and I want this illusion of time, a sense of immediacy, as though the painting had just been done, and something is about to happen. As for Fried … How does he use the term? Remind me.

DR: Well … as I understand him, this also involves an illusion of time, or rather the illusion of stepping outside of time, whereby the work momentarily transcends its material, literal components and achieves a wholeness through its very opticality; presentness, therefore, is an illusion as opposed to the raw, material presence of literal objecthood. It also gives us the illusion that we can 'get' the work in an instant, but as Fried suggests, the modernist work absorbs us and yields a kind of cycle of such instants, therefore allowing a corresponding, if somewhat contradictory, sustainment

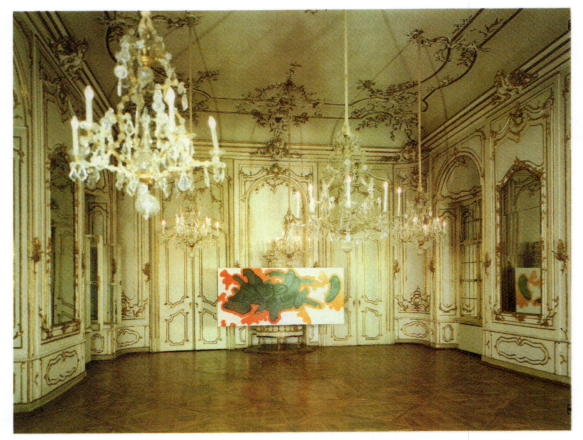

Figure 34 David Reed, # *349* 1996, Oil and alkyd on linen, 137 ×295 cm, Installation at the Mirror Room, Landesmuseum, Graz, Austria, 1996, Collection Dr Möllers, Munster, courtesy Galerie Rolf Ricke, Cologne. Photo: Johann Kowegg.

of depth, the work revealing itself more fully with renewed contact. I have a hunch that you use this term differently, particularly in the light of what you were saying about fragmentation.

DRd: Yes. I don't want a viewer to have a sense of the 'whole' of my painting immediately. Ideally, a viewer will experience fragments and not know how the whole fits together for some time while looking. This narrative interaction that a viewer creates with the painting takes place in time. The experience reminds us of time, doesn't go beyond it. From the beginning, I wanted my paintings to be about time and thus movement rather than stillness. Feelings start with motion. Seeing films and TV makes this necessary. I don't think we can go back to a notion of stillness or balance in painting and the kind of contemplation this implies.

DR: This leads me on to my next point: many of your paintings, of course not all, are on a very extended horizontal, and this seems to evoke a kind of Cinemascope.

DRd: Yes. My first painting using this format was 25 feet long and 8 inches high: four brushmarks chasing each other. I like extreme horizontal formats because then a viewer has to struggle to see the painting as a whole. And the format also helped the sense of movement in the painting. Movement is experienced most easily through peripheral vision.

DR: The painting you describe reminds me of the Richter brushstroke painting,[4] where there's a simulated gigantic brush stroke made up of concealed smaller ones giving the illusion of an unbroken stroke. Do you know the one?

DRd: Yes, I do. I saw it in his retrospective show in Bonn a few years ago. It's a wonderful painting. Yes, the marking and extreme horizontal format is similar to the painting that I just described, which was done about five years earlier. His painting is much larger and uses bright hues. Mine is basically black and white.

DR: Going back to film, I think it's interesting that you have a formal relationship with this medium, but I guess you also see it as a particular site where personal and collective meanings collide?

DRd: Very much so, yes. I was asked to do a show in San Francisco Art Institute.[5] Being from California, I didn't want to just send 'New York' paintings to be seen in San Francisco. I wanted to connect to the local context, to provide a local entry of some kind. Thinking about the light in California, I was reminded of Hitchcock's *Vertigo*. This film juxtaposes spatial, black and white illusions in some scenes, with flat, pastel hue contrasts in other scenes. I was thinking about this when the curator, Jeannie Weiffenbach, told me that the house used as Scottie's apartment in *Vertigo* was just around the corner from the school. Then, when Nick Wilder called John McLaughlin a 'bedroom painter', I thought of the bedrooms in *Vertigo* and decided to insert my paintings into those spaces for the show. Again, it was the light that made me think of Judy's bedroom in *Vertigo*. Her bedroom has a neon light directly outside the window that casts a wonderful turquoise glow into the room. It was that turquoise light that brought my various thoughts and feelings together. We all retain memories of these special places from movies. They aren't real, physical places where we've been, but we remember them as if they were. Nor are they private, as are our real bedrooms, because we share the memory with so many other people. These remembered places are ideal for paintings. Paintings want to be in these in-between places, between public and private.

DR: Was it also a kind of gesture that returned a painting to something that may have sparked it off in the first place?

DRd: That's interesting, I've never thought about my insertions as a process of 'returning'. I've been so influenced by the colour in movies. Yes, it would make sense that I would want to put a painting back into the colour from which it came.

DR: Is it important to you that you hold on to this duality of the public and the private, as well as often blurring these distinctions as with the Hitchcock piece? I'm thinking here of the notion of the 'bedroom painting' and the way you were talking earlier of how your paintings function in the museum.

DRd: A 'bedroom painting' exists in our most private environment: where we wake up, go to sleep, have our most intimate moments. It's there as a kind of observer, even a participant. The painting can be mixed into private fantasies and secret narratives. What does it witness? How does it participate? After a talk I gave at Art Center in Pasadena, a student asked: 'How can you say that your paintings are "bedroom paintings". They're too big'. Before I could think of an answer, another student replied: 'That's what we need—bigger bedrooms'. [laughs] The private and the public are becoming increasingly confused. The MCI company might say that they own the bedrooms in *Vertigo*, that I have to pay them to stay there! [laughs]. Yes, in the *Vertigo* installation the private becomes public and then private again.

In public spaces, paintings have to be carefully installed if they're to have private meanings. One can't hang paintings in the traditional way and hope that they'll have non-traditional meanings. I look for ways of installing my paintings that reflect their internal properties. They seem to move, so I hang them off balance, on the edges of walls or into corners. For my show at the Kunstverein in Cologne,[7] I hung fifteen paintings 10 centimetres apart along one long wall, leaving the opposite wall empty. Some painters were furious: they told me they couldn't see the paintings individually. I wanted a viewer to have to fight to see an individual painting as separate and discrete. We have experience in this and I was confident it could be done. I wanted viewers to find that a painting was interesting when seen combined with its neighbour, as if part of a long film strip. Paintings change because of the way they're installed. Instead of trying to avoid this, a painter can use it. A painting could be part of this long film strip, in a show, and then return, alone, into the bedroom of a private collector.

DR: Finally, what's your perception of abstraction now in the latter part of the 1990s?

DRd: It's a very exciting time now for painting. There's a lot of interesting work being done by the artists of my generation and younger generations. It's shocking to realise how much good painting there is. And it's all around the world. I have trouble keeping up. In the 1970s, I thought that painting might really be finished. Everyone told me that it was. I'm very optimistic about the younger painters whose work I follow. Where I have worries, and I think this is an important issue, is in how this richness of painting is presented so that it can be recognised and understood. It's the problem of presentation that needs to be solved. I've had work in lots of abstract painting group shows, some better, some worse. Usually in these shows, when there's one or a few works by each artist, the comparisons become formal; all of the particular issues of meaning in each work are lost. Each artist should at least have a room. It's a mistake to show paintings just with other paintings, to segregate by medium. Paintings show their meanings more clearly when shown with art in other media. Recently, I was in a show at the Württembergischer Kunstverein in Stuttgart with Beat Streuli, who does large-scale photographic pieces and projections. I loved showing in that context. It brought out a certain content in my work that is harder to see in relation to other paintings. Over and over I hear that abstract painting is too formal, too difficult, too removed from ordinary life. I feel that it is not at all. So much can be addressed through abstraction. What can be brought out by the way the work is shown? How can we create the best situation to view painting? What techniques do we use?

NOTES

1. Quoted in the biographical reference in 'Interpreting Contemporary Art', W Allen, S Bann (eds) Reaktion Books (London), 1991.
2. 'Going for Baroque: 18 Contemporary Artists Fascinated with the Baroque and Rococo', The Contemporary and Walters Art Gallery, Baltimore, 1996.
3. Michael Fried, *Art and Objecthood—Essays and Reviews*, University of Chicago (Chicago), 1998.
4. *Yellow Brushstroke* (1980).
5. San Francsico Art Institute, 1992
6. Kölnische Kunstverein, Cologne, 1995.

GARY STEPHAN: THE BRIEF AGAINST MATISSE (1982)
Robert Pincus-Witten

Gary Stephan, now in his late thirties: steel-rimmed glasses, incipient embonpoint, well-cut tweeds—no longer the appurtenances of a stylish boy, but those of a stylish man. Not gratuitous. Art, for Stephan, represents—at least in part—a conquest of good taste paralleling the adult conquest of infantile neuroses. Yet all this is ambivalent—since his sharp sense of taste is a quality to be subjugated. Stephan, like us all, broods on the unravelling complex formations occasioned by family and upbringing; ambivalence animates his recollections, say, of a Levittown adolescence.

'What were the 70s about?', I ask, 'And how did you fit in?'
'The strengths and freedoms of the 50s led to the narcissism and licence of the 60s. This led to a search for structure, for a logic behind the activity on which to base the activity. This belief in logic led to "flat geometrics". Soon we saw that flat geometrics were rigid, not optically responsive. Ultimately, they failed, and in failing, we were forced to turn back to appearances.'

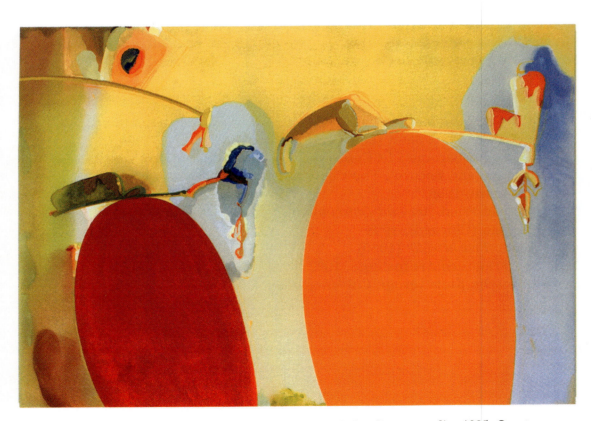

Figure 35 Gary Stephan, *Summer As Seen By the Blind*, Acrylic on muslin, 1995, Courtesy Baumgartner Gallery, NYC.

Stephan trained as an industrial designer at Pratt Institute, but went off instead to San Francisco before completing the degree. He recalls the Pratt formation as essentially Moholy-Nagy and New Bauhaus, very *Vision in Motion*. It was, after all, the prevailing art school mode persisting from the 1950s.

Stephan arrived in the Bay Area of the 1960s, a period when artists, especially California artists, were trying to draft a brief against Matisse. Ironically, official California painting today is dominated by the Matisse spin-off—a mode instigated by Richard Diebenkorn.

What this case signified for Stephan, at the time, was the frustration felt by painters identified as provincial and who partly believed the tag whether they wanted it or not—'provincials', then, both angry and envious of a formalism, the formalist criticism of a formalist clique, that excluded them: Greenberg and Co. All this is water under the bridge by now, and formalist criticism in the 1980s—late semiological analysis, say—by no stretch of the imagination alludes to Greenberg any longer. Still, San Francisco as a place, as locale, continues to encode, for Stephan, the consequences of 'narcissism' and 'license', as he called it.

Stephan's departure for San Francisco has all the marks of a sudden impulse, an impetuous fugue. He enrolled at the San Francisco Art Institute, finding himself in the same class as John Duff, James Reineking—strong sculptors—and the painter of masks, Michael Tetherow. Bruce Nauman regularly dropped in on yet another classmate whom they then regarded as their most brilliant peer, a certain Randy Hardy.

Stephan's psychoanalytical bent was sparked by a set of early paintings towards which he now feels a strong attraction/repulsion. We see them today as startling out-of-synch premonitions of the current New Figuration, Neo-Primitivism, Maximalism, what have you. Beyond this happenstance, his present masterful painterly abstractions on Christian themes or derived from El Greco's compositions are internally linked in his mind 'to the mad prophecy of these crazy student pictures'.

Stephan showed me some black and white glossies of these early works—wide, hilly vistas, 10 feet across, depopulated and schematic, chimneyed houses with smoke coming out, all rendered in a dumb sleazy way, more Walter Lantz than Walt Disney. These large overlapped landscaped passages painted on masonite date to about 1964–66 and are punctuated with legible—if un-understandable—shapes, an odd iconography.

'That "odd shape"', Stephan says, 'means roses that are chipped and wrapped in aluminium foil and then put in an ashtray'. See what I mean? Legible but un-understandable. Often enough, queer animals bear a resemblance to toilets or chemical alembics. Stephan vaguely recalls these 'anthropomorphic toilets' (dumb cartoon flowers stuck in their bowls) as a distant model for the thin-armed 'torso-shapes' that emerged in his paintings around 1980.

These quirky pictures were shown at the San Francisco Art Institute as part of his senior project. So unacceptable were they to the professoriate that he was obliged to take them down; only after protracted insistence that they were, after all, really meant to be 'paintings' was he permitted to put them up again. (Well, a history of affront and contretemps attaches itself to the 'MFA Show' or the 'Senior Crit', and so ubiquitous has the degree become, that practically every artist nurtures a favourite horror story.)

On showing these works, even if in student circumstances, the question was at last asked of the artist: 'Have you ever heard of Carl Jung?' Its reply led him to analysis and the belief in the insights available to painting that analysis provided.

These paintings are now stacked inaccessibly in the New York studio, but Stephan can get to at least one of them—*The Magic Motor Boat*, a scratched water view, a few scattered islands forming a narrow channel through which a motorboat passes, some lightning, a deformed horizontal shape.

'The odd shape "objectifies" the painting more clearly', Stephan says. Nailheads protrude from the scratched surface; again 'greater objectification'. Like a stiff altar cloth, the picture is hung in relief from an old bent curtain rod. 'The curtain rod indicates the use of rejected cultural artefacts as an art strategy'.

On leaving the cloister of the San Francisco Art Institute—its local quasi-paranoid tradition of the Transcendent Morality of Pure Painting still intact—Stephan returned to New York.

Of course, he had been picking up real-life clues all along, School of Hard Knocks style—funnier perhaps in the retelling. It was 1968, and Kynaston McShine was installing the Smith, Irwin, Davis show at the Jewish Museum, back when the Museum had defocused from ethnicity for a while. (Alan Solomon's first surveys of Johns and Rauschenberg are the now legendary inaugurations of this period.) Stephan and Neil Jenney worked on the installation. Jenney had heard Germano Celant's Arte Povera book 'chatted-up' in McShine's office, and knew that the future was in 'The Conceptual'—dirt, plants, wrapped earth—you remember. So they made some Arte Povera—I was calling it Postminimalism—and Jenney called Richard Bellamy to come down to inspect the stuff, with an eye to inviting them into the Green Gallery, then a leading avant-garde locale. A moment before Bellamy's epiphany, Jenney showed up in Stephan's studio to borrow some geranium plants for his installation. Stephan lent them, and Jenney gets taken by Bellamy—with no follow-up visit to Stephan's studio, 'though my work used geraniums too!' 'It is not who does it first', Jenney later explained by way of exculpation, 'it is who gets it first to the store'.

But, it was not all self-service. Later, at an art party, Jasper Johns had asked John Duff to become his studio assistant. Duff, having sufficient funds on which to get by, recommended his classmate. 'Johns', totally neutral and taciturn, 'is the absolutely perfect Freudian analyst'.

'How much do you want?' Johns asks.

'$3.50 an hour'—the salary he had been earning as a part-time art therapist in a clinic on the Upper West Side. Johns nods assent.
'And when can you come?' Stephan indicates the hours and the days. Again the nod.

For nearly two years, 1969–70, Stephan worked for Johns during the period of the painting of the second version of the Buckminster Fuller Dymaxion Map, arguably Johns' least agreeable work. Stephan gets to luncheon daily with Johns and his intimate circle, this by way of having invented the studio chores—sorting the mail, feeding the cats, stretching the canvases, and reserving the table at old Signor Ballotto's restaurant on Houston Street.

Such recollections are keys to work shown at the now defunct David Whitney Gallery. Whitney, a close friend of Phillip Johnson and Jasper Johns, had once worked for Castelli uptown. During the colonisation of SoHo, Whitney had opened a gallery midway down in the then Terra Incognita—4th Avenue and the low 20s—more or less diagonally across from the old Max's Kansas City, then a preferred watering hole for artists. True, not SoHo—but not upper-Madison Avenue either.

The gallery partially reflected the combined tastes of Whitney, Johnson, and Johns, and can now be seen to have had its moments—especially the sponsoring, say, of the early Duff/Stephan experimental work and the early Neil Jenney installations. These highpoints were countered by much late formalist Expressionism then called 'lyrical abstraction', an abstraction I obtusely insisted upon calling 'fat field'. Set upon the grey industrially carpeted floors and walls of the top floor of a small loft building, the mix was novel and anomalous. Whitney's 'go-fer' was David White, who had also started out as a Leo Castelli assistant, and the warm secretary was Jeanne Blake, who first 'gal-Friday'd' in the old Richard Feigen place just off Madison into which Bykert eventually moved.

Of all the artists who exhibited with David Whitney during the two years of the turn of the 1970s, Stephan was shown the most frequently—three times—and at length, he closed the gallery. His work, then similar to Duff's, experimented with rubber, latex, plastic and free-process—a kind of constructed painting strongly marked by an awareness of pictorialised modernist sculpture. His works, at the time, offer no particularly loveable resolutions, though they were, for Stephan, highly therapeutic.

'Being back in New York, getting rid of all that weird California shit, I tried to make the paint structural, to make the paint itself into the ground I was painting on. I see them as plastic paint.'

My description of these paintings makes them sound too reliant on an admittedly self-evident Expressionist bias—'pictorialised sculpture'—suggesting, in this way, that the paintings were worked in the absence of a specific set of informational cues. Quite to the contrary, numerous formal

concerns are noted within this group. For example, any pictorial element that carried colour was meant to be a specific formal cue. Such coloured shapes, for instance, always occur as 'negative shapes'—though they are afforded an unusual assertiveness since they hold the strongest positive colours. The areas of the plastic paintings that were executed in black and white (or which were piebald or parti-coloured) conveyed a sense of field or 'spread'. These 'striped' areas, loosely speaking, connected up with one another across the shape interruptions that held the primary one-coloured shapes together. Such stripes did not always take horizontal configurations either; at times they occur as radiating patterns. Last, a kind of order was imposed through the sense of symmetry occasioned by the strongly inflected bounding sides.

But, as Stephan notes, 'To match these figurative cues is to deprive it of other things'. In short, the paintings of circa 1969–70 attempted (through the application of an exiguous argument) to embody Stephan's desire to 'circumvent style'. Style, at the time, capital 'S' Style, was torn between the East Coast hegemony (a mode Stephan was, in some measure, attempting to accommodate) and West Coast latitudinarian *laissez-aller* (the dopey private mythologies he had abandoned).

With noteworthy Jesuitical reasoning, Stephen reduced this antagonism (purging from it its geographical references) to an argument in which Manet is pitted against Cézanne; or in an even larger context, Culture versus Perception.

How can this argument be schematised? Manet, for Stephan, emerges as a student of Spanish painting, meaning for him that Manet viewed historical issues as stylistic questions. 'These issues seen this way engage the artist's technical ability at reproducing the diverse, smooth, or rough brushwork of his chosen models. A skilful adoption then allows the artist to be judged as either good or bad; and attendant historical issues then become conventionalised to those called up by iconography or iconographic interpretation'.

Duchamp, in substituting mentality for retinality, re-routed this tradition through the introduction of paradox and irony—a content whose recognisability has scant shelf life. While the 'thing' remains—the painting, I mean—paradox and irony rapidly grow invisible.

Making a rather broad and pointed argumentative leap, Stephan sees this aesthetic curve-ball as a form of latent suicide, a self-destruction with regard to meaning in contemporary high formalist painting (especially that of marked iconographic profile—such as is now being made by Julian Schnabel and David Salle with whom, for better or worse, Stephan's present career is inescapably linked).

The warping of culture is countered in Stephan's argument by 'perception', that is to say, by questions concerning what it is that one is seeing. Such straight observations lead to instrumentalisation, to the tool rather than to stylistic questions. For Stephan, Cézanne inaugurated this

aspect of the modernist tradition (as we all believe anyway), not Manet. Much of what Stephan calls 'the perceptual tradition', we call straight formalism. Stephan considers an artist like Elsworth Kelly, say, to be an exemplar. 'Culture, leading to Duchamp, leads to the consequences of "reading"; whereas, perception leads to the consequences of sensory data.'

Culture, then, leads to irony, and as Stephan notes, 'Irony is a way to do what one does without assuming responsibility for the action'; or stated even more bluntly, 'Irony is visual cowardice'.

Stephan admits there is no pure case, though this really may represent an attempt to slip off the hook, for, granting his hyperbole, Stephan also believes that 'the social question always goes away. It always evaporates. The only things that have any chance of survival are the things that *remain*—remain, that is, *neurally*, not *socially*. That is where Piero is critical, and that is where Manet's occasional optical struggle to organise the spatial picture leads to less than authoritative spatial discrepancies'.

'What about quality?' I interject, 'or our predisposition toward classicism over the long haul? Doesn't the inescapable binding of the notion of quality and the notion of classicism amount to an almost mystical connection in our culture?'

'I don't believe in the question of classicism at all. Quality, for me, is neural, and the neural avoids the shoals of quality. Paintings do something. Like cars, they do something. And this 'doing' is perceptual and neural. Paintings operate. Something happens. That is why painting is a radical activity. It finally is anti-culture. It is in here' he says, pointing to his temples. 'It is in the engrams. It is purely Darwinian. Our receptors are set up through genetic encoding. Trial and error only help or hinder the process.'

'No', I interject. 'That is too positivist a model, too materialistic. It's got no nuances'.

'Look, genetic shuffling brings the syntax flat up against evolutionary limitations. We're on our own. Shuffling occurs within us and within the limits of the enterprise, especially within the limits of the tools used.'

If, from the vantage of the early 1980s, the wacky mythologies of the California work, or the degraded rubber and plastic pictures, are perhaps more congenial than the informational aspects also present in the latter group, then the body of work of the early 1970s is perhaps the most displaced. In the measure that an epistemic argument for the arts of the turn of the 1970s took hold, Stephan's paintings were thought to reflect this tendency—one that favoured information. In the degree that Stephan rejected confusion for simplification, the marriage of incipient Minimalism to a waxing sensibility became evident.

It is, of course, the classicising element of Stephan's work that would carry him through this moment despite his disavowal. His first successes were appreciated by a circle of artists and connoisseurs deeply associated with epistemic abstraction. Surely the soundest advice Stephan received in

the early 1970s came from Richard Serra (advice tendered during the group show of new tendencies organised by Jay Belloli for the Contemporary Arts Museum in Houston, Texas, September–November, 1972): 'In a work, never do anything more than once'.

This Minimalist maxim helps explain the reductivism of Stephan's work throughout the decade. All the consonances and dissonances of shape, scale, and colour relationships separate out; relationships simplify, providing only sufficient compositional fodder for single organisations, when previously such material had served as units of far more complex, polyphonic structures.

Two elements, reduced dualisms, now suffice to justify the organisation. Briefly, composition became that of a reductivist formal strategy: How does one scale or locate a figure? How do you validate a figure in its place? And how can the artist continue to reduce the number of pictorial elements from picture to picture? The answer to these questions at last led to the emblematic grey square that haunted Minimalist painting during its sway, and eventually occasioned the sense of the utterly contrived and academic that sounded the death knell of the style.

Stephan bridles (as any artist would) at this formulation of Minimalism's evolution. He would point instead to the 'neural' validation of shape and form. Shapes were thus and so because they inescapably had to be that way, not out of any accommodationist tactic to a larger controlling *zeitgeist*. For the public, though, Stephan's pictures at the time were seen as the chief representatives of a Minimalist gradualism, the vague colouristic and tonal aspects of which continue to place his work outside the theoretical pale of the absolutist 'heavies', a gradualism that continued to speak for pictorial qualities then seen as of dubious consequence. Among these properties were Stephan's 'designerish' organisation (from Bauhaus graphics, say) or a colour connoting a broad range of evocative association. These were regarded as sentimental hangovers that fell outside the pervasive Minimalist context. It is precisely in the degree that these works do fall outside the precinct that they are today able to be seen quite freshly.

Naturally, for Stephan, the whole issue of colour and formal connotation is false. His view of colour at the time was one of neurological absolutes: colours had to be (and are what they are) not because of a palette predicated on association, but because of a concentrated focus, a bearing down on the issues of pure abstraction. Then, if one speaks of a Mediterranean palette, or delicate ranges of *greige* or flesh, or refined hues as indications of a drained and tasteful imagery, such associations are made on the viewer's account, not the artist's.

All this nuanced colour is countermanded, as it were, by essential geometrical configurations based on simple weight displacements—a circle placed against a triangle, a semicircle against a rectangle. Such compositions are rendered in an equally reduced palette, one that seeks to establish no more than figure-ground relationships despite the unswerving delicacy of the

colours assigned to the figures and the ground. In this way, one may continue to make dubious bracketings between the pronounced sensibility Minimalism of the 1970s and Stephan. Figures like Brice Marden, or Ralph Humphrey, or Doug Ohlson, or Doug Sanderson, or Susanna Tanger all come to mind and all are, quite naturally, wrong in varying measure.

In truth, the Minimalist graphic attachments of Stephan's work of the early 1970s represented a return to painting itself, if only by fits and starts. Naturally, there had been the example of Ellsworth Kelly, whose work—though reductive and itself even attached to the prevailing epistemic enthusiasm of the mid 1960s—grew out of an abstraction grounded in distillations of landscape and architectural motifs. This abstraction as an essence of nature is, for the modernist, its most venerable form.

Still, for all that, the period is marked by a hostility towards an overt and unapologetic painting. Indeed, painting itself was taboo, and even as they painted, Stephan (and many others) regarded their work as akin to the analytic reduction of the clear informational structures of early Minimalism. In short, they worked from a hobbled apologetic stance. It was not until the middle of the decade that the need to rationalise and justify the very fact that one was painting faded. Work, as it were, stood on its own, freed from the highly referential systems imposed by epistemic abstraction.

The Garden Cycle, a group of ten approximately 44-inch square canvases, is characteristic of the shift. The paintings were shown at the Bykert Gallery in 1975. They may be understood as demonstrating elementary figure-ground relationships rendered ambivalent through spare illusionistic bends. This reading of convexity was occasioned by applications of denser pigment. At this moment, Stephan's characteristic impasto, a build of graduated crust along a slightly scored edge, becomes quite historicist iconography and associative colour. The instances of powdery brickish colours were specific to Stephan's art-book study of the programme for Giotto's Padua Arena Chapel, the fresco cycle depicting scenes from The Life and Passion of Christ.

The very use of the word 'cycle' in the Garden Cycle was triggered by this connection. Not only did fresco technique provide a range of chalky colour relationships; it provided, as well, an isolated focus on curious architectural settings and motifs to be seen throughout the programme. For example, the section depicting Anna and Joachim (the future parents of the Virgin) meeting at the Golden Gate—Giotto's imaginary Jerusalem—provided a set of architectonics that, when even further reduced, appear in Stephan's pictures as abstract figure-ground relationships emblematic of the distilled architectural motif.

Occasionally, the shapes are not modified at all; rather, they are 'lifted', traced from the compositions reproduced in glossy picture books or popular guides to religious art. Thus the figure-grounds, on a certain level, may be read as excised turret or fortress dentellations. In certain ways, bold elements were

meant to transfer the massive sack-like figures invented by Giotto suggesting, to Stephan, 'the human plus its metaphor in architecture'. All this *italianismo* comes to a head in 1975. Not only had Stephan visited Venice, California, in that year, he also made his first trip to the 'real' Venice, sojourns that had the effect of confirming the incipient Italian connections—associations, like particles of metal, that came to adhere to the magnet of Minimalism.

So excited was Stephan at this discovery, he communicated it to Brian Hunt, then beginning his own career in California. Hunt, excited by Stephan's discussion, literally built a model of the Golden Gate at which Anna met Joachim. Surely for a Californian, erstwhile or otherwise, the coincidence of 'Golden Gate' and Golden Gate would be very striking, as is the parallel Venice/Venice equally arresting.

Thus the Garden Cycle is a culminating effort for Stephan. Each element encodes highly conscious choices for the artist. Its shape, for example, purposefully equivocates on the format issue, being neither vertical nor horizontal. The implication of the square format was first guessed at during the Venice summer. A vertical format, Stephan suddenly grasped, invoked a mimetic 'other person', a peer and equal out there in the world. By contrast, the horizontal format came to conjure the spectator who looks out over the terrain. In this sense of inspection, the 'voyeur' (too erotic a notion) or the dutiful Christian (associated with a reconstruction of the lost earthly paradise) was invoked. But the square itself waffles. Stephan's perceptions were, of course, part of the growing awareness of the pronounced iconographic classicism that attached itself to Minimalist logic—Ellsworth Kelly's spare balances and swells born of an acute appreciation of classical epigraphy and letter forms; Bochner's *sinopia* and dry pigment fresco technique; Rockburne's golden sections and her own version of *Maestà* imagery; Marden's Fra Roberto Caracciolo of Lecce; Mangold's Albertian church facades; Novros' *predelle*, etc.

Behind much of this Pre-Raphaelite overload is to be found the neglected figure of Gordon Hart who, like many before, had been stimulated by Cennino and the recipes necessary to early Renaissance painting—grinding one's own pigment, setting down one's own perfect gesso ground, burnishing the hand-set gold leaf, rediscovering the lost techniques of egg tempera, studying the magical ratios of polyptychly subdivided surface, and on and on. Hart's career, though checkered, was pervasive in the 1970s, a prestige heightened through his friendship with Barnett Newman. 'While he didn't get to run with the ball', notes Stephan, 'he was the one who made the connection'.

The use of gold leaf in Lynda Benglis' sculpture, for example, may be traceable to a residual connection to Gordon Hart. On her arrival in New York from New Orleans in the late 1960s, Benglis, greatly associated with him, a point of some interest insofar as it was across Hart that Benglis first met Klaus Kertess, the Director of the Bykert Gallery, with whom she entered a friendship that spanned the decade.

Briefly then, at the very least, Sensibility Minimalism of the 1970s may be viewed as The Bykert Problem, insofar as Kertess' highly sensitised taste brought his gallery to the pivotal place it enjoyed at the time. We have already traced Stephan to the closing of the David Whitney space on Park Avenue South; indeed, it was on the closing of that gallery in 1972 that Stephan joined the Bykert stable. Before 1972, Kertess had been installed in a small office-like space on West 57th Street. Stephan remembers visiting him there, sitting at his makeshift card-table desk with these 'self-conscious mauve boxes posed on the floor', wondering, 'What is all this shit?' From there, Kertess moved up to 81st Street, settling into the old Richard Feigen quarters and remaining there until the gallery closed in 1976. The move uptown was made during the summer of 1968. Stephan, by way of supplementing his still uneven income, worked as library cataloguer for Feigen in anticipation of the latter's installation in an elegantly renovated 79th Street townhouse. Gallery chores were shared with Frederica Hunter, who would shortly open the Texas Gallery, still one of the better galleries devoted to reductivist Minimalist taste. Need one add, by way of noting the extraordinary network of apprenticeships, that Kertess' last gallery assistant was Mary Boone, whose early taste as a dealer was initially formed by the gallery and by her strong personal relationship with Kertess, Benglis and Stephan.

'The thing about Klaus that was so striking to artists', Stephan notes, 'was this unnerving ability just to look and look at a work, for a long period of time, staying with it longer, even, than the picture itself worked. Klaus, in a way, could watch a picture end. I think that's why', Stephan continues, 'so much of the art shown at Bykert was tinged with melancholy. They were seen through'.

Kertess' most profound friendship from among his roster of artists was with the young Brice Marden. The intensity of the connection inescapably marked the gallery's orientation. Stephan's belief in the neural engrammatic character of painting, its sheer essential quiddity as deriving from Cézanne (not Manet) was shared by Marden.

This staying with the work, Kertess' way, Bykert's way, Marden's way, may be taken to be yet another facet of the strong rejection of Greenberg's modernism felt at the time. Greenberg had postulated the original sanctions of the modernist dialectic as stemming from Manet. An essential character of modernist painting at the moment of its failure in the mid-1970s was its presumed instantaneity of perception. Painting, by way of differentiating it utterly from sculpture, had to be accessible within a single glance. This way of seeing equally was countered by a then contemporary reassessment of the work of Reinhardt, in whose painting glossy instantaneity was replaced by time-consuming, long looking. Thus it dislodged painting from its role merely as a screen of delectation to become, instead, one of meditation, as Reinhardt would have it. Need one note, then, that among the canonic field painters as determined by Greenberg—Newman, Rothko, Louis—Reinhardt's name does not appear.

Indeed, Stephan's first memory of a significant art experience is intimately allied with Reinhardt, but much before this date, when he was a callow mid-Long Island teenager who had been taken to see a Reinhardt painting, part of an exhibition organised by Vincent Price for the New York Coliseum; and like the rest of the teenhoods he was with, Stephan merely laughed as he was paraded through the gallery. An astute teacher, knowing him better than he knew himself, chastened him and sat him down before the Reinhardt: 'You just sit here and look hard', she said, 'and you will see something you have never seen before'. 'After a while this fuckin' black cross jumped out at me from the canvas', Stephan continues. 'I was so excited. When I got home, I had to make black on black pictures; and I had just seen Jackson Pollock on a talk show, too', which means this memory dates to 1956 or earlier. 'The point was to make fun of his "dripping", because they put him on with this jerk—WOW—who made a pair of wings to fly with. I put Pollock and Reinhardt together, mixing gravel and paint and throwing it in the form of a cross on my father's shirt cardboards. Then I made these crosses mixing Karo and chocolate syrup on the cardboard. They were slow gravity pictures and had to be turned once a week or else the stuff would fall off onto the floor. And my parents turned them faithfully once a week without complaining. They never really impeded anything that had to do with art for me.'

However, instantaneity is but one factor of the modernist problem—its essential question addresses the illusion of flatness. Stephan counters that 'painting's true space is all the space it is'—an affirmation of the artist's essentially existential and phenomenological attachments.

These, of course, led to the rejection of the progressive or evolutionary character implicit in Greenberg's notion of modernism, the notion of art as a result of dialectical process. Of course, to reduce Greenberg's historical machinery, to regard the procession towards literal flatness from Manet through the formalist painting of the 1960s as merely a progress from illusionistic space to flatness, is to deprive it of its paramount mystical feature, its tacit acceptance of the condition of 'quality', a condition that eludes all mechanistic use of history. Even for Greenberg, quality is a transcendent inspiriting force, fully palpable to the true connoisseur, but invisible to the laity. It is not so much that two pictures may present concordances of flatness, but that despite this concord, one still may note that one space is 'better' than the other or 'purer' or 'finer' or 'deeper'.

For Stephan, painting is constantly rejective of notions of transcendence, as indifferent to academic norms as to cultural desiderata. Painters are involved (as are all sensitive artists) in the instrumentalisation of their work, another way of saying that they keep their options open; but this in itself may yet prove to be simply an updated reprise of the Marxist dialectic necessary to Greenberg, whether one likes it or not. For Stephan, 'artists simply find ways of doing things', admitting all the while 'that their work is limited by their personality'.

Granting this, they ought not (as the expressed intention of painting) engage in 'personal production', ought not make 'ego-directed choices', ought not 'agonise over how the work will "look" or worry about "style".' Instead, the enterprise of painting has a kind of inadvertency attached to it. Things all happen 'because there is no way for them not to happen'. Through sheer repetition of the activity of painting, 'the unbidden subtext will emerge anyway, those formal and iconographic considerations through which we recognise an intelligent work'.

In a curious way, Stephan seems to be talking about statistical occurrences as a kind of demonstration of formal and iconographic content. He rejects seeing the intention of painting as merely the forcing of their appearance out into the open. When this happens, he speaks of a manifestly 'distressingly subtexted picture'. Thus painting for Stephan may become a kind of diffident exercise, a pragmatic activity engaged in without an end in view. As activity, it is all filler material. Formal values and iconography happen anyway, so why worry about them?

But all this has led me from The Bykert Problem. Kertess himself came to outgrow, if not resent, his 'helpmate' role—the myriad insistent details of 'just running' a gallery were, in the end, inimical to his ambition of being a writer. And he closed. At the same time, his attachment to his artists assumed the demands of their own destinies—in Marden's case, to the considerable glamour of the Pace Gallery and its powerful support system. For others, the situation they found themselves in did not prove so easy. The psychological sustenance of just being able to say that one is represented by this or that gallery is an immense aid; this whether or not one's work sells.

The closing of the Bykert Gallery was coincidental with the incipient, turbulent Expressionist resurgence, one that I have come to refer to as Maximalism, much of it stimulated out of sheer despair with so long a diet of Reductivist Minimalism. The bridge to this mode, so characteristic of the present moment, led to Mary Boone who, sloughing off Bykert, continued to enlarge her own taste, at length to support the more radical-seeming palimpsests of Schnabel and Salle and other Maximalist Neo-Expressionists.

Perhaps, by way of conclusion, a word separating Stephan from Schnabel and Salle is in order—especially after having forced so specious a link between them. The fundamental difference between Stephan and the others is primarily one of generational attitude. Stephan's first convincing style comes to fruition within a Minimalist frame of reference, theirs in a Postminimalist. Thus, there must be between them—on an artistic level—a profound antagonism. Stephan, like the other artists who matured when he did, can easily, naturally embrace the history of art. He can feel his work, in some sense, to be in continuity with it, can feel his work, in some natural way, to continue a self-aware tradition of high art, and can view this continuity as normal, associated with the grand epochs and great figures of the textbooks. In short, he can feel at ease in drawing connections between

his work and the artists and heroic 'isms' of early modernism—especially Mondrian, Malevich, Suprematism, de Stijl—and so on.

By contrast, generally speaking, this cultural baggage provides a kind of embarrassment, in both senses, of riches and emotional disturbance, to the younger painters. They feel, in some measure, ill at ease and a certain bad faith at the seeming pretensions of such adduced associations. Of course, words like 'bad faith' or 'embarrassment' say nothing of quality. Both Salle and Schnabel, not to mention other generational compeers, are quite simply superb painters. My words are meant to speak to a certain cast of mind, a position of awkwardness *vis-à-vis* a cultural history that, after all, has the effect of generating compensatory systems of ratiocination, a need to justify their arts and actions in ways that are far less convincing than the art itself. By contrast, the sovereign security of their painting is never in doubt.

In further contrast, Stephan does not believe in a generalised imagery of fractured and dispersed subject matter, but of highly specific and reduced information. His painting is not bidden by the democratising visual gambits ultimately ratified in the Combine Paintings of Rauschenberg. Stephan celebrates his sense of profound continuity with tradition, his emotional ease with the past. 'I want to reassert a sense of Mission. They', meaning the Postminimalists and Maximalists, 'need to cover their sense of shame about tradition through visual sarcasm. I wish I could feel what they feel. I wish I, too, could feel free of history. But, I'm not free of it, so I have to take it all in and still hope to make 'normal objects'—we call them paintings—objects that sit comfortably with the facts of themselves'.

Gary Stephan in Conversation with David Ryan (1996/7)

David Ryan: It would seem that many of the problems now being tackled in current American abstract painting have been present in your own work for a long time. I'm thinking of the way in which you've discussed the relationship between objecthood and illusion, and in particular, the essay where you play Barnett Newman and MC Escher off against each other in a highly improbable pairing. At the end of the essay you wrote, 'Seventeen years from the millennium, the terrible beauty of our century is coming into focus, every time has its form—this is the abstract century'.[1] With only three years to go, do you still feel as strongly about this?

Gary Stephan: Yes I do, because increasingly the organising forces in this world lie outside our senses and this makes for strange problems.

DR: In terms of art as well as social relationships?

GS: Right. When I was a teenager, I was very taken with the work of Jackson Pollock, and I had no problem with it; it didn't need a defence, it was in

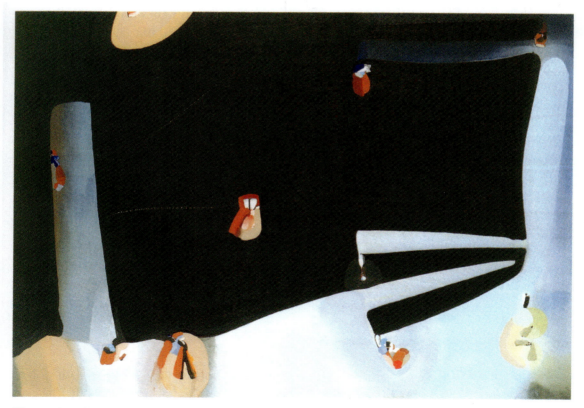

Figure 36 Gary Stephan, *Buried in Heaven* 1998, Acrylic on linen, 127 ×178 cm, Courtesy Gary Stephan.

itself interesting. When people asked me, 'what does it mean?' or, 'how does it work?', I didn't know where to go with these questions. Then I came across something in Carl Jung—who wasn't crazy about abstract painting, incidentally—suggesting that the case that could be made for abstraction was that it was trying to give iconic form to the fact that this century is characterised by increasingly 'invisible' forces. I felt this was a reasonable explanation for the urge toward abstraction in this century.

DR: I suppose there is a link that goes from more detached utilities, such as electricity etc, to the growth of information technologies with their corresponding invisibility. Do you see painting as operating, stubbornly, in the face of this—being perhaps a stubbornly concrete manifestation?

GS: Hmmm … no, I wouldn't be happy with the term, 'concrete'. The issues around painting that I was getting at during this time, and which, in many ways, I feel I've made my peace with since, were as follows: firstly, the paradoxical or unsavoury state within which painting can exist … This is what I was commenting on with Newman, and still think it's the case. I still believe that for a painting to be really interesting, it has to be in an in-between state where it's almost serviceable as a thing in itself, and almost serviceable as a view into a world. And the reason why it's so unpleasant or unsavoury, is because we have to keep on saying, 'almost' serviceable. This is where modernism's blind-spot lay, where it felt it had to clear out all the underbrush of pictorial association and get this thing to be 'itself'. Such a viewpoint went nowhere, experientially, for me. That's why I perversely and pointedly misread the Newmans as openings and closings, cracks in doors, shafts of light and all that kind of stuff, that you're not supposed to do. They're supposed to be closed, autonomous things. 'Like hell they are!', I thought. The reason they're so charged and re-chargeable, is that they're infused with their associations with the world around us. And this might be taken to a more general level: what you have in a painting is often this 'thing', which is generally a rectangle and flat, which is built, constructed, deployed across a plane and made. If it works interestingly, it is also supple and pliable, both opened in and out. It's only when these are in discourse that the thing becomes attractive. When you get the window with no wall, that's not interesting; nor is the wall with no window. When it's kind of satisfyingly 'cobbled' in the middle, it begins to work, and it's the unsettled nature of this situation that makes it fascinating.

DR: But also frustrating in some ways?

GS: Well, actually, you've hit on something that people don't like about abstraction, but in fact, may be its grace: namely that it's an object in the world that's accompanied by a 'what is it?' sensation. What a peculiar state of affairs, if we think about it!

DR: Going back to the relationship between the wall and the window, I was intrigued by the way you offered Newman and Escher as a kind of choice—that one had to choose between these. Surely your own position has been one of synthesis?

GS: That's my solution; I've chosen to bind them. Culturally, what has happened on the one hand, is a transferable, disembodied iconography, and on the other, these things that are almost too real. People imagine that they must choose between the two—between nuts and bolts, grounded in matter, or pure information. That's still a choice for many artists. I saw Escher's work as a perfect computer logo or wine label; here was an artist whose work had become simply popular, usable imagery, in that you can scan it, rescale it, use it for almost anything. Then you get the painters who try and nail it down in absolute scale and in 'real time'. Unfortunately, maybe, the die is cast. I think society has decided which way it is going to go: it wants the transparency of HDTV, not the sprockets and scratches of film.

DR: Can painting hold its own against this? Could there be a positive reaction to this situation on the part of painting?

GS: Well, let me save my soul on this one. I'm not comfortable with the state of painting today. I think abstraction always carried with it an anxiety that it could decay into decor. I imagine Rothko woke up in the night in a sweat, asking himself, 'Is this just decoration?' As long as people kept themselves at this point—that this painting problem had to be resolved at the level of human meaning—then they were okay. I don't think people do that anymore, and I think a lot of the stuff is collapsing into empty, pleasure-driven stand-ins for art. Empty signs. That really does bother me.

DR: What about the self-conscious usage of this sign value? I think it was Olivier Mosset or John Armleder who suggested that he chose abstract forms simply because, culturally, they operated as dominant signs for the culture of the twentieth century. Similarly, your own work has been described in a way that suggests that every mark is held in rigorous quotation marks. I'm sure you'd distance yourself from a recycling approach, but I wondered about your thoughts on abstraction as sign or quotation; do you see this as simply a commodification?

GS: This problem goes right back to Malevich's *White on White* [1919]; I think this isn't a painting any longer. It was a painting once, but we can no longer see it; it has been replaced by its own sign value. This has happened to a lot of early abstract paintings. We can no longer have a direct experience with them. Maybe they've become signs for human freedom or whatever, but we can't cross that gap that separates us, thinking about what it must have been

like then, or how you could conceive of making such an object, given the backdrop of history around it. That kind of historical bracketing is similar to the privilege of an archaic priesthood keeping aflame the fires of the deities. Once the 'priesthood' dies off and these things go naked into the world of the twenty-first century, nobody will be able to engage with them, or react to them. They have become secular relics. And these guys who think that the beauty of it is that it's a dead sign system, are just burying themselves, because the only way anything historically goes forward is if it existentially lives for people, who will have real experiences with it. The rest of it is temporary window dressing; you know, you might talk your friends into it, but long term, it's a dead-end.

DR: Do you feel the audience for painting—those willing to spend time with painting—is shrinking?

GS: Absolutely. There's the fifteen serious collectors, the ten critics who get together, the five hundred people who subscribe to the magazines, and then twenty practitioners—I'm exaggerating, of course, but it's a small world, and an exclusive one. I ask myself about the whiff of privilege here, especially where it becomes a self-generating, private scene, and it's increasingly, on the level of high school, about being in the club. This is not what people should spend their lives doing, in my opinion.

DR: Going back to the idea of self-consciousness, it was once suggested, in a review of one of your shows, that you 'learned the severity of self-consciousness from the master's hand'—Jasper Johns.[2] Having worked with Johns for some time, how much did you learn from him?

GS: A great deal. One of the main lessons I learnt from Jasper, was to keep my distance. As soon as I got done with work, I'd come home and take a shower. I was very afraid that if I didn't have a break-point, where, at the end of the day, I could get into my studio and do my work, then I'd become one of his acolytes. Because his world was so persuasive, I was forced to stick to my own knitting, so to speak, and be protective of my own practice. The way we saw the world was similar in some senses. I admire the way in which his work is amplified by other things. It resonates with other human activity: poetry, philosophy, even ethics. Actually, Jasper would probably hate me saying all this because he's so concerned with the object going out in the world without any attendant agenda. But it was never simply hermetic or didactic, like what we were discussing earlier, but rather in Johns' work, the object is sufficiently generous that it can touch on other things, and people will find it rewarding to return to it, at different times and for different reasons.

DR: Was Johns' approach to mirroring forms particularly interesting for you? Of course, you use this differently, but I'm thinking of these silhouetted forms where you exploit transformation of form through simple duplication.

GS: There is a lot of mirroring and doubling in my work, it's true. I don't think I got it directly from Jasper, though it's certainly present in his work. But it might relate to what you were getting at about self-consciousness. I always loved the drawings in children's colouring books—a landscape, for example, where you have to find faces in the rocks or something. But immediately the picture will look wrong. The forms are under too much stress, there's too much information, they're too self-conscious. That's how I want these paintings to function; I want them to picture a world that seems to be 'thinking'. One thing that intrigues me about Constable, is that the landscape is charged with consciousness. You know, you'll look at them and say, 'that's no landscape', because they're too fuelled up by a kind of mentality. By making the forms in these paintings so aware of each other, they cease to have an isolated existence. In my paintings, I want something of this quality—the forms seem to look each other over, or one form might suggest, 'I was once part of that' in relation to another. Or the way these two forms [pointing to a painting] melt into each other. Or over here, the way this form is the 'sad' twin of this one. It's like a kind of body language—you know, you'll walk into a restaurant and see two people at a table—and immediately get information about their relationship just by their positioning. Forms can be read in that way and abstraction can talk about such things. That's how it works; it's inferred from the way objects operate in the world.

DR: So it could be seen as psychological, or even psychoanalytic, in its approach?

GS: Yes it is, but that's all I can say. I don't want to 'figure' them out. I recognise a kind of fullness of meaning, but I no longer ask myself what the meaning is. I did this when I started painting. I made work that I felt was charged, but then I took the watch apart, and I'm not interested in doing that anymore.

DR: That approach to doubling could be seen as relating to certain Freudian readings, and I think Lacan somewhere talks about bifurcation or bipartitioning as an 'existential essence' of Being, where he says in both sexual union and the struggle with death, the being splits between Being and semblance, the doubling of the other and oneself is constantly at play.[3] I'm not forcing this onto your work, of course, but simply observing that this seems a dominant condition of your painted 'world'.

GS: That's very interesting. It also reminds me of the American painter, Albert Pinkham Ryder [1847-1917]. I remember experiencing a particular form in one painting, and spotting the same form in a painting of completely different subject matter. It was the shape of a saint-hermit by the roadside in *The Story of the True Cross* [late 1880s], becoming a tree in *The Forest of Arden* [late 1880s-90s] I traced them and they fitted exactly. This kind of memory does something—exactly what, I don't know. This, again, is something you touched on with the notion of transformation: here is the same form operating as another 'thing'. In my work, this happens on another level as well. Some of these forms have kind of phantom limbs; they seem on the verge of becoming something else. This is at its richest in Cézanne. Cézanne's landscapes are so animated by his consciousness, which is no surprise because he really did try and occupy those forms, and we sense the plasticity and mutability of them.

DR: I was recently reading a lecture from the early 1970s by Joseph Kosuth, where he suggested that when painting gave up a notion of 'fictive space', it entered into a phase of ossification, fossilisation even, paving the way for the literalist objects of Minimalism.[4] For Kosuth, such a move constituted a kind of crisis of meaning, in that this 'hardening', or increased opacity of painting, in its more reductive manifestation, was a sign that we stood outside of its belief system as a language. We are simply witness to its materiality, rather as an unfamiliar language will simply appear as a series of vocal noises. Surprisingly, such a position might be not so dissimilar to your own, although I suspect you would feel uncomfortable with such a logical, linear, 'modernist' progression.

GS: I agree with this. I think Joseph is dead right here, and it's what I said in so many words at a different point. I think those abstract artists who play the card of, 'we've got something like nothing else'—you know, that this is a completely autonomous work, closed off from the world—attempt to build a dam in a human river and they're crazy. The thing to do is to constantly renew the flood-plane of your work by returning it to a 'fictive space'. People like Tom Nozkowski and Jonathan Lasker explore this situation, and it works precisely because it is accessible through reading space in the way one knows space to be readable, in an experiential way, and also implying meaning in such a way that one knows form implies meaning in the real world.

DR: The difference between, say, Kosuth and yourself, is that you believe fictive space can be re-energised within painting, whereas for Kosuth it's a lost, historical moment. You also imply a sense of freedom from 'use-value', when techniques and traditions are revitalised in some way. You used a metaphor of sailing-ships, I think?

GS: Yes, that sailing-ships didn't go away when they ceased to be carriers of cargo; they simply changed their way of being in the world. One of the radical things that painting can do, and abstract painting in particular, I think, is that they can spring directly from the emotions and seduction of sensation; that's why real reductive pictures are such a dead-end, because they can't adequately deal with this fact. One of the most radical things in life is the way in which the pleasure principle manages to escape control and authority; state authority even. Traditionally, this is not just 'escape', but also a radical act—you know, once you got out of Pharaoh's sight-line, you could drink your homemade wine and kiss and hug and nobody could fuck with you anymore; you were in your own little cosmos. Regrettably, through mass advertising, the pleasure principle is now also being corralled by state authority and other means of control. I think it's still possible to distinguish between the 'false consciousness' of the pleasure-drive within the world of advertising and other forms. What artists have to do, is to realise that the radical status of their pictures lies in the fact that they will never be 'good citizens'. I'm a big defender of Renoir, and he's a great example of pleasure escaping the 'time-clock'. Get into a Renoir, and you're off the assembly line; the machinery of the state collapses.

DR: You have also suggested in the past, a shift in the power relationship between production and reception. In your own words, 'The knowledgeable father, the maker of masterpieces, is replaced by a psychiatrist, a witness to the viewer's self-discovery'.[5] This reminds me of Newman, who himself talked about a kind of transference of 'self-discovery' from artist to viewer.

GS: Absolutely—it's a search for a sense of self and the object facilitates this process, in the making and the looking. If paintings fail, it's when they become simply therapy (and I'm not arguing *for* that, despite the metaphor). Or, on the other hand, they become propaganda. One is too outer-directed and one too inner-directed. It's a situation whereby something that might have intensely private roots gets transposed to the level of the social, in that this thing doesn't remain at the private level, it becomes shared, enjoyed, and a rewarding experience for a variety of people. Something like that is definitely a condition of making a satisfying object, whereby this has to be something that the artist has to go through, as a process of self-integration. It really is for me, I know it. I need this 'surrogate universe' to ply the disorder, order, the beauty and even failure that occurs in my life. As my life gets more complex, the work is richer; it's more optimistic, it's more dense. It's clear to me that I'm building a compensatory, and also contestatory, world. It's really disturbing in many ways, because it's so much like a nineteenth-century idea.

DR: Going back to what we touched on earlier—the 'reading' of the paintings—you seem to stress the indeterminacy of the situation. But it's never a free-for-all: 'read this however you want'; it's always tempered by a relativism, in that it's only a *relatively* open situation that results from a high degree of executive control.

GS: Yes. What springs to mind, is that old atomic model where you get discrete electrons orbiting in particular paths, and subsequently a better picture: a quantum cloud that oscillates, within a range of possibilities, around the nucleus. So what you get is a situation rather like the way paintings are 'read'—it's not, 'oh, you can do anything you want with them', nor is it really, 'it's about the Battle of Trafalgar—the end'. There always exists a range of credible readings that enter into this cloud.

DR: Which brings me more specifically to the nature of words in relation to the artwork.

GS: This, in itself, is complex. As I said earlier, abstract form is often accompanied by a 'what is that?' sensation, which in turn is related to this situation of indeterminacy that we've just been talking about. Then there are titles, of course, which are kind of indications, somewhere between loose stage direction and poetic equivalence—they might get you in the right mood. This one [pointing to a painting] –*My Lost Soul*—has a very charged title—more so than most. And I was experimenting here with things like this [pointing], where the same colour would occupy this very weak, literally deflated form, which was connected with this very filled form, right in the middle of the picture. And I wanted to compare the forms almost in the manner of lucky and unlucky siblings. This relationship between emptiness and fullness also reminds me of an image from the children's stories of Pooh Bear. Piglet takes Ee-aw a burst balloon as a birthday present, and this particular story is bound up with many images of emptiness: the jar has no honey, the balloon is deflated. And despite this, the idea of this object going into an empty bottle is a pleasure to Ee-aw. And when you hear this at the age of five, it's like a Zen *koan*. It always struck me as a complex proposition, with all its inferences of interiority, etc, and its notion that, although surrounded by this emptiness or non-functionality, invention and pleasure win out.

DR: Are there generally strong overlaps with theoretical interests in your work?

GS: My theory days are over. I really saw my first twenty-five years of working as getting enough information together to feel qualified to go about

my business. So all the self-consciousness, the historical references, the various tropes and frameworks that I formulated were an aid in just getting me to a point where I didn't know what I was doing.

DR: But this was an essential part of the process, in the sense that you absorbed theoretical issues as a crucial part of the practice?

GS: Absolutely. But, to this day, I feel that painting is not a young person's activity, essentially. For my own part, all this information was simply something to 'let go with'. Intuition is so important, and so underplayed and undervalued today. But intuition can only be implemented through experience. You know, what do we have to draw on, or let go with, when we're eighteen? Theory is an enabler for younger artists, but it's no substitute for experience, and the way experience can be translated.

DR: Could you say something about the way the paintings have changed? I'm thinking here of the change in scale, colour, etc, in contrast to the work of the 1980s, say, where monumental, silhouetted forms operate in a very different way.

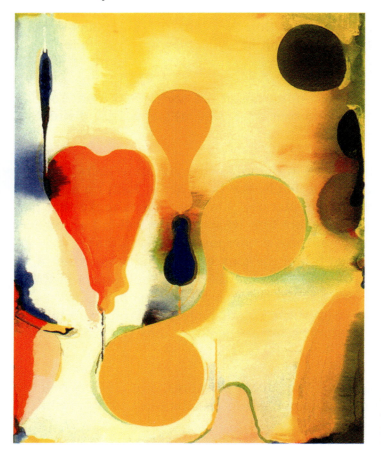

Figure 37 Gary Stephan, *My Lost Soul* 1993, 38 ×30 in, Acrylic on silk, Courtesy Baumgartner Gallery, NYC.

GS: These paintings moved out of the dark in 1992. There was a group of work I showed in Washington: the first section consisted of paintings like you've just described, and the last one explored a heightened colour.[6] There were five in all, but the transition looked like a movie that had been colourised, with the colour being turned right up to a maximum at the end. Following on from that show, I felt very clear about what I had to do. It was an exploration of the upper expressive limits of colour and light. There is no longer, I feel, any stylistic constraint—or any sense of 'braking'—through the interference of taste or sensibility. I wanted to find where this upper limit lay. And what's good about it is that these paintings are as much as I could possibly think to do to get to that end; there is no sense of holding back at all. They're less driven by taste, and more driven by an attempt to maximise the luminosity and the plasticity of the picture surface. I want the space to be very sensuous and very unstable. I want you to be able to enter it and track around the painting, but also be held by edges that both support and 'disappoint', in the old Wölffin sense. He would say that edges in a linear painting were a dependable transit, whereas in a painterly painting, one would enter into the centre of objects and the margins were less dependable. The contrast of, say, a Piero to a Rembrandt, sums up this situation. What I want is a situation where we can move back and forth between those two languages. The dependable edge that, within the same object, begins to fail, so that the whole space embraces a notion of sealedness and openness simultaneously.

DR: You mentioned the paintings 'coming out of the dark' earlier on. Your use of black functioned in many different ways, and was also very distinctive, somehow operating as 'blind-spots'.

GS: Exactly. There's this funny thing in painting, that any time there's a landscape behind figures, part of the landscape is an act of faith on our part, that it exists. Early on in my abstract pictures, I really tried to make that part of the content, and tried to use that fact that what went on behind an object could not be known. In fact, I would use it compositionally, so that you would have three or four ways of filling the gap, of guessing some kind of continuity in that 'blind-spot'. It's an intriguing thing. Another aspect of the black pictures was the scale—it's a more public scale, where things are turned to the world. Ironically, with these colour paintings, which are much brighter chromatically, these feel more inward looking; they've turned toward me.

DR: There's also more illusion in these recent paintings, and I wondered whether illusion was gaining the upper hand in this dialogue between the window and the wall?

GS: Well, I would no longer put it in those terms, or, in order to answer this, I can't use them. The criterion, as I see it now, is to move things to a different level. It's a situation whereby the preponderance of naming is resisted. Many of these forms lead you through a process of recognition that stops short of naming. Yet at the same time, it's a fully enterable world: that is extremely important to me. I now don't see that the object has any intrinsic human merit. I made an object—so what? The object is still there, and it'll take care of itself, and it's not going to be disguised. The painting will clearly be made out of paint and materials, but there is an alchemy that goes further than simply laying this out. The real point is, what does it mean that we can produce so much visual consequence from these meagre means? That is the interesting construct for me. I'm no longer interested in the kind of painting that says, 'Hey, is this a picture? ... no, wait a minute ... it's becoming an object ... but maybe not'. I don't think this, if it's foregrounded as content, means that much; I really don't. If a painting is really good, then it's like living. What life is like, is consciousness, both self-reflecting and negotiating the world—it's a dialogue. This is a complex situation. A painting is a thing. Inside this thing are also these operations that are like thoughts, like pictures; their identities are elusive; and we shouldn't minimise the elusiveness of this, any more than we should reduce a person to, say, the dangerous, behavioural reductionism of a Skinner.[7] Maybe it isn't such a coincidence that Skinner and also the notion of 'pure' abstraction came along at similar points in time ... I don't know.

DR: This idea of a painting becoming equivalent to real experience, becoming almost an organic, living and breathing thing, reminds me of Philip Guston, where the painting had to be animated to the extent of becoming almost a personage. Is there a point of contact here?

GS: I'm not as big a fan of Guston as I should be. Because so much in how paintings are animated, for me, is through the meaning of composition. And the composition—the way in which energy transits around and through a picture—means a great deal to me. And with Guston, quite frankly, the stuff moves with great difficulty. He's got a really nasty simple world: the wooden floor, the box, the bottle, the pink void; and boy, there's not many places to hide in those paintings. I like to be able to get into a painting and move around it, and feel that this circuitry is intelligible to me. Which is not to say that Guston's isn't; the bleak circuitry of Guston is true, and it's Beckett-like, and I wish them both the best of luck, but I'm just not going in, thank you ... I'm just not going in!

NOTES

1. Gary Stephan, 'Escher or Newman: Who Puts the Ghost in the Machine', *Artforum*, February 1983, pp. 64–7.

2. See JW Maloney, 'Gary Stephan at the Baumgartner Galleries', *Tema Celeste Contemporary Art Review*, no. 39, Winter, 1993, p. 85.
3. Jacques Lacan, *The Four Fundamental Concepts of Psycho-Analysis*, Norton (New York), 1981, p. 107.
4. Joseph Kosuth, 'Painting Versus Art Versus Culture', in *Art After Philosophy and After*, MIT Press (Cambridge, MA), 1991, pp. 89–94.
5. Stephan, 'Escher or Newman', op cit.
6. Gary Stephan, Baumgartner Galleries, Washington DC, 1992.
7. BF Skinner (1904–90), US psychologist whose stimulus-response experiments and behaviourist theories influenced methods of education and behaviour therapy.

WITH WANTON HEED ... (1999)
Jennifer Higgie

A bowling ball attached to the wall greets the visitor like an odd doorbell you can't ring. Every visitor—as if their curiosity is reason enough to privilege them—literally gets the red carpet treatment, a lush casino plush that follows glossy and curved fire-engine red walls until it bleeds a moment later into a room run amok, like a variation on a theme of an abandoned carnival or some strange collector's home (who collects radiators or granny lamps?). Coloured cables shimmy through the air like doodles made flesh or an Arte Povera exercise in vanishing perspective points. A battered boat dangles from a window. A large section of the gallery floor is covered with orange titles, while another has become a parking lot for trailers—the big, locked and secretive trailers you see trundling down highways through landscapes with a lot of sky. (They're parked neatly to one side, like they don't want to interfere in something they don't altogether understand. You get the feeling that maybe they were used to transport things that weren't regular. I don't know what though. Just not regular.) Colours leap about and peel away from

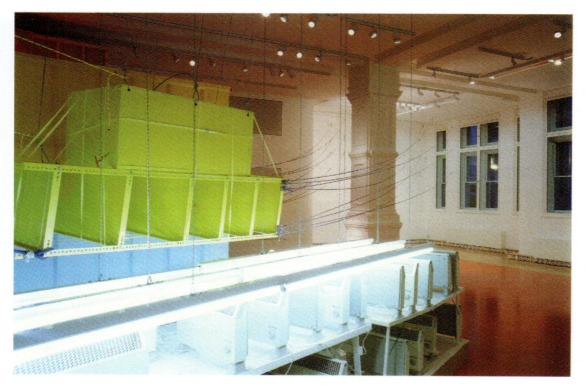

Figure 38 Jessica Stockholder, *With Wanton Heed & Giddy Cunning Hedging Red & That's Not Funny* 1999, Mixed media, Dimensions variable, Installation at Centre for Visual Arts, Cardiff. Photo: John Davies.

each other on the floor, the ceiling and the walls—brilliant shattered colours, acidic one minute, affectionate the next, stinging blues and greens and laughing oranges and haywire pink—which delineate the hard lines and parameters of … what? What has been done to this old Victorian room? And why? It's become as animated as a cartoon and as serious as a really good colour field painting, a playground, a grand metaphor, an elegant mess. It's become a picture that invites you to walk inside, but refuses to tell you why.

It's called *With Wanton Heed and Giddy Cunning Hedging Red and That's Not Funny* (1999); part Wordsworth, part make-believe. This one line—in which quotation and invention are hard to separate—is typical of Jessica Stockholder's approach to art-making. It's contradictory ('Wanton Heed'?), bossy ('That's Not Funny'), percussive, allusive, elusive and strangely lovely ('Giddy Cunning', 'Hedging Red'). It appropriates something that already exists (the line from a poem), and then merges it with something invented in order to transform an intensely personal experience (the things you inexplicably like, the way thinking happens in leaps and starts, the way you make sense of space when you move through the world) into something overwhelmingly public (title of inaugural show in a big new gallery).

Stockholder rearranges things and stale old perceptions of things until their frame of reference becomes enmeshed in a complicated series of fictions—fictions that tell endless stories reflecting real, and very subjective, situations and feelings. She chisels open surprising conceptual gaps and spaces between the most mundane of things and in so doing allows them to breathe a little more easily. (She's the art equivalent of a man loosening his tie after a particularly heavy meeting—the letting go of a structuring device, the loosening of convention). She connects objects that might initially appear unrelated (the bowling ball is actually attached to the boat by a meandering, circuitous cable), allowing the possibility of connection—almost any connection imaginable, literal ones or metaphorical ones—to create something tangible and fresh (after destruction, reconstruction begins). She encourages us to see how the world can be even stranger and more interesting than we assume it to be—but then it's hard not to feel that even the most ordinary objects and situations are, in the grand scheme of things, already pretty strange. It's like saying a familiar word over and over again, until all that remains are innate rhythms and residual meanings.

If this installation (such a dry word) were a shower, it would run hot and cold without your control. When it's cool, its very cool: restrained, hard-edged, particular (cold fluorescent light, stern white pillars, neat arrangements, hushed). When it's hot, it wavers between being literally hot—after all, if you turned on all 45 radiators, boy, would you sweat—and hot with hot colours, which erupt at odd moments in unexpected places—a soft gleam of light on the ceiling, for example, like the stain of a blush on an embarrassed cheek. In other words, and despite its conceptual bent, it's an intensely physical piece of art. If the twentieth century has been a century

more than any other when the idea in art has become as privileged as the object (abstraction, Minimalism, Formalism)—well, this work goes to enormous pains to remind you at every turn that it's made from the kind of stuff that can lend an idea a shape or set off a chain of thinking in a dreaming head (or a very awake one, for that matter).

The installation is filled with a weird functionalism. Most of its components have, at some time or other, worked for a living—lighting or heating or furnishing rooms, transporting people and goods, or being part of a sport. (Stockholder once commented that she 'likes to bring a little outside in'.) As they've all been displaced (refugees form the 'real' world) you might expect a certain forlorn quality to seep into the mood of the piece, but on the whole—as a whole—its mood is up, infectious, exuberant—things on holiday from their thing-ness.

Stockholder's giant installation is as indebted to the history of still-life painting as it is to the theatricality of process art. Even the most humble of still-life paintings employ a strategy not dissimilar to hers—re-presenting the mundane objects with which we surround ourselves, and often, ignore, focusing on them with an intensity that casts a different light on both their function and their context. The best still-life paintings examine the space between objects with the same kind of scrutiny they apply to the tangible objects that litter their surfaces. In this installation, and despite the cheerful cacophony of objects, there is plenty of empty space, which is activated not by what is in it, but by what contains it and surrounds it—the walls of the gallery, the windows that look over a busy Cardiff shopping street, patches of sky and the flower baskets that dangle from the street lights.

Spend some time with the work, and you begin to realise that to look for a meaning behind it, as something fixed, is a futile and somewhat killjoy endeavour (as if things could, or should, ever mean something singular). What emerges as a more engaging and fulfilling approach, is to concentrate on the ways in which the work pushes a feeling of how we experience time, channelled through objects—after all, the way we remember past events is often ruptured and unexpected, and embedded in the most banal of containers and markers. As a result, the look of time—which by its very nature you might assume to be an abstraction—begins to resemble something mysteriously concrete; something at once displaced and made present (what was this thing? What is it now? How can it mean something different if it still looks the same?) The intimations of domestic interiors—the lamps, the radiators, the carpet, the tiles—juxtaposed with the enormous conduits of movement (the trailers and boat), gesture towards almost filmic scenarios of travelling and coming home. That we are allowed to move around the gallery and see the installation from myriad possible angles implies an archaic theatre without a script, a scenario in which the viewer becomes at once participant, spectator and interpreter, whereas the large blocks of colour run a line straight back to the 'purity' of the modernist

endeavour; one in which the components of a piece of art would rely on nothing more than respective components of the piece itself.

So, to return to the original question: what is this room, and what has been done to it? It's not as symmetrical as a conventional 'white cube', but it's as loaded with expectation (people expect so much from a gallery); it was once a library; a Victorian structure. This is its framework, and quite naturally part of it needs to come to terms with its past, while rearranging or breaking out of the structures that originally defined it (after all, most prisoners who escape jail leave something behind). It's like stepping into a painting but conversely being very aware of being in a room filled with the ghosts of former inhabitants and histories, It's this combination of disjunction, narrative and of the idea of an ongoing memory of the past in the present to which Stockholder's installation responds in such an eloquent and joyful way—she has created a kind of architecture of thinking. Like an echo, it creates an atmosphere of something exploding beyond itself before bouncing back as something forever transformed.

Jessica Stockholder in Conversation with David Ryan (2000)

David Ryan: How do you see your work in relation to notions of abstraction?

Jessica Stockholder: I love abstraction and what I do is fundamentally abstract. But I don't take that to mean that it's without reference, content or even some kind of narrative.

DR: Could you say something about what you understand by these terms 'abstract' and 'narrative'?

JS: I see abstraction as being equivalent to fiction, in that it's bound up with the impulse to create another world. Abstraction and illusion share a remove from matter. I experience abstraction and my work as parallel to, or perhaps as metaphor for, the mind. On some level, I don't understand image-making,

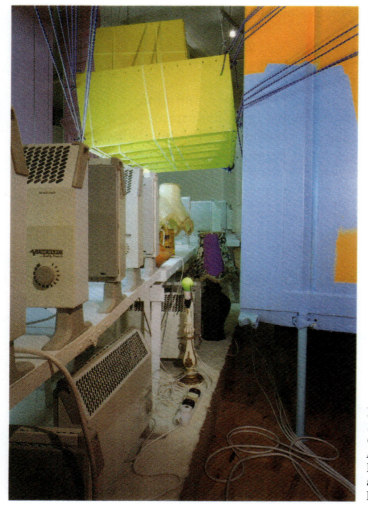

Figure 39 Jessica Stockholder, *With Wanton Heed & Giddy Cunning hedging Red & That's Not Funny* 1999, Mixed media, Dimensions variable, Installation at Centre for Visual Arts, Cardiff. Photo: John Davies.

or figuration, as distinct from abstraction, though I don't dispute that there are differences between the two.

DR: What informs the generation of an idea for a piece? How much are you affected by other artforms or even events outside of what we might describe as 'art'?

JS: I work in response to circumstances, space, people, available materials, my mood. My work also builds on itself. One work leads to the next. I also love reading fiction—I enjoy traditional narrative that has a beginning, middle and end. I enjoy character development and plot; I see this as equivalent to the tradition of realism in art, so I'm not sure why I'm so drawn to abstraction in visual art. It's obvious to me in retrospect that my work takes from many other artists, living and dead. I sometimes notice this as I'm working, but generally I don't set out to quote people. I don't see myself as working in opposition to my history; rather, I see the work of those before me and of my contemporaries as forming the ground I work on, or the world I live in.

DR: Have particular fictional narratives affected particular works?

JS: No. But more generally, I enjoy science-fiction and fantasy novels; the fictional space in this kind of work seems equivalent to the space in my work. Although I don't find it easy to read philosophy, what I have read has mattered to me a great deal. I've read some Hegel, Merleau-Ponty and Gadamer, and they've continued to resonate for me. The kind of thought that has developed from Merleau-Ponty in connection with Minimalism has been central to my work.

DR: How does one work lead to the next, as you've just suggested?

JS: I understand my work to be a continuous whole extending past the boundaries of each separate work. My process or journey of thinking through the work over time is more important than any single piece, and my activity and thinking has evolved and is still evolving; I'm not sure that it progresses.

DR: People often note the fact that your work is not painting but rather comments upon the practice of painting in an oblique way. I've always found such discussions involve making media-specific demarcations a little too much; I myself would prefer to see your work as a kind of 'expanded painting', where pictorial illusion is somehow existing as a dialogue within and with 'real' space. And yet there are definite degrees of both pictoriality and the sculptural—the smaller works, for example, have a frontality that aligns them to painting, but they also suggest the sculptural as defined space.

Could you say something about these different modes of working—say, in the studio, and the architectural considerations of the larger work?

JS: I do think it's interesting to talk about what painting is, and what sculpture is, as they're words we use complete with history and each embodies a complex convention. But I'm not myself concerned to define whether my work is painting or sculpture. It clearly depends on both conventions. In the studio I accept a whole array of different restraints than is necessary when I'm making a work that doesn't have to last past the exhibition. The installation work can 'bleed' into the space that houses it, the materials don't have to be archival and it doesn't have to be portable. Also, working in the studio is a private and more meandering activity. The installation work is performative and bound by a deadline.

DR: Following on from this, how do you approach a specific space? How do you see the reciprocity of bringing an idea to a space and the 'feedback' situation of how the space itself might radically alter these ideas that you bring to it? In fact, are there any spaces you've turned down or deemed too difficult?

JS: I'm not very judgemental about the quality of a space. I take it as a given most of the time. My work is rooted in what you're calling a 'feedback' situation. The work is all about how my activity meets the things I bump into out there.

DR: You've also mentioned, elsewhere, a relationship between the personal and memory in relation to the work—is it also a fruitful tension between what we might call 'chance' and the 'emotional life' of a particular work?

JS: Everybody's work must be personal and autobiographical. Each artist's project is an eccentric one. The reasons for making art are certainly not economic, as there are more certain ways to earn money. There has to be personal excitement, and an artist's choice of activity is eccentric and personal. What is made of, and in relation to, the personal is important beyond the particulars of any personal story. In my work, I'm keenly aware that I cannot choose to be someone other than who I am. Despite all my efforts to create chaos and disorder, the work remains organised by who I am. I also believe that a piece of us is unconscious. This is no small thing. My work provides an opportunity to glimpse that part of myself. Of course, if I were aware of those parts of my self they would no longer be unconscious. I have faith that there's some kind of order and sense to all my activities and I trust that the unconscious is also intelligent and ordered in some fashion. My work provides a way to explore how my conscious thought meets those parts of my thinking I'm not so aware of. It is very difficult to find chaos:

throw a bunch of things in the air and they don't land randomly. It seems that the relationship between control and chance is at issue for most people in different ways. It certainly is central to my work.

DR: The sensation of both space and thing-ness is quite striking in the work. In one way, you often play with a sense of painterly form, and a particular approach to the found object—polarities normally (at least in an 'academic' sense) kept apart. The found objects 'flimmer' in your work between recognition as everyday things and beyond this, as 'pure form', for want of a better term. What brings you to choose particular objects?

JS: This question is frequently asked. And I don't have a clear answer. I like to say that at some level I could use anything. I think there is some truth to that but clearly this is not the whole truth. I respond to things in many ways—to their structure, their abstract qualities, colour, weight, mass, to their history of production, to their wear and tear, and to how they act when displaced. I have often used the word 'narrative'. I think that narratives are given rise to by the work, though I don't think 'narrative' is quite the right word. I think I spend my time trying to disrupt narrative to see what will arise rather than trying to create it—perhaps like playing with blocking a stream of water to see what routes it will take.

DR: But you have a very particular conception of materials/objects to be used for a space—and often request specific things to use.

JS: Yes, I do. When I make an installation, I go to see the space beforehand and look around to see what kinds of materials are available. I also ask for catalogues to be sent to me and ask for any suggestions that people have regarding materials. Then I sit down at home and I make drawings, usually starting with a plan of the space. I sit in front of the piece of paper trying to find materials in my head. When I work in the studio, I use things cast off from my house, things people have given me, things I happen on to and things I think of to buy. So, I choose materials in many ways, both rational, predetermined and by chance, and some might say 'intuitively'. Though that word 'intuitive' is often used to imply lack of thought, I think it points to a kind of thinking difficult to define. On some level it seems right to say that I could choose any material and what matters to me is how the abstract making of fiction I'm involved with meets real materials in the world. On the other hand, this seems clearly to be not the whole story. I 'choose' from a vast array of things out there, and I'm happy for the narrative every material brings with it. Looking back at the history of what I've done, it's clear that there are things I gravitate towards: fridges, oranges, fans, lights, etc. How narrative does or doesn't emerge isn't something I suffer over. I watch it happen while I focus on bringing together the parts and constructing something light and airy that floats apart.

DR: These objects are sometimes engaged in a gestural approach. In fact, gesture is used in many different ways in the work—from references to 'colour fields' to broken, 'unfinished', hand-painted patches. Could you say something about this in relation to your recent work and thinking?

JS: I'm not sure what you're getting at by this question—unless you're talking about the hand in gesture, the gesture as personal, or the gesture as vulnerable? That's all in there.

DR: Yes, I do mean all those things—but also the fact that there's often a very formal quality to the gestures, and yet they never reach the kind of 'harmonic closure' you might find in a traditional abstract painting.

JS: You're using the word 'gesture' to mean many different things. It isn't a word I've used a lot. Though I do remember Lynne Tillman once described the painted pieces in my work as being almost like different characters in a fictional narrative. Her observation has stayed with me. Each painted 'character' could also be understood as a gesture; it also makes sense to think of my work as a gesture towards the dialogue or conversation of art.

Figure 40 Jessica Stockholder, *Vortex in the Play of Theatre with Real Passion*
2000, Mixed media, Dimensions variable, Installation at Kunstmuseum St Gallen, Switzerland, Courtesy Gorney Bravin + Lee, New York.

DR: I remember seeing the work at the Hayward in London,[1] some years ago now, and I was intrigued as to how you articulated the space; it seemed very controlled in one sense—I remember the installation led around a corner and into another area that had a dramatically different feel to it. It underlined a feeling of an expanding and ever-more complex space—the second half of the installation utilising fridges and lights. This may well be connected to the construction of a visually formal narrative, which you've already mentioned—but also the 'theatrical' in the way that the spectator is bound up with the piece on a temporal level, almost like wandering in the space of painting. How do you see this element of the theatrical—or we might even call it cinematic—not unlike that movie *Fantastic Voyage*—the spectacle of being inside a body?

JS: The piece at the Hayward was self-consciously part of a 'painting show'. It presented two different faces, like two different paintings—with a lot of space between them; I've been thinking a fair amount about theatre in art ...

DR: In what sense?

JS: Well, when I was a student, 'theatrical' was a bad word, for whatever reason. When I was in graduate school I read Brain O'Doherty's book *Inside the White Cube*. This set of essays served to articulate the thinking I'd grown up within; it set forth quite clearly the immediate bit of history that I was growing from. He described the uncomfortable and fraught relationship between the artwork and its physical context. I understand the turmoil and shifting he describes as an exploration of the context of art within the culture. We understand art as something separate from, and removed from, the rest of our living. Our galleries and museums function to uphold the separation, and I'm both in love with, and upset by, such a separation. At the moment, it's clear that all attempts to escape the gallery were on some level unsuccessful. Gallery and museum spaces continue to bracket or frame art.

DR: But I suppose the kinds of platforms or prop-like nature of events in some of the works, even the earlier ones, could be related to the theatrical?

JS: Yes, I think that is right, although maybe I haven't always seen it in that light. In the aftermath of this struggle with the physical bracketing of art, things in the gallery have become like props on a stage. Having struggled out of the frame and off the pedestal it's clear that art nevertheless rests on the frame of the gallery. As so much 'sculpture' today is not sitting on a pedestal and we recognise that the move off the pedestal into the space of the gallery is not revolutionary, the gesture instead becomes theatrical. The space of the gallery houses a kind of theatre, illusion or fiction. It's become clear that in order to be shared, art must be bracketed by something. Instead of attacking

the space of the gallery, many artists are exploring alternative brackets: the fashion world, television, the Internet.

DR: What you've just described also brings up the issue of the boundary or the 'frame', which we've already touched upon. I was interested to read your statement: 'the frame, though it is only an abstraction, functions to hold the work apart from 'real time' and remove it to an elevated timelessness'.[2] But you also go on to suggest that it's the viewer who frames: the processes of 'unbinding', dissolving the 'frame' of the work is complemented by its active 're-framing' on the part of the viewer. Is this also connected to what you've been referring to as 'narrative'?

JS: Yes, I think so. The frame is such a powerful convention. Framing is everywhere: in magazines, TV, doorways, windows … houses are rectangular and walls frame things. Framing is both physical and conceptual. Recently, I've been thinking about framing in relation to private property and ownership. I've just moved from Brooklyn NY to New Haven, where I'm surrounded by houses and lawns. I notice that each property is made pictorial; each house and its landscaping is composed within the bounds of ownership. I'm thinking about taking some photographs in order to explore this. I find it exciting to think about the frame so powerfully functioning outside of the gallery. My work has always acted in relation to ideas of framing; ideas that exist inside people's heads. The idea of the frame is an abstraction. My work depends on that abstraction to cohere.

DR: It's an interesting fact that the more we become immersed in electronic media, the more we find work—such as your own and many others—that rejects a bounded unity of surface (ironically we can see this as 'screen-like' in its own way) and incorporates the environment in an active and heterogeneous way, perhaps emphasising the material over the immaterial, and stressing the physical, active participation of the viewer?

JS: I'm interested in the balance between the material and immaterial; between action and passivity in the viewer. The abstraction of the frame as backbone to my work seems not unrelated to cyberspace. Both experiences are intense because we experience them as concrete though they don't consist of matter. However, the speed with which electronic media are being developed at the moment does make me feel my age. And, my living, ageing body is material; this fact of life won't go away.

DR: In this context, I'm also interested in how you talk about electricity as a 'flow' or an energy in the work—literally a flow through wiring in some of the installations. Could you say something about this?

JS: I began using electricity because I enjoyed how it's active, though we can't see it move. As such, it's in contradiction to the static unmoving composition that my work depends on. Right from the start, I also enjoyed the way plugging something in, anchors it to place and time. The flow of electrical energy can be understood as a metaphor for human energy. I've never been sure what the words 'spiritual' or 'transcendental' mean ... Perhaps my work winds its way through or towards an attempt to understand what they might mean, leaving the romantic out of it. It also makes sense to see my work through the lens of the old mind/body question.

DR: You once suggested that you see 'collage as a way to include a huge array of subjects'.[3] Is this also a process of gathering what might be seen as irreconcilable differences? What are your approaches to the issue of collage?

JS: Yes, I like difference, chaos, contradiction. I use collage in the same way I use architecture.

DR: I recently came across a quote by John Rajchman discussing Deleuze, in particular his ideas around the 'virtual' in relation to blankness, where he suggests: 'To paint one must see the surface not so much as empty but rather as intense, where intensity means filled with the unseen virtuality of other strange possibilities—one must become blind enough to see the surface as mixed or assembled in a particular transformable and deformable manner rather than just flat'.[4] I wondered if you found this sympathetic to how you might treat a particular building or architectural space—experiencing it as 'intense', rather than empty?

JS: Yes, I like that description of the canvas and it describes my relationship to canvas well. An empty canvas, like an empty gallery, pretends to be blank when it isn't. Working on canvas I felt angry at the amount of power I was given. Every slight gesture changes the 'world' within the canvas. Working in relation to buildings and with things from daily life, in addition to pretended neutrality and emptiness, I have a lot of 'content' to deal with. Things fight back and resist me. My subjectivity is not all that's at issue.

DR: Thinking about this expansion from the flat plane, you've used objects, electricity, lights etc—sometimes projected light against the wall (as in *Kissing the Wall #4: Red and Green*, 1988)—but would you ever consider incorporating the moving image, as in film or video, perhaps using them as interruption, dislocation, rupture? How do you feel about this?

JS: What you say reminds me of Pipilotti Rist's installations. Do you know her work?

DR: Yes, but not that well.

JS: In her last show, she used projections—many of them very small—onto furniture. She used domestic lamps, decoration etc, and the whole thing was rich and visually complex. I was interested in how the projections mingled with those things and did feel an affinity with my own work. Perhaps I will use video or film but I do feel ambivalent about it. There's an enforced distance or detachment that arises from any photographic imagery. I enjoy, and use, these things in my work at present, but I also enjoy shattering the feeling of distance by working with things. I've never much enjoyed being behind a camera, and I tend to have an embattled relationship to being photographed. There's a voyeuristic aspect to photography. It's a little violent. Through my work I struggle to get closer to particular experience; I struggle to provide it for myself and for others. Film has much to offer, but it does render the viewer passive.

NOTES

1. 'Unbound: Possibilities in Painting', Hayward Gallery, London, 1994.
2. Barry Schwabsky, Lynne Tillman, Lynne Cook, *Jessica Stockholder*, Phaidon (London) 1995, p. 142.
3. Dialogue between Fabian Marcaccio and Jessica Stockholder, April 15–May 22, 1998, in *Fabian Marcaccio, Jessica Stockholder*, Sammlung Goetz (Munich), Kunstverlag Ingvild Goetz, 1998, p. 52.
4. John Rajchman, *Constructions*, MIT Press (Cambridge, MA), 1997, p. 61.

NOTES ON ARTISTS AND CONTRIBUTORS
Artists

Ian Davenport was born 1966 in Kent, and studied at Goldsmiths College, London. He has exhibited extensively in England and abroad, including one-person shows in Waddington Galleries, London, Dundee Contemporary Arts and Tate Liverpool. Various group exhibitions include 'About Vision' at the Museum of Modern Art, Oxford; 'Real Art', which toured various venues in the UK, and numerous others in Bremen, Berlin and Madrid. He was also included in the 1996 survey show 'Nuevas Abstracciones' at the Reina Sofia, Madrid. He lives and works in London.

Lydia Dona was born in Rumania in 1955 and studied art in Jerusalem and New York, where she is now based. She has exhibited widely in Europe, including Galerie Barbara Farber, Amsterdam; Marc Jancou Galleries, both in London and Zurich, as well as Galerie Nacht St Stephan, Vienna. A travelling survey show, 'Lydia Dona 1989-95 Survey', was organised by the University of Buffalo Art Gallery/Center in Art and Culture.

Günther Förg was born in 1952 in Füssen, studied in Munich and now lives in Areuse, Switzerland. In 1996, he was awarded the Wolfgang Hahn Prize. He has exhibited his sculpture, paintings and photographs together and singly, and has received major one-person shows at the Secession, Vienna, the Stedelijk Museum, Amsterdam, and more recently, a touring show that included the Reina Sofia, Madrid and the Arken Museum for Moderne Kunst, Copenhagen. He has also been represented in various group shows, such as the 1996 survey, 'Nuevas Abstracciones', Reina Sofia, Madrid.

Bernard Frize lives and works in Paris. He has received many solo exhibitions including Villa Medici, Rome; Kunsthalle, Zurich; Galerie Nacht St Stephan, Vienna; Frith Street Gallery, London, and Musée St Etienne. Group exhibitions have included the 'Carnegie International', Pittsburgh; 'Der Zerbrochene Speigel- Positionzur Malerei', Kunsthalle, Vienna; 'Chance, Choice and Irony' at the Todd Gallery, London, and 'Now and Forever' at Pat Hearn Gallery and Matthew Marks Gallery, New York. His major retrospective of 200 paintings was shown at various museums including Musée d'Art Contemporain, Nimes, and Museum Moderner Kunst, Siftung Lundwig, Vienna.

Mary Heilmann was born in San Francisco in 1940. She attended the University of California at Santa Barbara, and UC Berkeley. From 1979 to 1986 she taught at the School of the Visual Arts; she has also been a visiting professor at the San Francisco art institute and at Skowhegan School of Painting and Sculpture, Maine. She has been included in various group

shows in Europe and many acclaimed solo exhibitions in the US, including 'Mary Heilmann: Survey' at the Boston Institute of Contemporary Arts, and 'Mary Heilmann: Greatest Hits' at Pat Hearn Gallery, New York.

Shirley Kaneda was born in Tokyo 1951, and moved to New York in 1970. She has received various solo exhibitions at Jack Shainman and Feigen Contemporary in New York, as well as Galerie Evelyne Canus, France, and Rafaella Cortesa Gallery, Milan. Besides the many group shows in which she has been included, Kaneda has also been actively involved with the discourse around contemporary abstract painting, publishing numerous articles and interviews with artists. She has shown recent work in Centre d'Art d'Ivry in France and is a recipient of a Guggenheim fellowship.

Jonathan Lasker was born in Jersey City, New Jersey, in 1948. He attended the School of Visual Arts, New York and the California Institute of the Arts. Since 1981, he has shown with Tibor de Nagy (New York), Michael Werner (Cologne), Thadeus Roppac (Paris), Timothy Taylor (London), Sperone Westwater (New York), amongst others. His work is owned by numerous museums and was the subject of a travelling museum retrospective including the Stedelijk Museum in Amsterdam, and venues in France, Switzerland and Germany. He has also recently shown paintings from the 1990s in a touring exhibition in the United States entitled 'Selective Identity'.

Fabian Marcaccio was born in Argentina in 1962, where he studied at the Facultad de Filosofia de la Universidad Nacional de Rosario. He has had numerous one-person shows at Galerie Rolf Ricke, Cologne, Bravin Post Lee Gallery, New York, Ruth Benzacar in Buenos Aires, Argentina, and other venues in Holland, Mexico and Brazil. His work has also been shown in various group shows curated by David Moos, Michael Darling, Udo Kitelmann and Carlos Basualdo amongst others. Two recent major exhibitions include, 'Withject, Spain' at Galerie Salvador Diaz/Juan Prats in Madrid, and 'Fabian Marcaccio/Jessica Stockholder', at Sammlung Goetz, Munich. He was also included in the exhibition 'Hybrids' at Tate Liverpool.

Thomas Nozkowski was born in New Jersey in 1944. Educated at The Cooper Union, New York City, he has since been recipient of numerous awards including a Guggenheim Fellowship and National Endowment for the Arts. His work is in many public collections including the Addison Gallery of American Art (Andover, MA), The Hirshhorn Museum and Sculpture Garden (Washington DC), the Metropolitan Museum of Art (New York), the Museum of Modern Art (New York) and the Philips Collection (New York).

David Reed was born in San Diego, California in 1946 and lives and works in New York. He has received Rockerfeller, Guggenheim and National

Endowment for the Arts Fellowships. He has received one-person exhibitions at Rolfe Ricke, Cologne; Max Protetch, New York; the San Francisco Art Institute, amongst others, and more recently, showed a series of 'vampire paintings' with related material at the Landesmuseum, Graz, Austria. A retrospective exhibition entitled *Moving Pictures* was held at the Museum of Contemporary Art, San Diego, and at PS1 Art Center, New York.

Gary Stephan was born in Brooklyn, New York in 1942. He was educated at Parsons School of Design, the Art Students League, New York, the Pratt Institute, New York and in California at the San Francisco Art Institute. Since the late 1960s, Stephan has received numerous one-person shows including Mary Boone gallery, New York, the Baumgartner Galleries, Washington DC and Galeria Siboney in Santander, Spain, together with inclusion in group shows across the US and Europe. Stephan has also been the subject of a travelling survey exhibition in the United States.

Jessica Stockholder was born in 1959 in Seattle, Washington, studied at the University of British Columbia, and undertook her MFA at Yale University. She has exhibited at many eminent venues including the Whitney Biennial (New York), Paula Cooper (New York), the Kunsthalle, Zurich, Thread Waxing Space, (New York), the Hayward Gallery, London, the Saatchi Gallery (in the show 'Young Americans'), also in London, and more recently, Centre for the Visual Arts, Cardiff, and Kunstmuseum St Gallen, Switzerland. She is currently Director of Graduate Studies in Sculpture, Yale University.

Contributors

Carlos Basualdo is an Argentinian poet, art critic and independent curator. He has contributed to *Artforum* and is a Contributing Editor of *Trans*.

'Tents of War' originally appeared as 'Tiendas de Guerra' in *Art Nexus*, no 24, April 1997.

Andrew Benjamin is a Professor in the Department of Philosophy, University of Warwick and Director of the Centre for Research in Philosophy and Literature at Warwick. He has also been a visiting Professor at Columbia University, New York. Besides various publications concerned with philosophy, his writings on art include: *Art, Mimesis and the Avant-Garde; The Plural Event; Object—Painting* and *What is Abstraction?*

Arthur C Danto is a distinguished philosopher who has written extensively on art. His publications have included *The Transfiguration of the Commonplace; The Philosophical Disenfranchisement of Art; Beyond the Brillo Box* and more recently *After the End of Art: Contemporary Art and the Pale of*

History and two volumes of essays entitled *The Seat of the Soul*. He is the Johnsonian Professor Emeritus of Philosophy at Columbia University. In 1990, he was awarded the National Book Critics Circle Prize in Criticism.

'Between the Bed and the Brushstroke' was originally published in *David Reed*, Stuttgart, Köln, Münster Kunstvereins, Verlag Cantz 1995, and reprinted by permission of George Borchhardt Inc.

Jeremy Gilbert-Rolfe is a critic and abstract painter. He presently teaches at the Art Center College of Design, Pasadena, California. He is author of *Beyond Piety: Collected Essays on the Visual Arts, 1986–1993* and has contributed *to Artforum, Arts Magazine and Art & Text* as well as numerous catalogues and essays. His recent publications include *Beauty and the Contemporary Sublime*. He has been awarded National Endowment for the Arts fellowships in painting and criticism as well as a Guggenheim fellowship in painting, and was presented the 1998 Frank Jewett Mather Award for Art Criticism by the College Art Association. As an artist, he has exhibited regularly in the US and Europe since 1974.

'Notes on Being Framed by a Surface' is an expanded version of an article of the same title published in *Art & Text*, Summer 1998.

Jennifer Higgie is an Australian writer who lives in London. She is the Reviews Editor of *Frieze* magazine.

'With Wanton Heed ...' was first published in *With Wanton Heed and Giddy Cunning Hedging Red and That's Not Funny*, Centre for Visual Arts (Cardiff), 1999.

David Joselit is author of *Infinite Regress: Marcel Duchamp 1910–1941* and writes regularly on issues of contemporary art and culture for *Art in America*. He is currently an Assistant Professor in the Department of Art History at the University of California, Irvine.

'Mary Heilmann's Embodied Grids' was originally published in *Mary Heilmann: A Survey*, Boston Institute of Contemporary Arts, 1990.

Joseph Mashek is an art historian and critic. Professor of art history at Hofstra University, outside New York, he has also taught at Barnard College, Columbia and Harvard. He edited *Artforum* from 1977–1980. His books include *Building-Art: Modern Architecture Under Cultural Construction; Modernities: Art-Matters in the Present*; and, most recently, the introduction to a new edition of Arthur Wesley Dow's *Composition* of 1899.

'Painting in the Double Negative: Jonathan Lasker', was originally published in this version in *Modernities: Art-Matters in the Present*, Pennsylvania State University Press, University Park, 1993.

David Moos is a writer and curator. He has co-authored several books with Rainer Crone such as *Object/Objectif*; and *Kasimir Malevich: The Climax of Disclosure*, and edited *Painting in the Age of Artificial Intelligence* for A & D magazine. He has been Director of Exhibitions at the Edwin A Ulrich Museum, Wichita, Kansas, and more recently, Curator of Painting, Sculpture and Graphic Arts at the Birmingham Museum of Art, Alabama. He curated an international touring exhibition, *Theories of the Decorative*, which was featured as part of the 1997 Edinburgh International Festival and included David Reed, Fabian Marcaccio, Juan Uslé, Ingo Meller and Beatriz Milhazes, amongst others.

'Lydia Dona: Architecture of Anxiety', was originally published in the 'Abstraction' issue of *Journal of Philosophy and the Visual Arts* (no 5), ed Andrew Benjamin, Academy Editions (London), 1995.

Robert Pincus-Witten is the author of various collections of essays, and has held various editorial posts, including 1966-76, Editor and Senior editor at *Artforum* and from 1976-89, Associate Editor at *Arts Magazine*. He has also held various Professorships in Art History at the City University of New York and his publications include: *Entries (Maximalism): Art at the Turn of the Decade*, and *Postminimalism into Maximalism: American Art 1966–86*, together with numerous articles, reviews and catalogue essays.

'Gary Stephan: The Brief Against Matisse' was originally published in *Arts Magazine*, March 1982 .

David Ryan is an abstract painter and writer, living and working in London. He has a strong interest in contemporary music and has written on John Cage's music and visual work as well as Morton Feldman, Helmut Lachenmann and Earle Brown. He is currently a Senior Lecturer at Chelsea College of Art and Design in London. He has written on Shirley Kaneda, Bernard Frize, John Riddy, Katherina Grosse, Karin Sander, Fabian Marcaccio, amongst others, and for *Dissonanz, Contemporary Visual Arts, Tempo, Modern Painters, Artes de Mexico*. He has also contributed to numerous catalogues including publications for Camden Arts Centre, London, Galeria Salvador Diaz, Madrid, Tate Liverpool, Sammlung Goetz, Munich, and the University of Mexico (UNAM) in Mexico City.

All the interviews conducted by Ryan presented here are exclusive to this publication except that with Fabian Marcaccio, which appeared in a slightly different form as 'Paradoxical Networks' in *Fabian Marcaccio/Jessica*

Stockholder, Sammlung Goetz, Munich; and in *Withject, Spain*, Galeria Salvador Diaz/Juan Prats (Madrid), both 1998.

Peter Schjeldahl was formerly the art critic for *The Village Voice*, and more recently, *The New Yorker*.

'Hard Bliss: The Essential Thomas Nozkowski', originally appeared in *Thomas Nozkowski: Twenty-Four Paintings*, Corcoran Gallery (Washington DC), 1997.

Guy Tosatto was born in 1958 in Grenoble. After graduating in Art History, he was the first Director of the Musée départmental de Rochechouart, where he constituted the collection and programmed temporary exhibitions, for example, of the work of Richard Long, Christian Boltanski and Annette Messager. Since 1993, he has been Head of Carré d'Art, Museum of Contemporary Art in Nîmes, where he has organised various exhibitions with Juan Muñoz, Sigmar Polke, Guiseppe Penone, Gerhard Richter, Alan Charlton, Bernard Frize and others. He has published essays on each artist in the accompanying catalogues. Since 1997, he has also directed the Musée des Beaux Arts de Nîmes.

'Rules and Their Exceptions' was originally published in *Bernard Frize, Size Matters*, Actes Sud (Nîmes), 1999.

Max Wechsler is a writer and lecturer currently teaching at the School of Art and Design in Lucerne, Switzerland. As a freelance art critic, he is a frequent contributor to books, exhibition catalogues and art journals. He has written on Marcel Duchamp, Per Kirkeby, Reinhard Mucha, Blinky Palermo, Markus Raetz and Ulrich Ruckreim amongst others. Recently, he collaborated on a series of exhibitions with Günther Förg, Thomas Hirschhorn and Imi Knoebel at the Luzern Kunstmuseum.

'A Complex Spectacle, Staged with Careful Attention to Detail: An Essay on the Art of Günther Förg' was originally published as 'Ein Komplexes Schau-Spiel, inszeniert auch im Detail: Kunst von Günther Förg' in the catalogue *Günther Förg*, Kunstverein Hanover, 1995/6.

Andrew Wilson is an art historian, art critic and curator. He is currently assistant editor of *Art Monthly* (London) and was the London Correspondent of Forum International (Antwerp) 1990-93. He has published widely, and recent publications include catalogues for Brad Lochore, Bridget Smith, Mark Wallinger, Jeff Luke, Bridget Smith and Fiona Banner and books on Gustav Metzger, Paul Graham and Vorticism. He also wrote the catalogue for the exhibition *From Here, Painting in the 90s* Waddington Galleries, London, 1995. He lives in London.